THE CROSS
MEDITATIONS AND IMAGES

The Cross

Published by Gilgamesh Publishing in 2013
Email: info@gilgamesh-publishing.co.uk
www.gilgamesh-publishing.co.uk

ISBN 978-1-908531-29-2

CIP Data: A catalogue for this book is
available from the British Library

Endpapers: Graffiti crosses, the Church of the Holy Sepulchre, Jerusalem, Israel

By the same author:
Faces of India: An Anthology of Poetry and Pictures
for Mother Teresa of Calcutta, 1974.

Printed in the UK by Butler Tanner and Dennis Ltd

THE CROSS
MEDITATIONS AND IMAGES

SERENA FASS

FOREWORD BY HRH THE PRINCE OF WALES

GILGAMESH
PUBLISHING LTD

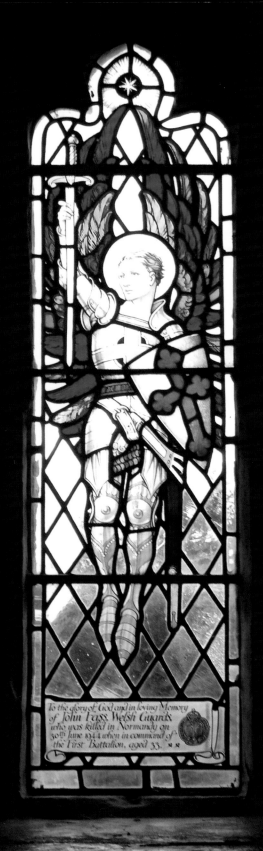

To the glory of God and in loving Memory
of John Fass Welsh Guards
who was killed in Normandy on
30th June 1944 when in command of
the First Battalion, aged 33.

For my father

whose Cross of sacrifice stands in France

20th-century stained glass window, Cross Bottony, commemorating
Lt Colonel John E Fass, Welsh Guards, St Michael's Church, Inkpen, Berkshire.

CLARENCE HOUSE

As Colonel of The Welsh Guards, I have met Serena Fass on a number of occasions at Welsh Guards Remembrance Services, normally held at The Guards Chapel in London, where a commemorative plaque is dedicated to her father, the late Lieutenant Colonel John Fass, who was sadly killed leading the 1st Battalion in Normandy in 1944.

As Patron of The Welsh Guards Afghanistan Appeal, I can only commend Serena for providing a donation raised from the proceeds of this book to the Appeal. It speaks volumes not only of her charitable instincts, but also of the uniqueness of a family regiment that continues to provide for those serving, past, present and future.

Charles

HRH The Prince of Wales KG, Garter Day 1990, Windsor Castle, England.
Members of the Most Noble Order of the Garter, wearing their ceremonial vestments and insignia, meet in the state apartments in the Upper Ward of Windsor Castle. Led by the Military Knights of Windsor, they process on foot through the castle to St George's Chapel, for the service. New knights are installed on this occasion. After the service, members return to the Upper Ward by Carriage.

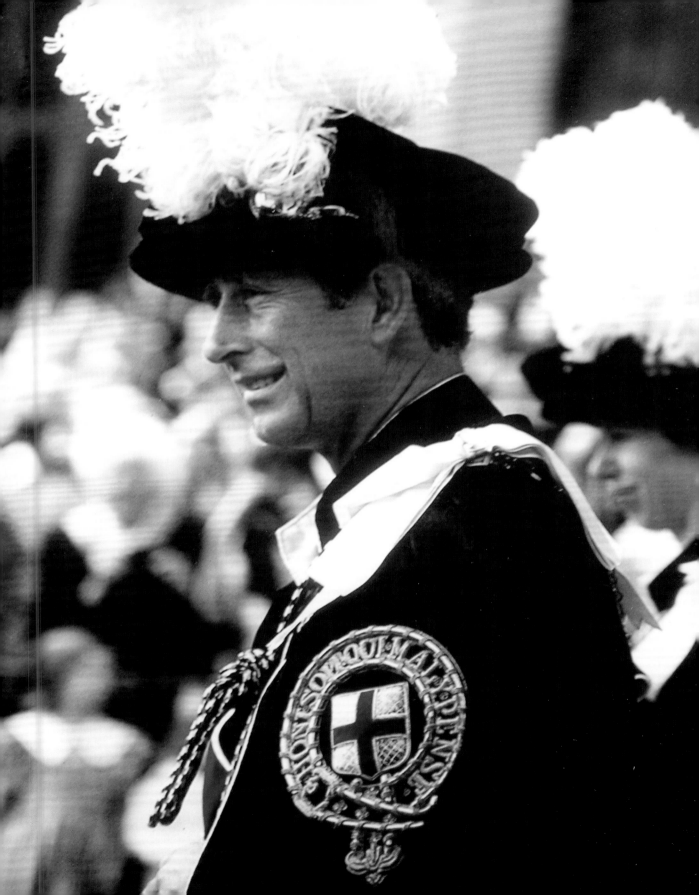

Contents

16th-century royal doors, tempera and gesso on wood panel, Rostov-Suzdal school, Russia.

Photograph: courtesy of The Temple Gallery.

Acknowledgements

My grateful thanks are due to HRH The Prince of Wales, for writing my foreword.

To John and Susan Wright, for inspiration to compile this book.

To John Julius Norwich; Field Marshal Lord Guthrie of Craigiebank and David Verey for their commendations and to Abbot Timothy Wright OSB in Rome for his *Reflections on the Cross through Images*.

To HM King Simeon of Bulgaria for his pectoral cross; Caroline Lees for her Russian altar cross and her new icon of St Catherine; David Maude-Roxby-Montalto, Duke of Fragnito, for his new Processional Cross and Peregrine Bertie for photographs of his brother, Fra Andrew Bertie's State Funeral in Rome.

For writing special meditations:
Alexandra Asseily; Richard Bergmann; Roy Calvocoressi; the Rt Rev'd and Rt Hon Lord Carey of Clifton, PC; Costas Carras; the Rt Rev'd and Rt Hon Richard Chartres, Bishop of London; Fiona Costa: the Venerable Patrick Cullen, Archdeacon of Vienna; Dr Giancarlo Elia; the Lord Elton; Dr Peter Frankopan; Abbot Gennadios, (translated by Daphnis Panagides); David E Hunt; Nigel Inglis-Jones: the Rev'd Canon J.John; the Rev'd Prebendary Dr Brian Leathard; Ramani Leathard; Christian de Lisle; Princess Tatiana Metternich; the Rt Rev'd Sandy Millar, Assistant Bishop in London; Antonia Moffat; the Rev'd Canon Dr David Reindorp; the Rev'd Dr William Taylor; the Rt Rev'd Derek Watson; the Venerable Sheila Watson, Archdeacon of Canterbury; John Wright and Abbot Timothy Wright OSB.

For extracts from their sermons:
The Right Rev'd Michael Langrish, Bishop of Exeter; the late Rev'd Dr Robert Martin-Achard, (Geneva); the Venerable Dr Jane Hedges, Canon Steward and Archdeacon of Westminster; Metropolitan Kallistos of Diokleia; the Most Reverent Vincent Nichols, Archbishop of Westminster and the Most Rev'd Metropolitan Seraphim El-Suriani of Glastonbury, of the British Orthodox Church within the Coptic Orthodox Patriarchate of Alexandria.

Gerard de Lisle for translations from the Italian by Ambrose de Lisle; Elise, widow of Richard Hobbs and the executers of the late Cardinal Basil Hume, for permission to quote from their work; the late Henry E Verey.

For their help with research:
Michael Burrell; Marie-Claire Cuendet (Geneva); Michael Dormer; Sally Dudley-Smith; Dr Giancarlo Elia; the Rev'd Dr Michael Fass; Marchese Tullo Guerrieri Gonzaga (Verona); Archbishop Gregorios of Thyateira and Great Britain; Lady Guthrie; Jonathan Harris; Elisabeth Kontidou (Thessalonika); Claire-Lise Presel (Washington); Metropolitan Seraphim El-Suriani; Baroness Stillfried (Vienna); Sir Richard Temple, Bt; Jessica Tcherepnine (New York) and Dr John Villiers.

All photographs are taken by the author unless otherwise stated.

Photograph credits:
Henrietta Armfield; Richard Bergmann; Jane Blunden; Jennifer, Marchioness of Bute; Harriet Cullen; Giancarlo Elia; Roddy Fisher; John Gunter Rare Books, Hamburg; Nabila Harris; Dr John Hemming; Iain Hepbun; Justin Hunt; the late Blaise Junod; Anusha Leathard; Caroline Lees; Lady McNair-Wilson; Indar Pasricha; Claire-Lise Presel; Piffa Schroder; Metropolitan Seraphim; the late Sir Reresby Sitwell Bt; Spinks, London; Dr Christopher Tadgell; Jane Taylor; Terence Tofield; Philippa Vaughan; Jim Wheeler; David Wright and Abbot Timothy Wright OSB.

Photographs taken by, or with permission, in the following museums:
Trustees of the Alte Pinakothek, Munich; Trustees of the Museo Arqueológico, Madrid; Trustees of the Musee de l'Art et de l'Histoire, Geneva; Trustees of the Ashmolean Museum, Oxford; Trustees of the Benaki Museum, Athens; Trustees of the British Museum, London; Trustees of the Byzantine Museum, Athens; Trustees of the Byzantine Museum, Thessalonika; Trustees of the Castle Museum, Passau; Trustees of the Coptic Museum, Cairo; Trustees of the Kunsthistorisches Museum, Vienna; Trustees of the Galleria Nazionale dell'Umbria; Trustees of Melk Abbey; Trustees of the Metropolitan Museum of Art (Cloisters), New York; Trustees of the Musee de la Reform, Geneva; Trustees of the Residenz, Munich; Trustees of the Museo di San Francesco, Montefalco, Italy; Trustees of the History Museum, Sofia; Omer M Koç and the Sadberk Hanim Museum, Istanbul; Trustees of the Victoria and Albert Museum, London; Trustees of the Virginia Museum of Fine Art, Virginia; also The Temple Gallery; the Provost, Eton College and the Warden and Scholars, Winchester College.

To Bridget Bell; Henry Dallal; Algernon and the Hon Jane Heber-Percy; the Hon Susan Pakenham; Martin Kochanski; Barnaby Rogerson; Antony Snow; Emma Verey; Lord Vinson and Jim Wheeler for all their help.

To Caroline Lees for introducing me to Max Scott and Charles Powell of Gilgamesh Publishing, who have produced this book in record time while satisfying my every wish and to the many other friends who have helped me complete this project, my heartfelt thanks.

Serena Fass
Epiphany 2013

11

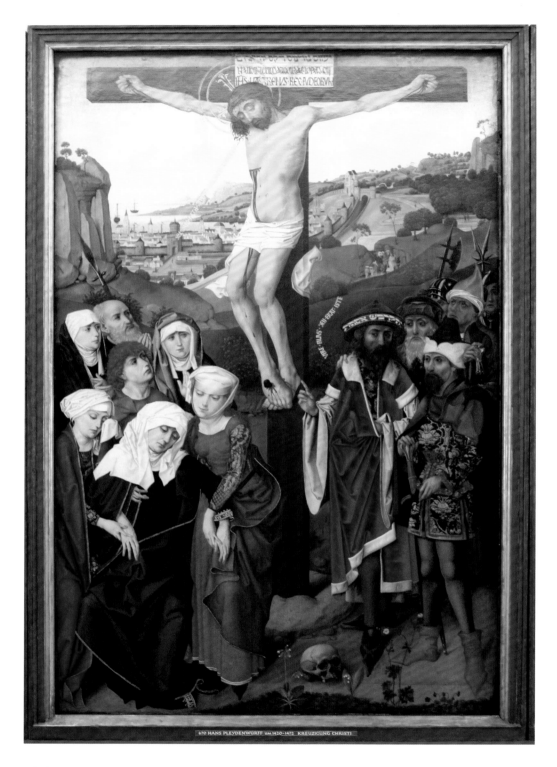

Painting, 1465, mixed media on panel. Christ on the Cross with the Virgin Mary,
St Mary Magdalene, St John, the High Priest Caiaphas and Herod.
Hans Pleydenwurff (1420-1472). Alte Pinakothek, Munich, Germany.

Photograph: courtesy of Alte Pinakothek.

Reflections on the Cross through Images

The Cross, however designed, represents the most horrific way any human being could die. It symbolises the worst that humans do to each other. It shows the most degrading way of treating the human body and is the most cruel method of extinguishing a human life. It allows no comfort to those who stand and watch their loved ones die. Crucifixion degrades judge, executioner, victim and observer. It still continues.

Beyond this degradation, Christians have been empowered to see something greater, and new, emerging from the crucified corpse of the God who became Man, in Jesus Christ. Like so many millions of others, before and since, he was a victim. Nothing in his behaviour was criminal enough to deserve such a capital sentence. The authorities of his time thought differently. To them he was a threat to their power for Jesus healed people, he did not exploit them. Even on holy days when 'work' was not permitted, he brought healing, repairing broken bodies, giving life to the dead, even controlling nature – disempowering wind, expanding a few loaves to feed multitudes, walking on water to save his struggling friends.

Such work can only be a threat to those who hunger for the power to exploit.

That power is destructive, of the victim and the agent, of community and humanity.

Power used for selfish ends always destroys someone else. The power that Jesus brought to the world, was a power to affirm, to heal, to expand. Nowhere was this power more convincingly shown than in the manner of his death. He alone held the key to unlock the door, closed tight till then for the whole of human history. Not even the great men and women of Hebrew history, like Abraham, Moses, or David, not Deborah, Ruth, or Esther. Without the key they could only dream of a future beyond the door. Dreams come and go, and the hints of life beyond that door were held by some and ignored by others. Jesus had the key, shown by his teaching, demonstrated in miracle and promised to the thief dying alongside him. The empty tomb, followed by Jesus' real appearance to Mary Magdalene, changed it all. No wonder the disciples who met the Risen Jesus on the road to Emmaus, were so astonished. It is precisely that astonishment we recall when we look at the Cross. Death no longer has any power, not just for a few, but for anyone who sees the Cross as the gift of life, a gift to be shared with the 'other', not possessed for myself. That is what makes the Cross unique and precious. Without it the future is increased pain, suffering and despair. With it we look forward with hope and trust to eternal joy in the presence of God. No eye has seen, no ear has heard, no mind has conceived, what God has prepared for those who love Him. This is the message of the Cross.

20th century marble cross, Jerusalem, Israel.

With this in mind, I have three special crosses which I gaze at each day.

The first is a simple stone cross, made by an artist in Bethlehem, from the local stone, on which Jesus would have stood and walked. It is a pink 'marble' with white streaks. Its simplicity says it all. There is no corpse. Jesus now lives by His resurrection and the pink reminds me of the blood that was shed to secure life beyond death. It also reminds me of the blood shed by millions of innocent people, caught in the cross-fire of rivalries, great and small, especially the pain and suffering being endured today in that land where Jesus was born.

The second is a corpus carved in wood, and subsequently mounted on a plain wooden cross of English oak. The figure is quite unlike any other. Jesus hangs with a dislocated neck. That adds another dimension to his pain-filled suffering. The carver was Zimbabwean and reminds me not only of the destruction in that beautiful country, but also the destruction of our natural world by the insatiable energies of human greed. It is more than pain, it is the distortion of the natural world for short-term ends.

The third cross comes from Tanzania, in an area where Benedictine monks have worked for many decades. The cross is designed by a monk produced by local carvers and offered to all as a sign of the Christian faith. On top of the cross sits the Risen Christ, dramatically signifying our faith in resurrection and reminding us that death is a doorway, not an end. Now we share partially in that risen life. It is a carving of great hope.

So the pink streaks in the stone, the dislocated neck of the dying Jesus, and the risen Christ seated on the empty cross, offers a threefold reminder, of the evil we can do to our neighbour, deliberately or not, of the destruction caused by our distorted greed, and, the gift that is available to all, that has the power to transform evil and distortion into beauty. From the cold absence of the dead Jesus to the loving presence sitting atop the instrument of his death to the moment, we reflect on the journey each of us has to make, excited by the promise that the end of that journey will see our love, limited now, expanding in rising with Christ, to become ever closer to the Love who is God, Father, Son and Holy Spirit, now and for ever. Amen.

Abbot Timothy Wright OSB
Abbot Emeritus of Ampleforth Abbey, York, England.
Currently working in the Pontificio Collegio, Rome, Italy, as adviser to the Abbot Primate Notker Wolf OSB on the relationship between Benedictine communities and Islam.
Rome 2012

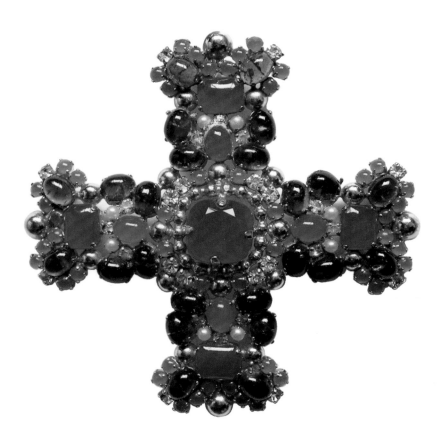

Preface

I have been interested in crosses for over forty years. Thanks to being in the travel business since 1970, I have photographed countless examples as I went around the world for my travel company Serenissima and subsequently for Noble Caledonia and TransIndus. My collection of colour slides provided me with a substantial choice of crosses from destinations as far apart as Peru and Australia. I have tried to present a balance between the many different strands of the Christian faith, for each century, from the earliest Christians in Pompeii until today, and criss-crossing the globe from North to South and East to West. Categories include architecture, painting, sculpture, ivories, textiles, metalwork, jewellery and portraits of people wearing crosses, as well as examples of the cross in nature.

The pages are arranged chronologically within each country, beginning with Israel. They radiate out from Jerusalem, first through the Middle East and Turkey, then to the Orthodox world which includes the Greeks and the Russians, the Copts and the early independent churches of the Armenians and the Georgians. Then they feature the Catholic Mediterranean world, and move north to where the Western Church was split by the Reformation. Finally to the ends of the earth, with the expansion of empires by the Portuguese, the Spanish and the British.

This attempts to illustrate Jesus' Great Commission: *Go into all the world and preach the gospel to all creation.* (Mark 16:15).

Serena Fass,
Chelsea, London,
Epiphany 2013

20th-century silver-gilt cross with semi-precious stones,
Christian Dior, author's collection.

17

The Holy Land and Middle East:

Jerusalem (Israel)
Syria
Lebanon
Jordan
Asia Minor (Turkey)

Cross in Bethlehem

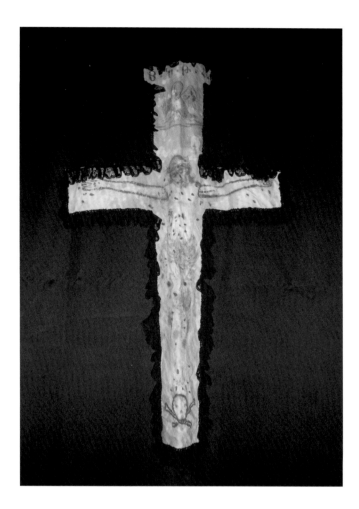

Greek Orthodox linen panel, edged with black lace, with a painted image of the Crucifixion with a skull and crossbones. It hangs on an altar curtain in the Church of the Nativity, Bethlehem, the Palestinian territories.

One of the oldest continuously operating churches in the world, built over the cave which traditionally marks the spot where Jesus was born, it is a combination of two churches, with a crypt beneath: the stairways on either side of the Sanctuary lead down to the Grotto. The first Basilica on this site was begun by St Helena, the mother of the Emperor Constantine, under the supervision of Bishop Makarios of Jerusalem. Construction started in 327 and was completed in 333. It was burnt down in 529 and rebuilt in its present form in 565 by the Emperor Justinian I. When the Sassanid Empire under Khosrau II invaded in 614, they did not destroy it: according to legend, their commander Shahrbaraz, was moved when he saw the mosaics of the Three *Magi* wearing Persian clothes and commanded that the building be spared. The Crusaders made further repairs and additions during the Latin Kingdom of Jerusalem with permission and help given by the Byzantine Emperor, and Baldwin I of Jerusalem was crowned in the church. It is administered jointly by Greek Orthodox, Armenian Apostolic and Roman Catholic authorities. All three traditions maintain monastic communities on the site.

Cross-shaped Font

What did you see in the baptistery? Water, certainly, but not water alone; you saw the deacons (like the Levites of old) exercising their ministry and the bishop (like the chief priest of old) asking questions and bestowing sanctification.

The Apostle Paul taught you to look not at what is visible but at what is invisible; for visible things will pass away but the invisible things are eternal. As you read elsewhere: Since the creation of the world, the invisible attributes of God, his eternal power and his divinity are understood through the things that he has done. The Lord himself says: If you do not believe in me, believe in my works. So here, at baptism, believe that the Godhead is present. Can you believe that God is at work and yet deny that he is present? How can any work happen unless the one who performs it is already there?

Consider how ancient this mystery is; for it is prefigured even in the origin of the world itself. In the very beginning, when God made the heaven and the earth, it is said: The Spirit moved upon the waters. He who was moving over the waters, was he not acting on them as well?

You can recognize that he was working in that moment of creation, when you see how the prophet says: By the word of the Lord were the heavens made, and all their strength by the spirit of his mouth. There is as much support from the prophets for one thing as for the other. Moses says that the spirit of God was moving and David the psalmist testifies that he was working.

Here is another piece of evidence. By its own iniquities all flesh was corrupted. And God says: My Spirit shall not remain among men, because they are flesh. This goes to show that carnal impurity and the pollution of grave sin turn away the grace of the Spirit. Since that had happened, God sought to repair his disfigured creation. He sent the flood and commanded Noah, the just man, to go up into the ark. As the waters of the flood were receding Noah sent first a raven (which did not return) and then a dove, which came back with an olive branch, as we read in the scriptures. And now you see the water, you see the wood, you see the dove, and you still doubt the mystery?

The water is the water into which the flesh is dipped, to wash away all the sins of the flesh. And so is all sin buried. The wood is the wood on which the Lord Jesus was fastened when he suffered for us. The dove symbolizes the Holy Spirit's taking on the form of a dove, as you have learnt from the New Testament: the Spirit who brings peace to your soul and calm to your troubled mind.

St Ambrose of Milan,
339-397

5th-century marble baptismal font, Tabga, Israel.

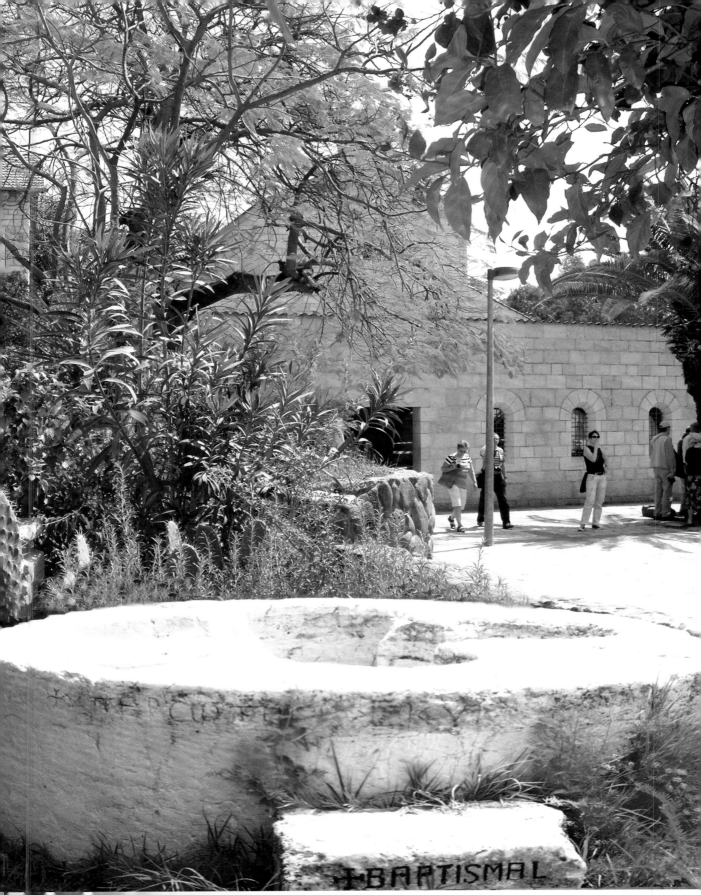

Cross of Baptism

Because the demonic powers that oppose the will of God lurk in the water, the Lord descended into the waters of the Jordan to crush the heads of these powers and to bind the strong one. Life came and death was muzzled, so that all of us, who have been saved, may shout: "O Death, where is thy victory? O Death, where is thy sting?" The sting of death is undone by the Baptism.

St Cyril of Jerusalem,
c. 315-386

Greek Orthodox pilgrims, Yardenit, Israel.
Pilgrims wearing the white shifts that they will wear for their burial,
gather beside the River Jordan for a second baptism by full immersion.

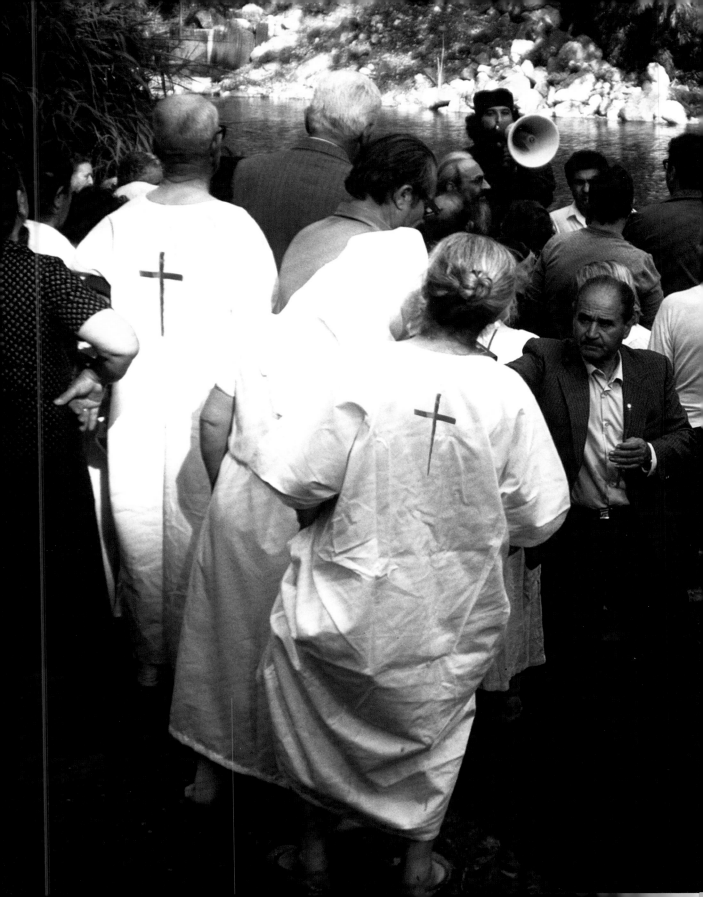

Crosses on Bunting

O place of peace, Jerusalem,
Set high on Zion's hill,
Where, crucified, our Savior died,
God's purpose to fulfill;
And where he left an empty tomb
We come His Name to bless,
While pilgrims throng its streets along –
A place of Holiness.

O David's royal Jerusalem
Where still the Temple wall
Proclaims its hour of erstwhile power,
Its ancient rise and fall;
Where Christ, rejected and despis'd,
Received not by His own,
So low did lie – but mounted high,
Ascended to His throne.

"Jerusalem, Jerusalem,
Your prophets you have slain!
Your house was left, destroyed, bereft,
Today you stand again!"
We see a city shining
Where God's great love was shown,
His diadem, Jerusalem,
And Christ its cornerstone.

David E Hunt,
1931-

Bunting, Greek Patriarchate, Jerusalem, Israel.
During Holy Week bunting adorns the street that leads down to the Holy Sepulchre.
The yellow flag with the Byzantine double eagle is that of the Greek Patriarchate, the
red cross on a white ground is that of St George, and the blue and white flag is the
national flag of Greece.

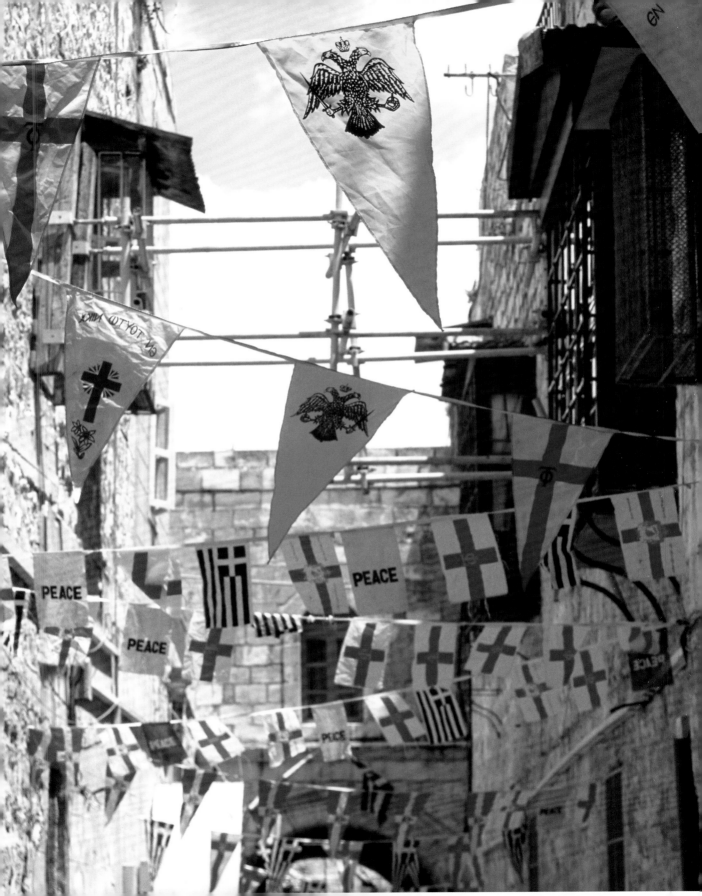

Cross on the *Via Dolorosa*

Jesus is condemned to death
Jesus carries His cross
Jesus falls for the first time under the weight of the cross
Jesus meets His blessed mother
Simon of Cyrene helps Jesus to carry His cross
Veronica wipes the face of Jesus
Jesus falls the second time
Jesus consoles the women of Jerusalem who weep for Him
Jesus falls the third time
Jesus is stripped of His garments
Jesus is nailed to the cross
Jesus dies on the cross
Jesus is taken down from the cross and laid in the arms of His mother
Jesus is placed in the tomb.

The Stations of the Cross

Orthodox pilgrims beside the Ecce Homo Arch, the Via Dolorosa, Jerusalem, Israel. Pilgrims pause on Great Friday as they process past each of the Stations of the Cross to the Holy Sepulchre. As early as the 5th century, a group of connected chapels was constructed at the monastery of Santo Stefano, Bologna, by its Bishop, St Petronius, to represent the more important shrines of Jerusalem. Several travellers who visited the Holy Land during the 12th, 13th, and 14th centuries mention a *Via Sacra*, but the devotion of the *Via Dolorosa* was not developed until the Franciscans were granted administration of the Christian Holy Places in Jerusalem in 1342.

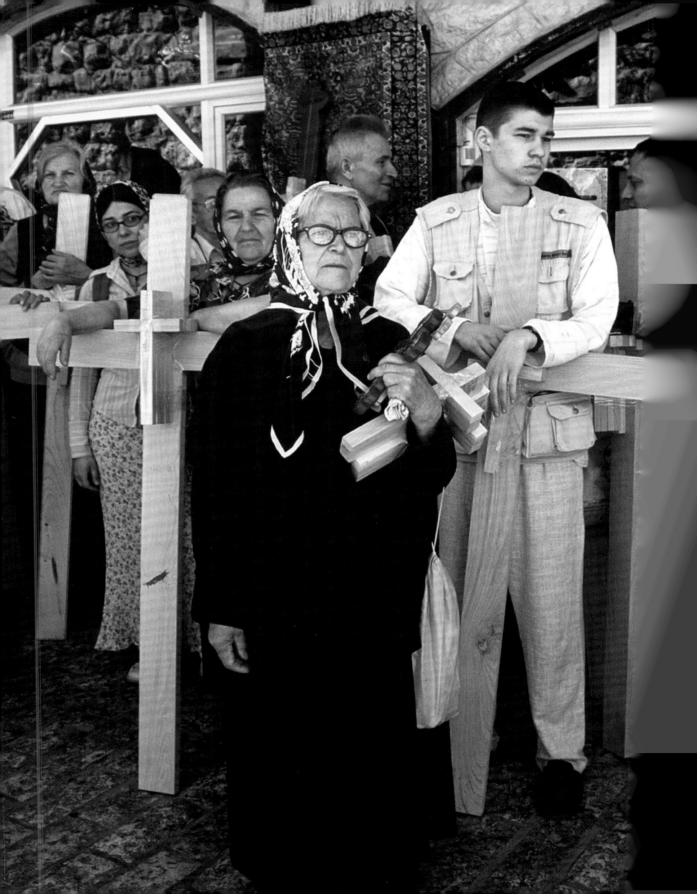

Deacon's Candle and Cross

From glory to glory advancing, we praise thee, O Lord;
Thy name with the Father and Spirit be ever adored.

From strength unto strength we go forward on Zion's highway,
To appear before God in the city of infinite day.

Thanksgiving, and glory and worship, and blessing and love,
One heart and one song have the saints upon earth and above.

Evermore, O Lord, to thy servants thy presence be nigh;
Ever fit us by service on earth for thy service on high.

The Liturgy of St James

Greek Orthodox Deacon, Church of the Holy Sepulchre, Jerusalem, Israel.
A young deacon holds a cross and a candle in the Church of the Holy Sepulchre, during the phenomenon of the miracle of the Holy Fire on Holy Saturday which has been recorded by witnesses in Jerusalem since the very earliest times: year after year, without fail, the Holy Fire sets light to the Greek Orthodox Patriarch's candle, mysteriously rising up from the slab of Jesus' tomb inside the *aedicule* – the place of His resurrection. The Armenian *Catolicus* stands beside him to receive the fire. Sometimes it happens quickly, other years it can take several hours before the Holy Fire ignites. Simultaneously, the Holy Fire darts around in zigzags of electrical blue streaks (like lightning) and sets alight the candles held by pilgrims in the upper galleries and a great cry goes up "Christ is Risen" – "He is Risen Indeed". When Saladin conquered the Holy City in 1187 he was curious to witness the Holy Fire and sure enough he did, having ordered his soldiers to make a thorough search of the Church and lock it securely before the ceremony. Two Muslim families, the Joudeh, who have the key, and the Nusseibeh, who have been the custodians since the days of Caliph Omar in 637, symbolically still do this today. The Joudehs bring the key to the door which is unlocked by a member of the Nusseibehs. Israeli soldiers search the entire church using sniffer dogs and are on guard throughout, representing the Roman soldiers who guarded Jesus' tomb and failed to prevent the Resurrection.

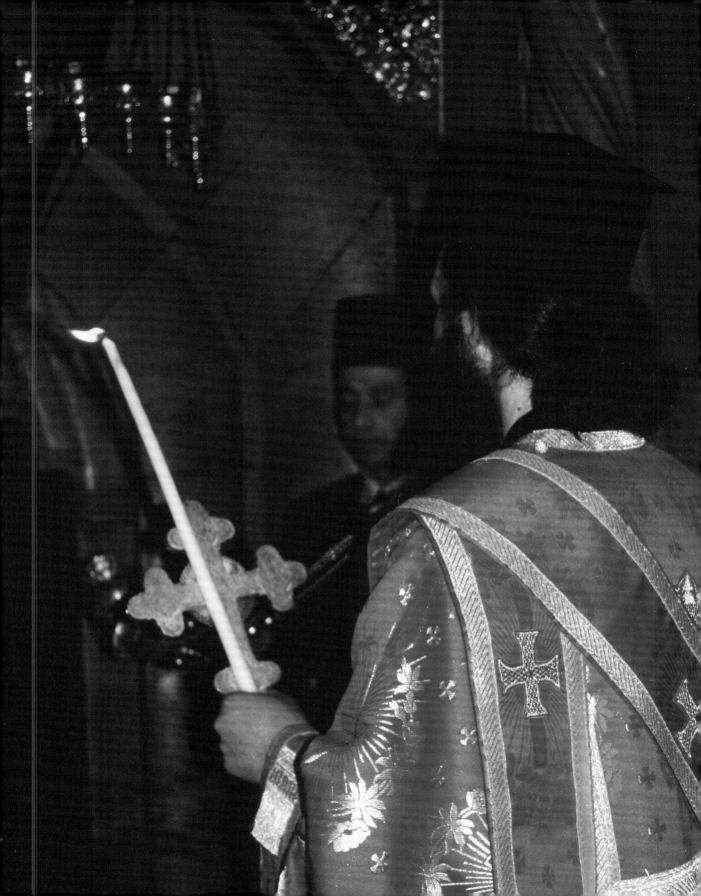

Cross in the Holy Sepulchre

Seven times He spake, Seven words of love,
And all three hours His silence cried
For mercy on the souls of men:
Jesus, our Lord, is crucified!

Father forgive them for they know not what they do.
Luke 23:34

Truly I say to you today you will be with me in Paradise.
Luke 23:43

Woman behold your son! Behold your mother.
John 19:26-27

My God, my God, why hast thou forsaken me.
Matthew 27:46

I thirst.
John 19:28

Father into thy hands I commit my spirit.
Luke 23:46

It is finished.
John 19:30

Greater love hath no one than this, that he lay down his life for his friends.
John 15:13.

Christ on His Cross, Greek Orthodox Calvary, the Church of the Holy Sepulchre, Jerusalem, Israel.
The Cross marks the spot where Jesus' Cross traditionally stood on the Place of the Skull. A legend that says that the wood of the Cross on which Christ was crucified was taken from the acacia tree. As time went on, the Ark of the Covenant, the pole on which the bronze serpent was lifted and other items, were made from this tree.

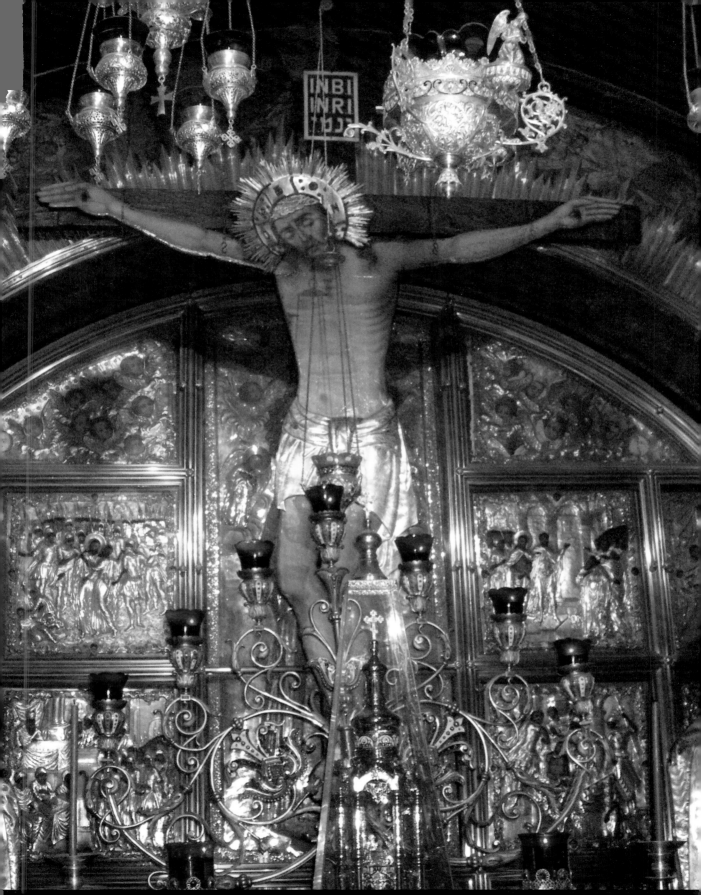

Thirteen Crosses

Oh Lord, our hearts are restless until they find rest in Thee.

St Augustine of Hippo,
354-430

Plaited leather cross, the Coptic Patriarchate, Jerusalem, Israel.

Worn daily by all Coptic Monks and Nuns, plaited crosses are made in several different colours and sizes, sometimes all black, black and white, black and beige. Copts pray daily for the reunion of all Christian Churches. They pray for Egypt, its Nile, its crops, its President, its army, its government, and above all its people. They pray for the peace of the world and for the well-being of the human race.

Young Coptic monk, monastery of El Baramous, Wadi El Natrun, Egypt.

Thirteen crosses embroidered on his cap represent Christ and His twelve Apostles. The stitching down the centre commemorates St Anthony's cowl, which was ripped off his head by the devil and St Anthony stitched it back together again.

Aspiring Coptic monks are encouraged to lead a civilian life before joining a monastery and are usually well-educated and at least 24 years old before they join, having done their military service and trained in a profession. After two years' probation as a novice, ten to fifteen percent are rejected, of which three-quarters leave voluntarily. The rest take their vows of poverty, chastity and obedience and become professed monks. Only monks can become Bishops, and each Coptic Pope is always chosen from amongst them. Traditionally, the mothers and sisters of the young novices embroider their caps with Coptic crosses, which they wear at all times, including under their Episcopal headgear when they become Bishops. The Monks pray in the chapel at 4am, again at 6am for Mass. From 8am to 12pm they work (and again till 2pm in winter and 4pm in summer). They have free time in the afternoon for study or a walk and assemble again at 5pm for Vespers. Their music uses the same melodies as those used by the Pharaohs. All monks are vegetarian and teetotal. Beans and homemade brown bread form their main diet, supplemented by their own fruit and vegetables.

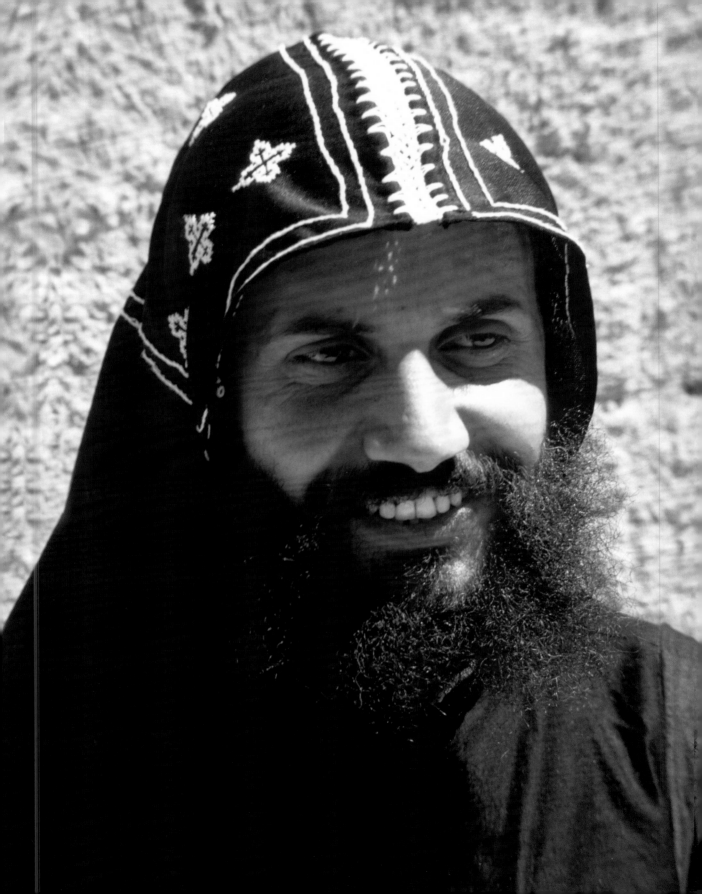

Armenian *pietra dura* Cross

Count it all joy, my brethren when you fall into various trials; for you know that the testing of your faith produces steadfastness. And let steadfastness have its full effect, that you may be perfect and complete, lacking in nothing.

If any of you lack wisdom, let him ask of God, who gives to all men generously, and without reproaching, and it will be given him. But let him ask in faith, with no doubting. For he who doubts is like a wave of the sea that is driven and tossed by the wind. For that person must not suppose that a double-minded man, unstable in all his ways will receive any thing of the Lord.

Let the lowly brother boast in his exaltation: and the rich, in that his humiliation, because like the flower of the grass he will pass away. For the sun rises with its scorching heat and withers the grass; its flower falls, and its beauty perishes. So will the rich man fade away in midst of his pursuits.

Blessed is the man that endures trial, for when he has stood the test, he will receive the crown of life, which God has promised to those who love him.

The first Epistle of James: 2-11.

Armenian *pietra dura* Cross, 1927, set into the wall of the vaulted passage of the 12th-century Cathedral of St James, the Just, the first leader of the Jerusalem church (son of St Joseph and step-brother of Jesus), martyred here in 69 and buried beneath the High Altar of the Cathedral. The Armenian Quarter, Jerusalem, Israel.

The Armenian presence in the Holy Land dates back to the earliest years of Christianity, even before the conversion of the Armenian King Tiridates III around 301. There is recorded historical evidence that as early as 254, bishops of the Armenian Church, in cooperation with bishops of the Greek Orthodox Churches in Jerusalem and Alexandria, Egypt, were actively engaged in the discovery and confirmation of Holy Places related to the activities of Jesus, and in the construction of buildings. Armenian pilgrims began trekking to the Holy Land on spiritual journeys in steady and continuous numbers, braving disruptive political upheavals and other hardships. A large number of them chose to remain in Jerusalem, and to take up residence in the proximity of the sanctuaries owned by the Patriarchate (the Armenian Convent), for the preservation of these early Christian treasures with St James' Cathedral, (the area near the Patriarchate in the southwestern corner of the Old City of Jerusalem) as its centrepiece. According to historical records, as early as the 3rd century, the Armenian Church, under the uninterrupted leadership of successive bishops, not only maintained the integrity of the Holy Places, but also had a leading role in their protection and reconstruction following their repeated destruction by invading armies. At its peak, the Armenian presence in Jerusalem numbered 25,000.

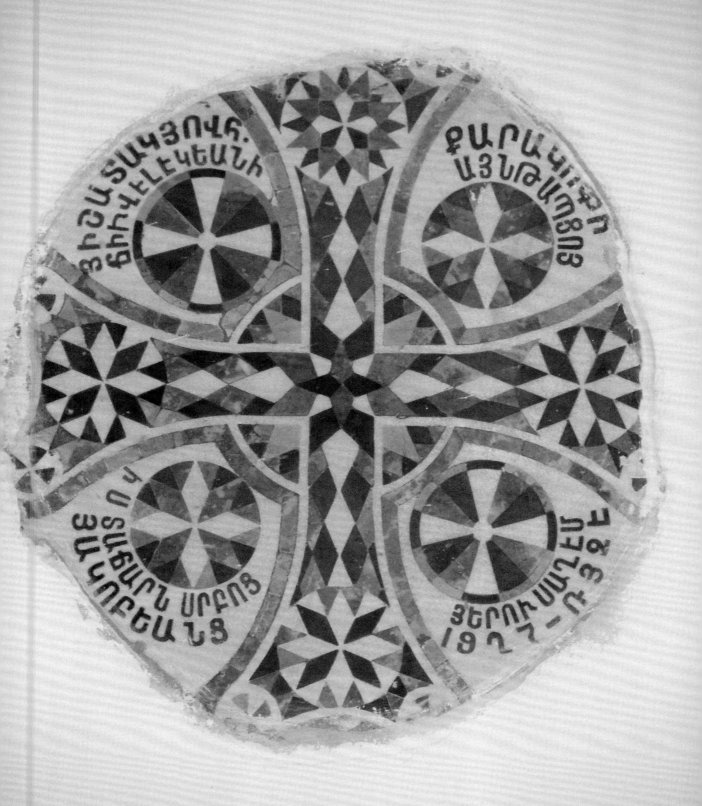

Graffiti Crosses

All the things that the world loveth, such as pleasures, honours, praises, and riches, are to me so many crosses; and all the things that the world reputes as crosses are what I court after, and embrace with the tenderest affection.

St Bernard of Clairvaux,
1090-1153

11th-century Crusader's graffiti crosses on the stairs to St Helena's chapel, Holy Sepulchre, Jerusalem, Israel.

On November 27, 1095 at the Council of Clermont, France, Pope Urban II, in one of history's most impassioned pleas, launched the Crusades, which were to continue for two hundred years. In a rare public session in an open field, he urged the knights and noblemen to win back the Holy Land, to face their sins, and called upon those present to save their souls and become "Soldiers of Christ." Those who undertook the venture were to wear an emblem in the shape of a red cross on their body. And so derived the word "Crusader," from the Latin word cruciare – to mark with a cross. By the time his speech ended, the captivated audience began shouting "Deus le volt! – God wills it!" The expression became the battle-cry of the Crusades.

The presence of the Franciscans in the Holy Land goes back to the origins of the Order, founded by St Francis of Assisi in 1209. The Province of the Holy Land was created in 1217 at the General Chapter that divided the Order into Provinces, it grew to include all the lands around the southeast Mediterranean basin, from Egypt to Greece and beyond and included the land of Christ's birth. This jewel among the other Provinces was visited by St Francis himself, who stayed here for several months during his voyages to Egypt, Syria and Palestine from 1219-1220. Today, the Custody of the Holy Land is the only Province of the Order with an international character, composed of friars from all around the world. The Friars Minor are the official guardians of the Holy Places by the desire and at the request of the Universal Church. Pope Paul VI, the first Pope since St Peter to visit the Holy Land, recalled this fact and it was confirmed by Pope John Paul II during his pilgrimage in the Great Jubilee year of 2000.

Symbol of the Franciscans, custodians and protectors of the Holy Places in Jerusalem, Bethlehem, Nazareth and elsewhere in Israel since 1220.

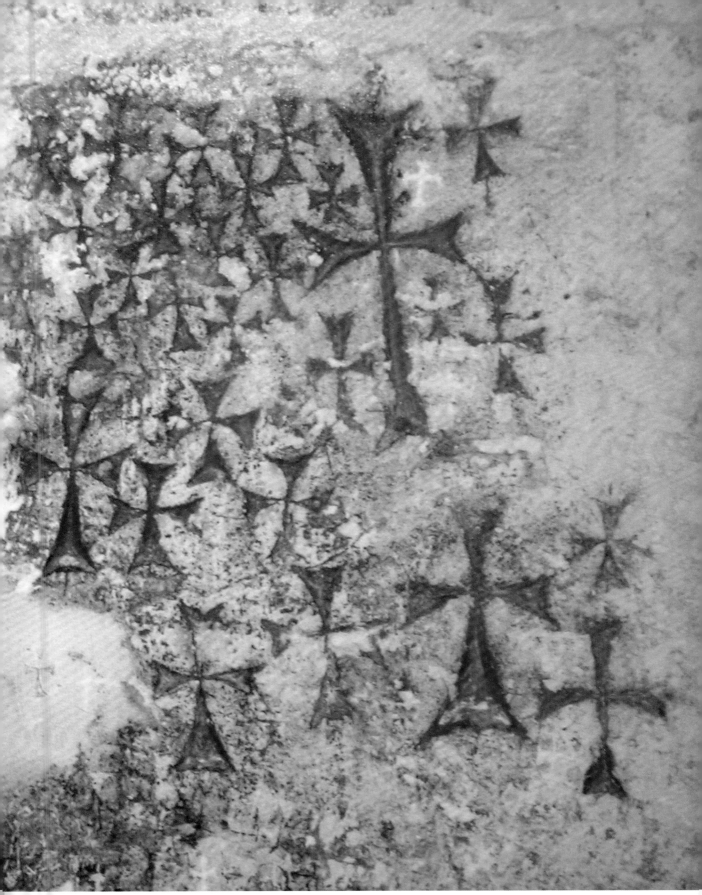

Cross on a Pilgrim's Oyster Shell

On the way (to Alexandria from Thebes) her boats were held up by some disorderly youths who started a fight with local residents… one cut a eunuch's finger, while others threw the most holy Bishop Dionysius into the river…

Palladius,
c. 408-461
Historia Lausiaca 35: The wealthy Christian Pilgrim Paemenia's entourage is attacked in Egypt.

Decorated pilgrim souvenir shell, (1700-1900), the Holy Land, Israel, with incised decoration resembling engravings on paper. Four roundels separated by floral ornaments show scenes from the life of Christ.
Top left: the Resurrection
Bottom left: the Nativity
Top right: the Transfiguration
Bottom right: the Annunciation

Photograph: courtesy of the Ashmolean Museum, Oxford, England.

Once Constantine had established Jerusalem as a centre for Christian pilgrimage, many travellers, not all of them celebrities like Paemenia, visited the Holy Land. From Western Europe most pilgrims travelled by sea, landing in Egypt at Alexandria. Many visited the nearby monastery of St Menas and bought as souvenirs small ceramic flasks for holy water. Those who travelled across the Sinai desert to Jerusalem might visit the imposing Monastery of St Catherine, who had been martyred in Alexandria. Since its foundation by Alexander the Great in the 330s BC, Alexandria had become the leading centre of pagan learning and culture. In the later Roman Empire the city housed a volatile population of pagans, Jews and Christians. Zealous Christians burned the famous temple of the Egyptian god Serapis in 391.

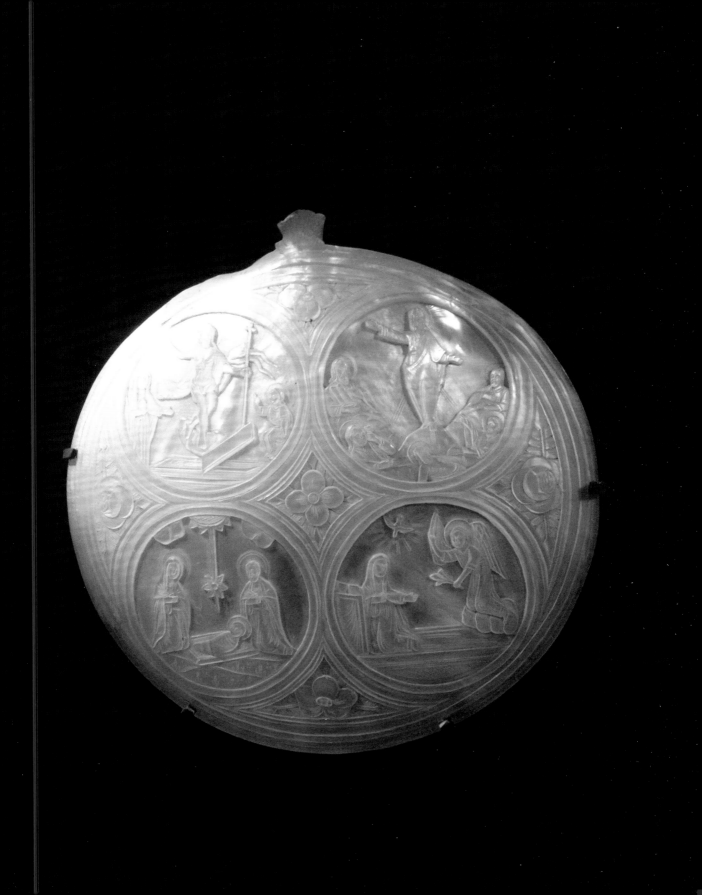

Plundered Cross

O God, who, for our redemption, didst give thine only begotten Son to the death of the Cross and by his glorious resurrection hast delivered us from the power of the enemy, grant us to die daily to sin, that we may evermore live with him, in the joy of his resurrection; through the same Jesus Christ our Lord.

St Gregory the Great,
c. 540-604

Two 6th-century Byzantine columns, Venice, Italy.

Originally from the Byzantine Church of St John of Acco (Acre) in Palestine, to prevent them from falling into Muslim hands, they were saved by Princess Anicia Juliana, who installed them and other columns in the Church of St Polyeuctus that she founded in Constantinople. They were plundered by the Venetians in 1204 during the Crusaders' sack of the city and brought to Venice, where they were placed beside the Cathedral of San Marco.

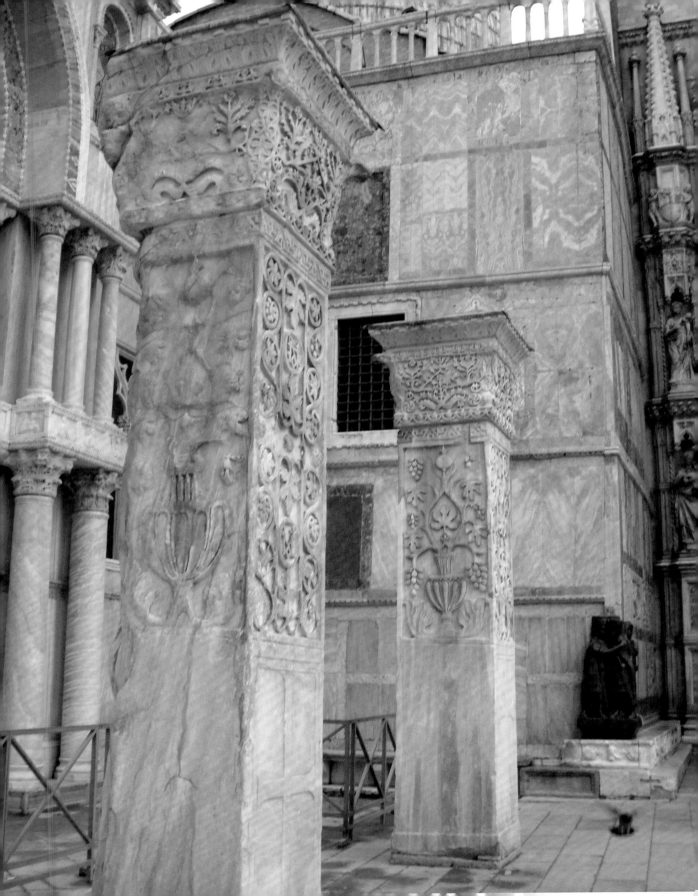

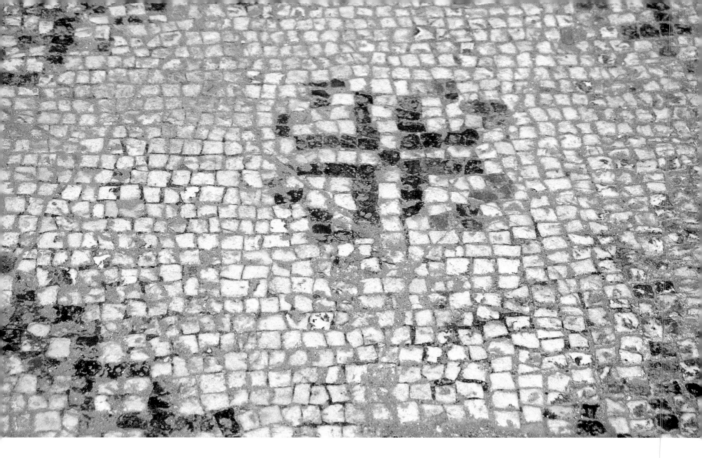

Decorated with a Cross

Antioch. The place where Christians were first called so. And the empty cross. The smart London jeweller asking me if I wanted a cross "with a little man on it." No. The Empty Cross – *in hoc signo vinces* – the Cross in Light with no body on it because the body of Christ has been raised. Antioch, with its eastern faith, and the recollection that in the first Christian millennium the cross did not display the body of Jesus but was empty – like this cross in the mosaic Antioch floor. Or sometimes, the Greek letters Alpha and Omega were suspended from the arms of the cross, for in Christ is our beginning and our end. Outside the realms of time now, Christ has gone before where we will follow – leading captivity captive. An Orthodox hymn reminds us that Christ descended to earth to redeem humanity, and not finding humanity there, descended to hell. There He found us. Having found us, he takes us with Him in his victory parade. Beyond the cross. Beyond death. Beyond the grave. Antioch. Here, we take our name and our identity. The Empty Cross. *In hoc signo vinces.*

The Rev'd Dr William Taylor, Chairman, Anglican & Eastern Churches Association, 1956-

Above: Entrance to the 1st century church of St Peter and St Paul, Antioch, Turkey, where Christians were first called Christians.
Opposite: 6th-century floor of a ruined church, Tyre, Lebanon.

Hiram I, King of Tyre from 980-947 BC established Tyre as one of the most important Phoenician cities, forging a strong relationship with King Solomon of Israel and developing rewarding trade routes along the Red Sea and into Africa and Mesopotamia. He sent the wood of the famed Cedars of Lebanon to build the Temple of Jerusalem, started by King David.

For centuries, Tyre was a great and flourishing Phoenician island city, renowned and envied in the ancient world for its magnificence and wealth created by trade and its discovery of the 'Imperial Purple' dye from the Murex shell. One of the many who tried to destroy Tyre and her empire was Alexander the Great who besieged Tyre for seven months in 332 BC, eventually razing it to the ground by building a causeway from the mainland to the City walls. During the following centuries, many others attempted to take Tyre, including the Crusaders. In spite of so many sieges, attacks and earthquakes, plagues and hardships, Tyre was able, over and over again, to rise from her ruins.

Let us pray that we can begin to heal the wounds of history, by addressing the roots of violence with love, forgiveness and compassion.

Alexandra Asseily,
1937-

The Last Supper and the Cross

Every act and miraculous energy of Christ is very great and divine and marvellous, but the most amazing of all is His precious Cross. For death was not abolished by any other means; the sin of our forefather was not forgiven; Hades was not emptied and robbed; the Resurrection was not given to us; the power to despise the present and even death itself has not been given to us; our return to the ancient blessedness was not accomplished; the gates of Paradise have not been opened; human nature was not given the place of honour at the right hand of God; we did not become children and inheritors of God, except by the Cross of our Lord Jesus Christ alone. All these have been achieved by the death of the Lord on the Cross

St John of Damascus,
c. 657-749

Late medieval icon, oil on wood, 4th-century Monastery of St Sergius, Ma'lula, Syria.

Our father, who art in heaven, hallowed be thy name. Thy kingdom come. Thy will be done on earth, as it is in heaven. Give us this day our daily bread, and forgive us our trespasses, as we forgive those who trespass against us, and lead us not into temptation, but deliver us from evil. Amen.

ابانا الذي في السموات ليتقدس اسمك ، ليأت ملكوتك ، لتكن مشيئتك كما في السماء كذلك على الارض .

اعطنا خبزنا كفاف يومنا واغفر لنا خطايانا كما نحن نغفر لمن اساء، الينا ولا تدخلنا في التجارب لكن نجنا من الشرير . امين .

Prayer card: The Lord's Prayer in English, Aramaic (the language of Jesus, still the official language of the Syriac Orthodox Church) and Arabic.

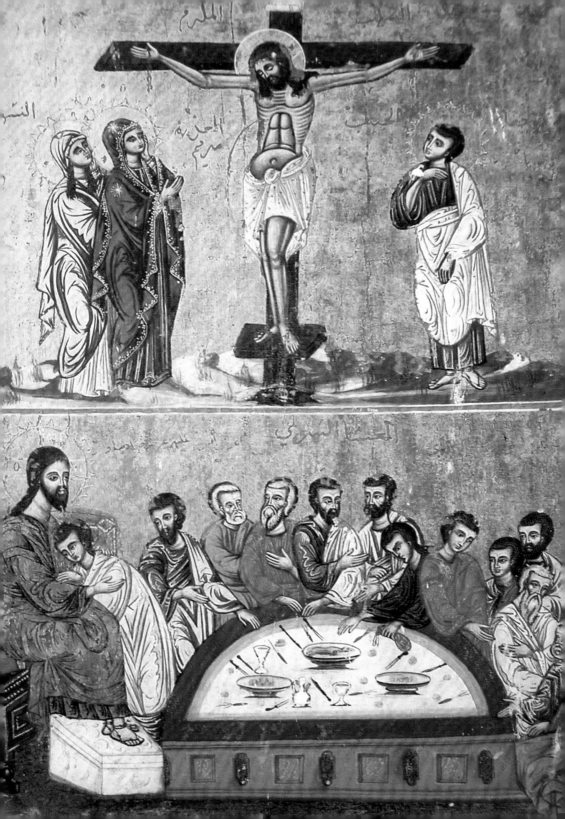

Moses' Snake on a Cross

The Lord said to Moses, "Make a snake and put it up on a pole; anyone who is bitten can look at it and live." So Moses made a bronze snake and put it up on a pole. Then when anyone was bitten by a snake and looked at the bronze snake, he lived.

Numbers 21:8-9.

According to Jesus himself, "The Son of Man must be lifted up as the serpent was lifted up by Moses in the wilderness, so that everyone who has faith in him may possess eternal life"

John 3:14

Today, this has happened: they raised you up on a cross. You took advantage of that to hold out your arms and draw people up to you. And countless people have come to the foot of the cross, to fling themselves into your arms.

Faced with the sight of all these people pouring in for so many centuries, and from every part of the world, to the crucified man, a question arises: were you merely a great and good man, or a God? You gave us the answer yourself, and anyone whose eyes are longing for the light and are not obscured by prejudice accepts it.

Pope John Paul I,
1912-1978

Modern bronze sculpture by Gian Paolo Fantoni of Florence, Mount Nebo, Jordan.

Pisgah is where Moses is presumed to have died and been buried overlooking the Jordan Valley and the Dead Sea. The cross symbolises the serpent lifted up by Moses in the desert, as well as the crucifixion of Jesus. When the Israelites were bitten by poisonous snakes (being the sign of sin and earthly or demonic wisdom) the brass serpent that was lifted up was a type of the cross. Jesus Christ *"became sin"* (2 Corinthians 5:21) for us and triumphed over the poisonous and lethal power of sin. Hence, the snake on the Cross recalls this story and the words of the Lord in John 3:14: *"As Moses lifted up the serpent in the wilderness, even so must the Son of man be lifted up."* Another way to consider the snakes is to see them not as symbols of false wisdom (James 3:15) but of true and holy wisdom, as in Lord's saying (Matthew 10:16): *"Behold, I send you out as sheep in the midst of wolves; so be wise as serpents and innocent as doves."*

Cross of the Nicene Creed

We believe in one God, the Father, the Almighty, maker of heaven and earth and of all that is seen and unseen.

We believe in one Lord, Jesus Christ, the only Son of God, eternally begotten of the Father, God from God, Light from Light, true God from true God, begotten, not made, one in Being with the Father. Through Him all things were made. For us men and for our salvation He came down from heaven: by the power of the Holy Spirit He was born of the Virgin Mary, and became man. For our sake He was crucified under Pontius Pilate; He suffered, died, and was buried. On the third day He rose again in fulfillment of the Scriptures; He ascended into heaven and is seated at the right hand of the Father. He will come again to judge the living and the dead, and His kingdom will have no end.

We believe in the Holy Spirit, the Lord the giver of life, who proceeds from the Father and the Son. With the Father and the Son He is worshipped and glorified. He has spoken through the Prophets.

We believe in one holy catholic and apostolic Church. We acknowledge one baptism for the forgiveness of sins. We look for the resurrection of the dead, and the life of the world to come. Amen.

The Creed of Nicaea,
325

5th-century *ambo* from Justinian's Church of Hagia Sophia (Holy Wisdom), Nicaea, Turkey.

The Nicene Creed was first incorporated into the Liturgy at Antioch in the 5th century as a safeguard against Arianism. The Ecumenical Council of Nicaea was convened by the Emperor Constantine I in 325 under the presidency of St Hosius of Cordova and St Alexander of Alexandria to resolve a theological dispute about the nature of Christ that spread throughout the Christian world. Begun by an Alexandrian Presbyter of Alexandria named Arius and known as "Arianism", it eventually led to the formulation of the Nicene Creed .

Cross in Ephesus

Polycarp and the presbyters with him, to the church of God, the one temporarily residing in Philippi. Mercy to you and peace from God the all-powerful and Jesus Christ our Savior be multiplied.

I rejoice with you greatly in our Lord Jesus Christ, having welcomed the replicas of true love and having sent on their way, as was incumbent upon you, those confined by chains fitting for saints which are the crowns of those truly chosen by God and our Lord. And because of the secure root of our faith, being proclaimed from ancient times, still continues and bears fruit to our Lord Jesus Christ, who endured because of our sins to reach even death, whom God raised up having loosed the birth pains of Hades. In whom, not having seen, you believe with joy inexpressible and glorious, which many long to experience, knowing that by grace you have been saved, not by works, but the will of God through Jesus Christ.

Therefore prepare yourselves. Serve God in reverence and truth, leaving behind empty, fruitless talk and the deception of the crowd, believing in the one who raised our Lord Jesus Christ from the dead and gave him glory and a throne at his right hand, to whom all things in heaven and earth are subject, whom every breathing thing worships, who is coming as judge of the living and dead, whose blood God will require from those who disobey him. But the one who raised him from the dead also will raise us if we do his will and follow in his footsteps.

St Polycarp,
Bishop of Smyrna and Martyr,
c. 69-155

6th-century Byzantine marble *sarcophagus*, Basilica of St John the Divine, built by Justinian, Seljuk, Turkey.

The Council of Ephesus heard a theological dispute in the 5th century which occurred over the teachings of Nestorius, the Patriarch of Constantinople, who taught that God the Word was not hypostatically joined with human nature, but rather dwelt in the man Jesus. As a consequence of this, he denied the title "Mother of God", *Theocrato,* to the Virgin Mary, declaring her instead to be "Mother of Christ" *Christotokos.* When reports of this reached the Apostolic Throne of St Mark, Pope Saint Cyril I of Alexandria acted quickly to correct this breach with orthodoxy, requesting that Nestorius repent. When he would not, the Synod of Alexandria met in an emergency session and a unanimous agreement was reached affirming her title as "*Theocrato*".

Cross of an Emperor

On the Lord's day, which is the first day of the week, on Christmas, and on the days of Epiphany, Easter, and Pentecost, inasmuch as then the (white) garments (of Christians) symbolizing the light of heavenly cleansing bear witness to the new light of holy baptism, at the time also of the suffering of the apostles, the example for all Christians, the pleasures of the theatres and games are to be kept from the people in all cities, and all the thoughts of Christians and believers are to be occupied with the worship of God. And if any are kept from that worship through the madness of Jewish impiety or the error and insanity of foolish paganism, let them know that there is one time for prayer and another for pleasure. And lest anyone should think he is compelled by the honour due to our person, as if by the greater necessity of his imperial office, or that unless he attempted to hold the games in contempt of the religious prohibition, he might offend our serenity in showing less than the usual devotion toward us; let no one doubt that our clemency is revered in the highest degree by humankind when the worship of the whole world is paid to the might and goodness of God.

Theodosius Augustus and Caesar Valentinian,
Codex Theodosianus, XV. 5.1
347-395

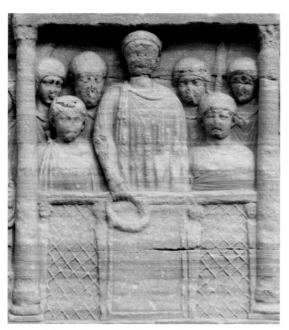

Base of the column, showing the Emperor Theodosius I in the Royal Box, giving a prize to a charioteer, the Hippodrome, Istanbul, Turkey.

Porphyry tomb of Emperor Theodosius I, 347-395, the Archaeological museum, Istanbul, Turkey.

Also known as Theodosius the Great, he was Roman Emperor from 379 to 395 and the last to rule over both the Eastern and the Western halves of the Roman Empire. During his reign, the Goths secured control of the Roman province of Illyricum after the Gothic War (376-382), establishing their homeland south of the Danube within the Empire's borders. He also issued decrees that effectively made Christianity the official State religion of the Roman Empire. He is recognized by the Eastern Orthodox Church as St Theodosius. After his death, his sons Arcadius and Honorius inherited the Eastern and Western halves of the Empire respectively, and the Roman Empire was never again reunited.

At the Council of Constantinople in 381, St Timothy I of Alexandria presided over the second ecumenical council known as the Ecumenical Council of Constantinople, which confirmed the divinity of the Holy Spirit in the Nicene Creed.

Hierarchs' Crosses

O Lord, Who hast delivered us from every arrow that flieth by day, deliver us from everything that walketh in darkness. Receive as an evening sacrifice the lifting up of our hands. Vouchsafe us also to pass through the course of the night without blemish, untempted by evil. And deliver us from every anxiety and fear that come to us from the devil. Grant unto our souls compunction, and unto our thoughts solicitude concerning the trial at Thy dread and righteous judgment. Nail down our flesh with the fear of Thee, and mortify our earthly members, that in quietness of sleep we may be enlightened by the vision of Thy judgments. Take from us every unseemly dream and pernicious carnal desire. Raise us up at the hour of prayer, fortified in faith and advancing in Thy commandments; through the benevolence and goodness of Thine Only-begotten Son, with Whom Thou art blessed, together with Thy most-holy and good and life creating Spirit, now and ever, and unto the ages of ages.
Amen.

St Basil the Great,
c. 330-379

Memorial stone to the three Orthodox Hierarchs, with crosses on their vestments and stoles, Archaeological Museum, Burdur, Turkey.

The early churches have given Basil of Caesarea, Gregory of Nazianzus, and John Chrysostom the title of the Three Holy Hierarchs. Basil of Caesarea, also called St Basil the Great, was Bishop of Caeserea Mazaca in Cappadocia, Asia Minor and an influential 4th-century Christian theologian and monastic. Theologically, Basil was a supporter of the First Council of Nicaea faction of the church, as opposed to Arianism on one side and the followers of Apollinarias of Leodicea on the other. His ability to balance the theological convictions with his political connections made Basil a powerful advocate for the Nicaea position. In addition to his work as a theologian, Basil was known for his care of the poor and underprivileged. Basil established guidelines for monastic life which focus on community life, liturgical prayer and manual labour. Together with Pachomius he is remembered as a father of Cenobites in Eastern Christianity. He is considered a saint by the traditions of both Eastern and Western Christianity.

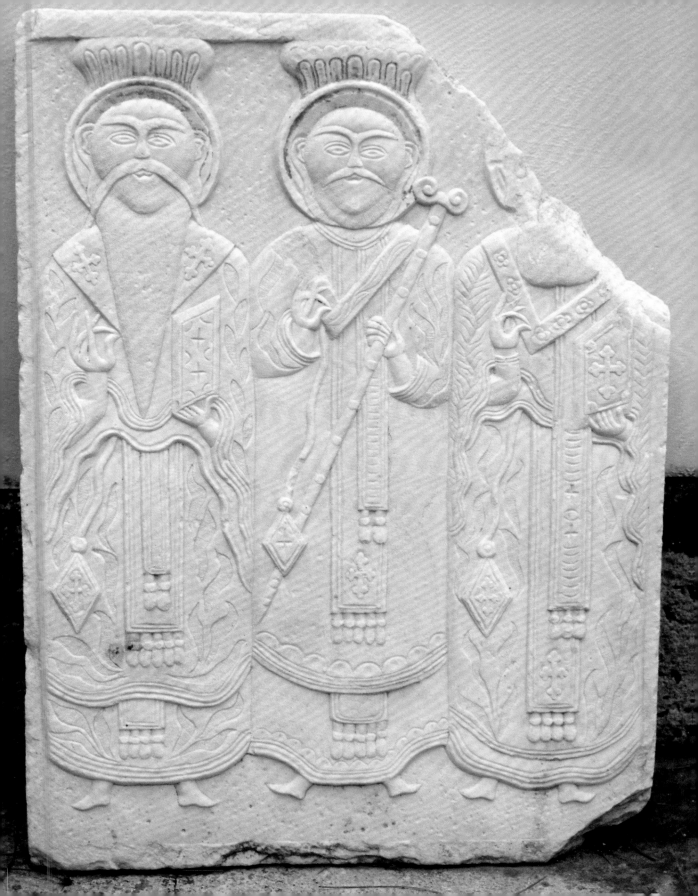

Cross in Aphrodisias

In the eyes of the foolish they seem to have died, and their departure was thought to be a disaster, and their going from us to be their destruction; but they are at peace.

For though in the sight of others they were punished, their hope is full of immortality.

Having been disciplined a little, they will receive great good, because God tested them and found them worthy of himself; like gold in the furnace he tried them, and like a sacrificial burnt-offering he accepted them.

In the time of their visitation they will shine forth, and will run like sparks through the stubble. They will govern nations and rule over peoples, and the Lord will reign over them for ever.

Those who trust in him will understand truth, and the faithful will abide with him in love, because grace and mercy are upon his holy ones, and he watches over his elect.

The Book of Wisdom 3:1-9

5th-century 8-pointed cross on an *ambo*, Aphrodisias, Turkey.

4th or 5th-century Byzantine marble tomb or altar panel, Aphrodisias, Turkey.

The cross design on this stone is part of a collection of Byzantine decoration dating from the 4th or 5th centuries, dug up by Kenan Erim and which now lies out of context near the S-E corner of the Cathedral Church, formerly the Temple of Aphrodisias, an important Christian centre of a Bishopric. It is probably a tomb covering, but it might just as easily have been an altar panel. As quarrying in Aprodisias had almost stopped by then and stones were being re-carved from old pieces, this slab may well be carved from recycled stone. Despite the repeated lootings and regime changes, the Cathedral building remained in use until its final burning in 1140, when the wooden roof timbers caught fire and destroyed the building. The city of Aphrodisias was destroyed by an earthquake in the 7th century and rebuilt to be destroyed again in the 12th century.

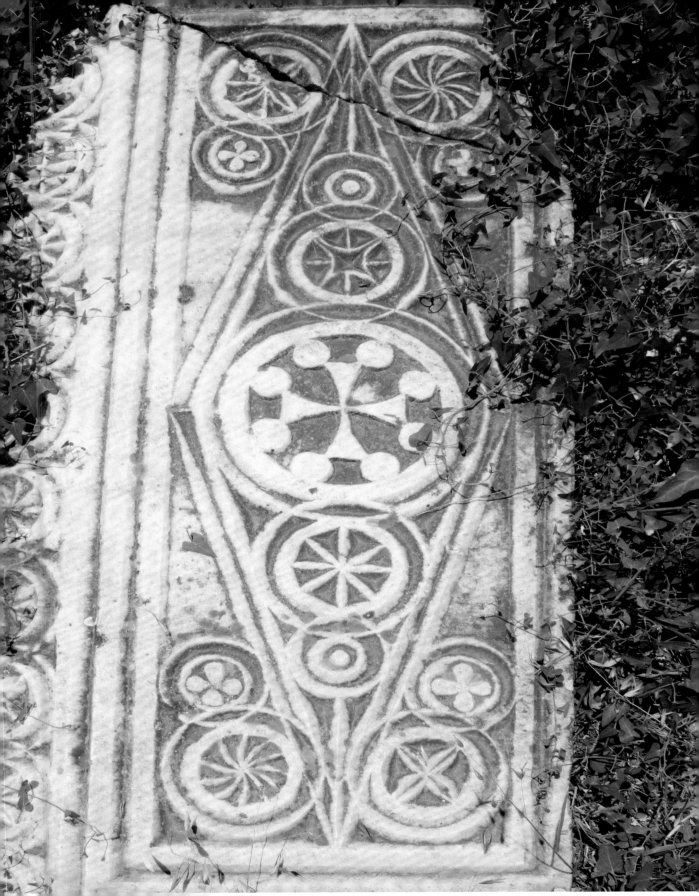

Cross of the *Magi*

And wise men from the East came to Jerusalem saying "Where is he who has been born King of the Jews? For we have seen his star in the East and have come to worship him."

Matthew 2:1-2

Stone lectern used when there are large congregations in the courtyard of the church of the Mother of God, Hah.

4th-century apse and altar, Syriac Orthodox monastery church of the Mother of God, Hah, Tur Abdin, Eastern Turkey.

Photograph: Claire-Lise Presel

The legend preserved in Hah to this day says that twelve *magi* set out from their capital, Takt-e-Soleyman, in present day Azerbaijan, Persia. They were Zoroastrian astrologers who in 5 BC saw a great star in the rare conjunction of Saturn, Mars & Jupiter, in the constellation of Pisces which was visible for 70 days. They set out on a three month journey to follow it westwards, for safety reasons, as part of a camel train along the silk route. The twelve reached King Hanna of Hah in the Tur Abdin region of Turkey and drew lots to see who would proceed while the other nine waited in Hah. Three *magi* bearing their typically Persian gifts of gold, frankincense and myrrh, continued to follow the star and eventually stopped to enquire of King Herod the Great in Jerusalem (who died in 4 BC) before finding Mother and Child in Bethlehem. After presenting their gifts, the Virgin Mary gave them a piece of Jesus' swaddling cloth and they returned to Hah with this gift. As Zoroastrians they were unwilling to cut it, but as they each wanted a memento, they decided to burn it and instead of the ash that they were expecting, twelve gold medallions appeared from the fire, one for each of the *magi*. They stayed in Hah for three years and sold eleven medallions to raise the Bishopric in the Tur Abdin, Turkey, traditionally founded in honour of the Mother of God and her infant Son by the Three Wise Men or *Magi* and their nine companions.

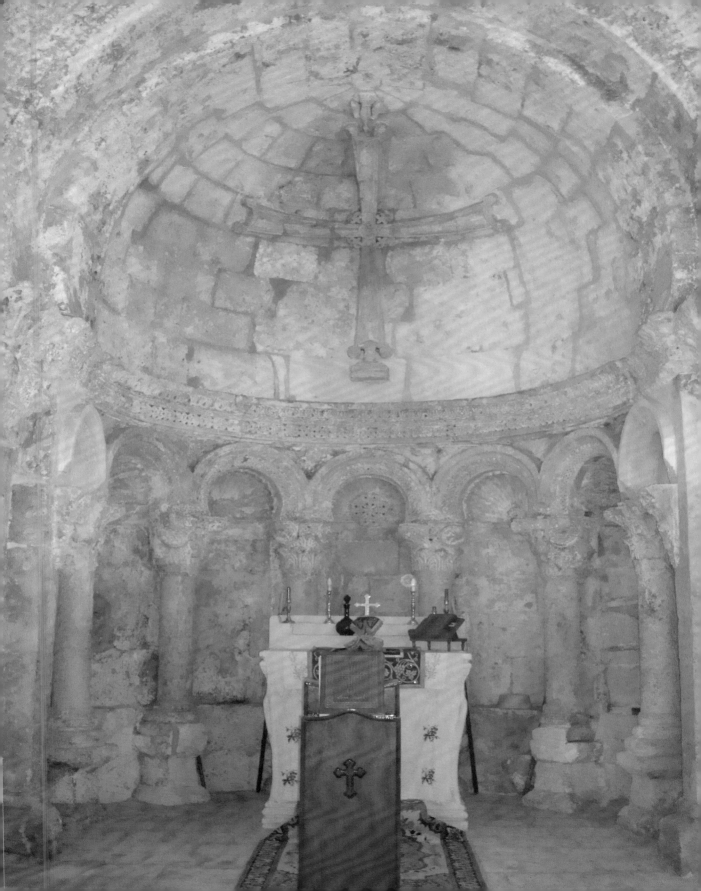

Bishop's Cross

Where the Bishop is, there let the multitude of believers be; even as where Jesus is, there is the Catholic Church.

St Ignatius of Antioch,
c. 35-107

His Grace Mor Philoxenus Saliba Ozmen, Archbishop of Mardin and Diabakir, and Abbot of Deir Za'faran, Mardin, Turkey.

The clergy of the Syriac Orthodox Church have unique vestments that are quite different from other Christian denominations. The vestments worn by the clergy vary with their order in the priesthood. The deacons, the priests, the bishops, and the patriarch each have different vestments. The priest's usual dress is black. Bishops usually wear a black or a red robe with a red belt. They do not, however, wear a red robe in the presence of the Patriarch who wears a red robe. Bishops visiting a diocese outside their jurisdiction also wear black robes in deference to the bishop of the diocese, who alone wears red robes.

Founded by Peter the Apostle and an independent church since the Apostolic Era, the Syriac Orthodox Church, (the Church of Antioch), played a significant part in the first three Synods held at Nicaea (325), Constantinople (381) and Ephesus (431), shaping the formulation and early interpretation of Christian doctrines. The name was changed to disassociate the church from the polity of Syria.

The Christological controversies that followed the Council of Chalcedon in 451 resulted in a long struggle for the Patriarchate between those who accepted and those who rejected the Council. In 518, Patriarch Mar Severius of Antioch was exiled from the city of Antioch and took refuge in Alexandria. On account of many historical upheavals and consequent hardships which the church had to undergo, the Patriarchate was transferred to different monasteries in Mesopotamia. In the 13th century it was transferred to the Mor Hananyo Monastery (Deir al-Za'faran), in southeastern Turkey near Mardin, where it remained until 1933. Due to an adverse political situation, it was transferred to Homs, Syria, and in 1959 was transferred again to Damascus.

Opposite: 4th-century Apse of the Syriac Orthodox church of the Monastery of Deir al-Za`faran. Eastern Turkey.

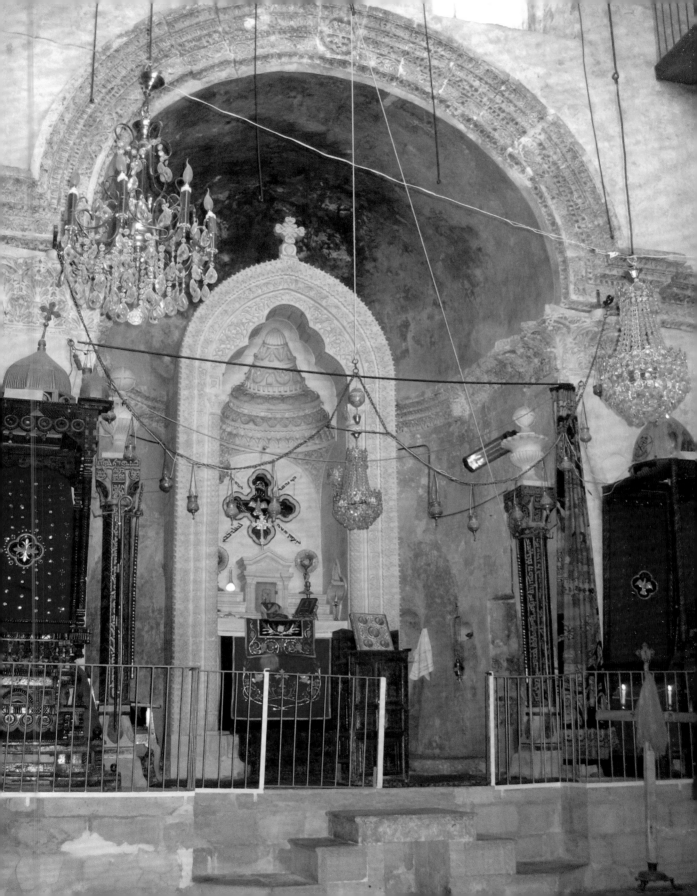

Cross on a Curtain

O Lord and Master of my life! Take from me the spirit of sloth, faint-heartedness, lust of power, and idle talk. But give rather the spirit of chastity, humility, patience, and love to Thy servant. Yea, O Lord and King! Grant me to see my own errors and not to judge my brother; For Thou art blessed unto ages of ages.

Amen

This prayer is said twice at the end of each Lenten service from Monday to Friday (not on Saturdays and Sundays) At the first reading, a prostration follows each petition. Then all bow twelve times saying: "O God, cleanse me a sinner." The entire prayer is repeated with one final prostration at the end.

St Ephraim the Syrian,
Lenten Prayer
306-373

Modern painted sanctuary veil drawn over a side chapel, Mor Barsawmo, Midyat, Tur Abdin, Eastern Turkey.

This curtain separates the clergy and the altar from the faithful at various points during the service in the church and depicts Jesus bursting from the tomb in his burial shroud above the crucifixion.

According to the Syriac Tradition, an ecclesiastical day starts at sunset. The worshipper has to face the east while worshipping. The Holy *Qurbono* (the Eucharist), is celebrated on Sundays and special occasions. The Holy Eucharist consists of Gospel Reading, Bible Readings, Prayers, and Songs. During the celebration of the Eucharist priests and deacons put on elaborate vestments which are unique to the Syriac Orthodox Church. Whether in the Middle East, India, Europe, the Americas or Australia, the same vestments are worn by all clergy. Apart from certain readings, all prayers are sung in the form of chants and melodies. Hundreds of melodies remain and these are preserved in the book known as *Beth Gazo*. It is the key reference to Syriac Orthodox church music.

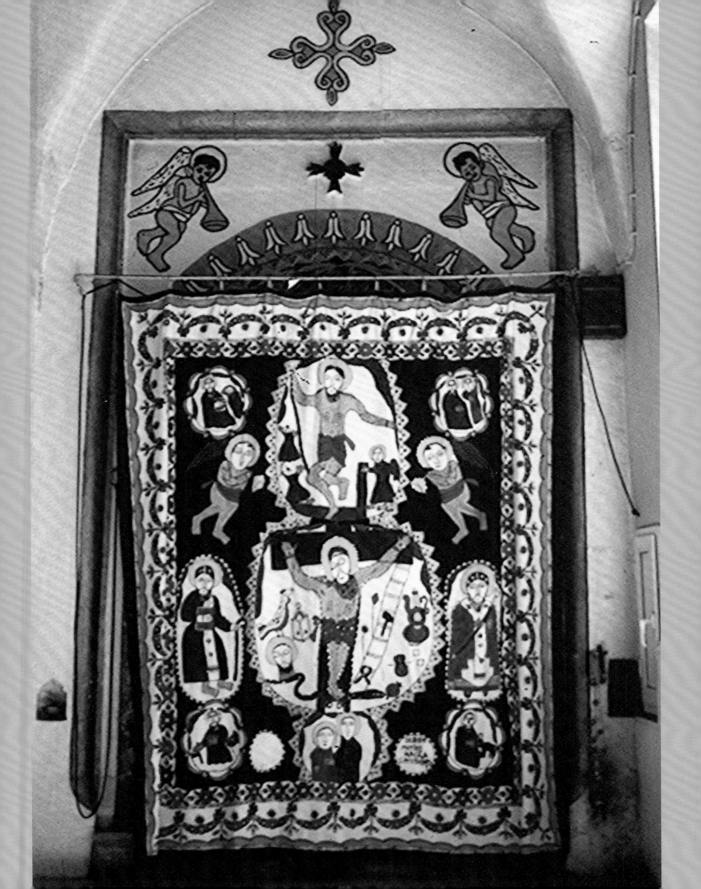

Armenian Cross-in-Square Church

The earth is the Lord's and everything in it,
the world, and all who live in it;
for He founded it on the seas and established it on the waters.
Who may ascend the mountain of the Lord?
Who may stand in His holy place?

The one who has clean hands and a pure heart,
who does not trust in an idol or swear by a false god.

They will receive blessing from the Lord and vindication from God their Saviour.
Such is the generation of those who seek Him, who seek your face, God of Jacob.

Lift up your heads, you gates; be lifted up, you ancient doors,
that the King of glory may come in.
Who is this King of glory?
The Lord strong and mighty, the Lord mighty in battle.

Lift up your heads, you gates; lift them up, you ancient doors,
that the King of glory may come in.
Who is he, this King of glory?
The Lord Almighty – He is the King of glory.

Psalm 24

10th-century cruciform Armenian Church of the Holy Cross, Aghtamar Island, Lake Van, Eastern Turkey.

The church and monastery of the Holy Cross built by King Gagik I (908 -936) originally held a piece of the True Cross, hence its name.

The Armenian Church adheres to the doctrine defined by Cyril I of Alexandria, considered a saint by the Council of Chalcedon as well, who described Christ as being of one incarnate nature, where both divine and human nature are united (*miaphysis*). To distinguish this from Eutychian and other versions of Monophysitism, this position is called *Miaphysitism*. The prefix *mono* refers to a singular one, the prefix *mia* refers to a compound one.

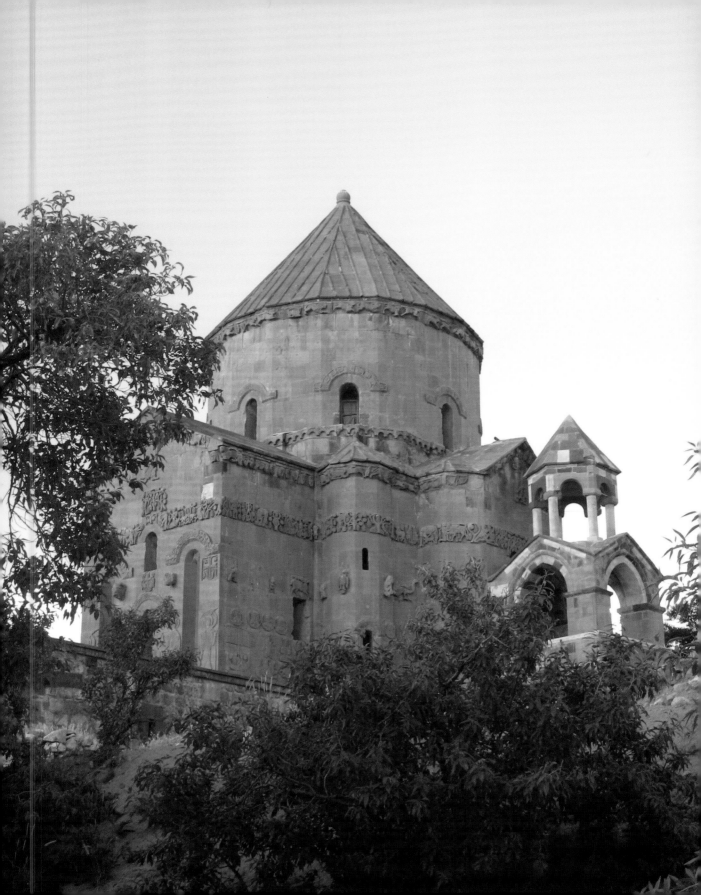

The Mediterranean Orthodox World:

Greece
Cyprus
Bulgaria
Sinai (Egypt)

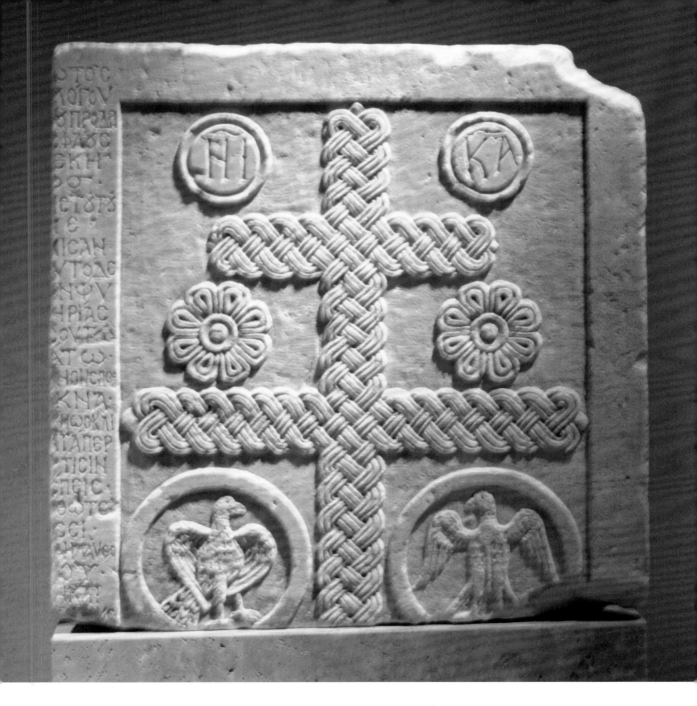

Cross on an Altar Panel

5th-century altar stone from a Greek church, courtesy of the Byzantine Museum, Athens, Greece.

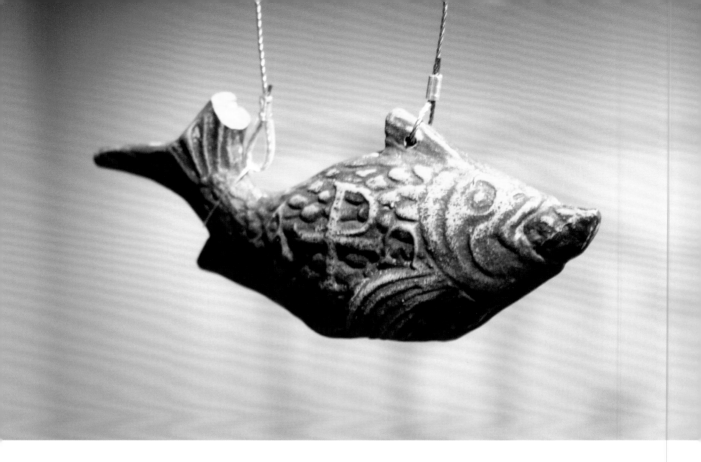

Cross on a fish

Grace to you and peace from him who is and who was and who is to come, and from the seven spirits who are before his throne, and from Jesus Christ, the faithful witness, the firstborn of the dead, and the ruler of the kings of the earth.
To him who loves us and freed us from our sins by his blood, and made us to be a kingdom, priests serving his God and Father, to him be glory and dominion for ever and ever. Amen.
Look! He is coming with the clouds; every eye will see him, even those who pierced him; and on his account all the tribes of the earth will wail.
So it is to be. Amen. "I am the Alpha and the Omega," says the Lord God, who is and who was and who is to come, the Almighty.

St John the Divine,
Revelation 1:4-8

4th-5th-century clay fish-shaped hanging lamp with relief Christograms and the apocalyptic letters A and Ω.

Cross on Lamps

Before the divine sojourn of the Saviour, even the holiest of men were afraid of death, and mourned the dead as those who perish. But now that the Saviour has raised His body, death is no longer terrible, but all those who believe in Christ tread it underfoot as nothing, and prefer to die rather than to deny their faith in Christ, knowing full well that when they die they do not perish, but live indeed, and become incorruptible through the resurrection.

St Athanasius,
Bishop of Alexandria,
251-356

Two 5th-7th-century copper lamps with cross-shaped handles.
Photographs: courtesy of the Byzantine Museum, Athens, Greece.

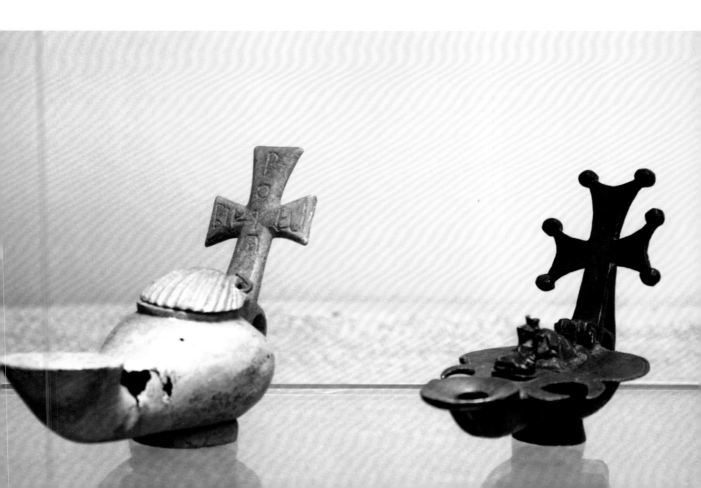

Cross on a Gravestone

He who dwells in the shelter of the Most High will rest in the shadow of the Almighty.

I will say of the LORD, "He is my refuge and my fortress, my God, in whom I trust."

Surely he will save you from the fowler's snare and from the deadly pestilence.

He will cover you with his feathers, and under his wings you will find refuge; his faithfulness will be your shield and rampart.

You will not fear the terror of night, nor the arrow that flies by day, nor the pestilence that stalks in the darkness, nor the plague that destroys at midday.

A thousand may fall at your side, ten thousand at your right hand, but it will not come near you.

You will only observe with your eyes and see the punishment of the wicked.

If you make the Most High your dwelling – even the LORD, who is my refuge, then no harm will befall you, no disaster will come near your tent.

For he will command his angels concerning you to guard you in all your ways.

Psalm 91:1-11

St John Chrysostom incorporated these verses into the Orthodox burial service.

6th-7th-century painted gravestone found in the Christian Cemetery, Thessalonika, Greece.

Photograph: courtesy of the Byzantine Museum of Thessalonika.

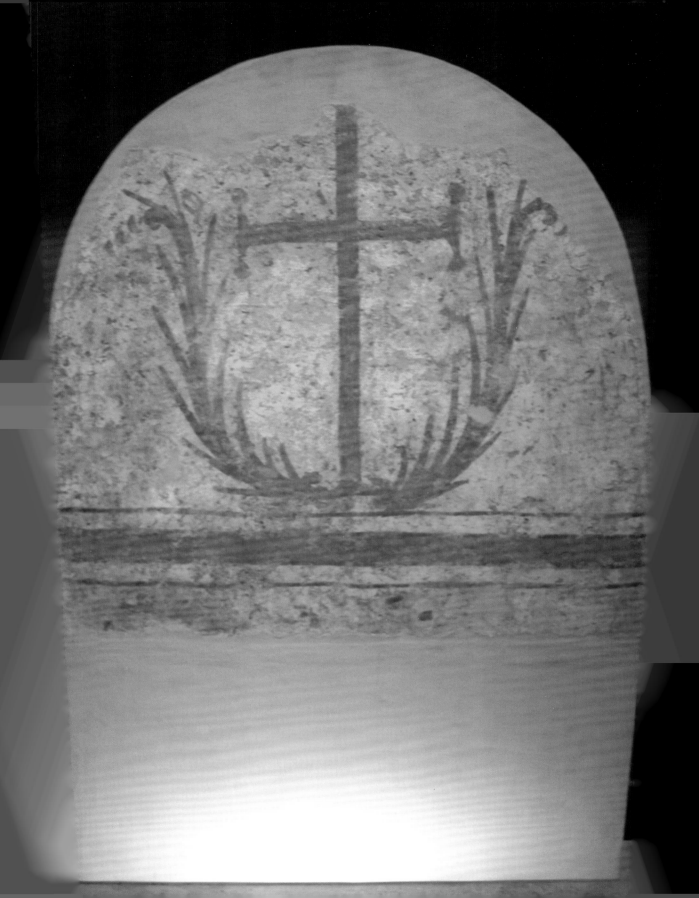

Crosses on a *Polycandelon*

Light shines on us without evening, without change, without alteration, without form. It speaks, works, lives, gives life, and changes into light those whom it illuminates. We bear witness that "God is light," and those to whom it has been granted to see Him have all beheld Him as light. Those who have seen Him have received Him as light, because the light of His glory goes before Him, and it is impossible for Him to appear without light. Those who have not seen His light have not seen Him, for He is the light, and those who have not received the light have not yet received grace. Those who have received grace have received the light of God and have received God, even as Christ Himself, who is the Light, has said, "I will live in them and move among them." (2 Corinthians 6:16).

St Symeon the New Theologian,
Discourse XXVIII
949-1022

6th-century copper *polycandelon* (lamp holder) ring with votive inscription, Limni, Euboea, Greece.

Photograph: courtesy of the Byzantine Museum, Athens, Greece.

St Symeon, a Byzantine monk and poet, the last of the saints canonised by the Orthodox Church, called the Theologian, not in the modern academic sense but as someone who spoke from a personal encounter with God

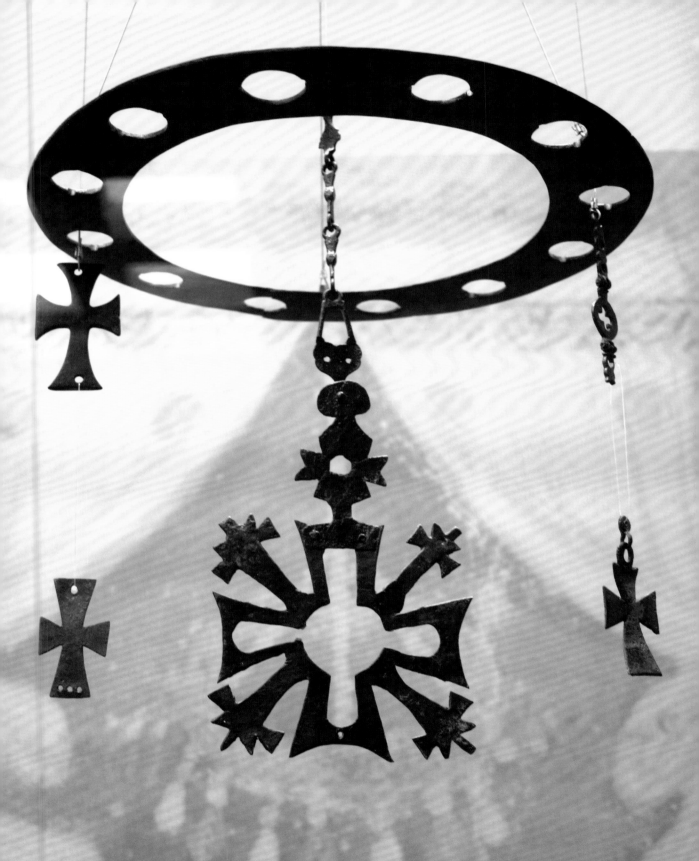

Iconoclastic Cross

Although debate was centred in the Imperial city of Constantinople, "iconoclasm" (lit. breaking of images) sparked controversy across Europe. Leo's declaration was vehemently rejected by Pope Gregory III, who called iconoclasm not just wrong but heretical. Passions flared for many decades, the issue of how religious images could or should be depicted producing furious propaganda from both camps, now almost exclusively known from the side of the iconophiles (those who support icons).

It is difficult to be sure exactly how far the destruction of sacred images went, as the sources are not always entirely reliable and trustworthy. In some cases, certainly, images were removed, destroyed or covered up such as above the south-western vestibule in the cathedral of St Sophia in Constantinople. However, it is likely the process was uneven, both in terms of geography and period and also depending on how enthusiasms waxed and waned. Having been firmly reinstated at the palace of Hieria at Chalcedon in 754, the ban on icons was lifted by the Empress Irene in 787 at the Second Council of Nicaea. Iconoclasm was once again officially re-introduced in 815, though this period seems to have been considerably more tolerant. It was finally discarded once and for all in 843 when the Triumph of Orthodoxy was declared.

In the iconoclast periods (730-787; 815-43), religious artifacts and objects continued to be produced, some of high quality. Secular objects like coins, which had had an image of the Emperor on one side and, from the late 7th Century, of Christ on the other, had religious images replaced; the design of lead seals, used to verify and authenticate documents, was also modified with many pieces bearing an image of the cross – a much favoured iconoclast symbol which represented Christ but did not depict Him.

The causes of iconoclasm are obscure and complicated. However, it is significant that it was introduced at a time of growing spiritual angst, with the volcanic eruption at Thira (Santorini) in 726, military setbacks against Arabs in the east and Bulgars in the west and economic contraction all serving to provide a context where radical solutions for the bleak situation – and lack of God's intercession – found a ready audience. It was not hard to see why the suffering in Byzantium would strike a chord with accusations of idolatry: this was after all why God had turned away from the Israelites in the Old Testament (Exodus 20:4). It was not without irony, therefore, that iconoclasm itself was declared heretical in 843: suffering had many causes but destroying the work of those who had tried to encourage prayer and devotion could be ruled out as one of them.

Dr Peter Frankopan,
Senior Research Fellow at Worcester College, Oxford and Director of the Oxford Centre for Byzantine Research at Oxford University, England.
1971-

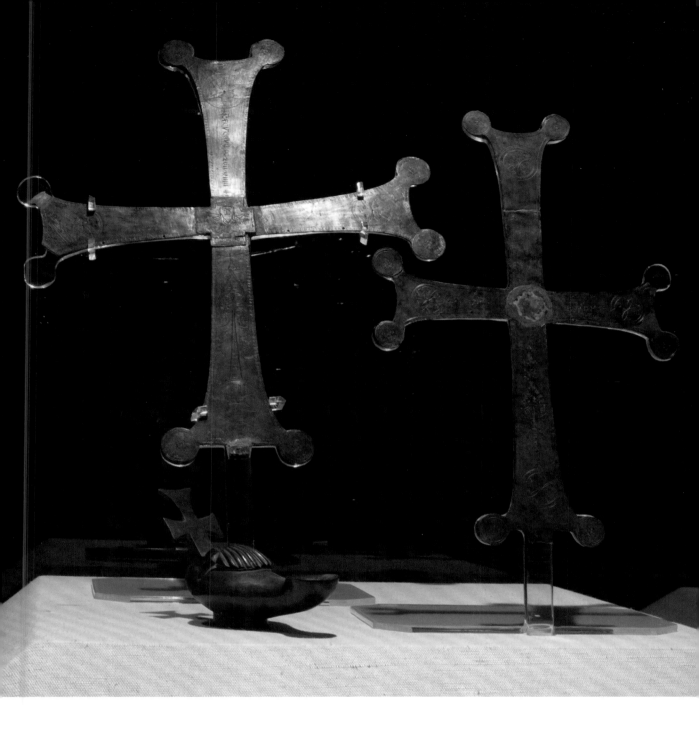

Pair of eight-pointed silver crosses from the iconoclastic period of the 8th century (with a little oil lamp), Sadberk Hanim Museum, Istanbul, Turkey.

Photograph: courtesy of Omer M. Koç and Sadberk Hanim Museum.

Crosses of St Nicholas of Myra

"You proved to be a model of faith, the image of gentleness, and a master of temperance through the example of your life, father Bishop Nicholas!"

This is how the hymnographer of the Eastern Christian Orthodox Tradition, describes St Nicholas, Bishop of Myra, (270-343).

These are virtues which are absent from our contemporary life, a life characterized by confusion perplexity and despair.

Faith, gentleness and temperance!

Faith: generates hope and love.

Gentleness: A product of the imitation of Christ Himself. "I am gentle and humble in heart" (Matthew 11.29)

Temperance: As the answer to the uncontrolled consumerism, St Nicholas is proposing through his example , austerity by applying the cardinal rule of saintly life, the distinction between "I desire" and "I need".

St Nicholas shows us the correct attitude towards the material world. We are managers of our natural environment and we can be truly free people by living a life of temperance following the example of this great saint.

If we want to be free people, among the crowds of people enslaved by the pursuit of material things and wealth, we need to turn to the example of St Nicholas, the model of faith, the image of gentleness and the master of temperance.

This wonder worker saint is remembered and revered among Catholic and Orthodox Christians, but also among many Protestant denominations.

Archimandrite Gennadios, Abbot of the Holy Monastery of the Archangel Michael, Monagri, Cyprus. (Translated by Daphnis Panagides)
1966-

Byzantine icon of St Nicholas, Bishop of Myra in Lycia and Pamphylia, Asia Minor (Turkey) in the Basilica built to house his relics, Bari, Apulia, Italy.

One of the Early Church Father, St Nicholas (270-343) is depicted as an Orthodox bishop, wearing the omophorion and holding a Gospel. In commemoration of the miracle attributed to him by tradition at the Ecumenical Council of Nicaea, he is depicted with Christ over his left shoulder holding out a Gospel and the Theotokos over his right shoulder holding the omophorion. A gift from King Stephen Uroš III of Serbia to express his thankfulness to St Nicholas for the miraculous returning of his vision, the donors' royal portraits are at the foot of the icon. There is a common belief that the face was painted at the time when St Nicholas was alive; he is depicted as an elderly man with a short, full white beard and balding head.

St Nicholas is Patron saint of Greece

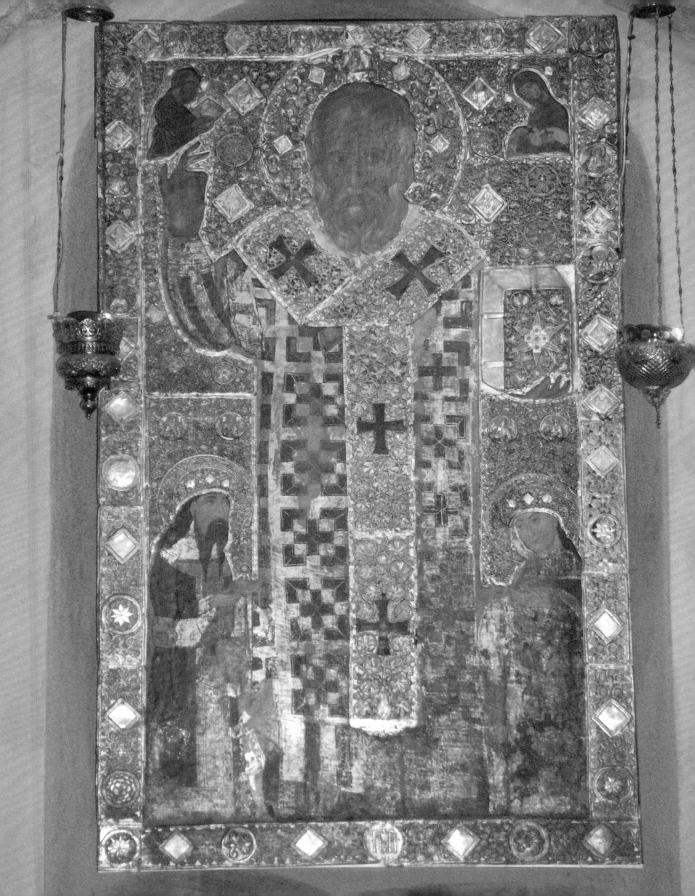

Jewelled Crosses

The Orthodox Church has a profound wealth in its spiritual tradition, which retains a cosmic, liturgical and mystical world view. This is why current issues of global concern, such as the ecological crisis, are of utmost importance to us inasmuch as they underline how doctrine and ethos are integrally related. The way we worship and pray to God reflects the way we lead our lives and treat our planet.

The Orthodox Church is often seen as a traditional Church. And, while it is true that we preserve many elements from the early Apostolic community, which witnessed the Resurrection of our Lord and the Pentecost of the Church, we are also a Church that seeks to dialogue with the present. In this regard, we are a Church that looks both to the past (with the treasures of the Church of the Fathers) as well as to the future (with an expectation of the heavenly kingdom, as we profess in the Nicene Creed). This all-embracing theology and all-encompassing spirituality is... *always prepared to give an answer to everyone who asks us to give the reason for the hope that lies within us.* (1 Peter 3:15)

His All-Holiness Bartholomaeus I, Archbishop of Constantinople, New Rome, Oecumenical Patriarch (1991-)
1940-

Top Left: 11th-12th-century Byzantine gold and enamel cloisonné pectoral Cross, with precious stones.
Bottom right: 10th-century Byzantine cross of gold with pearls and precious stones.

Photographs: Blaise Junod, courtesy of the Musée d'Art et d'Histoire, Geneva.

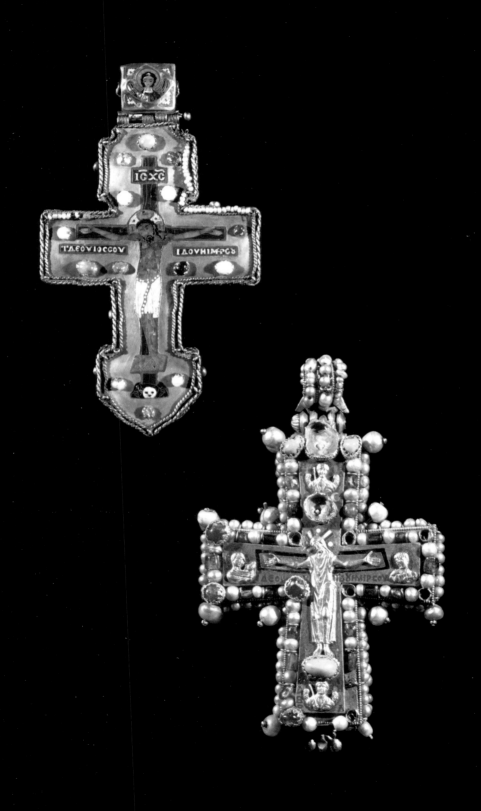

Cross on a Halo

From as early as the third century, the West emphasised the role of the Church in the present world, excelling in law, ethics, and the worldly institution. By contrast, the East stressed the heavenly (or eschatological) dimension of the Church, presenting unparalleled models and examples of mysticism and spirituality. So both East and West can learn from one another. The Orthodox Church can reveal how the Holy Spirit and the Divine Liturgy are able to inspire all aspects of the earthly Church – including the organisational leadership of the Church and the social standards of the people.

The Orthodox Christian religion is a key trait of a Greco-Slavic Civilization, as it is often described by western scholars and while it is true that Orthodox Christianity was the cradle of civilization on the Eastern world – both Greek and Slavic – the unfortunate truth is that the Western world has neglected its Byzantine roots. It is a sad reality that Western historians have been dominated by the importance and influence of the Renaissance, while overlooking the fact that Constantine the Great moved the capital of the Empire to New Rome, Constantinople, in 330 AD as well as the fact that all seven Ecumenical Councils of undivided Christianity were held not in Greece or Rome but in the East in what is now Turkey.

Nevertheless, more recent scholarship has embraced a more comprehensive view of history. As shown in Dr. Runciman's great books, the memory preserved by the Mother Church of Constantinople through the centuries was the memory of an Orthodox ecumenical civilization. However, it is not easy to turn around a tide of historical prejudice.

His All-Holiness Bartholomaeus I, Archbishop of Constantinople, New Rome,
Oecumenical Patriarch (1991-)
1940-

13th-century mosaic of Christ *Pantocrator,* holding the Book of Life, Santa Sophia, Istanbul, Turkey.

Photograph: Jane Taylor.

The mosaic shows a tri-radiant halo, which is reserved for depictions of God and that in each of the three sections are the Greek letters O Ω N (He-who-is) which echo Exodus 3:145, "*I am that I am*" – to emphasise that Christ is one with the God revealed in the Old Testament.

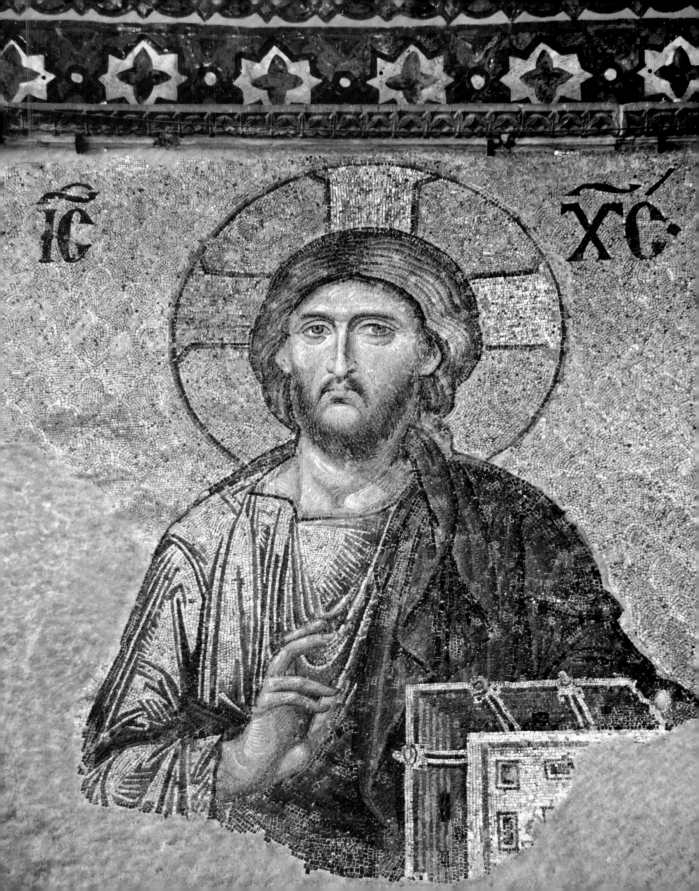

The Cross Triumphs over Death

Christ the victor descended into Hades and liberated the dead of all time. For the moment we simply offer one particularly striking remark of St John Chrysostom to underscore the total defeat and destruction of death and Hades. For "in the Orthodox doctrine of salvation the centre of emphasis in the redemptive power of the Cross is not so much on the satisfaction of divine righteousness and the removal of guilt from the transgressor (man), as it is on the very destruction of death and the power of the devil". This is why the divinely wise Father remarks as follows: the Sacred Scripture does not simply say that the crucified Lord "opened the doors of bronze", but rather that "He shattered the doors of bronze" precisely in order to render entirely useless the prison of death and of Hades. The God-Man did not simply remove the bars of gloomy Hades; He completely destroyed them, not only so that the horrible prison would not again be opened, but so that He may render it entirely useless and harmless. For where there is no bar and no door, even if one enters he cannot be imprisoned. Christ therefore, because he wanted to show that "death is at an end, shattered its bronze gates". Those gates are called bronze to indicate hardness and intensity, "the cruelty and necessity of death". Bronze and iron indicate this cruelty, this "hard, unyielding, implacable and ferocious aspect" of death.

St John Chrysostom,
349-407

Fresco of the *Anastasis*, 1320, church of St Saviour in Chora, Istanbul, Turkey.

Jesus pulls Adam and Eve from the grave, the first fruits of the dead at the resurrection. The broken gates of Hell form a cross beneath Christ's feet.

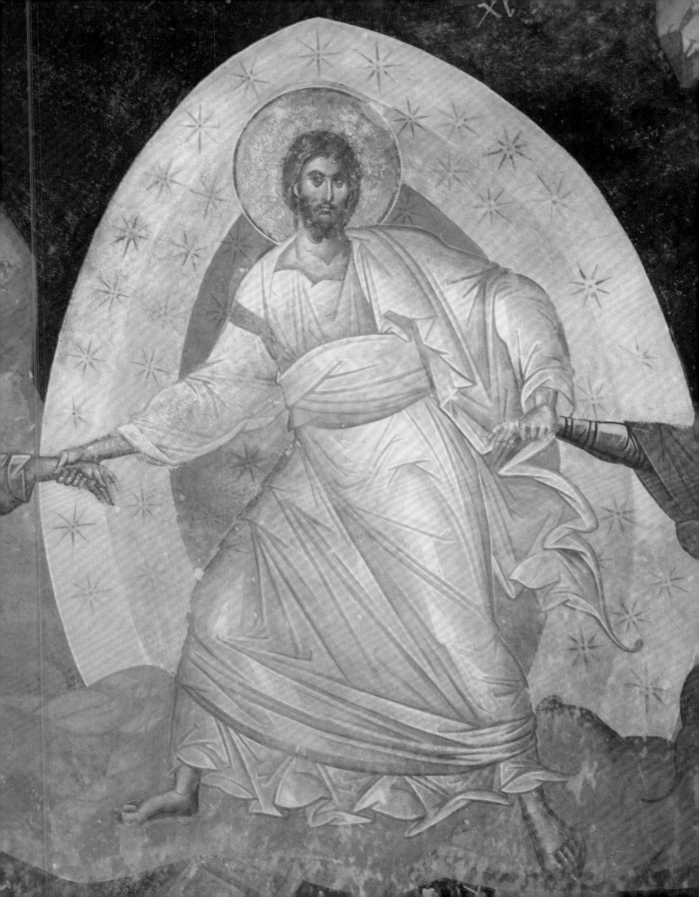

Cross of St Cyril

The Cross, then, that Christ bore, was not for his own deserts, but was the Cross that awaited us, and was our due, through our condemnation by the Law. For as He was numbered among the dead, not for Himself, but for our sakes, that we might find in Him, the Author of everlasting life, subduing of Himself the power of death; so also, He took upon himself the Cross that was our due, passing on Himself the condemnation of the Law, that the mouth of lawlessness might henceforth be stopped, according to the saying of the Psalmist; the Sinless having suffered condemnation for the sin of all. And of great profit will the deed which Christ performed be to our souls – I mean, as a type of true manliness in God's service. For in no other way can we triumphantly attain to perfection in all virtue and perfect union with God, save by setting our love toward Him above the earthly life, and zealously waging battle for the truth, if occasion calls us so to do.

Moreover, our Lord Jesus Christ says: *"Every man that doth not take his cross and follow after Me, is not worthy of Me"*. And taking up the Cross means, I think, nothing else than bidding farewell to the world for God's sake, and preferring, if the opportunity arises, the hope of future glory to life in the body.

St Cyril of Alexandria,
Commentary on the Gospel of St John, book 12
412-444

Fresco of St Cyril of Alexandria wearing a bishop's cloak covered with crosses (*polystavrion*, meaning many crosses) 1320, church of St Saviour in Chora, Istanbul, Turkey.

Pope Cyril I of Alexandria, supported by the entire See, sent a letter to Nestorius known as *The Third Epistle of St Cyril to Nestorius*. This epistle drew heavily on the established Patristic Constitutions and contained the most famous article of Alexandrian Orthodoxy: *The Twelve Anathemas of St Cyril*. In these anathemas, Cyril excommunicated anyone who followed the teachings of Nestorius. For example, "Anyone who dares to deny the Holy Virgin Mary, the mother of Jesus *the title Theotokos is Anathema*!" Nestorius, however, still would not repent and so this led to the convening of the First Ecumenical Council of Ephesus of 431, over which Cyril I of Alexandria presided.

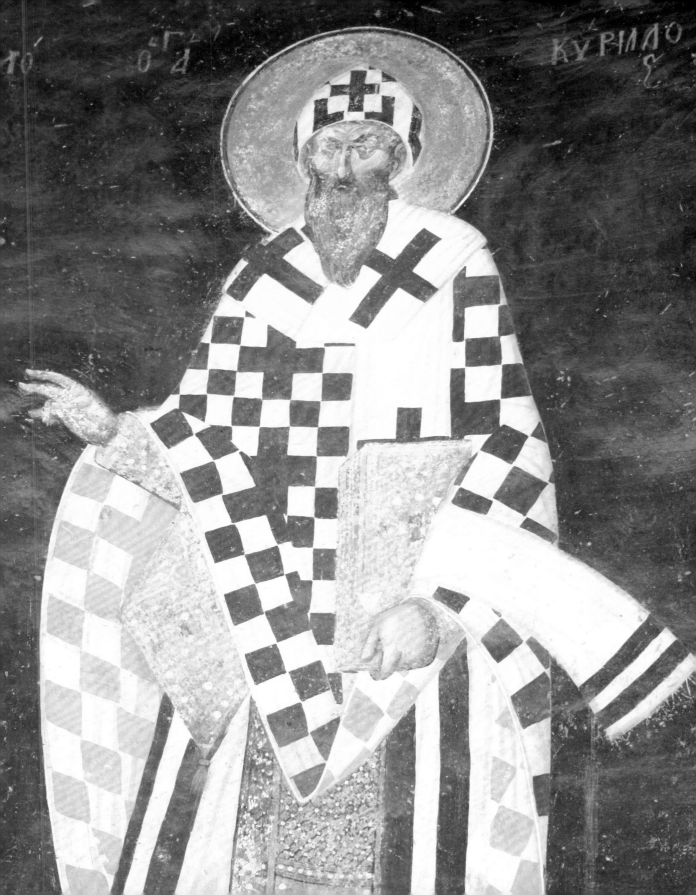

Ο ΑΓ(ΙΟΣ) ΚΥΡΙΛΛΟ(Σ)

Woven Velvet Cross

In the beginning was the Word, and the Word was with God, and the Word was God. He was in the beginning with God. All things came into being through Him, and apart from Him nothing came into being that has come into being. In Him was life, and the life was the Light of men. The Light shines in the darkness, and the darkness did not comprehend it.

There was the true Light which, coming into the world, enlightens every man. He was in the world, and the world was made through Him, and the world did not know Him. He came to His own, and those who were His own did not receive Him. But as many as received Him, to them He gave the right to become children of God, even to those who believe in His name, who were born, not of blood nor of the will of the flesh nor of the will of man, but of God.

And the Word became flesh, and dwelt among us, and we saw His glory, glory as of the only begotten from the Father, full of grace and truth.

John 1:1-5, 9-14.

12th-century parchment *Evangelistarion* (gospel lectionary) with a 17th-18th-century woven velvet cover, Ottoman design of tulip and carnation motifs, Istanbul, Turkey.

Photograph: courtesy of the Byzantine Museum, Athens, Greece.

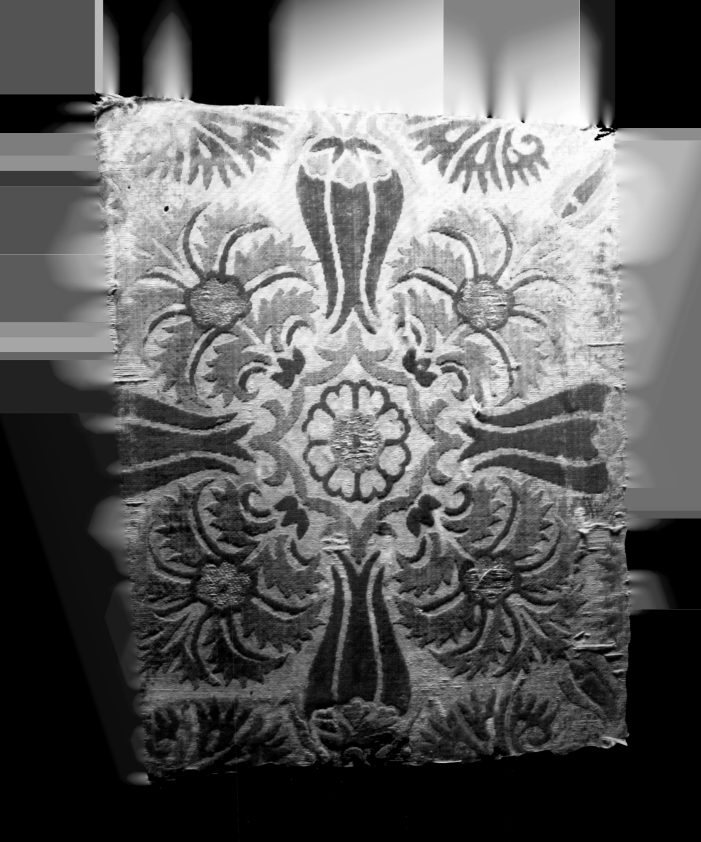

Cross and Seraphim

The Cross of the Lord is "a seal of salvation". It is a banner of victory and power. It is "the power of victory" over death.

Our holy Church honours and reveres the precious Cross of the Lord, because upon it the God-Man effected a unique victory and an unrepeatable triumph.

For the Cross is the symbol of the new life, the symbol of incorruptibility. This is why we chant: "The world kisses your Cross, O Lord, as it is the life of creation..." The life-bearing Cross, or more correctly, the solemn passion of the Lord upon the Cross, is the sign of the "seal" of our own salvation, and at the same time the sign of the glory of the God-Man.

The Son of God became man, when the evil of mankind had reached its climax and could go no further, in order to offer Himself "a sacrifice able to cleanse us", and moreover to reconcile us, through His death, with God the Father.

St John Chrysostom,
349-407

17th-century Greek Orthodox Priest's robe of green brocaded silk (*kemha*), incorporating crosses and seraphim, woven in Bursa, Turkey, with an embroidered velvet cross on the back, seen by the congregation as the priest always faces the altar and the rising sun.

Photograph: courtesy of the Sadebek Hanum Museum, Istanbul, Turkey.

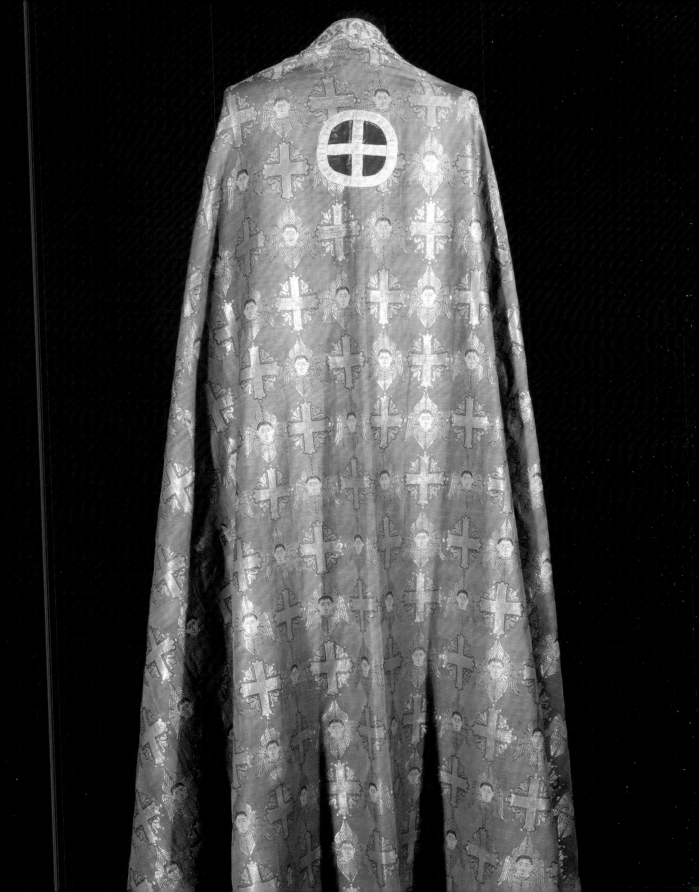

Cross on a Wall Tile

Here, in the "well-protected domains" of the Ottoman Empire, the Cross stands at its heart, reminding all of the co-existence of Muslims and Christians, the majority faith of the Ottoman domains when this tile was created. Those marked with the Cross lived as "*millet.*" Ambiguous too, this *millet* life, of the cross-bearers living under Islam. The Cross for them never a weapon, but a way of life.

Do we see in this tile, a black robed monk living "The Way", and dead to the world, before his monastic enclosure? But in this Levantine world, for good and ill, the Cross lives with the sickle moon of side by side, in multiplicity. Like the multiplicity of Crosses here. Do we see a symbol of Christ in the larger Cross, with the Apostles in the smaller ones? Or do we see the many ethnicities and identities of churches all under the Cross of Constantinople? Only the long dead artist knows. What we do know is the prayer of protection of the *Christaraksha*, as we pray it for all in the well-protected domains – that the cross may "guard, protect and deliver."

The Rev'd Dr William Taylor, Chairman, Anglican & Eastern Churches Association, 1956-

Early 18th-century Ottoman hexagonal wall tile, Kutahya, Turkey.

Photograph: courtesy of the Sedebek Hanum Museum, Istanbul, Turkey.

Cross of the Grand Master

Lord Jesus,
Thou hast seen fit to enlist me for Thy service
among the Knights of St John of Jerusalem.
I humbly entreat Thee through the intercession of the
most holy Virgin of Philermo, of St John the Baptist,
Blessed Gerard and all the Saints,
to keep me faithful to the traditions of our Order.
Be it mine to practice and defend the Catholic, the Apostolic,
the Roman faith against the enemies of religion:
be it mine to practice charity towards my neighbours,
especially the poor and the sick;
Give me the strength I need to carry out this my resolve,
forgetful of myself, learning ever from Thy holy Gospel
a spirit of deep and generous Christian devotion,
striving ever to promote God's glory, the world's peace,
and all that may benefit the Order of St John of Jerusalem.

Amen.

Prayer of the Sovereign Military Order of the Hospital
of St John of Jerusalem, of Rhodes and of Malta.

Stone memorial plaque, 1480, of Pierre d'Aubusson, Cardinal Grand Master of the Order of the Knights of St John of Jerusalem, the castle of the Knights of St John, Bodrum, Turkey.

After the fall of Constantinople, Sultan Mahomet II directed his attention to the task of destroying Rhodes. Henceforth the Order, thrown on the defensive, lived perpetually on the alert. Under its Grand Master, Pierre d'Aubusson, it repulsed all the Ottoman forces in the siege of Rhodes of 1480.

The Sovereign Military Order of the Hospital of St John of Jerusalem, of Rhodes and of Malta was established to care for pilgrims in 11th-century Jerusalem during the Crusades. The order is now also a sovereign state, holding observer status at the United Nations and maintaining diplomatic relations with 100 countries. Although the Knights are a religious order, the vast majority of its members are lay. It is a Catholic organization, but its humanitarian operations are open to people of all faiths. The Order lives on today as a lay Catholic religious order. The Knights carry out charitable and medical operations throughout the world, providing medical and social services, particularly in war zones and impoverished areas.

Illuminated Cross

Anyone who loves their father or mother more than me is not worthy of me; anyone who loves their son or daughter more than me is not worthy of me. Whoever does not take up their cross and follow me is not worthy of me. Whoever finds their life will lose it, and whoever loses their life for my sake will find it.

Matthew 10:37-39

9th-10th-century Greek Orthodox illuminated Bible, open at the gospel of Matthew.

Photograph: courtesy of the Byzantine Museum, Thessalonika, Greece.

ΤΗ ΕΠΑΥ
ΡΙΟΝ ΤΗΣ ΠΕΝΤΗΚΟ
ΤΗΣ ΗΓΟΥΝ
ΑΓΙΩΝ

✠ ΕΚ ΤΟΥ ΚΑΤΑ ΜΑΤΘΑΙΟΝ :

ειπεν ο κς̅ ο ραπε μαρ γαρ ιμ̅ τ ο τι
μι και αφερει κ οταν ρμει αν τ ο μεν
οη̅ πο θμοσ τ ω μ ο ωοιο · δι α τ αυ
μι ερ ω̅ τ ου τ αρτ το συμ̅ η που σι το

Cross on St Anne's Cloak

He was born of a woman to regenerate those who are born. He was crucified voluntarily to draw near to Himself those who were not crucified with their will. He died willingly to raise those who died unwillingly. He, who is not susceptible to death, accepted to die in order to give life to those who are under death. Death swallowed Christ unknowingly, but as soon as it did, death knew whom it had swallowed. Death swallowed life and was defeated by life. It swallowed the one after the many and it lost the many through the one. Death snatched as a lion and its teeth were smashed. This is why death is ignored by us as something weak. We are no longer afraid of death as a lion, but as a hide that we walk on!

St Basil the Great,
c. 330-379

14th-century fresco of the Palaeologian renaissance, painted according to the Macedonian school technique, probably depicting St Anne, the Church of Panagia Kera, Kritsa, Crete, Greece.

Icon of the Cross

The whole image seems to be endowed with life and even to participate in movement. If one will but direct his gaze to the parts of the picture, one after another, it will seem to him that some alter, some increase, some change, some experience or effect difference as if waxing and waining. Accordingly the dead body in the picture, even that which in fact seems so lifeless, will appear endowed with life. One knee has bent under him for when the body is upright the legs do not extend evenly. This is because people controlled by their inborn spirit maintain an even tension of the body but when the spirit is dispersed the resulting corpus sags upon itself since the joining of the bones is slightly relaxed.

Michael Psellos,
Sermon on crucifixion.
1017-1096

14th-century icon of the Crucifixion with the Virgin Mary, St Mary Magdalene and St John with St Peter. Constantinople workshop. The Church of Elkomenos, Monemvasia. Greece.

Photograph: courtesy of the Church of Elkomenos.

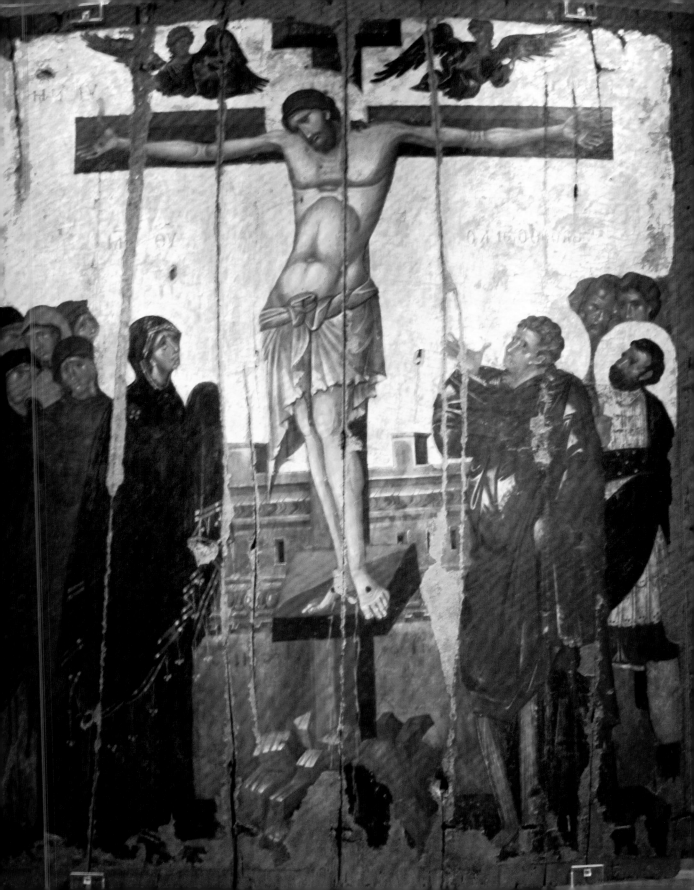

A Cross within the IHS

When Jesus saw his mother, and the disciple whom he loved standing near, he said to his mother, "Woman, behold, your son!" Then he said to the disciple, "Behold, your mother!"
John 19:26-27.

With these words Jesus gave the Blessed Virgin Mary a new mission and established a special relationship of love between her and all the disciples. The universal motherhood of Mary, the "Woman" of the wedding at Cana and of Calvary, recalls Eve, "Mother of all living" (Genesis 3:20). However, while the latter helped to bring sin into the world, the new Eve, Mary, co-operates in the saving event of Redemption. Thus in the Blessed Virgin the figure of "woman" is rehabilitated.

Blessed Pope John Paul II,
1920-2005

Second half of the 15th-century gold panel, oil on wood, Andreas Ritzos, Crete, Greece (when Crete was under Venetian Occupation). The Crucifixion on the left half of the icon is followed by the *Lithos* (Rolling Stone), the Greek way of presenting the Resurrection. The artist balances the beliefs and co-existence on the island of both the Eastern and Western Churches. Latin letters on the cross are IHS *Iesus Hominum Salvator*. The *Lithos* scene is balanced by the usual Greek Resurrection presentation of the Descent to Hades.

Cross in a Printed Bible

Happy are those who find wisdom, and those who get understanding,
for her income is better than silver, and her revenue better than gold.
She is more precious than jewels,
and nothing you desire can compare with her.
Long life is in her right hand;
in her left hand are riches and honour.
Her ways are ways of pleasantness, and all her paths are peace.
She is a tree of life to those who lay hold of her;
those who hold her fast are called happy.

Proverbs 3:13-18

Printed Greek version of the Bible, 1560, showing the Crucifixion.

Photograph: courtesy of the Byzantine Museum, Athens, Greece.

Pocket Cross

I carry a cross in my pocket
a sober reminder to me,
of the fact that I am a Christian,
no matter where I may be.
This little cross is not magic,
nor is it a good luck charm,
it isn't meant to protect me
from every physical harm.

It's not for identification
for all the world to see
it's simply an understanding
between my Savior and me.
When I put my hand in my pocket
to bring out a coin or a key.
the cross is there to remind me
of the price he paid for me.

It reminds me too to be thankful
for my blessings day by day
and to strive to serve him better
in all that I do or say.
It's also a daily reminder
of the peace and comfort I share
with all who know my master
and to give themselves to his care.

So I carry a cross in my pocket
reminding no-one but me
that Jesus Christ is Lord of my life
if only I'll let him be.

Anonymous.

18th-century (or earlier) carved and pierced, double-sided, boxwood cross, Mount Athos, Greece, in a velvet lined fish skin case, made for it in England in the 18th century. Private collection.

Front: the Crucifixion; *Reverse*: the Baptism. Made either to hang as a pectoral cross, or held in the hand, by screwing a handle, now missing, into the base of the gold lacquered brass surround.

Cross of the Greek War of Independence

The evolution of the cross from a religious to a partly religious/partly national symbol is illustrated in many of the flags of the Greek War of Independence. That which became the flag of modern Greece first appeared on the island of Skiathos: it combines the cross with nine bars, in blue and white, which correspond to the nine syllables of the revolutionary watchword "*Eleftheria i Thanatos*", "Liberty or Death".

The flag of Hydra, one of the three islands with a strong merchant marine that became crucial for the success of the insurgents, is a good example of the mixture of Christian and classical Greek elements of Greek identity. The Cross here is a symbol simultaneously of persistent faith, past repression, present struggle and future victory. It impales a reversed Islamic crescent, which does double service as a classical shield, on which are inscribed the famous Doric words of command from ancient Spartan mothers to their sons departing for battle: "Return with it or on it", "Η Ταν ή επί Τας 1821".

On one side of the Cross is a lance with a flag featuring the head of Athena. On the other side an anchor representing seapower, appropriate to Hydra, coiled around by a snake that is being attacked by a bird, probably the owl of wisdom, flying down from the eye of God, seen within the Sun of justice at the upper left.

The contribution of Hydra was critical for modern Greek independence. The combination of classical antiquity, mercantile power and Christian faith, centred on the symbol of the Cross, have been central to modern Greek history ever since.

Costas Carras,
1938-

Showcase celebrating the Greek hero Andreas Miaoulis, the Admiral and Commander of the Greek Navy during the 1821 War of Independence, their flag, and a model of their boats with which they harassed the Turks. The spear is a reminder of the unbroken National Consciousness that carried them through the dire times, as well as the spear that pierced Christ.

Photograph: courtesy of the Benaki Museum, Athens, Greece.

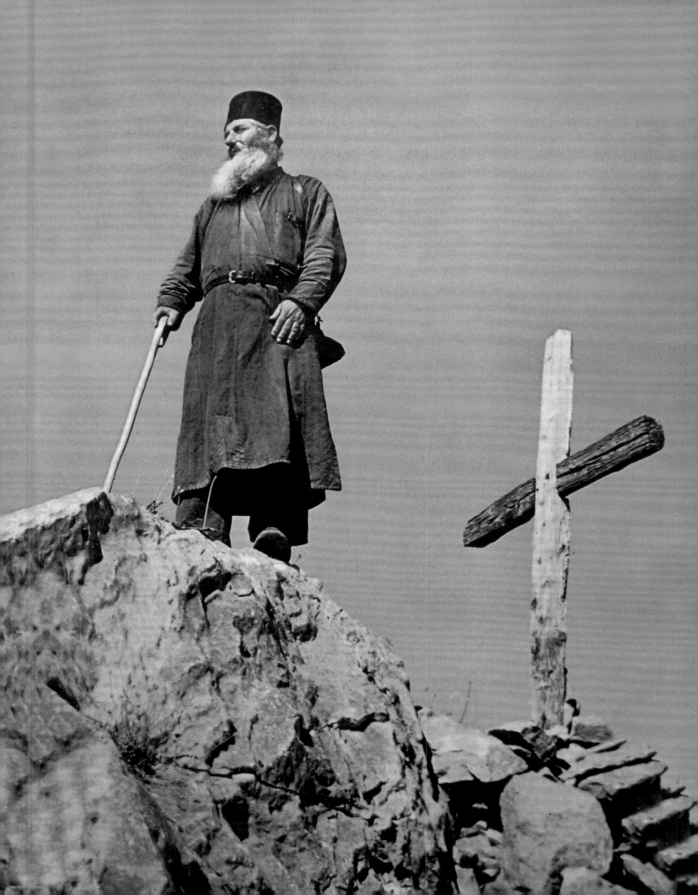

Cross on a Belfry

Holy God, Holy Mighty, Holy Immortal, have mercy on us.

The Trisagion.

Belfry of the Holy Church of Panagia of the Akathistos Hymn,Oia, Santorini, Greece. The Akathistos Hymn, is also locally called *Platsani*, from the icon of the Virgin Mary, carried to Oia by the waves of the sea. The splashing sound of the waves created the adjective *platsani*.

18th-century church of Agios Minas, Oia, overlooking the island of Therasia, Santorini, Greece.

The hymn is of great antiquity, and perhaps much older than the event assigned by the Greek Menology as connected to its origin. The Orthodox Church believes that the Trisagion originated from Nicodemus. While taking the body of Christ off the cross with Joseph of Arimathea, Nicodemus saw Jesus Christ's eyes open and then shouted "Holy God, Holy Mighty, Holy Immortal". Traditionally, it is also considered proof that His Divinity did not part from His humanity. This hymn was one of the exclamations of the fathers at the Council of Chalcedon in 451 and it is common not only to all the Greek Oriental liturgies, but was used also in the Gallican Liturgy of Saint Germain of Paris. This suggests that the hymn is extremely ancient, even perhaps dating from the apostolic era.

According to tradition, during the reign of Theodosius II (40-450), Constantinople was shaken by a violent earthquake on 24 September 447, and while the people, the emperor and the Proclus of Constantinople were praying for heavenly assistance, a child was suddenly lifted into midair, to whom all cried out *Kyrie eleison* (Lord, have mercy). The child was then seen descending again to the earth, and in a loud voice he implored the people to pray: "Holy God, Holy and Strong, Holy and Immortal". After giving this exhortation, the child died.

Cross on a Woven Shawl

A wife of noble character who can find? She is worth far more than rubies.
Her husband has full confidence in her and lacks nothing of value.
She brings him good, not harm, all the days of her life.
She selects wool and flax and works with eager hands.
She is like the merchant ships, bringing her food from afar. She gets up while it is still night;
she provides food for her family and portions for her female servants.
She considers a field and buys it; out of her earnings she plants a vineyard.
She sets about her work vigorously; her arms are strong for her tasks.
She sees that her trading is profitable, and her lamp does not go out at night.
In her hand she holds the distaff and grasps the spindle with her fingers.
She opens her arms to the poor and extends her hands to the needy.

Proverbs 31:10-20

Who doesn't feel daunted by this portrait of the ideal woman of God? Her attributes and skills are without compare. She is godly, hardworking, gifted, wise and compassionate.

She is successful in her family life, successful in business and respected in her community. In today's language she 'has it all'. Is it any wonder that, as the writer points out, she is hard to find.

She has many of the attributes that women today admire and strive for. She is respected in her own right, she is strong and capable, she has influence.

How do we respond to this portrait? Few of us will ever match up to her.

The most important quality of her life is one that all of us can emulate and put into practice.

She is a woman who fears God. Her priorities are determined by God's will, not her own.

She knows that she needs to rely on Him. 'A woman who fears The Lord is to be praised'

This Greek lady has long since lost the beauty of youth. That is not what is important to God. As Rick Warren says, "the goal of life is to grow in character in Christlikeness". As we endeavour to live each day in the fear of God, we can pray that God will work in and through us to mirror those qualities of Christlikeness that this lady of Metsovon demonstrates.

Fiona Costa
1955-

Woman wearing the shawl she has woven with a design of crosses, Metsovon, Northern Greece.

Cross on the Eighth of May

The Allied armies, through sacrifice and devotion and with God's help, have wrung from Germany a final and unconditional surrender. The western world has been freed of the evil forces which for five years and longer have imprisoned the bodies and broken the lives of millions upon millions of free-born men. They have violated their churches, destroyed their homes, corrupted their children, and murdered their loved ones. Our Armies of Liberation have restored freedom to these suffering peoples, whose spirit and will the oppressors could never enslave.

For the triumph of spirit and of arms which we have won, and for its promise to the peoples everywhere who join us in the love of freedom, it is fitting that we, as a nation, give thanks to Almighty God, who has strengthened us and given us the victory.

I call upon the people of the United States, whatever their faith, to unite in offering joyful thanks to God for the victory we have won, and to pray that He will support us to the end of our present struggle and guide us into the ways of peace.

Harry S Truman,
President of the United States of America,
Speech on May 8th 1945.
1884-1972

Greek Orthodox priests and bishops wearing embroidered stoles and crosses on the island of Simi, one of the Dodecanese Islands, Greece, for a Thanksgiving service to celebrate VE-Day and their liberation in 1945.

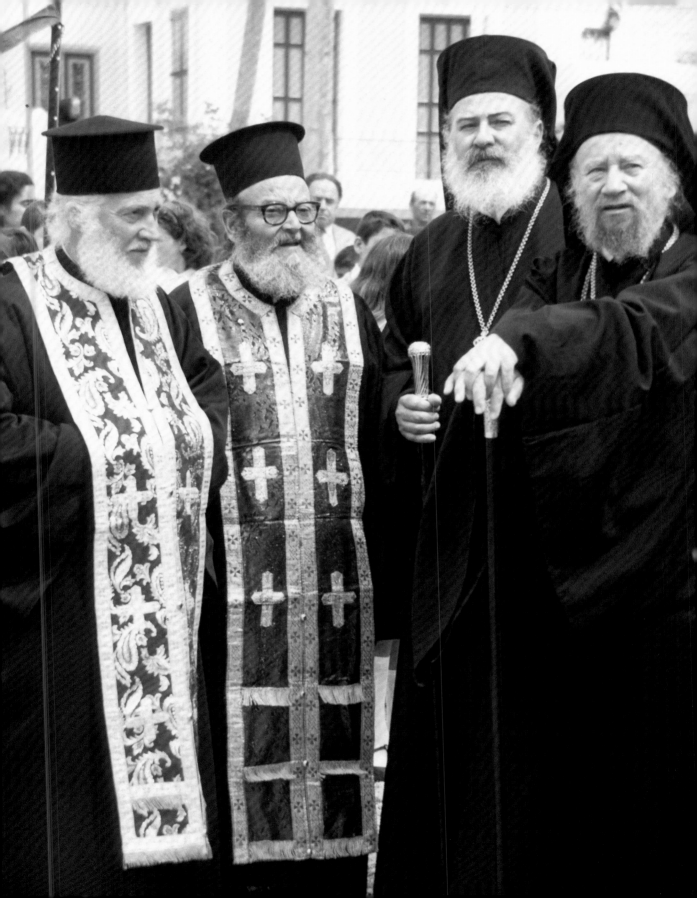

Cross in Cyprus

It says much for the enduring solidity of the Christian faith that, perhaps 700 years after it was painted, almost all the elements of this scene are easily recognisable to anyone with even the slightest knowledge of the accounts of the crucifixion. To the left of the cross are the three women (all named Mary by tradition) while to the right stands St John the Apostle. Further to the right, dressed in Byzantine armour, stand the two Roman guards. The one with the halo is the centurion (given the name Longinus by tradition), who in the Gospels acknowledges that Jesus was indeed the Son of God.

Yet if these elements are readily recognisable to the modern eye, two features will no doubt puzzle us. In the sky are two circular faces; one to the left of the cross is red and male, the other, to the right, is white and female. Each is drawn gazing down on the crucifixion and apparently breathing on Christ. In a painting that is otherwise stylised reality, their obvious symbolism is striking. With a little research we find that they represent the sun and the moon and learn that this pairing of personified astronomical bodies is not uncommon in Eastern depictions of the crucifixion.

One of the great works of theology of the early church was *On the Incarnation* by St Athanasius, written in the middle of the fourth century. It was a time, not unlike our own, in which there were pressures for the church to turn from believing in a divine Christ – a God somehow made flesh – to a Christ who was little more than a great prophet. Almost alone, Athanasius rebutted this and his book is still standard reading in many theological colleges today. In it he writes, "He it is who was crucified with the sun and moon as witnesses; and by His death salvation has come to all men, and all creation has been redeemed."

Athanasius is presumably referring both to the account in the Gospels of how, on that first Good Friday, a darkness fell across the sun, and the reference in Acts 2:20 to the 'moon turning to blood'. His point is that the universe itself testified that despite all the shame and humiliation of his death Jesus is no mere man but is the Lord of the universe. And in turn our unknown Byzantine painter is reminding those who look at his work that what he is depicting is not just a tragic, painful and shameful end to a noble life. It is an event on a scale that we can barely grasp. The sun and the moon – the very cosmos itself – are bearing testimony that this dying man is in fact their Maker, the creator of the universe. And if He is their king, He should be ours too.

The Rev'd Canon J John

14th-century fresco, part of a cycle of the life of Christ, 11th-century monastery of Agios Nikolaos tis Stegis, (St Nicholas of the roof) Kakopetria, Troodos Mountains, Cyprus.

Photograph: Blaise Junod

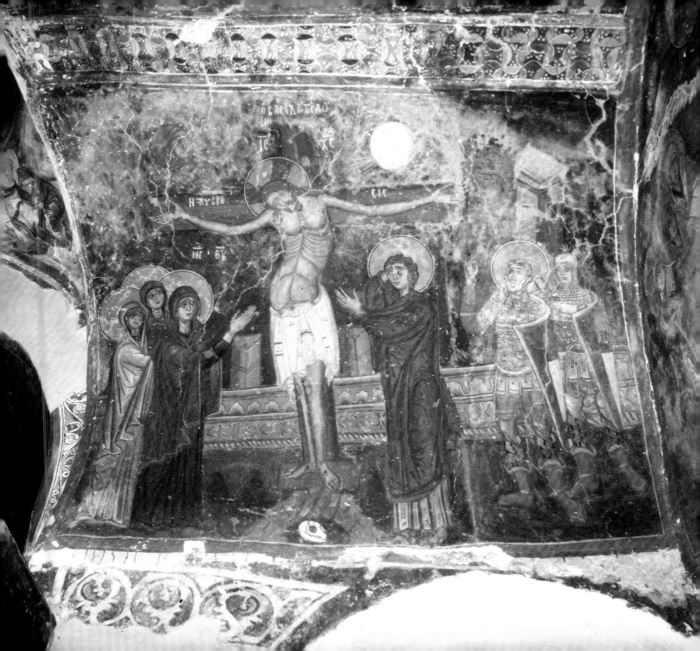

Cross in Sinai

Icon of St Catherine, Sinai, Egypt, copied by Caroline Lees in 2011.

6th-century carved stone emblems adorn the stout outer walls.

Now Moses was tending the flock of Jethro, his father-in-law, the priest of Midian, and he led the flock to the far side of the wilderness and came to Horeb, the mountain of God. There the angel of the Lord appeared to him in flames of fire from within a bush. Moses saw that though the bush was on fire it did not burn up. So Moses thought, "I will go over and see this strange sight – why the bush does not burn up."

When the Lord saw that he had gone over to look, God called to him from within the bush, "Moses! Moses!" And Moses said, "Here I am."

"Do not come any closer," God said. "Take off your sandals, for the place where you are standing is holy ground." Then he said, "I am the God of your father, the God of Abraham, the God of Isaac and the God of Jacob." At this, Moses hid his face, because he was afraid to look at God.

Exodus 3:1-6

St Catherine's Monastery, 6th century, Sinai, Egypt.

Photograph: Iain Hepburn.

St Catherine's Monastery lies on the Sinai Peninsula, at the mouth of a gorge at the foot of Mount Sinai. The monastery was built by order of the Eastern Roman Emperor Justinian I (reigned 527-565) at the site where Moses is supposed to have seen the burning bush. The library preserves the second largest collection of early codices and manuscripts in the world, outnumbered only by the Vatican Library

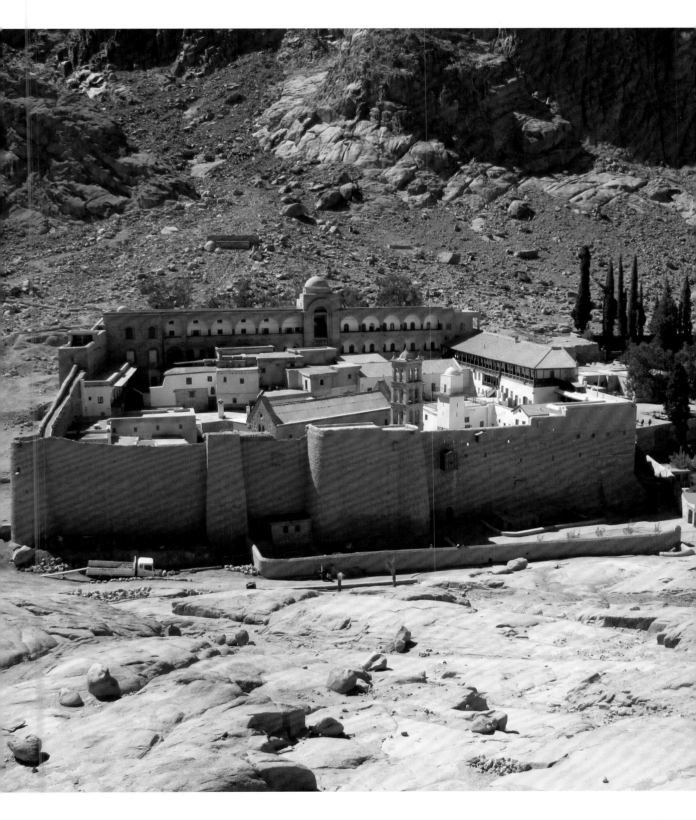

The Coptic World:

Egypt
Ethiopia

The Cross in Africa:

Tanzania
Zimbabwe
Mozambique
Réunion

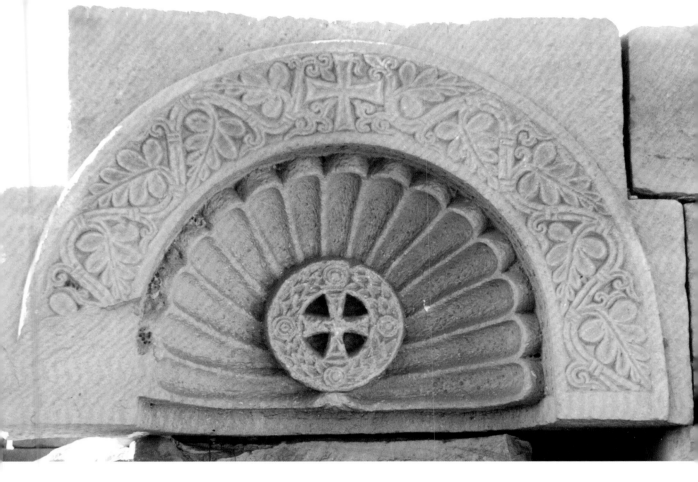

Cross in a Shell

In that day there will be an altar to the Lord in the midst of the land of Egypt, and a pillar to the Lord at its border.

Isaiah 19:19

Remains of a 6th-century chapel in the ruined Coptic church in the temple of Hathor, Dendera, Upper Egypt.

The Coptic Church, which is more than nineteen centuries old, is based on the teachings of St Mark who brought Christianity to Egypt during the reign of the Roman emperor Nero in the first century, a dozen of years after the Lord's ascension. He was one of the four evangelists and the one who wrote the oldest canonical gospel. Christianity spread throughout Egypt within half a century of St Mark's arrival in Alexandria as is clear from the New Testament writings found in Bahnasa, in Middle Egypt, which date from around 200, and a fragment of the Gospel of St John, written in the Coptic language, was found in Upper Egypt and can be dated to the first half of the second century. The Coptic Church was the subject of many prophecies in the Old Testament.

Cross in a Circle

We give Thee thanks, our Father, for the Holy Resurrection which Thou has manifested to us through Jesus, Thy Son, and even as this bread which is here upon this table was formerly scattered abroad and has been made compact so may Thy Church be reunited from the ends of the earth for Thy Kingdom, for Thine is the power and the glory, for ever and ever. Amen.

Attributed to St Athanasius the Great, c. 296-373

Eight-pointed plaster Cross above the doorway of a house in Old Cairo, Egypt. The cypress tree represents eternal life.

5th-century cross made of painted mud over the door of the Sanctuary of the monastery of El Baramous, Wadi Natrun.

6th-century cross or *Salib* of mud plaster, the Monastery of El Baramous, Wadi Natrun, Egypt.

Photograph: Piffa Schroder

This is one of the places where traditionally the Holy Family stayed during the three years and eleven months they spent in Egypt. Dedicated to the Virgin of Baramous, it is the northernmost of the four active monasteries and was probably the first to be established in the Wadi El-Natrun, Egypt.

The Monks of El Baramous explain the Symbolism of the Cross in the circle:
The Circle stands for the Eternity of God and also the Crown of Thorns.
The Cross stands for the four Evangelists and also four Branches divided by three, meaning the Trinity.
The eight cavities are the eight days that Noah remained in the Ark after he landed on dry land; also for the eight Beatitudes and also for Jesus who appeared to His Disciples eight days after the Resurrection.
The middle is the Vine, the rest are the branches representing us.
The twelve points represent the twelve Apostles. It is painted red and white to symbolize the blood and water coming out of Jesus' side.

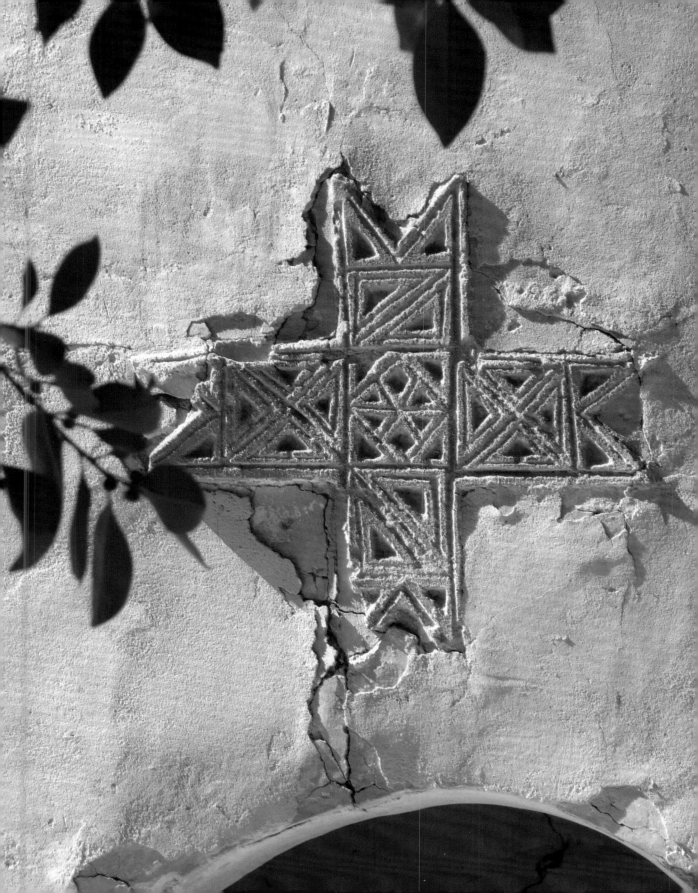

Cross on a *Stele*

Our Bridegroom has not been taken from us. He stands in our midst, though we see him not. The Priest is within the holy place. He is entered into that within the veil, whither our forerunner Christ has entered for us (cf. Hebrews 6:20). He has left behind him the curtain of the flesh. No longer does he pray to the type or shadow of the things in heaven, but he looks upon the very embodiment of these realities. No longer through a glass darkly does he intercede with God, but face to face he intercedes with Him: and he intercedes for us, and for the "negligences and ignorances" of the people. He has put away the coats of skin (cf. Genesis 3:21); no need is there now for the dwellers in paradise of such garments as these; but he wears the raiment which the purity of his life has woven into a glorious dress. "Precious in the sight of the Lord is the death" of such a man, or rather it is not death, but the breaking of bonds, as it is said, "You have broken my bonds asunder." Simeon has been let depart. He has been freed from the bondage of the body. The "snare is broken and the bird has flown away." He has left Egypt behind, this material life. He has crossed, not this Red Sea of ours, but the black gloomy sea of life. He has entered upon the land of promise, and holds high converse with God upon the mount. He has loosed the sandal of his soul, that with the pure step of thought he may set foot upon that holy land where there is the Vision of God.

St Gregory of Nyssa,
Funeral oration for St Meletios of Antioch
c. 335-396

6th-century Coptic sandstone memorial *stele*, with a Greek inscription to the deceased architect Euprepios. Armant, the former Greek city of Hermonthis, on the west bank of the Nile just south of Thebes, Upper Egypt.

Photograph: courtesy of the Vatican Museum, Rome, Italy.

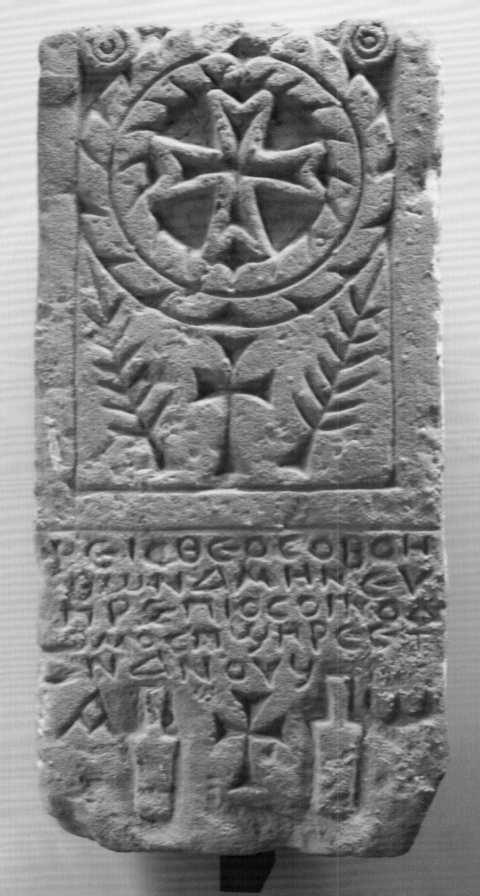

Cross of St Anthony in the Desert

He went into the church pondering these things, and just then it happened that the Gospel was being read, and he heard the Lord saying to the rich man, "If you would be perfect, go, sell what you possess and give to the poor, and you will have treasure in heaven." It was as if by God's design he held the saints in his recollection, and as if the passage were read on his account. Immediately Anthony went out from the Lord's house and gave to the townspeople the possessions he had from his forebears.

St Athanasius the Great,
The Life of St Anthony,
c. 296-373

St Anthony and his friend St Paul, the first hermit, with the raven that took bread daily from St Anthony to St Paul. Red Sea, Egypt.

Modern entrance to St Anthony's 3rd century monastery, Red Sea, Egypt.

Photograph: Philippa Vaughan

Sometime around 270, Anthony, a twenty year old Christian, who had been raised in Alexandria, gave away all his possessions and went to live in the desert. Although he returned to the "old world" several times, he continued to live in solitude for the rest of his life. In the desert he prayed and supported his existence by manual labour. He soon became famous for his holiness and men came to live near him, and imitate his solitary existence. Anthony clearly embraced the ascetic life, a form of existence which became increasingly popular now that martyrdom was no longer possible, many people saw in Anthony a fundamentally new way of demonstrating their devotion to God. The monastery of St Anthony – Deir Mar Antonios – near the Red Sea, is the oldest monastery in Egypt.

The Coptic church has an unbroken tradition since 451. Currently 110 monks are living within the ancient mud walls. The name Baramous means "That of the Romans" and derives from Maximus and Domitius, Coptic and Roman saints who lived in the monastery as early as St Macarius the Great himself.

Left: A monk from St Anthony's Monastery greeting a monk from St Paul's Monastery, Red Sea, Egypt.
Photograph Caroline Lees.

Cross in the *Deisis*

The passion of our Lord and Savior Jesus Christ is the hope of glory and a lesson in patience. What may not the hearts of believers promise themselves as the gift of God's grace, when for their sake God's only Son, co-eternal with the Father, was not content only to be born as man from human stock but even died at the hands of the men he had created?

It is a great thing that we are promised by the Lord; but far greater is what has already been done for us, and which we now commemorate. Where were the sinners, what were they doing when Christ died for them? When Christ has already given us the gift of his death, who is to doubt that he will give the saints the gift of his own life? Why does our human frailty hesitate to believe that mankind will one day live with God?

Who is Christ if not the Word of God: *In the beginning was the Word, and the Word was with God, and the Word was God?* This power of himself to die for us: he had to take from us our mortal flesh. This was the way in which, though immortal, he was able to die; the way in which he chose to give life to mortal men: he would first share with us, and then enable us to share with him. Of ourselves we had no power to live, nor did he of himself have the power to die. Accordingly, he effected a wonderful exchange with us, through mutual sharing: we gave him the power to die, he will give us the power to live. The death of the Lord our God should not be a cause of shame for us; rather, it should be our greatest hope, our greatest glory. In taking upon himself the death that he found in us, he has most faithfully promised to give us life in him, such as we cannot have of ourselves.

He loved us so much that, sinless himself, he suffered for us sinners the punishment we deserved for our sins. How then can he fail to give us the reward we deserve for our righteousness, for he is the source of righteousness? How can he, whose promises are true, fail to reward the saints when he bore the punishment of sinners, though without sin himself? Brethren, let us then fearlessly acknowledge, and even openly proclaim, that Christ was crucified for us; let us confess it, not in fear but in joy, not in shame but in glory.

St Augustine of Hippo,
354-430

6th-7th-century *Deisis* fresco, the *Deisis* Chapel, Monastery of St Anthony, Egypt.

Photograph: Jane Taylor

Christ in Majesty is in the centre, with the Virgin Mary and John the Baptist petitioning Christ on behalf of mankind. The four living creatures looking like cherubim (three with animal heads) are also petitioning. The inscription on the curved red band at Christ's feet reads (in Coptic) "Lord Jesus Christ, have pity on me". The *mandorla* (large, almond-shaped "halo" surrounding the whole figure of Christ) is supported by four angels, and on either side of it are representations of the sun and the moon.

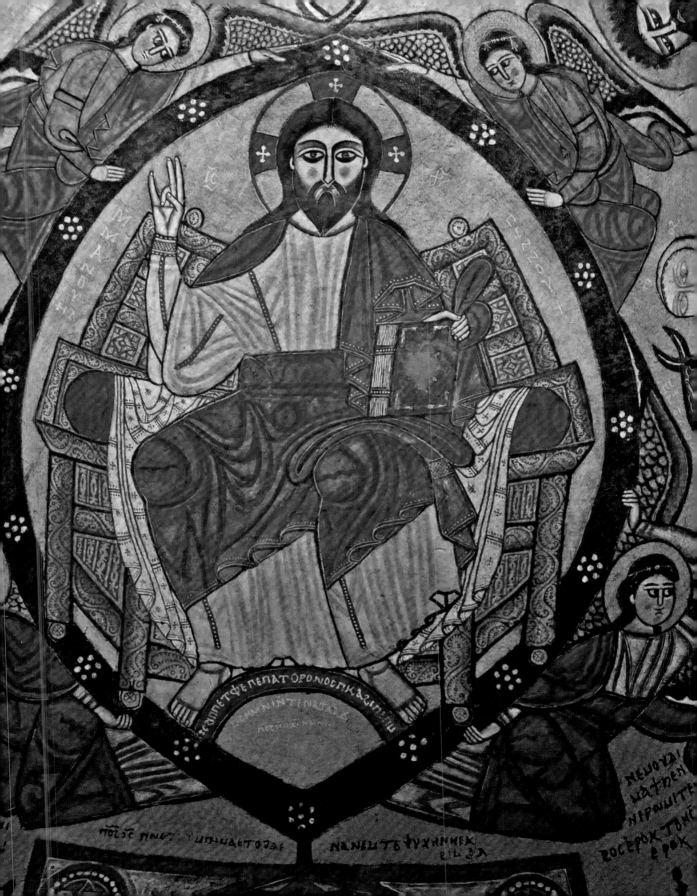

Woven Cross

After the sign of the cross, grace immediately thus operates and composes all the members and the heart, so that the soul from its abounding gladness seems as a youth that knows not evil. Indeed it drives away evil. St Antony the Great speaks of defending himself by faith and the sign of the cross and St Athanasios the Apostolic says, *"By the sign of the cross all magic ceases; all incantations are powerless; every idol is abandoned and deserted; all irrational voluptuousness is quelled, and each one looks up from earth to heaven."*

St Macarios the Great of Egypt,
300-391

6th-8th-century woven wool and linen Coptic textile.

Photograph: courtesy of the Benaki Museum, Athens, Greece.

Fine Coptic textiles are the products of the Egyptian textile craftsmen, who may or may not have been Christian, who lived in the beginning of the Christian era. Weaving in the early Christian era was, as in earlier times, mainly on linen although there is also some evidence of silk weaving. The techniques – the so-called tapestry-weave and loom weaving – were inherited from the ancient Egyptians. The width of the loom used in Coptic tapestries is the same as that in the time of the pharaohs, and the special "Egyptian knot" was used as well. In the 4th century a new variant to wool weaving was introduced loop weaving in which the waft was not pulled quite tight. Silk became popular in the 6th century and by the 8th century full clerical tunics were woven in both linen and silk; the weaving of some articles appeared so fine as to look more like intricate embroidery.

Embroidered Cross

Holy God, Holy Mighty, Holy Immortal, Who was born of the Virgin, have mercy on us. Holy God, Holy Mighty, Holy Immortal, Who was crucified for us, have mercy on us. Holy God, Holy Mighty, Holy Immortal, Who rose from the dead and ascended into the heavens, have mercy on us.
Glory to the Father, and to the Son, and to the Holy Spirit, now and forever and unto the ages of all ages. Amen.

O Holy Trinity, have mercy on us. O Holy Trinity, have mercy on us. O Holy Trinity, have mercy on us.
O Lord, forgive us our sins. O Lord, forgive us our iniquities. O Lord, forgive us our trespasses.
O Lord, visit the sick of Your people, heal them for the sake of Your holy name. Our fathers and brothers who have slept, O Lord, repose their souls.
O You Who are without sin, Lord have mercy on us. O You Who are without sin, Lord help us and receive our supplications. For Yours is the glory, the dominion, and triple holiness.

Lord have mercy. Lord have mercy. Lord bless. Amen.

The Trisagion of the Coptic Church.

The Four Evangelists, Matthew, Mark, Luke and John are woven in silver and coloured silk thread surround Christ on this Cross motive which was sewn on the back of the Bishop's robe in the Coptic Museum, Cairo, Egypt.

Photograph: courtesy of the Coptic Museum, Cairo, Egypt.

The term "Copt" originally derived from the Arabic word "*Qibt*", which in its term is merely a shorten form of the Greek word Aigyptios, Egyptian, from which the initial diphthong "ai" and the adjectival suffix "ios" have fallen away leaving the form gypt or Qibt. This means that the Coptic Church is the Egyptian Church, which can trace its origin to apostolic times. Following the flight of the Holy family from Bethlehem to Egypt, St Luke informs us that Egyptians were also present on the first day of Pentecost when the Holy Spirit descended upon the faithful in Jerusalem. There is good reason to believe that some of these Egyptian Jews returned to their homes where they established Christian congregations. Jews had flourished in Alexandria and throughout the Nile Valley from the early days of the Ptolemies, who ruled Egypt for about three centuries (323-30 BC) and early Egyptian Christians owed a great deal to the philosopher Philo, a contemporary of Jesus and the apostles, who during his life time was perhaps the most influential Jew in Alexandria. In fact, the works of Philo served as a model for the Christian theologians of Alexandria. He provided the young Christian community in Egypt with a way of reconciling their Christian message with the Egyptian cultural background.

Cross on a *Tonia*

Detail of the silk embroidered crosses on the *tonia* sleeve.

6th-8th-century leather shoes with gold leaf decorations, worn in the tomb for burial.

From an object of destruction and shame, the cross has become the emblem of pride and respect. We raise it high over our churches; we decorate our most sacred objects with it whether they are buildings, or fabrics; we suspend it around our necks; in the Coptic tradition it is tattooed on the wrists and hands of infants; in the Oriental Orthodox churches the priests and bishops always carry a hand-cross to confer blessings; we begin our prayers with it; we use it to bless our food; it is to be found in all services and sacraments of the church and in the benediction of parents to their children. It is an ubiquitous and potent symbol. In itself it is a means of grace.

Many Coptic Christians proudly bear the name *Salib*, which means Cross.

The Most Rev'd Metropolitan Seraphim El-Suriani of Glastonbury, the British Orthodox Church within the Coptic Orthodox Patriarchate of Alexandria, 1948-

18th-century Coptic Priest's white cotton liturgical *tonia* (Coptic alb), with representation of a female saint (Damiana?) flanked by 40 female saints. Embroidered with red and black silk thread.

Photographs: courtesy of Byzantine Museum, Athens.

The Coptic Church has never believed in monophysitism in the way it was portrayed in the Council of Chalcedon which meant believing in the one nature of Christ. Copts believe that the Lord is perfect in His divinity, and He is perfect in His humanity, but His divinity and His humanity were united in one nature called "the nature of the incarnate word", which was reiterated by St Cyril of Alexandria. Copts thus, believe that the two natures "human" and "divine" that are united in one "without mingling, without confusion, and without alteration" (from the declaration of faith at the end of the Coptic divine liturgy. These two natures "did not separate for a moment or the twinkling of an eye" (from the declaration of faith at the end of the Coptic divine liturgy).

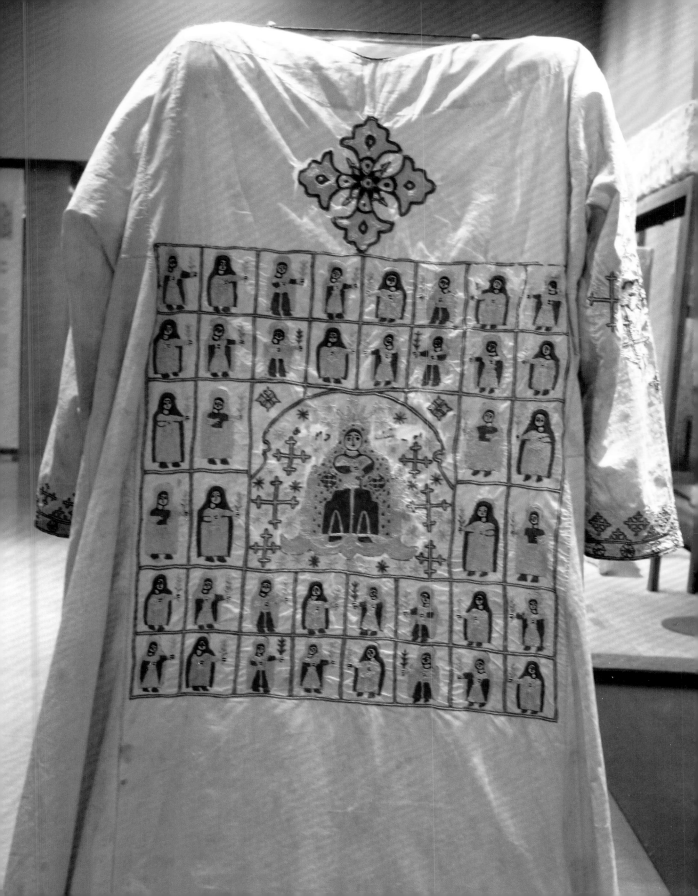

Cross on Vellum

In Orthodox theology the holy icons are much, much more than edifying religious art. The Risen Christ was raised in His Body, bearing for all time the marks of His passion, just as we also shall be resurrected in our bodies.

Pope Shenouda observed that in making the sign of the cross we declare our belief in the Incarnation and Redemption. In signing ourselves from forehead to chest, we remember that God came down from earth to heaven and from left to right, that we have passed from darkness to light, from life to death.

That humbling of which Saint Cyril speaks, means that we also must bear our cross with the Lord. In the Gospels the Lord invites anyone who desires to come after him to deny himself, "*take up his cross*" and follow Him (Matthew 16:24 and Mark 8:34). There is no doubt of the imperative nature of this command as He also warns that "*whoever does not bear his cross and come after me cannot be my disciple.*" (Luke 14:27) This simple message, summed up in the old maxim, "No cross, no crown" inspired the apostles in proclaiming the Gospel; it has sustained the faith of Christians through times of fierce persecution and personal tragedy; it has animated the monastic fathers and ascetics. In the Coptic tradition the monastic fathers are known as "the cross bearers." Following in the footsteps of the Lord, the saints and martyrs of every age, and still today, have willingly borne their crosses.

The Most Rev'd Metropolitan Seraphim El-Suriani of Glastonbury, the British Orthodox Church within the Coptic Orthodox Patriarchate of Alexandria, 1948-

18th-century Coptic icon of the Crucifixion with the Virgin Mary and St John. Note that the *titulus* is in Arabic, whereas the IC XC is in Greek, the inscription is also in Arabic. Church of Abu Serga, Old Cairo, Egypt.

Photograph: Nabila Harris

The Holy Family is said to have spent three and a half years in Egypt, some of it in Old Cairo, known as Misr El Kadima. The Governor of what was then Fustat, enraged by the tumbling down of idols at Jesus' approach, sought to kill the Child. But they took shelter from his wrath in a cave above which, in later years, the Church of Abu Serga (St Sergius) was built.

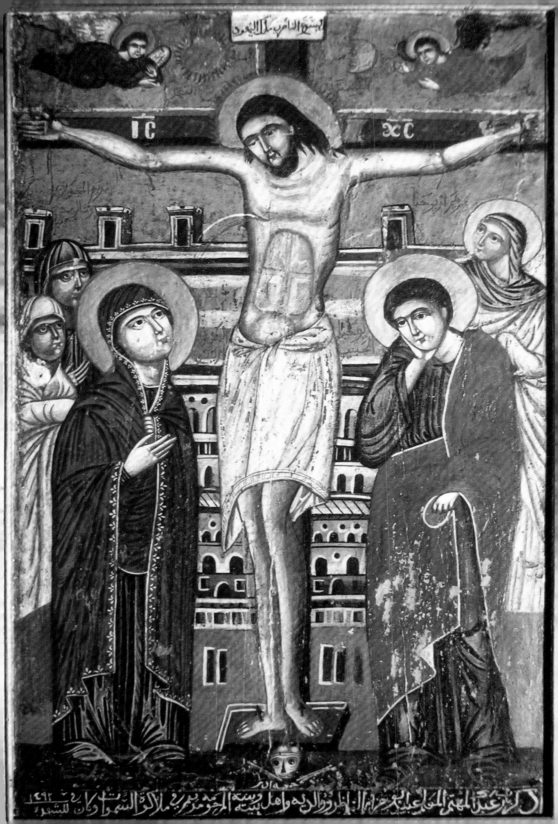

IC XC

Crosses of Inlaid Wood

St John Chrysostom highlights the paradox that it is in the very offence of the cross that we discover its call. He says, "The gospel produces the exact opposite of what people want and expect, but it is that very fact which persuades them to accept it in the end. The apostles won their case, not simply without a sign, but by something which appeared to go against all the known signs. The cross seems to be a cause of offence, but far from simply offending, it attracts and calls believers to itself."

The message of the cross has such a power because it is a crucial component in the economy of salvation. Just as the cross of the Lord preceded His Resurrection, so our dying to sin and submission to His purpose, leads to our new life. Symbolised by our immersion in the baptismal waters, we rise to become partakers of the divine nature and incorporated into the Body of Christ. We suffer with Him that we may be glorified together (Romans 8:17); He tells us that if we suffer reviling, persecution and falsehoods for His sake we should *"rejoice and be exceedingly glad"* because our reward in heaven will be great (Matthew 5:11-12). Indeed, the glory we receive through bearing the cross is beyond our comprehension. Saint Paul says, *"For I consider that the sufferings of this present time are not worthy to be compared with the glory which shall be revealed in us"* (Romans 8:18).

The Most Rev'd Metropolitan Seraphim El-Suriani of Glastonbury, the British Orthodox Church within the Coptic Orthodox Patriarchate of Alexandria, 1948-

Traditional 18th-century walnut, ebony and ivroy inlaid woodwork crosses, part of the Haikal (Sanctury) screen in Cairo's oldest church, dedicated to the martyrs Saints Sergius and Bacchus, (Abu Sarga), Cairo, Egypt.

Photograph: Nabila Harris

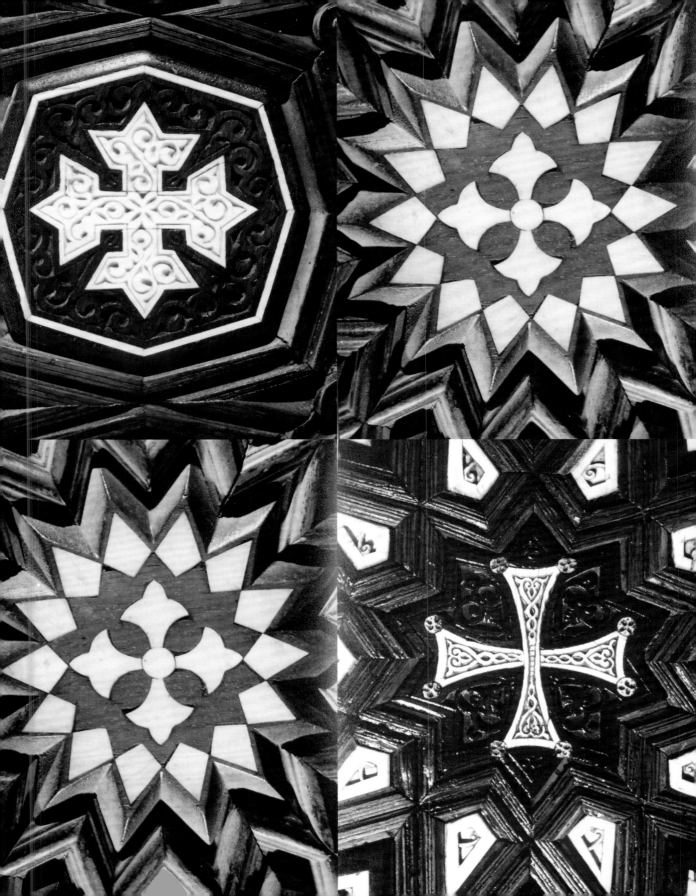

Cross on a Patriarch's Stole

In thy patience thou didst win thy reward, O righteous father.
Thou didst persevere unremittingly in prayer,
thou didst love the poor, and didst provide for them bountifully.
But intercede with Christ our God,
O blessed John the Almsgiver,
that our souls be saved.
Thou didst dispense thy wealth to the poor,
and now thou hast obtained the wealth of the Heavens,
O supremely-wise John.
Wherefore, we all acclaim thee and celebrate thy memory,
O namesake of mercy.

Prayer to St John the Almsgiver,
Patriarch of Alexandria,
c. 550-616

Modern icon of St John the Almsgiver, St Edward Orthodox church, Brookwood, Surrey England.

Photograph: Justin Hunt.

A native of Cyprus, St John (Ioannes III Eleemon), rose to be a much loved and influential Greek Patriarch of Alexandria, Egypt between 610-621. Evidence of Mediterranean trade exists in a single passage in the life of St John the Almsgiver, in which reference is made to a vessel sailing to Alexandria from Britain with a cargo of tin from Cornwall.

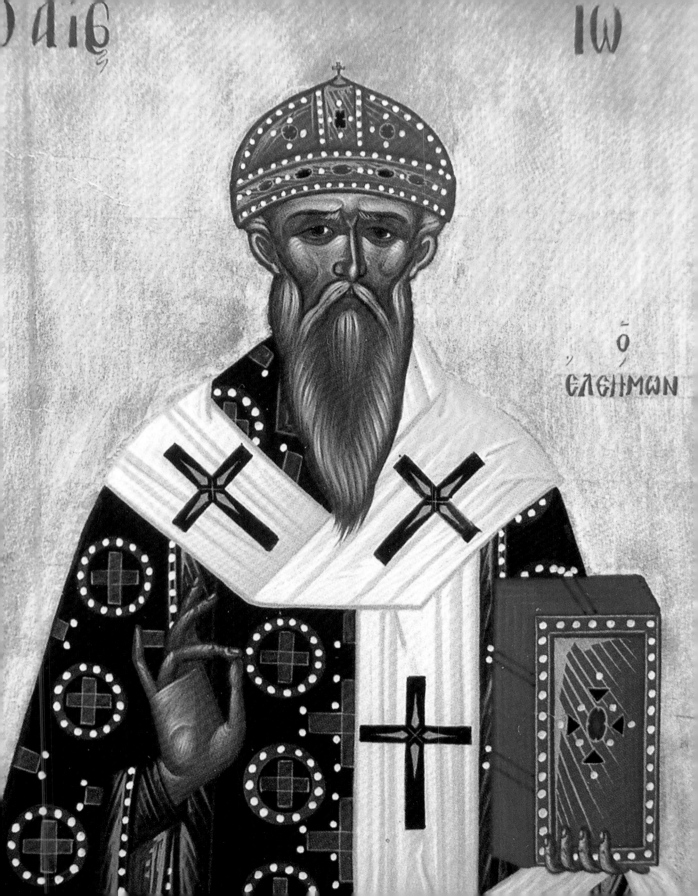

Cross on a Rock-Cut Roof

We, who believe, are saved by the power of His Cross.

St Yared,
505-571

12th-century rock-cut church of St George, Lalibela, Ethiopia.

The Ethiopian Orthodox Tewahedo Church was officially organized in 328 after Christianity was introduced to the country by the Eunuch converted by St Philip in the apostolic era. In 341 Frumentius established such strong ties between the Egyptian and Ethiopian churches, that until 1959, the Egyptian church always provided the archbishop or abuna. Since her recognition as an Episcopate in 330, the Ethiopian Orthodox Tewahedo Church, one of the most ancient churches in Christendom, has been fullfilling her Apostolic duties up to the present time. Her faith is based on the teaching of the Ethiopian Eunuch, St Matthew and other Apostles. In addition, she accepted the canon and the decisions of the first three Ecumenical Councils of Nicaea in 325, Constantinople in 381 and Ephesus in 431 and continues to teach their creed decisions and serving the Lord.

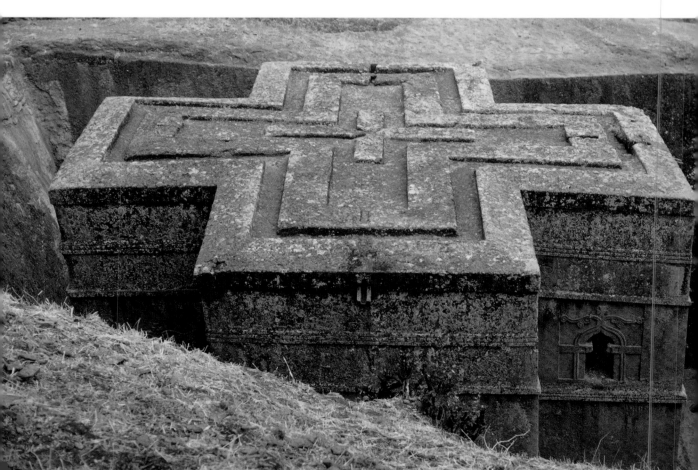

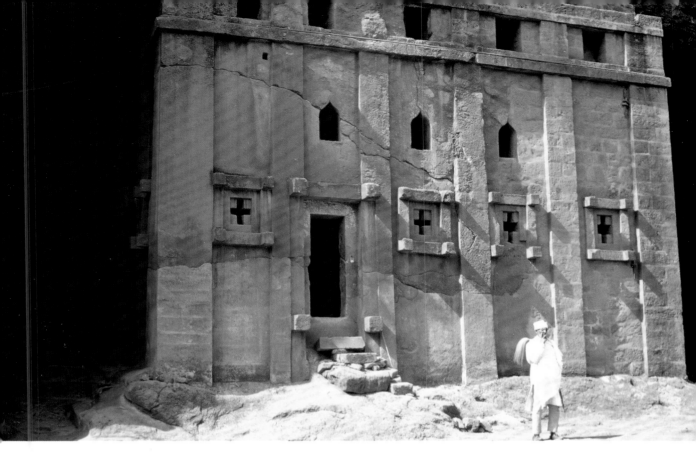

Windows of Crosses

Praise the Lord.
Praise God in his sanctuary; praise him in his mighty heavens.
Praise him for his acts of power; praise him for his surpassing greatness.
Praise him with the sounding of the trumpet, praise him with the harp and lyre,
Praise him with timbrel and dancing, praise him with the strings and pipe,
Praise him with the clash of cymbals, praise him with resounding cymbals.
Let everything that has breath praise the Lord.

Psalm 150

12th-century church of Abba Libanos. Lalibela, Ethiopia.

Unique among the churches of Lalibela, it is the only structure that is not free
standing. According to legend, this church was made in just one night by angels, who
hewed it from a hillside; the roof has not been separated from the surrounding rock.

Cross and Crowns

Now an angel of the Lord said to Philip, "Go south to the road – the desert road, that goes down from Jerusalem to Gaza.". So he started out, and on his way he met an Ethiopian eunuch, an important official in charge of all the treasury of the Kandake (which means "queen of the Ethiopians"). This man had gone to Jerusalem to worship, and on his way home was sitting in his chariot reading the Book of Isaiah the prophet. The Spirit told Philip, "Go to that chariot and stay near it." Then Philip ran up to the chariot and heard the man reading Isaiah the prophet. "Do you understand what you are reading?" Philip asked. "How can I," he said, "unless someone explains it to me?" So he invited Philip to come up and sit with him.

This is the passage of Scripture the eunuch was reading: "He was led like a sheep to the slaughter, and as a lamb before its shearer is silent, so he did not open his mouth. In his humiliation he was deprived of justice. Who can speak of his descendants? For his life was taken from the earth."

The eunuch asked Philip, "Tell me, please, who is the prophet talking about, himself or someone else?" Then Philip began with that very passage of Scripture and told him the good news about Jesus. As they travelled along the road, they came to some water and the eunuch said, "Look, here is water. What can stand in the way of my being baptized?" And he gave orders to stop the chariot. Then both Philip and the eunuch went down into the water and Philip baptized him. When they came up out of the water, the Spirit of the Lord suddenly took Philip away, and the eunuch did not see him again, but went on his way rejoicing. Philip, however, appeared at Azotus and travelled about, preaching the gospel in all the towns until he reached Caesarea.

Acts 8:26-40

12th-century solid gold processional cross, Coptic Orthodox priest, six ceremonial crowns including the Coronation crown of the Ethiopian Emperor Menelik II, made of gold and precious stones, St Mary's Church, Axum, Ethiopia.

In the cages behind the priest are two lion cubs, the symbol of the Emperor of Ethiopia – the Lion of Judah, who tradition says is descended from King Solomon and the Queen of Sheba.

African Crosses

God of all
We know that in Christ there is no east or west, no south or north
Inspire us with love,
Enable us to cross bridges of culture, race and language
To understand each other
To share and give of what we have to nourish this parish link
in fellowship and communion with our brothers and sisters in Chimoio
That we may celebrate our unity in diversity.
Amen.

Ramani Leathard,
1955-

Top left: The Blue Church of Chimoio is the Parish Church in Manica, Mozambique: Anusha Leathard.
Top right and *bottom left*: Crosses from Zimbabwe and Tanzania belonging to Abbot Timothy Wright OSB.
Bottom right: Ecumenical Church, Réunion, Blaise Junod.

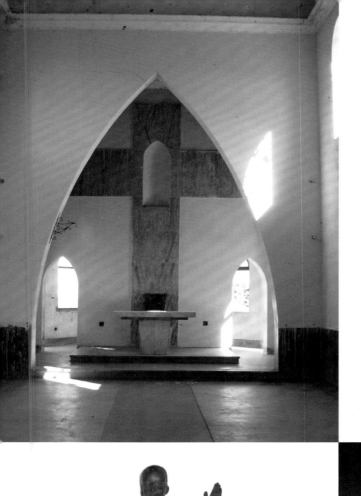

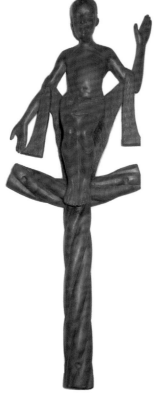

The Independent Early Churches:

Georgia
Armenia

The Nestorian World:

Mesopotamia (Iraq)
Persia (Iran)

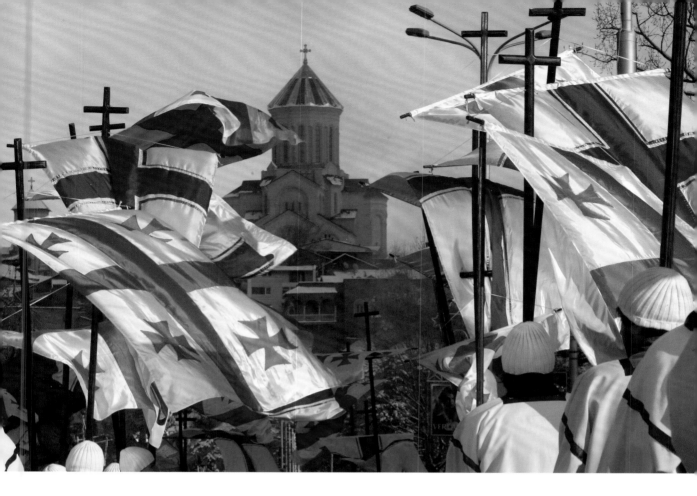

The Cross in Georgia

There is also in the East another Christian people, who are very warlike and valiant in battle, being strong in body and powerful in the countless numbers of their warriors. They are much dreaded by the Saracens and have often by their invasions done great damage to the Persians, Medes and Assyrians on whose borders they dwell, being entirely surrounded by infidel nations. These men are called Georgians, because they especially revere and worship St George, whom they make their patron and standard-bearer in their fight with the infidels, and they honour him above all other saints. Whenever they come on pilgrimage to the Lord's Sepulchre, they march into the Holy City with banners displayed, without paying tribute to anyone, for the Saracens dare in no wise molest them. They wear their hair and beards about a cubit long and have hats on their heads.

Jacques de Vitry,
Latin Patriarch of Jerusalem,
c. 1160-1240

Procession of Georgians carrying their national flag.
Photograph courtesy of Caucasus Travel, Tbilisi, Georgia

151

Shafted Cross

It was on a Friday that my Lord Jesus Christ in His Passion, with His bands nailed to the Cross, exposed the enemy of all mankind and put him to shame to all the ends of the earth. Now grant me too that I may take up the struggle against that foe of the Christians, and by shedding my blood for Christ, may turn him into an object of contempt and derision for all Christians because he imagined that he could estrange me by fear of death from the love of my Lord Jesus Christ. But I shall pour scorn on his plans and overcome him by Christ's grace and thus repay my twofold debt to my Saviour.

St Abo, Martyr and patron saint of Tiflis, Georgia
c. 756-786

11th-century pectoral cross of the crucifixion: silver, niello and gold, Xosrovanusi, Georgia

Shafted cross of the crucifixion, 973, silver and part-gilt, Isxani, Georgia.
(Note the *Titulus* is in old Georgian).

Photograph: Blaise Junod, courtesy of the Musée d'Art et d'Histoire, Geneva, Switzerland.

The Latin Crusaders refer to the Georgians or Iberians, as a Christian nation living in the Caucasus between the Black Sea and the Caspian, close to the Saracens and the Tartars, and near the land of Gog and Magog. A similar tribute is paid to the Georgians by the medieval Arab writer al-'Umari, who describes the army of the Georgians as "the kernel of the religion of the Cross," adding that the Mamluk Sultans of Egypt used to address the Georgian king as "the great monarch, the hero, the bold, just to his subjects, the successor of the Greek kings, protector of the homeland of the knights, supporter of the faith of Jesus, the anointed leader of Christian heroes, the best of close companions, and the friend of kings and sultans".

Enameled Cloisonné Cross

The Son of God became man, when the evil of mankind had reached its climax and could go no further, in order to offer Himself *"a sacrifice able to cleanse us,"* and, moreover to reconcile us, through His death, with God the Father.

We humans raised the Cross because of sin. And while we who are guilty should have been crucified, it was He who was nailed to the Cross, He who was not guilty of any condemnation or death, since "He committed no sin and no guile was found on His lips". Thus, the absolutely sinless Lord "took upon Himself our infirmities and carried our illnesses and was wounded for our transgressions, so that with His stripes we can be healed. He also redeemed us from being accursed by becoming Himself a curse and suffering the most dishonourable death in order to lead us again to the glorious life". The Lord raised the Cross and accepted to be nailed upon it as a criminal and in this way held the curse of sin and of death, marking the end of sin and death with that final word, "It is finished". God the Father willed to allow His only begotten Son, who did not know sin from experience, to be condemned as a sinner for our sake, "so that in Him we might become the righteousness of God" through our union with Him.

St Basil the Great,
c. 330-379

Top left: 10th-century Crucifixion, enamel cloisonné plaque, quatrofoil lamina, depicting Christ, the Virgin Mary, St John, St Mary Magdalene & Mary Salome; Semokmedi, Georgia.
Bottom right: 9th-century cover of a gold and enamel reliquery. Both in the Musée, d'Art et d'Histoire.

Photographs: Blaise Junod, courtesy of the Musée d'Art et d'Histoire, Geneva, Switzerland.

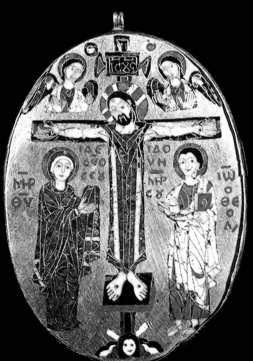

Cross in Samtavisi

Christ our God was crucified for the sake of the world, and we likewise have been crucified for His sake. We bared our breasts for this small Georgia, and on our breasts, as on a rock, we erected a temple to the Christian God. Instead of stone we offered our bones, and instead of lime we offered our blood, and the gates of hell will not prevail against it!

St Ilia Chavchavadze the Righteous of Georgia,
1837-1907

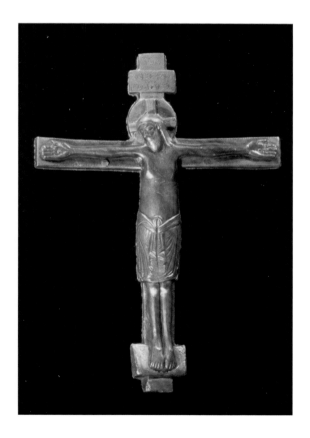

Eastern facade of the Cathedral of Samtavisi, founded in 1030, Georgia.

Left: Large shafted cross, silver and part gilt, 973, Iszani, Georgia.

Photographs: Blaise Junod, courtesy of the Musée d'Art et d'Histoire, Geneva, Switzerland

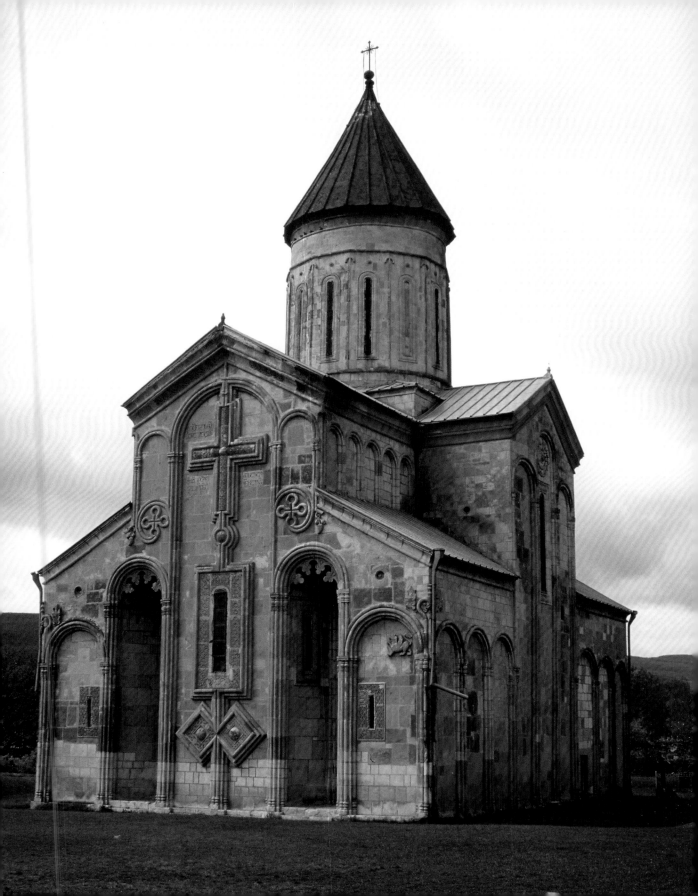

Armenian Cross

Thanksgiving, and glory and worship, and blessing and love,
One heart and one song have the saints upon earth and above.
Evermore, O Lord, to thy servants thy presence be nigh;
Ever fit us by service on earth for thy service on high.

The Armenian Liturgy of St James.

O Jesus, wisdom of the Father,
Grant me wisdom,
That I may, at all times, think,
speak and do before Thee that which is good in Thy sight.
And save me from evil thoughts, words and deeds.
Have mercy upon Thy creatures,
and upon me, great sinner that I am.

Armenian prayer for wisdom.

12th-century carved granite cross, Geghard monastery, Armenia.

Initially the Armenian church participated in the larger church world. Its Catholicos
was represented at the First Council of Nicaea and the First Council of
Constantinople. Although unable to attend the First Council of Ephesus, the
Catholicos Isaac Parthiev sent a message agreeing with its decisions. In 451 the
Armenian Church split from the Orthodox Church after the Council of Chalcedon,
together with Georgians, Syrians, Copts, Ethiopians and the Malabar Christians of
South India. The official name of the Church is the One Holy Universal Apostolic
Orthodox Armenian Church. It is sometimes referred to as the Gregorian Church, but
the Armenian Church views the Apostles St Bartholomew and St Jude as its founders,
and Gregory the Illuminator as the first official head of her Church. The invention of
the alphabet was the beginning of Armenian literature and has helped to reinforce
both religious and national unity through Armenia's turbulent history.

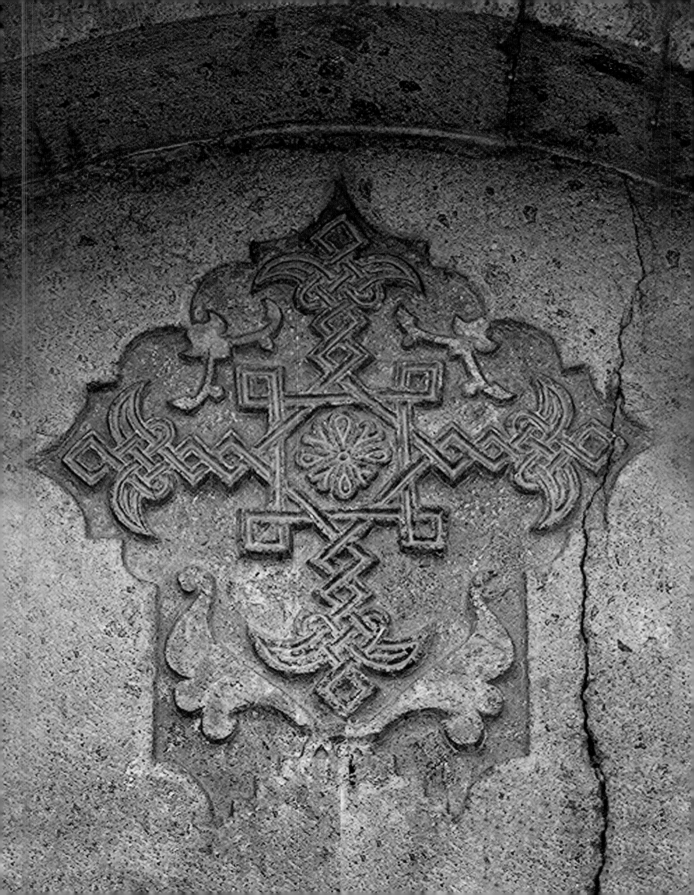

Cross in Aleppo

I pray to you, Christ, Saviour of the world. Look down and have mercy on me. Save me from the multitude of my transgressions, for I have disdained all the good things you have done for me since I was a child. Foolish and stupid as I am now, you fashioned me as a vessel filled with your knowledge and wisdom. Multiply in me your graces. Satisfy my hunger, quench my thirst, enlighten my darkened mind, and focus my wandering thoughts.

And now I bow down and pray to you. I fall down and beg you, acknowledging your goodness. Interrupt the stream of your mercy into me and keep it in your treasury for me so that you might give it to me on that day. Do not be angry with me, loving Lord, for I cannot endure your threats. This is why I fervently beg you, abound in me, for my tongue has grown weak, unable to speak of your grace. My mind is seized in amazement, unable to bear the greatness of the waves of your grace. O Appearance and Radiance of the Father's blessing, cease its flow into me here so that like fire it may enflame my insides and my heart. Now again grant me your grace, and let me live in your kingdom.

But with weeping tears, I entreat your love of mankind, save me from the multitude of my iniquities, and grant me your kingdom. Show me, a sinner, your ineffable love. Make me like the thief, who, with one word, became an heir of paradise. Take me there, to the promise you will keep.

Glory to the Father, our Creator, and to the Son, our Saviour, and to the Holy Spirit, our Restorer, unto unending and indelible eternity. Amen.

St Ephraim the Syrian,
A Prayer of Contrition and Confession,
c. 306-373

11th-century crosses on an Armenian granite tombstone, Aleppo, Syria.

St Ephraim the Syrian, known in Armenian as "Khouri' (Cleric), is the foremost writer in the Syriac Christian tradition, which was influential in the formation of early Armenian. Armenia remains one of the most ancient Christian communities and traces its origins to the missions of the Apostles: St Bartholomew the Apostle, one of the Twelve, and St Thaddeus, one of the Seventy, who brought the message of the cross to Armenia, shortly after the crucifixion. Here St Bartholomew met St Thaddeus at the beginning of their missionary journey. St Thaddeus brought with him the lance of Longinus that is now with the Catholicos in Etchmiadzin and he was in Armenia when the Virgin Mary died in 58. St Bartholomew was martyred in 66 just over the border in Iran, at Babhkale, near Lake Van (which was then in Armenia) having spent from 44-60 in Armenia. St Thaddeus was martyred between 62-65 and is buried in the monastery bearing his name near Maku in north-west Iran, close to the present Turkish border. Christianity must have reached Armenia at an early date as persecutions against Christians in 110, 230, and 287 were recorded by outside writers like Eusebius and Tertullian.

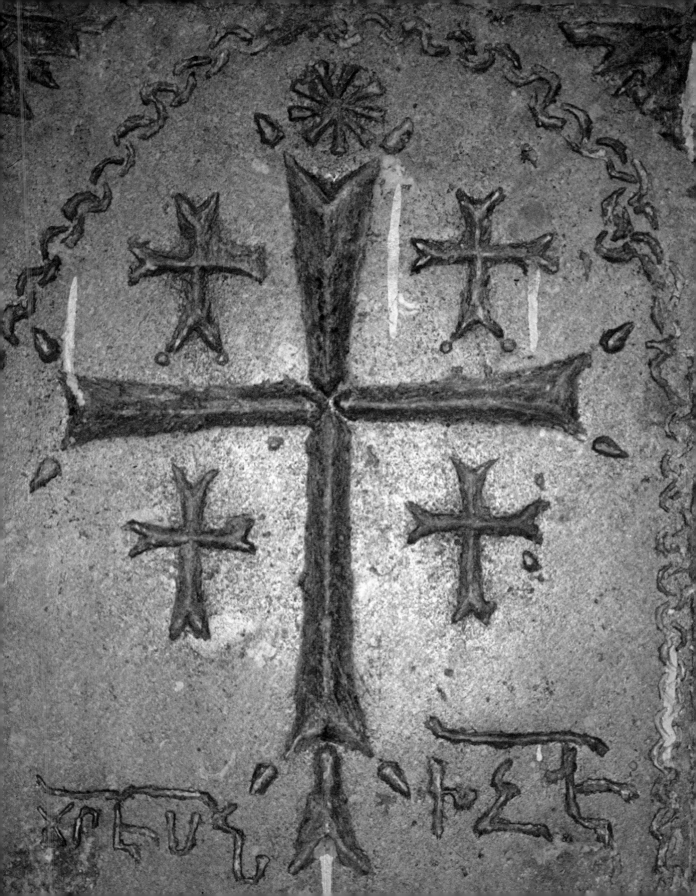

Cross in New Julfa

We humans raised the Cross because of sin. And while we who are guilty should have been crucified, it was He who was nailed to the Cross, He who was not guilty of any condemnation or death, since "He committed no sin and no guile was found on His lips". Thus, the absolutely sinless Lord "took upon Himself our infirmities and carried our illnesses and was wounded for our transgressions, so that with His stripes we can be healed. He also redeemed us from being accursed by becoming Himself a curse and suffering the most dishonourable death in order to lead us again to the glorious life". The Lord raised the Cross and accepted to be nailed upon it as a criminal and in this way held the curse of sin and of death, marking the end of sin and death with that final word, "It is finished". God the Father willed to allow His only begotten Son, who did not know sin from experience, to be condemned as a sinner for our sake, "so that in Him we might become the righteousness of God" through our union with Him.

St Basil the Great,
c. 330-379

Armenian memorial stone depicting the Crucifixion, with the sun and the moon together with six martyrs, Vank Cathedral of All Saviours, New Julfa, Isfahan, Iran.

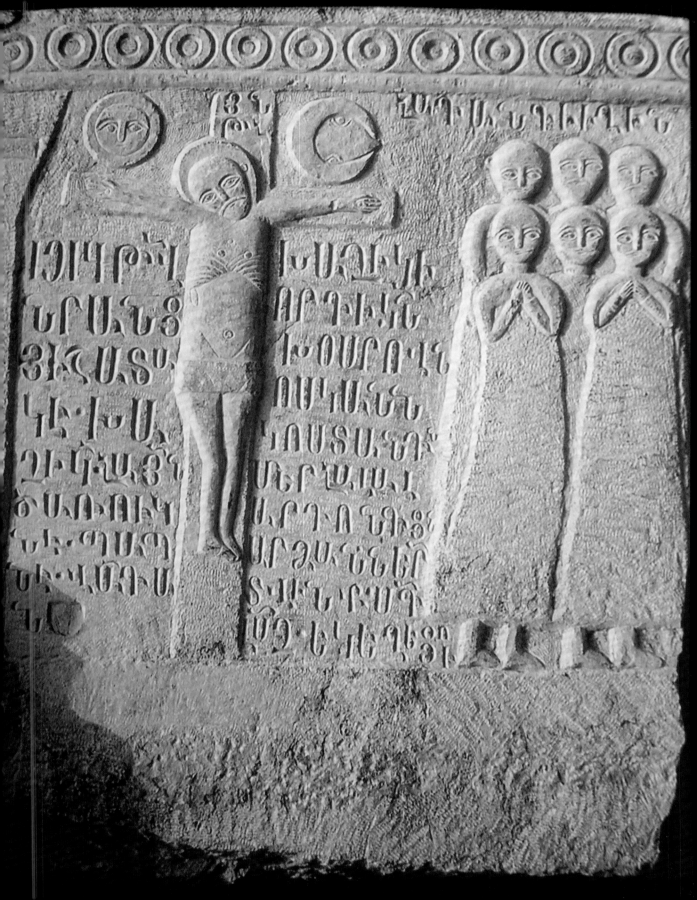

Cross on a Bowl

O Lord my God, I thank you, and I magnify you, and I glorify you, for today you have made unworthy me worthy to share in your divine and terrible Mystery, in your immaculate Body and precious Blood. Having them as intercessors, I pray: Keep me in your holiness every day and every hour of my life, so that by remembering your goodness, I may live with you, who suffered, and died, and rose for us.

My Lord and God, my soul being sealed with your precious Blood, keep the destroyer away from me. Most powerful One, the only sinless One, cleanse me of my every useless deed with your holy Body and Blood.

Strengthen my life, Lord, against every temptation, and turn my adversary away from me ashamed and confounded every time he attacks me. Strengthen every step of my mind and tongue, and every move of my body.

Be with me always by your unfailing promise, "Whoever eats my Body and drinks my Blood abides in me and I in him." You said it, loving God. Uphold the words of your divine and irrevocable commandments. For you are a God of mercy, and of compassion, and of love, and the bestower of all good things. And you are worthy of glory, together with your Father and your most-holy Spirit, now and always and unto the ages of ages.
Amen.

St John Chrysostom,
A Prayer of Preparation for Receiving Holy Communion
349-407

Mid 18th-century spouted Ottoman ceramic bowl, Kutahya, showing cherubim and crosses.

Photograph courtesy of Omer M. Koç, Sadberk Hanim Museum, Istanbul, Turkey.

St John Chrysostom's writings were among the first documents translated into Armenian after the Bible. More manuscripts of Chrysostom's works have come down to us than of any other Armenian or non-Armenian author, a sure sign of his unquestioned authority in the Armenian Church.

Cross on a Hierarch's Crosier

Blessed is your love for mankind, my Lord and Saviour Jesus Christ. Why do you forsake me? You alone are without sin, and your name shows kindness and love for mankind. Show me compassion, for you alone love mankind.

Save me, who have fallen into sin, for you alone are without sin. Remove me from the mire of my iniquity, for I am submerged forever and ever. Save me from my enemies, for like a lion they growl and roar, seeking to swallow me up. Now, my Lord, flash your lightning and destroy their power. May they fear you and be cut off from the light of your face, since they cannot stand in your presence, Lord, nor in the presence of those who love you. Whoever calls on you sees the power of the sign of your Cross, Lord, and trembles and shies away from it.

Now, Lord, save and keep me, for I have put my trust in you. Liberate me from my trouble, so that the malicious one will not cast me into oblivion, for he battles against me in his insidious ways. Even over secrets you have dominion, Lord, and you search the hearts and innermost being. Purify my heart and my thoughts of all lewd and vile thoughts so that I will not be lost into eternal perdition.

Have mercy on me, God, who have power over all, and grant the grace of tears to my sinful soul, so that I may wash the multitude of my sins; so that I may be saved from the hand of merciless angels who cast innocent ones into the fires of hell. I should weep continually, praying to you God, that I may not be found unworthy at that hour when you will come, lest I hear that awful voice. "Be gone servant of evil. I do not know where you are from." Exalted God, the only sinless one, grant me, this sinner, your abundant compassion on that day, so that my secret wickedness will not be revealed in the sight of the angels and archangels, the prophets, the apostles and all the righteous. But save me, this wicked one, by the grace of your mercy. Receive me into paradise with the perfectly just. Receive the prayers of this your sinful servant by the intercession of the saints who are pleasing to you, Jesus Christ our Lord. Glory to you with the Father and the Holy Spirit unto the ages of ages.
Amen.

St Gregory the Illuminator,
c. 257-337

Modern gold Armenian Episcopal staff used during the Divine Liturgy by Metropolitan Seraphim, London, England.

Photograph: Metropolitan Seraphim.

The Orthodox Episcopal staff has the cross on an orb with two serpents. This staff reminds us of the brazen serpent erected by Moses in the desert.

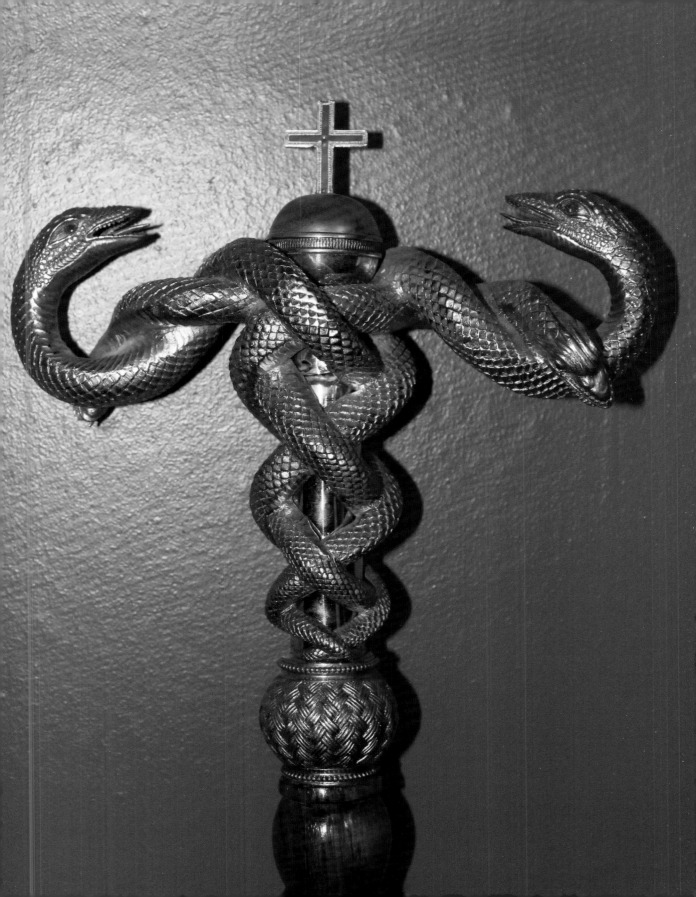

Cross of St Thomas in Iraq

Thomas, the faithful doubter, proved a true disciple. Having experienced the life-giving power of the resurrected Jesus he spent the remainder of his life telling the story far and wide. We don't know exactly where Thomas went, but if the geography of his influence is mapped then he ventured far across the Middle East, South Asia and East Asia. This cross, which bears the Thomas style, is from current day Iraq, but across Southern India and beyond, this style has been associated with Thomas since very early days. Above the teaming city of Chennai, Tamil Nadu, India, stands a shrine to Thomas, who is believed to have died here and the cross of Thomas is everywhere to be seen. We cannot say exactly where he is buried, but we do know that Christians in Asia have named themselves after St Thomas since the 2nd century. I was presented with a priest's stole bearing the cross of St Thomas, with its distinctive underlay of tropical fronds when I became Commissary for the Anglican Bishops in Sri Lanka. It is a cross dear to the hearts of Sri Lankan Christians of all denominations, for it is to be found not only as the emblem of the former Anglican Province of India, Pakistan, Burma and Ceylon, but much more anciently, it is to be seen in a decoration from the 5th century at the court of the Sinhala Kings in the ancient city of Anuradhapura. Its power remains as a symbol of the fullness of new life for minority communities in ancient and modern Asia.

The Rev'd Prebendary Dr Brian Leathard, Rector of Chelsea, 1956-

Cross on the Mitre and above the door, the Monastery Church of Mar Behnam, Mosul, Iraq.

Mosul has the highest proportion of Christians of all the Iraqi cities, including several interesting old churches, some of which originally date back to the early centuries of Christianity. The Apostle St Thomas stopped here on his way to evangelise India. The exact date of its foundation is unknown, but it is prior to 770, because references say that Al-Mahdi, the Abbasid Caliph, listened to a grievance concerning this church on his trip to Mosul.

St Thomas the Apostle, also called Doubting Thomas or Didymus (meaning the Twin) was one of Jesus' Twelve Apostles. He is best known for questioning Jesus' resurrection when first told of it, then proclaiming "My Lord and my God" on seeing Jesus. St Thomas was perhaps the only one of the twelve Apostles who travelled outside the Roman Empire to preach the Gospel. He is also believed to have crossed the largest area, which includes the Parthian Empire and the Middle Kingdoms of India. St Thomas is traditionally believed to have sailed to India in 52 to spread the Christian faith among the Jewish diaspora who lived in Kerala at the time. He is supposed to have landed at the ancient port of Muziris. He then went to Palayoor (near present-day Guruvayoor), which was a Hindu priestly community at that time. He left Palayoor in 52 for the southern part of what is now the state of Kerala, where he established the *Ezhara Pallikal*, or Seven and Half Churches. "It was to a land of dark people he was sent, to clothe them by Baptism in white robes. His grateful dawn dispelled India's painful darkness. It was his mission to espouse India to the One-Begotten." St Thomas is said to have been killed by a poisoned arrow, just south of Madras, Tamil Nadu, India.

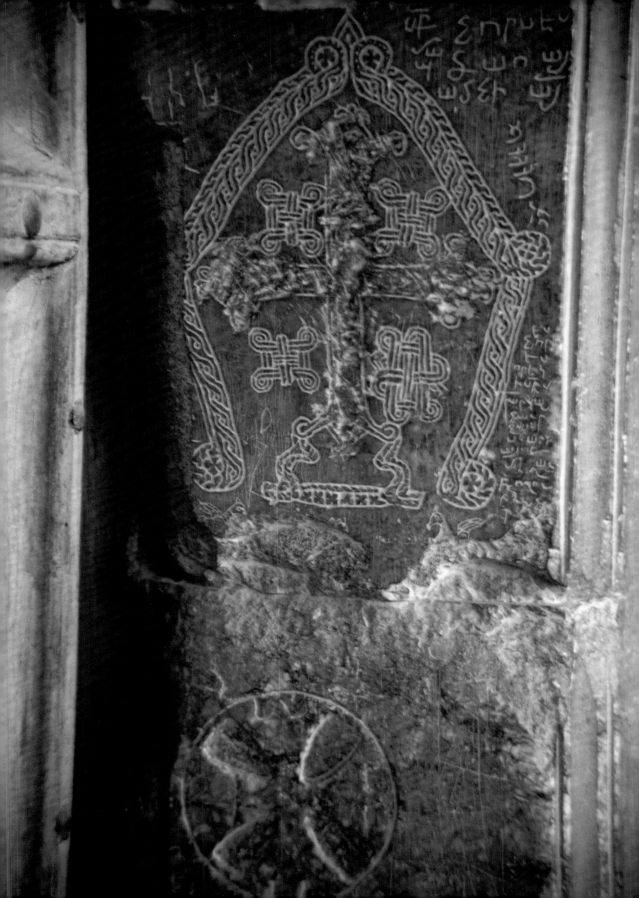

The Slavic Orthodox World:

Bulgaria
Macedonia
Ukraine
Russia
Serbia

The Slavic Catholic World:

Bosnia – Herzegovina

Cross on a Reliquary

18th-century gold and silver reliquary for St Dionysius, the National History Museum, Sofia, Bulgaria.

Photograph: courtesy of the National History Museum

Cross and an Iconostasis

Do you see a marvellous victory? Do you see the achievements of the Cross? But let me tell you of something even more marvellous. Learn the manner of the victory and you shall be more surprised. The weapons with which the devil prevailed, Christ used the same himself and defeated the devil. Listen how: the symbols of our defeat in paradise were the virgin, the tree and death. Eve was the virgin, for she had not yet known Adam. The tree was the tree of "the knowledge of good and evil". Death was the punishment of Adam.

But behold, now again we have a virgin, a tree and death, the symbols of defeat now become the symbols of victory! For instead of Eve, we now have the Virgin Mary. Instead of the tree of "the knowledge of good and evil", we have the tree of the Cross. Instead of the death of Adam, we have the death of Christ. Do you see how death was defeated by the same means by which it had prevailed? The devil attacked Adam with the tree; Christ fought the devil with the tree. The old tree led man to Hades, while the new tree, the Cross, recalled and liberated to life even those who had been there. The old death condemned those of old who were born after the disobedience, but the death of the new Adam resurrected even those who were born before Him.

St John Chrysostom,
349-407

18th-century cross, gates and *iconostasis* in the Orthodox Monastery of Royen, Bulgaria.

Photograph: Blaise Junod.

Left: 17th-century Hierarch's Crosier with coral snake's eyes and another in the centre of the cross; Bulgaria.

Photograph courtesy of the National History Museum, Sofia, Bulgaria.

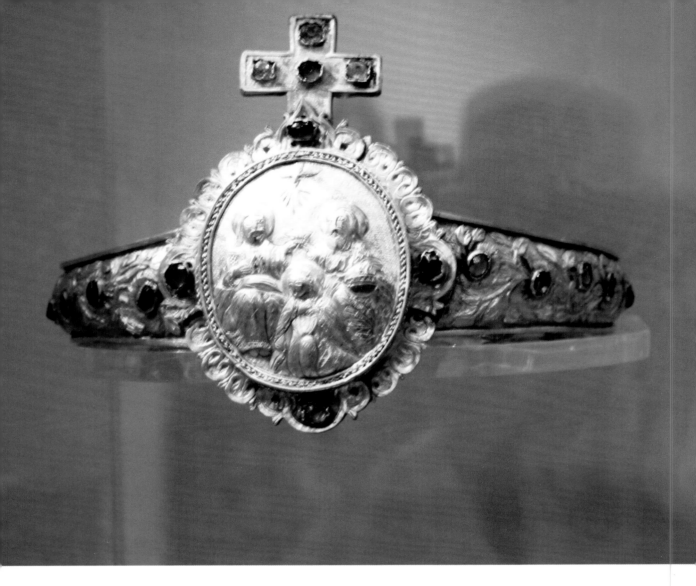

Cross on Wedding Crowns

See that ye love one another with a pure heart fervently.

1 Peter 1:22

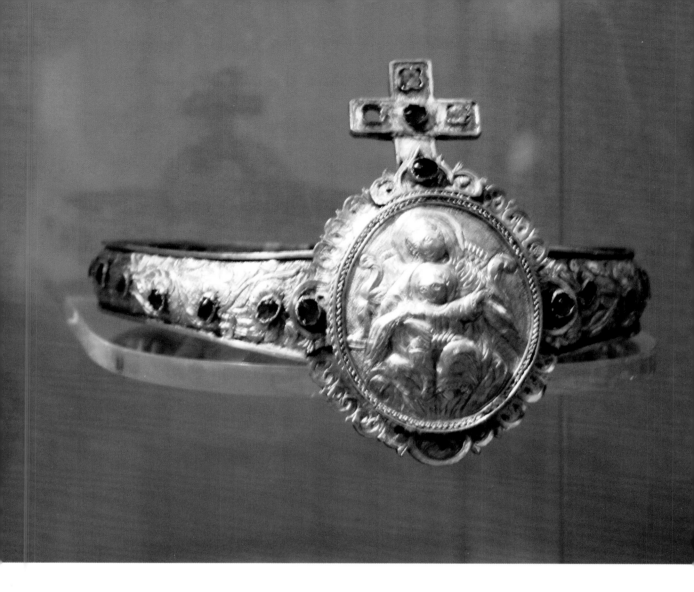

Pair of 19th-century gold Bulgarian wedding crowns with a cross on the top of each, studded with precious jewels, Philippopolis, (modern Bulgaria, but previously part of the Eastern Roman Byzantine Empire under Ottoman occupation).

Photograph: courtesy of Byzantine Museum, Athens.

These crowns are used during all Orthodox marriage services, to crown the bride and bridegroom at various points during the ceremonies.

Cross on Golden Cupolas

Lord Jesus Christ, son of God, pray for me a miserable sinner.

The Philokalia

The Prayer of the Heart, also known as the Prayer of Jesus, can be traced back nearly 2000 years. According to St Paul in Thessalonians 5:18, we should Pray without ceasing.

The writings of the desert fathers and others who were engaged in spiritual warfare, and who practiced the prayer, are preserved in the Philokalia. The Greek Philokalia was compiled by Metropolitan Macarius of Corinth and St Nicodemus the Hagiorite and first published in Venice 1782. There are three version of the Philokalia: the original Greek, the Slavonic and the Russian translations. The texts cover the writings of the Fathers of the Church from the 4th to the 14th century.

Shipka Memorial Church, designed and paid for by the Russians, commemorating the thousands of Russian and Bulgarian dead in the crucial battle against the Ottoman Turks in 1877, the Shipka Pass, Bulgaria.

Left: Cross made with the colours of the National flag of Bulgaria, made of gold, emeralds, rubies and diamonds, given as a present at the \orthodox ritual of anointment of the heir to the crown, Prince Boris l of Tarnovo (Tzar Boris III) by his godfather, Tsar Nicholas of Russia in 1896.
Property of HM Tsar Simeon II of Bulgaria.

Cross of the Penitent Thief

Lord, You made the thief worthy to inherit paradise on the same day that he repented and confessed you as Lord. Enlighten me, too, with the life-bearing wood of Your Cross, which is a source of light and salvation, and save me.

Our Lord, You were counted among the criminal thieves, as if You too, who are absolutely sinless, were a criminal. But through Your solemn Passion You crushed the devil and delivered all of us from the sin of disobedience, to which we had been drawn by the ancient deceiver and vile devil. The evil sword of Your executioners was being sharpened upon You. But by the virtue of Your all-holy and sinless Passion, when the sword of the powerful devil struck You, it lost its power to cut. At the same time, however, the flaming sword of the Cherubim, guarding the entrance to the ancient Garden of Eden, became useless, being itself set aside. Entrance into the new kingdom is now open and free to all. The Cross was shown to be the powerful weapon upon which the swords of the powerful are broken by the fire of the all-powerful energy and will of the Holy Trinity.

The Lenten Triodion of the Orthodox Church.

Fresco of the Crucifixion, 1298, the church of St Nicholas, Pridep, Bosnia.

Photograph: Blaise Junod.

Christ on the cross between the Penitent Thief (on the left of Christ) together with the Virgin Mary, St Mary Magdalene, St John and the unrepentant Thief on the right.

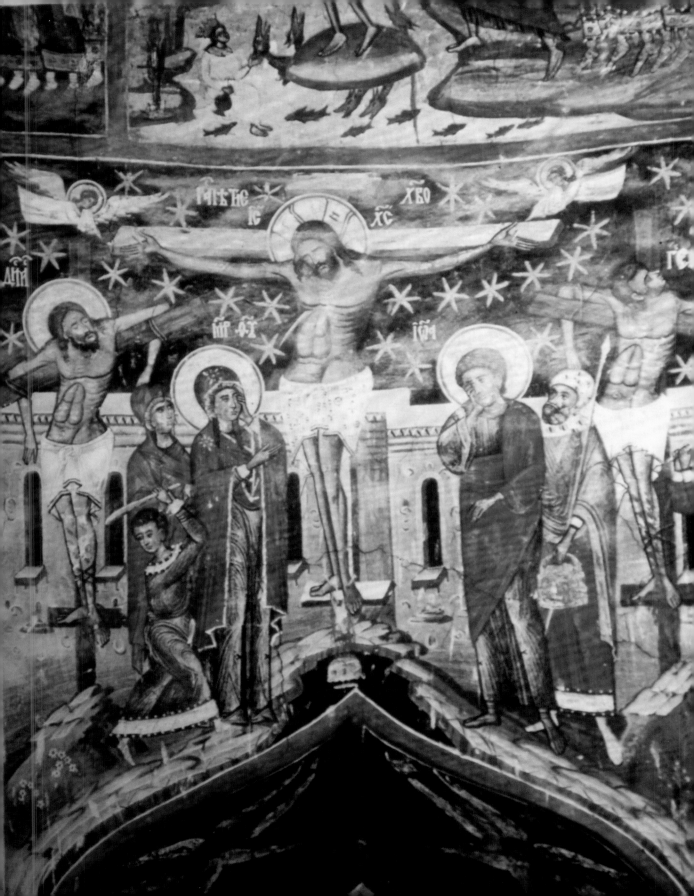

Cross on a Bishop's Mitre

The Lord gives the monk the love of the Holy Spirit, and by virtue of this love the monk's heart sorrows over the people because not all men are working out their salvation. The Lord Himself is so grieved over the people that He gave Himself to death on the Cross.

Staretz Silouan,
1866-1938

18th-century gold embroidered velvet Bishop's Mitre, with a painted panel of the Assumption of the Virgin, surmounted by a crystal cross; the Pechersk Lavra Museum, Kiev, Ukraine.

Left: 19th-century Russian Easter Egg opened to show the Virgin Mary holding the child Jesus, the Pechersk Lavra Museum, Kiev, Ukraine..

Photographs: Giancarlo Elia, courtesy of the Pechersk Lavra Museum.

180

Tombstone Cross

Orthodoxy is not just a kind of Roman Catholicism without the Pope, but something quite distinct from any religious system in the West. Yet those who look more closely at this "unknown world" will discover much in it which, while different, is yet curiously familiar. "But that is what I have always believed!" Such has been the reaction of many, on learning more fully about the Orthodox Church and what it teaches; and they are partly right. For more than nine hundred years the Greek East and the Latin West have been growing steadily apart, each following its own way, yet in the early centuries of Christendom both sides can find common ground. Athanasius and Basil lived in the east, but they belong also to the west; and Orthodox who live in France, Britain, or Ireland can in their turn look upon the national saints of these lands – Alban and Patrick, Cuthbert and Bede, Geneviève of Paris and Augustine of Canterbury – not as strangers but as members of their own Church. All Europe was once as much part of Orthodoxy as Greece and Christian Russia are today.

Metropolitan Kalistos Ware,
1934-

11th-century carved granite tombstone cross, Novgorod, Russia.

Photograph: Blaise Junod

The Annunciation, Nativity, Crucifixion, Transfiguration and Christ in Glory are all carved within the shape of a cross.

Cross of a Tsar

Orthodox theology is emphatically a "theology of glory" because it is primarily "a theology of the Cross". The very Cross itself is the sign of glory. The Cross is considered not so much as the climax of the humiliation of Christ, but rather as the revelation of divine power and glory. The Lord, directly after the departure of Judas, who was to betray Him, said "Now is the Son of man glorified, and in Him God is glorified" (John. 13: 31). Thus, the death of the Lord on the Cross, through which our own death would be destroyed, was an extreme humiliation for the God-Man, but it was also a glory. It was a victory and a triumph over the powers of Satan. For it was a liberation of us men from sin and death, and our reconciliation with God the Father. This is precisely what we confess each Sunday in that beautiful hymn, "Having seen the Resurrection", which we recite after the morning Gospel, when we say "Behold, joy has come through the Cross to the whole world". The whole world rejoices because the death of the Lord 'on the Cross was a revelation of life'. The work of the creation of man "was fulfilled on the Cross". For this reason, the holy Fathers tell us, the death of Christ on the Cross was effective not only as a death of one innocent and pure person, nor simply as a sign of submission and patience, nor again simply as a demonstration of human obedience, but primarily as a death of God Incarnate, as a revelation of the Lordship of Christ.

Fr Georges Florovsky,
1893-1979

11th-12th-century fresco of John Konstantine and his young son and heir who offer their endowment of a monastery. The inscription is written in Old Church Slavonic. The dedication *Voivode*, is a Predstoyashchie, meaning a military commander. Novgorod, Russia.
Photograph: Blaise Junod.

The acceptance of Byzantine Orthodox Christianity by Grand Prince Vladimir of Kiev in 988 established the cultural landscape in the lands of Rus' for the following centuries. Byzantine books and icons were sent from Constantinople, and Byzantine artists worked in the important early Russian cities of Kiev, Vladimir and Novgorod. Moscow itself, first mentioned in 1147, did not develop as a major fortified city around its Kremlin until the period when the Russian lands were occupied by the Tatar Golden Horde. After the shock of the Mongolian invasions, which started in 1237, the Mongal yoke continued for several centuries. It was the Grand Princes of Muscovy who, in the 14th century, emerged as the dominant leaders of the Rus'. Their hegemony is reflected in the flourishing of the arts in late 14th century Moscow and in the rebuilding of the Kremlin and its cathedrals in the late 15th century under Ivan III, "The Great" (1462-1505). The rise of Moscow as the capital of a centralised Russian state was assisted by various events and ideas, such as the fall of the Byzantine empire in 1453, the belief in a "Third Rome" formulated in the early 16th century ("two Romes have fallen, the third stands, there will not be a fourth") and the crowning of Ivan IV "the Terrible" (1533-84) in 1547.

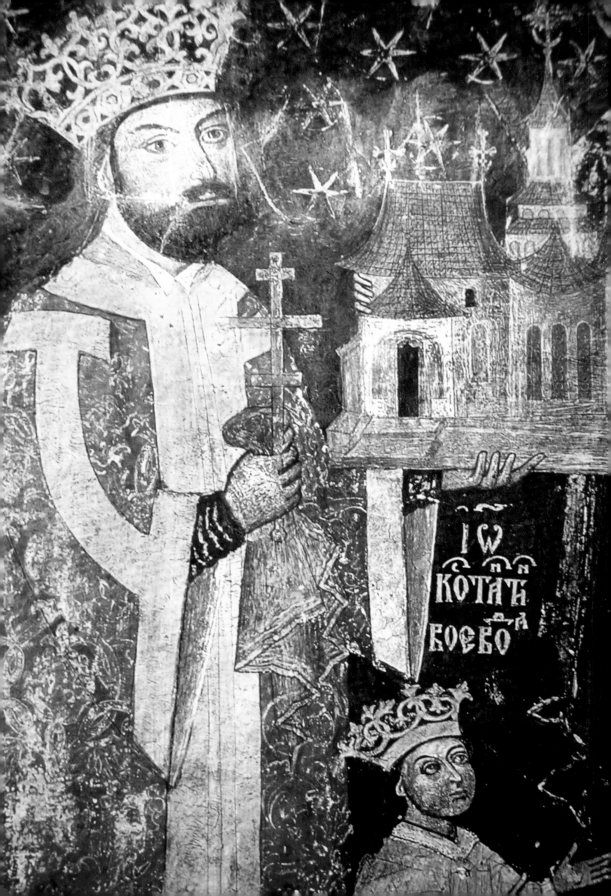

ІѠ
КОТАЇ
ВОЄВО

The Cross in Red Square

My Lord, I know not what I ought to ask of Thee.
Thou and Thou alone knowest my needs.
Thou lovest me more than I am able to love Thee.
O Father, grant unto me, Thy servant, all which I cannot ask.
For a cross I dare not ask, nor for consolation;
I dare only to stand in Thy presence.
My heart is open to Thee.
Thou seest my needs of which I myself am unaware.
Behold and lift me up!
In Thy presence I stand,
awed and silenced by Thy will and Thy judgments,
into which my mind cannot penetrate.
To Thee I offer myself as a sacrifice.
No other desire is mine but to fulfil Thy will.
Teach me how to pray.
Do Thyself pray within me.
Amen.

Philaret, Metropolitan of Moscow,
1782-1867

St Basil's Cathedral, Moscow, Russia.

Photograph: Henrietta Armfield

Built in 1555 by Tsar Ivan the Terrible. The distinctive onion domes, it gradually evolved from the original Byzantine cube shaped roofs to withstand the heavy snowfalls.

One of the most outstanding hierarchs of the Russian Church in any century, Philaret was born Basil Drozdov, the son of a priest: Although small in stature he stood out among his fellow students at the St Sergius Holy Trinity Seminary by reason of his lively intelligence and genuine piety. His early talent for preaching brought him to the attention of Metropolitan Platon of Moscow, who said of him "I give sermons like a man, but he speaks like an angel." Until his death he lived a routine and outwardly uneventful life of prayer.

Cross on an Azure Cupola

Christianity, while universal in its mission, has tended in practice to be associated with three cultures: the Semitic, the Greek, and the Latin. As a result of the first separation the Semitic Christians of Syria, with their flourishing school of theologians and writers, were cut off from the rest of Christendom. Then followed the second separation, which drove a wedge between the Greek and the Latin traditions in Christianity. So it has come about that in Orthodoxy the primary cultural influence has been that of Greece. Yet it must not therefore be thought that the Orthodox Church is exclusively a Greek Church and nothing else, since Syriac and Latin Fathers also have a place in the fullness of Orthodox tradition.

While the Orthodox Church became bounded first on the eastern and then on the western side, it expanded to the north. In 863 Saint Cyril and Saint Methodius, the Apostles of the Slavs, travelled northward to undertake missionary work beyond the frontiers of the Byzantine Empire, and their efforts led eventually to the conversion of Bulgaria, Serbia, and Russia. As the Byzantine power dwindled, these newer Churches of the north increased in importance, and on the fall of Constantinople to the Turks in 1453 the Principality of Moscow was ready to take Byzantium's place as the protector of the Orthodox world.

The four ancient Patriarchates are: Constantinople, Alexandria, Antioch and Jerusalem. Though greatly reduced in size, these four Churches for historical reasons occupy a special position in the Orthodox Church, and rank first in honour. The heads of these four Churches bear the title Patriarch.

There are eleven other autocephalous Churches: Russia, Romania, Serbia, Bulgaria, Georgia, Cyprus, Poland, Albania, Czechoslovakia and Sinai. All except three of these Churches — Czechoslovakia, Poland, and Albania — are in countries where the Christian population is entirely or predominantly Orthodox. The Churches of Greece, Cyprus, and Sinai are Greek; five of the others — Russia, Serbia, Bulgaria, Czechoslovakia, Poland — are Slavonic. The heads of the Russian, Romanian, Serbian, and Bulgarian Churches are known by the title Patriarch; the head of the Georgian Church is called Catholicos-Patriarch; the heads of the other churches are called either Archbishop or Metropolitan.

Metropolitan Kalistos Ware,
1934-

Trinity Church, Sergiev Posad, Russia.

Photograph: Henrietta Armfield

Crosses on Silver Cupolas

In the time of Herod king of Judea there was a priest named Zechariah, who belonged to the priestly division of Abijah; his wife Elizabeth was also a descendant of Aaron. Both of them were righteous in the sight of God, observing all the Lord's commands and decrees blamelessly. But they were childless because Elizabeth was not able to conceive, and they were both very old.

Once when Zechariah's division was on duty and he was serving as priest before God, he was chosen by lot, according to the custom of the priesthood, to go into the temple of the Lord and burn incense. And when the time for the burning of incense came, all the assembled worshipers were praying outside.

Then an angel of the Lord appeared to him, standing at the right side of the altar of incense. When Zechariah saw him, he was startled and was gripped with fear. But the angel said to him: "Do not be afraid, Zechariah; your prayer has been heard. Your wife Elizabeth will bear you a son, and you are to call him John. He will be a joy and delight to you, and many will rejoice because of his birth, for he will be great in the sight of the Lord. He is never to take wine or other fermented drink, and he will be filled with the Holy Spirit even before he is born. He will bring back many of the people of Israel to the Lord their God. And he will go on before the Lord, in the spirit and power of Elijah, to turn the hearts of the parents to their children and the disobedient to the wisdom of the righteous—to make ready a people prepared for the Lord."

Luke 1:5-25

Church of the Birth of St John the Baptist, St Petersburg, Russia.

Photograph: Henrietta Armfield.

Built in 1777-1780 to Yury Felten's design, in honour of the victory of the Russian Navy over the Turkish Fleet in Chesme Bay, it was closed in 1919. but it has recently been restored and services are now held there once again.

Red Cross Easter Egg

Christos Voskrese – Voistinu Voskrese!

Christ is Risen – He is Risen indeed!

Enamel, silver, gold and mother-of-pearl Imperial Red Cross Easter Egg of 1915 (3 inches high.), Peter Carl Faberge, Russia,1846-1920. It is one of the few Imperial Easter Eggs that opens vertically. Bequest of Lillian Thomas Pratt to the Virginia Museum of Fine Arts, Richmond.

Photograph: Katherine Wetzel, courtesy of the Virginia Museum of Fine Arts, Richmond, Virginia, USA.

For centuries many Christians have shared dyed and painted eggs particularly on Easter Sunday. The eggs represent new life, and Christ bursting forth from the tomb. Among Eastern Orthodox Christians (including Albanian, Armenian, Bulgarian, Greek, Lebanese, Macedonian, Russian, Romanian, Serbian and Ukrainian) this sharing is accompanied by the proclamation "Christ is risen!"

One tradition says that, following the death and resurrection of Jesus, Mary Magdalene used her position to gain an invitation to a banquet given by Emperor Tiberius. When she met him, Mary held a plain egg in her hand and exclaimed: "Christ is risen!" Caesar laughed, and said that Christ rising from the dead was as likely as the egg in her hand turning red while she held it. Before he finished speaking, the egg in her hand turned a bright red, and she continued proclaiming the Gospel to the entire Imperial household

Symbols of the Cross

Symbols are the only way of conveying transcendence, of describing the transparence of creation, which is a transparence to God's presence, which is the great secret of Christianity.

The Cross and the Square symbolise Creation.

The Intersection of the Cross (a dot) symbolises transcendence, the cross is therefore a centre reaching out in four directions, which it reunites and brings back to the centre.
Its function is *re-ligare*, to bind heaven and earth.

The Cross is the umbilical cord between the created Cosmos and its original centre, bringing time and space together.

Among all symbols, it is the most total and universal of all. It is the symbol of the intermediary, of the mediator, of the eternal gathering of the Spirit in the universe, and communication between heaven and earth in both directions.

The symbol of the Cross is present in all creation: Man with outstretched arms, birds with outstretched wings, etc. etc. The whole Universe "is the Absolute in Becoming" which is the end and aim of the divine-human process.

Princess Tatiana Metternich,
The Symbol of the Cross
1916-2006

Modern egg tempera and gold leaf on wood, Russian Processional Altar Cross, Caroline Lees. Church of the Assumption, St Petersburg, Russia.

Photograph: Tim White.

The Church of the Assumption of the Blessed Virgin was built in commemoration of the tragic events of the Leningrad blockade. It was laid on the holy day of the Assumption of the Blessed Virgin, on August 26, 1996; Vladimir, Metropolitan of St Petersburg and Ladoga blessed the construction. The idea to build a temple of Grief and Glory belongs to Valentin Leonovich Kovalevsky, the President of "Ost-West" Association. The memories of the horrible days of the siege are still alive. But it is often forgotten that besieged Leningrad believed and prayed.

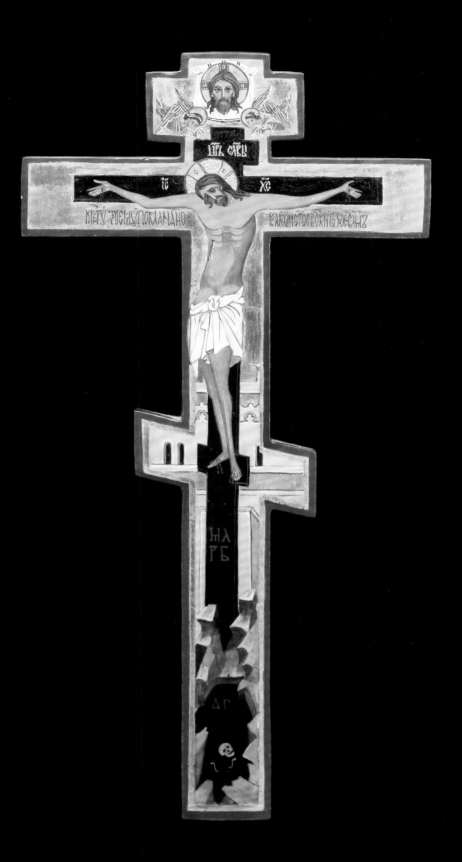

Cross on a Stovepipe Hat

St John of Damascus said that Adam fell into sin through stretching out in a mistaken way towards God. And indeed, speaking as a Serbian Orthodox Christian, my personal experience tells me that the Devil is a very powerful agent, with a dynamic capacity to draw us. All of this, however, pales into insignificance when compared with the vision of meeting the God who comes out to meet us. When, with bitter tears for my sins, I had that experience – which was indeed an experience of bitter dissatisfaction even with my success – then I realized that the Devil is in fact very weak, and that man is stronger both than the Devil and the archangel. And because Christians were living in a regime which imposed itself, not only by force but also with a very attractive ideology, I understood then why the Devil is so aggressive in our lives. He is aggressive because he is by no means certain that he can win man over.

Serbian Orthodox Metropolitan Athanasios of Hercegovina,
1938-

Serbian Orthodox Monk, the Monastery of Sopocani, near Novi Pazar, Serbia.

Christ mounts His Cross

Christ the Lord is risen again!
Christ hath broken every chain,
Hark, the angels shout for joy
Singing evermore on high:
Alleluya!

He who gave for us his life,
Who for us endured the strife,
Is our Paschal lamb to-day!
We too sing for joy, and say:
Alleluya!

He who bore all pain and loss
Comfortless upon the cross,
Lives in glory now on high,
Pleads for us, and hears our cry:
Alleluya!

Though, our Paschal lamb indeed,
Christ, to-day thy people feed;
Take our sins and guilt away,
That we all may sing for ay:
Alleluya!

Michael Weisse,
1480-1534

Fresco, 1298, the church of St Nicholas, Prilep, Macedonia.

Photograph: Blaise Junod.

This very rare iconography showing Christ mounting His cross on a ladder, assisted by Roman soldiers, only occurs in the Orthodox Church. Note the skull beneath the Cross.

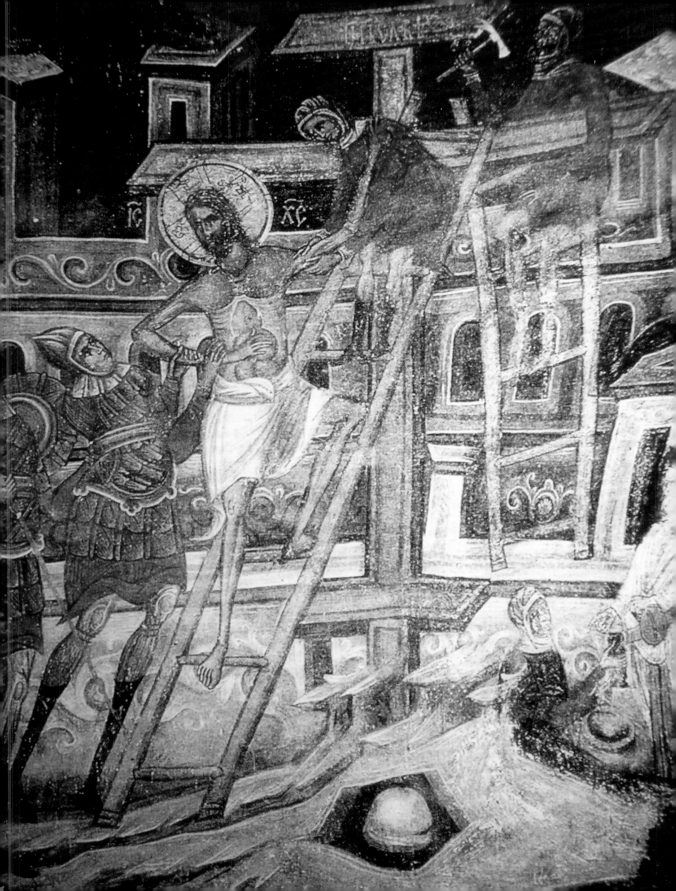

Cross and Resurrection

THE CROSS

The cross was where men chose to chasten God.
The hands that kindly healed, the feet that trod
The Galilean waters – these they nailed,
Hammered through splintering bone, and spat and
railed
And laughed, while money for His clothes they gave:
"He saved others; Himself He cannot save!"
Then earthquakes came, and darkness, and He cried
"God, why hast Thou forsaken me?" – and died.
A lone centurion knelt in holy dread:
"Truly this was the Son of God!" he said.

THE RESURRECTION

"It cannot be," in disbelief they said,
Those who had claimed none rises from the dead.
The woman, seeing a gardener close at hand,
Spoke, weeping, for she did not understand:
The corpse was gone, small wonder she was wary –
Until that moment and that one word "Mary".

The same day, disillusionment and chaos
Clouded the minds of walkers to Emmaus –
Until that moment when the bread was blessed
At table by their unsuspected Guest.
How strange that closest friends could
misconstrue Him!

But now their eyes were opened and they knew Him.
How could those fishermen at sea forget
His features when He told them "Cast the net"?
No recognition, not a sign to snatch –
Until that moment of a record catch.
Astonishment! so many fish aboard!

"Who art thou?" Then they knew it was the Lord.
The evidence of others Thomas flouted.
Because he could not touch the wounds, he doubted –
Until that moment when, through the shut door,
Came Jesus in the flesh, just as before.
Much mortified, the truth he now perceived:
"My Lord and God!" said Thomas – and believed!
Which goes to show, whatever our objection,
It doesn't do to doubt the Resurrection!

David A E Hunt,
1931-

12-foot bronze statue, Christ rising from his Cross, A. Ajdic 1998.
Medjugorje, Bosnia, Herzogovina.

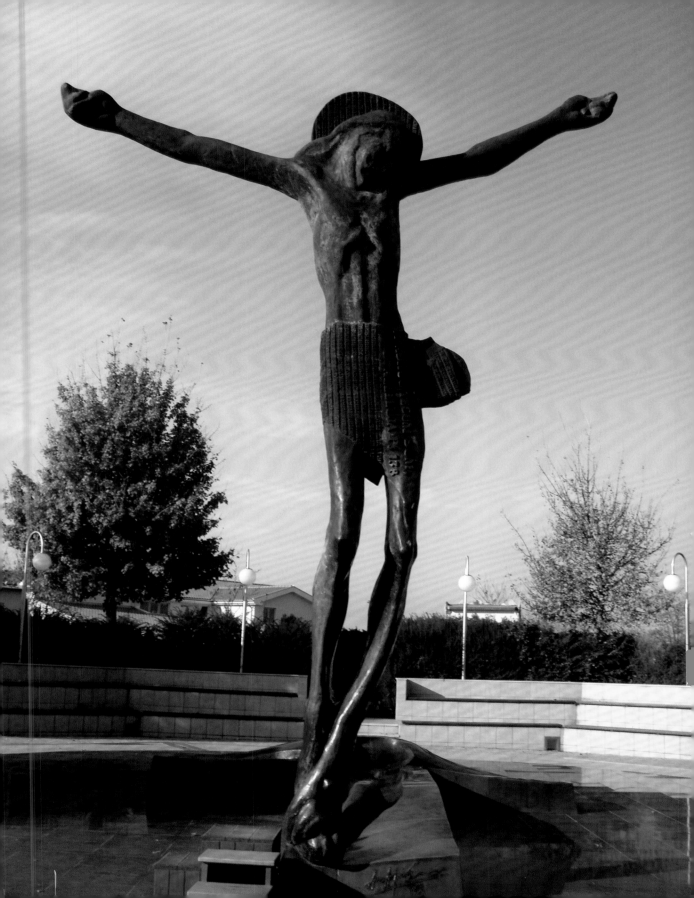

The Mediterranean Catholic World:

Italy
France
Spain
Portugal

Cross in Pompeii

1st-century mosaic floor in a merchant's house, Pompeii, Italy.

Christian merchant's floor, created with a cross design of black and white *tessare* in
his hall, covered by lava in the eruption of 79 and only uncovered in the 19th century.
This is the earliest image of a cross in the book.

Cross of the Good Shepherd

O Lord, who hast mercy upon all, take away from me my sins,
and mercifully kindle in me the fire of thy Holy Spirit.
Take away from me the heart of stone, and give me a heart of flesh,
a heart to love and adore Thee, a heart to delight in Thee,
to follow and enjoy Thee, for Christ's sake,
Amen

St Ambrose of Milan,
339-397

5th-century gold mosaic panel, mausoleum of Galla Placidia, Ravenna, Italy.

Photograph: Blaise Junod.

The image of Christ the Good Shepherd is the most common of the symbolic
representations found in early Christian art in the Catacombs of Rome, before
Christian imagery became explicit. It continued to be used in the centuries after
Christianity was legalised in 313. Initially it was probably not understood as a
portrait of Jesus.

Cross on a Sarcophagus

Anyone who has a true devotion to the passion of the Lord must so contemplate Jesus on the cross with the eyes of his heart that Jesus' flesh is his own.

Let earth tremble at the torments of its Redeemer, let the rocks of faithless hearts be split, and, now that the mighty obstacles have been shattered, let those leap forth who are weighed down by the tombs of mortality. May signs of the future resurrection appear now in the Holy City, that is, the Church of God, and hearts experience that which our bodies will undergo. The victory of the cross is denied to none of the weak; there is no man who can not be helped by the prayer of Christ, for if his prayer aided the multitudes who raged against him, how much more does it help those who turn to Him?

St Leo the Great,
The contemplation of the Lord's passion.
c. 391-461

5th-century Byzantine mosaic of the Cross representing Jesus on His throne,
the Baptistry of Arius, Ravenna, Italy..

Cross of Santa Fosca

Four crosses, high up on the walls of Santa Fosca, are both an invitation and a challenge.

No word is written near them, no word is heard from any pulpit near them, but they are not silent. They all present an offer that needs to be considered, eventually accepted or rejected. The silent crosses are too visible, too bold in their absolute simplicity to be ignored. The cross here is no longer a symbol of religion, lifestyle, tradition, nor a sign of protection or victory. It is an offer, disturbing and puzzling, since God did not intervene in human history to offer explanations, solutions, political or moral programs, but a person who is inextricably joined to a cross. That person completed his tasks not in triumph, but leaving behind an empty cross, both a real challenge because we cannot remain unaffected by either one.

We may reject that person and of course his cross. However, today's rejection will not cause the offer to be withdrawn. The silent crosses of Santa Fosca are not erased or concealed. They stay there as long as the supporting walls of the church are standing. Today's rejection may be a missed opportunity, but those crosses will still be there tomorrow.

We may always go back and change our mind, or attitude, and accept their offer. The motivation why we want to do so does not make any difference. It may be an impelling need, a call for help, curiosity, ever critical analysis. Our motivation is irrelevant. The offer is what matters, it never changes and it is still available today.

Dr. Giancarlo Elia,
1943-

9th-century church of Santa Fosca, Torcello, Venice, Italy.

Left: Byzantine marble plaque of the *Crux Gemmata* (representing precious stones) flanked by two cypress trees (representing Eternal Life), set into the wall of the 11th-century church of San Donato, Torcello, Venice, Italy.

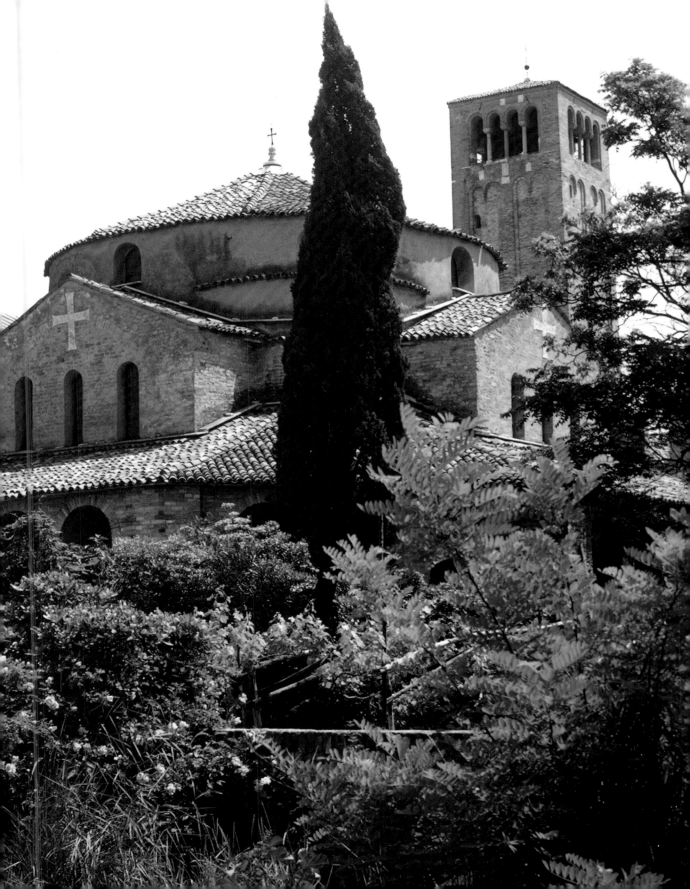

Cross of the Holy Face

Lord Jesus, crucified and resurrected, image of the Glory of the Father, O Holy Face who is looking at us and is scrutinizing us, merciful and gentle, to call us to conversion and to invite us into His full love, we adore You and we bless You. In Your luminous face we learn how to be loved and how to love; how to find liberty and reconciliation; how to become instruments of the peace which irradiates from You, and is leading us.

In your glorified Holy Face, we learn to overcome every form of selfishness and to hope against all hope, to choose the works of life against the actions of death.

Give us the grace of putting You at the centre of our life; to remain faithful to our Christian vocation in the midst of risk and of the changes taking place in the world; to announce to all people the power of the Cross and of the Word, which says to be vigilant and active, paying attention to our small brothers; to detect the traces of the true liberation which has started with You and will be completed by You, Our Lord.

Grant to Your church to remain, like the Virgin Mother, near to your glorious Cross, and near to the crosses of all men, to bring them consolation, hope and comfort.

May the Spirit which You have given us, bring to fruition Your work of salvation in order that all earth's creatures, freed from the bonds of death, may contemplate Your Holy Face, which blazes luminously down the centuries, to the glory of God the Father, Amen.

Blessed John Paul II,
Prayer to The Holy Face
1920-2005

8th-9th and 12th-century, painted wooden sculpture, *Il Volto Santo* (The Holy Face), Sansepolcro, Italy.

Photograph: Justin Hunt

The Holy Face represents Christ as King and High Priest, who has conquered death, and He is dressed with the clothes of a King and of a High Priest and reigns over the Universe from the Cross, no longer a symbol of torture, but of victory. It is the most ancient wooden sculpture of this type known to date and was made with a single piece of walnut wood between the 8th and 9th centuries. Restoration of the marvellous original polychrome painting, which dates from the 12th century, began in 1983. Traces of 12 previous coats of colour were found, applied directly to the wood. Executed by a great artist over layers of canvas and gesso which was applied to the sculpture – the aim was to obtain a uniform and flat surface. The Holy Face is a very ancient representation of Oriental origin: the crucified Christ (this prototype is attributed to the tradition of Nicodemus, which would have been inspired by God).

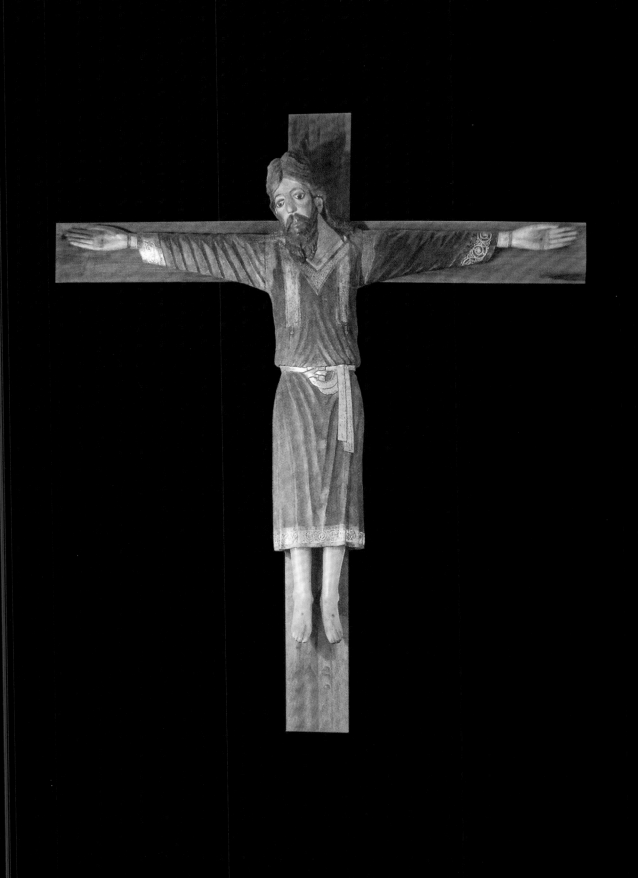

Cross and the Birds

If we were to seek a title for this depiction of the Crucified, words like reconciliation and peace would immediately occur to us.

Christ has inclined his head and given his Spirit into the hands of his Father. A great peace emanates from his face and from his entire figure. Pain is overcome. Nothing of wrath, of bitterness, of accusation lies in the picture. The biblical saying that love is stronger than death can be seen here. Death is not the main thing we see. We see love that through death is not abolished but rather stands out more than ever. Earthly life is extinguished, but love remains. The Resurrection thus shines already through the scene of crucifixion. Four sources of water originate, at which deer slake their thirst. The rich network of branches fills the entire breadth of the picture and is not simply decorative. It is a great vine, whose branches grow forth from the roots and limb of the cross. They extend over the whole world in great circling motions, drawing it into itself. The world itself has become a single large vineyard.

From above, out of the mystery of God, the hand of the Father reaches down. Thereby, movement comes into the image. On the one hand, the divine hand appears to lower the Cross from the height of the eternal in order to bring the world life and reconciliation, but it draws upward at the same time. The descent of God's goodness brings the whole tree, with all of its branches, into the ascent of the sun, into the upward dynamic of his love. The world moves from the Cross upward to the freedom and expanse of the promise of God. The Cross creates a new dynamic: the eternal, the futile circling of what is always the same, the vain circular motion of endless repetition, is broken open. The descending Cross is, at the same time, the fish hook of God with which he reels up the entire world to his height. No longer circling, but ascent is now the direction of history and human life. Life has received a destination; it goes with Christ to the hands of God.

His Holiness Pope Benedict XVI,
1927-

Early 12th-century apse mosaic, Basilica of San Clemente, Rome, Italy.

Photograph: Justin Hunt

The eleven birds on the cross represent eleven faithful disciples: Judas is not amongst them. The church is dedicated to Rome's fourth Pope, Clement.

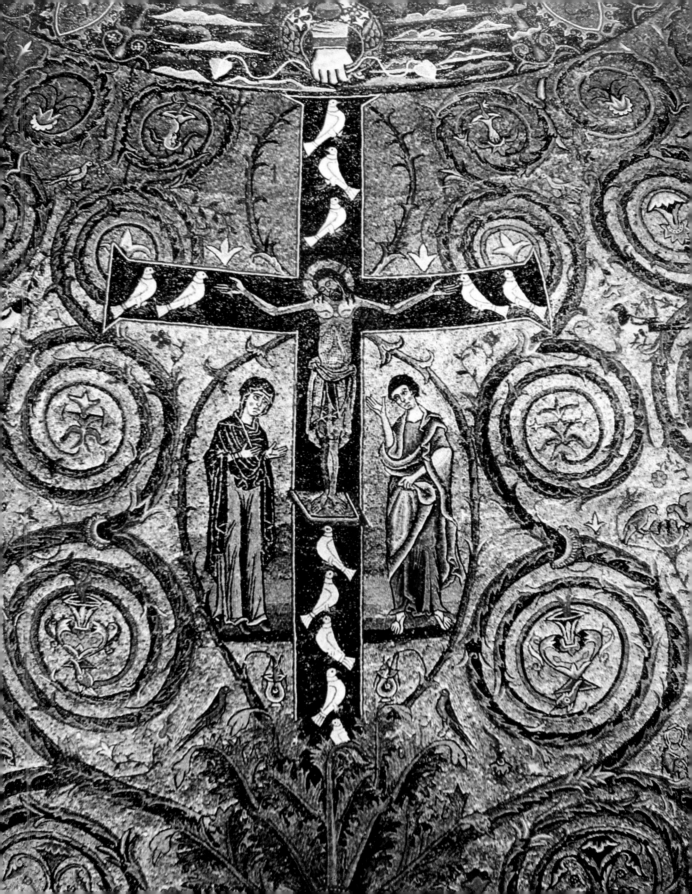

Cross on Bronze Doors

I have had the privilege of serving the British Army as a priest for 25 years. Although I have not been on an operation myself, I have looked after soldiers who have. In my experience soldiers are asked by society to take on those difficult tasks that society does not find easy. The soldiers who crucified Jesus would not have relished their task but would have seen it as their duty to carry out what had been ordained by the authorities. The Roman Army was the most successful army the world had ever seen. It was tough and its organisation is still the basis of the British Army today. A centurion being in charge of a hundred men finds his equivalent in the sergeant major of today.

They must have been used to executions and the variety of people they had to execute. Some would be villains, some a threat to the state, as Jesus was. My hunch would be that they would concentrate on the task in hand without unnecessary cruelty. The fact that Jesus had nails put through his hands and feet was not their decision – it is how crucifixion was done. The body had to be put on the cross in that way, for the cruelty of crucifixion was by so doing the body was put in a position where you would be unable after a few hours to breathe. Quite literally you drowned on dry land as the lungs filled up with liquid.

My surmise is that they would have wanted it over as quickly as possible. In St Mark's Gospel it is recorded that the centurion as Jesus died said "Truly this man was the Son of God". One thing I have learnt from soldiers is that you can never fool or patronise them. The centurion had seen something different from the many executions and the many people he had had to put to death.

The Rev'd Canon Dr David Reindorp, Chaplain to the Honorable Artillery Company (1992-), 1952-

Six 12th-century bronze panels attached to the wooden door of the Basilica of San Zeno Maggiore, Verona, Italy.

Top left: The flagellation. Note the Jews who were compelled to wear triangular-shaped hats in Spain.
Top right: Jesus on the cross.
Middle left: The Raising of Lazarus.
Middle right: Christ in Glory, upheld by angels.
Bottom left: St John the Baptist in prison.
Bottom right: Salome dancing for Herod for the head of St John the Baptist.

Photograph: Blaise Junod.

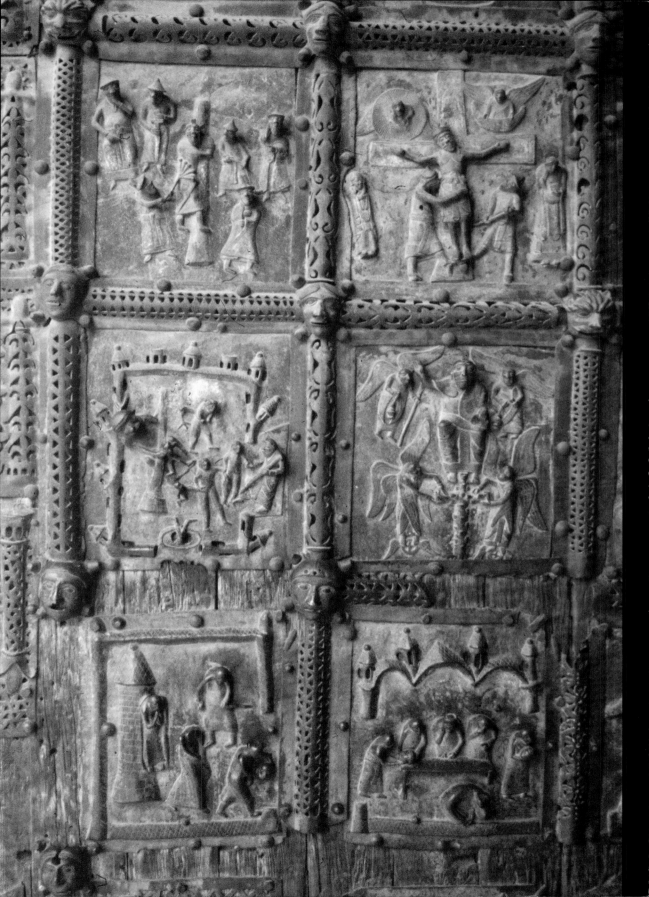

Cross of Inlaid Stones

I have shown you how you can be one
by bringing you together
from the East and from the West.
No one asked if you were
a Catholic or an Orthodox
but you all praise my name as one body.
There will be pain for you in the future
if you are true to what you have learned.
You will be accused of disloyalty
to your church and even to your country.
But remember that I made you one living body,
to suffer and to rejoice together.
For you are one nation called to holiness,
my people called to re-present
my passion, death and resurrection to the world
so that the world may believe.

Richard Hobbs,
1934-1993

12th-century Cross of marble and inlaid stones, Norman *Capella Paletina*, Palermo, Sicily, Italy.

Left: King Roger II of Sicily's Coronation Robe, 1100. Treasury of the Kunsthistorisches Museum, Vienna, Austria.

The Finding of the True Cross

The Empress Helena, from her long meditations on the Passion conceived such a tender love for Jesus crucified, that even though she could have been sure of saving her soul in the midst of honours and pleasures, she would, nevertheless, have chosen the way of the Cross, to resemble a little her divine Lord. From hence she derived that courage with which she made light of, and concealed all her infirmities and pains of body, without making any complaint, or lamenting over them. And to those who showed signs of compassion for her at such times, this exalted princess, but humble servant of our Lord, used to reply: "This Cross is very light and very dear to me; I should not be happy without it; I have great need of it, I assure you; but for this I should be puffed up with pride and vanity."

The Empress Helena,
c. 250-330

A fragment of the True Cross.

Late 12th-century Norman marble capital of Constantine and his mother St Helena standing either side of the True Cross, cloister of Monreale, Palermo, Sicily, Italy.

The True Cross is the name for the physical remnants which, by a tradition, are believed to be from the cross upon which Jesus was crucified. According to Socrates Scholasticus and others, the Empress Helena of Constantinople, mother of Emperor Constantine, the first Christian Emperor of Rome, travelled to the Holy Land, (dated by modern historians in 326-28), founding churches and establishing relief agencies for the poor. It was afterwards claimed, in the later fourth-century history by Gelasius of Caesarea, followed by Tyrannius Rufinus additions to Church History (Eusebius) , that she discovered the hiding place of three crosses, believed to be used at the Crucifixion of Jesus and the two thieves St Dismas and Gestas, who were crucified with Him, and that through a miracle, it was revealed which of the three was the True Cross.

Cross on a Manuscript

Holy Spirit, come into my heart;
draw it to Thee by Thy power, O my God,
and grant me charity with filial fear.
Preserve me, O ineffable Love,
from every evil thought;
warm me, inflame me with Thy dear love,
and every pain will seem light to me.
My Father, my sweet Lord,
help me in all my actions.
Jesus, love, Jesus, love.
Amen.

St Catherine of Siena,
1347-1380

The Abbey Bible: illuminated manuscript on velum, Bologna, Italy, 1260s in Latin, by Cardinalis and Rugerinus of Forli for *Frédol de Saint-Bonnet*, for use in a Dominican convent. Prologue attributed to St Jerome. Arcana Collection.

St Catherine was born in Siena, Italy in 1347. She pursued a life of prayer, fasting and penance as a Dominican from the age of 16. She was passionate in her love for Christ and the Church, and in1376 she wrote successfully to Pope Gregory XI to induce him to return the papacy from Avignon to Rome. She left behind remarkable writings of spiritual and theological doctrine. She died in Rome in 1380 and was canonized by Pius II in 1461.



...manfit ab hiis q erat sup firmamtu. Et factu e ita. Uocauitq; ds firmamtu celum. Et factu e uespe et mane. dies scds. Dixit uo deus. Congregent aq q sub celo sunt in locu unu. et appareat arida. factuq; e ita. Et uocauit deus aridam terram. Congregatioesq; aquar appellauit maria. Et uidit deus q esset bonu. Germinet tra herbam uirentem et facientem semen. et lignu pomiferu. faciens fructu iuxta genus suu: cui sem in semetipo sit sup tra. Et factu e ita. Et protulit tra herba uirente. et afferente semen iuxta genus suu: ligniuq; faciens fructu. et hns unumquodq; sementem scdm speciem sua. Et uidit deus q esset bonu. Et factuq; e uespe et mane. dies tcius. Dixit aut ds. fiant luminaria in firmameto celi. et diuidant diem ac nocte. et sint in signa et tempora. et dies. et annos. ut luceant in firmameto celi. et illu...

Right column:

...in genere... tir. scdm species suas. factuq; e ita. Et uidit deus uolatilia celi. uniuersaq; uolatile scdm genus suu. Et uidit deus q esset bonu. Ait. faciamus hoiem ad ymagine et similitudine nram. et psit piscib; maris. et uolatilib; celi. et bestiis. uniuseq; terre. omniq; reptili qd mouet in tra. Et creauit ds hoiem ad ymagine et similitudine sua. ad ymaginem dei creauit illu. masculum et femina creauit eos. Bndixitq; illis deus. et ait. Crescite et multiplicamini. et replete tra. et subiecte ea. et dnamini piscib; maris. et uolatilib; celi. et uniuisis ãtantib; que mouent sup tra. Dixitq; ds. Ecce dedi uobis oem herbam afferente sem sup tra. et uniuisa ligna q hnt in semetipis sementem gñis sui. ut sint uobis in escam. et cuctis ãtantib; tre. omniq; uolucri celi. et uniuisis q mouentur in tra. et in quib; est aia uiuens. ut hnt ad uescendu. Et factu e ita. Vidit deus cucta q fecerat. et erant ualde bona. Et factu e uespe et mane. dies septimus.

Igit pfecti sunt celi et tra. et omnis ornatus eor. Copleuitq; deus die septimo opus suu qd fecerat. et requieuit die septimo ab uniuso ope qd patrarat. Et bndixit diei septimo. et sctificauit illu. qa in ipo cessauerat ab oi ope suo qd creauit deus ut faceret. Iste sunt gene...

Cross of Montefalco

Lord, in Thy pierced hands I lay my heart;
Lord, at Thy pierced feet
I choose my part;
Lord, in Thy wounded side
Let me abide.

May Jesus Christ, the King of Glory,
help us to make the right use of all the suffering that comes to us,
and offer to him the incense of a patient and trustful heart;
for his Name's sake.

Amen.

John Tauler,
Suffering
1300-1361

The Great Crucifix, attributed to a principal collaborator of Giotto (1267-1337) in the Assisi area, known as the Master of the Montefalco Crucifix. Museum of San Francesco, Montefalco, Umbria, Italy.

Photograph: Jennifer, Marchioness of Bute.

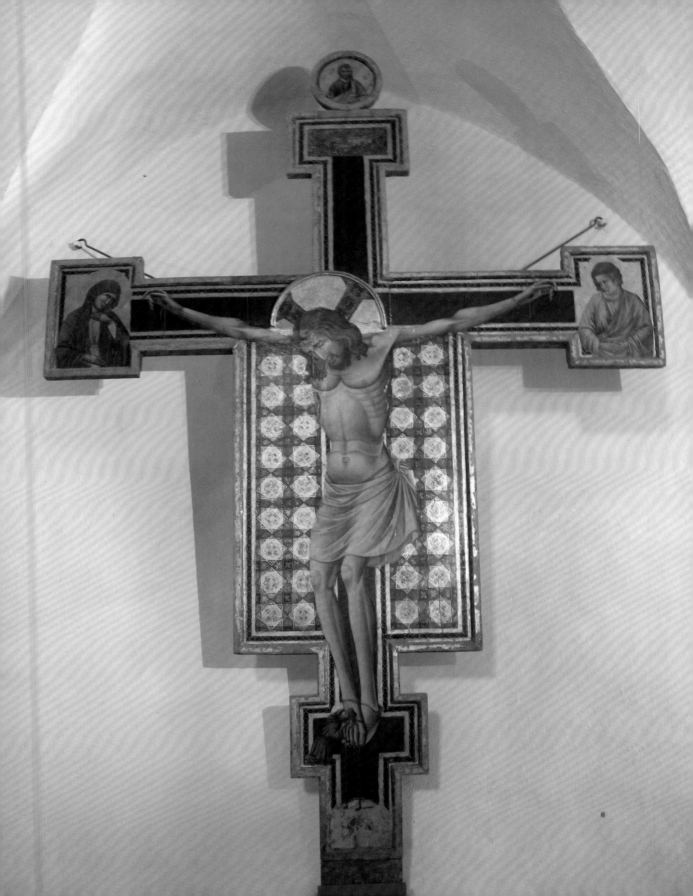

Cross, Ox and Lion

If without miracles the world was turned to Christianity,
that is so great a miracle that, all the rest are not its hundredth part:
for you were poor and hungry when you found the field
and sowed the good plant once a vine and now a thorn.
There is no child of the Church Militant who has more hope than he has,
as is written within the Sun whose rays reach all our ranks:
thus it is granted him to come from Egypt into Jerusalem that he have vision of it,
before his term of warring ends.

Thus I began again:
My charity results from all those things whose bite can bring the heart to turn to God;
the world's existence and mine,
the death that He sustained that I might live,
and that which is the hope of all believers,
as it is my hope,
together with living knowledge I have spoken of,
these drew me from the sea of twisted love and set me on the shore of the right love.

The leaves enleaving all the garden of the Everlasting Gardener,
I love according to the good He gave to them.

Dante Alighieri,
The Divine Comedy: Cantos XXIII-XXVII
1265-1321

Uncovered fresco depicting the Crucifixion, of an earlier date than the 14th-century
altar of red porphyry, probably the remains of a porch of the *duecento,* which
incorporates *left*: St Luke's ox and *right*: St Mark's lion, Basilica of St Zeno
Maggiore, Verona, Italy.

Photograph: Dr Christopher Tadgell.

Cross on a Wellhead

In the midday sun a woman coming to the well for water encounters Jesus who asks her for a drink. Nothing unusual you may think. It is hot. She has a bucket to draw water. So, what is more natural than for a thirsty Jesus, sitting on the rim, to ask for water?

Yet it is a highly unusual, shocking scene. No self-respecting woman would normally come there alone at midday. If she did, a man would not talk to her. If he were a Jew, he certainly would not ask a Samaritan woman for a drink.

Jesus breaks two taboos in talking to the lone woman and in asking her a Samaritan for a drink (Jews and Samaritans would not share drinking vessels).

Showing her astonishment the woman demands to know why Jesus is talking to her and asking her for a drink. Jesus replies that if she knew who he was she would have asked him for a drink and received living water, the water of life itself. In the exchange which follows she is amazed at how much Jesus knows about her (that she has had 5 husbands). She sees that he is a prophet and then, prompted further, recognises him as the awaited Messiah. In her excitement she rushes off without her precious water from the well back to the city to tell people to come and see Jesus. Many believe because of her testimony. Jesus' disciples, meanwhile, are shocked to have found him speaking to her.

Watching the scene what do we conclude? The water from the well or the water of life? Spiritual refreshment matters more than physical nourishment. The first preacher of the Good News in John is a woman: God's call is to the unexpected and sometimes shocks. Jesus sits on a well waiting for us. Do we dare to draw near?

The Venerable Sheila Watson, Archdeacon of Canterbury,
1953-

13th-century stone V*era da Pozzo*, (with metal lid), for drinking water, Venice, Italy.

Several similar *pozzi* are in the quarter where Marco Polo lived after his return from the Orient.

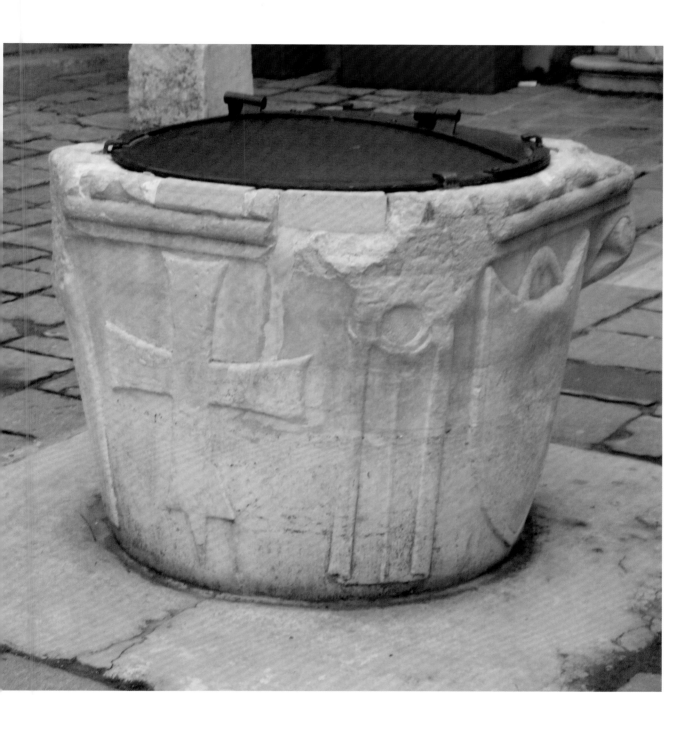

Cross of St George and the Princess

But on his breast a bloody Cross he bore,
The dear remembrance of his dying Lord,
For whose sweet sake that glorious badge he wore
And dead (as living) ever he adored.
We are told also that the hero thought continually of wreaking vengeance:
Upon his foe, a dragon horrible and stern.

Edmund Spenser,
The Faerie Queene
1552-1599

Mid 14th-century fresco: *St George and the Dragon with the Princess*, attributed to the Second San Zeno Master, Basilica of San Zeno Maggiore, Verona, Italy.

The *Legenda Aurea* tells of a terrible dragon, who had ravaged all the country round Selena, a city in Libya, making its lair in a marshy swamp. Its breath caused pestilence whenever it approached the town, so the people gave the monster two sheep every day to satisfy its hunger, but, when the sheep ran out, a human victim was necessary and lots were drawn to determine the victim. On one occasion this fell to the king's little daughter, Cleodolinda. The king offered all his wealth to buy a substitute, but the people had pledged themselves that none should be allowed, so the maiden, dressed as a bride, was led to the marsh. There St George chanced to ride by, and asked the maiden what she did, but she asked him to leave in case he too might perish. He stayed, however, and, when the dragon appeared, St George, making the sign of the cross, attacked it and transfixed it with his lance. He asked the maiden for her girdle and bound it round the neck of the monster, and the princess was able to lead it like a lamb. They returned to the city, where St George told the people to have no fear, but to be baptized. He cut off the dragon's head and they were all converted. The king offered to give St George half his kingdom, but the saint replied that he must ride on, bidding the king to take good care of God's churches, honour the clergy, and have pity on the poor. All this happened during the reign of Diocletian.

Jesus carries His Cross through Jerusalem

Faithful Cross,
Above all other,
one and only noble Tree;
None in foliage, none in blossom,
none in fruit thy peers may be;
sweetest wood and sweetest iron!
Sweetest Weight is hung on thee!

Lofty tree, bend down thy branches,
to embrace thy sacred load;
oh, relax the native tension
of that all too rigid wood;
gently, gently bear the members
of thy dying King and God.

Tree, which solely wast found worthy
this world's Victim to sustain;
harbour from the raging tempest.
Ark, that saved the world again!
Tree, with sacred blood anointed
of the Lamb for sinners slain.

Blessing, honour, everlasting,
to the immortal Deity;
to the Father, Son, and Spirit,
equal praises ever be;
glory through the earth and heaven
to Trinity in Unity.
Amen.

Venantius Fortunatus,
530-600

Christ carrying the Cross. Fresco, Barna da Siena (1330-1350), possibly Lippo Memmi (fl. c. 1333-1341). Collegiata (Santa Maria Assunta), San Gimignano, Italy. Photograph: Dr Christopher Tadgell.

The New Testament cycle is composed of 22 episodes on three levels representing the life and Passion of Christ. It is one of the great works of Italian Gothic painting. For long attributed to Barna da Siena (fl. c. 1330-50), it is now thought to have been executed in 1333-41 by a master from the workshop of Simone Martini, possibly Lippo Memmi, assisted by his brother Federico and by Simone's brother Donato.

Perugino's Cross

When you said: "Blessed are the poor, blessed are the persecuted", I wasn't with you. If I had been, I'd have whispered into your ear: "For heaven's sake, Lord change the subject, if you want to keep any followers at all. Don't you know that everyone wants riches and comfort? Cato promised his soldiers the figs of Africa, Caesar promised his the riches of Gaul, and, for better or worse, the soldiers followed them. But you're promising poverty and persecution. Who do you think's going to follow you?" You went ahead unafraid, and I can hear you saying you were the grain of wheat that must die before it bore fruit; and that you must be raised upon a cross and from there draw the whole world up to you.

Today, this has happened: they raised you up on a cross. You took advantage of that to hold out your arms and draw people up to you. And countless people have come to the foot of the cross, to fling themselves into your arms.

Faced with the sight of all these people pouring in for so many centuries, and from every part of the world, to the crucified man, a question arises: were you merely a great and good man, or a God? You gave us the answer yourself, and anyone whose eyes are longing for the light and are not obscured by prejudice accepts it.

... I have written to you, but never have I been so dissatisfied with what I have written as I am this time. I feel I have left out most of what could be said about you, and have said badly what could have been said much better. But there is this comfort: the important thing is not for one person to write about Christ, but for many to love and imitate him.
And happily, in spite of everything, this still happens.

Pope John Paul I,
1912-1978

Tempera on panel c. 1503-1504. The Crucifixion, known as *the Altarpiece of Monteripido*, Pietro Vannucci, called Perugino (c. 1450-1523). National Gallery of Umbria, Perugia, Italy.

Photograph: Justin Hunt

In 1502 Perugino was commissioned by the Franciscan monks of Monteripido, Perugia, to paint a double-sided panel to be placed on the altar of their church, behind the wooden crucifix that had recently been installed. The monks' contract specified that he should include the figures of the Virgin Mary, St John the Evangelist, St Mary Magdalene, St Francis and two angels on the side towards the choir; and on the reverse facing the chapel reserved for women the Coronation of the Virgin with the Apostles below. In 1797 the altarpiece was removed to Paris by Napoleon's troops, rescued and given back in 1817 and replaced on the altar in 1822. Since 1863 it has been in the National Gallery of Umbria.

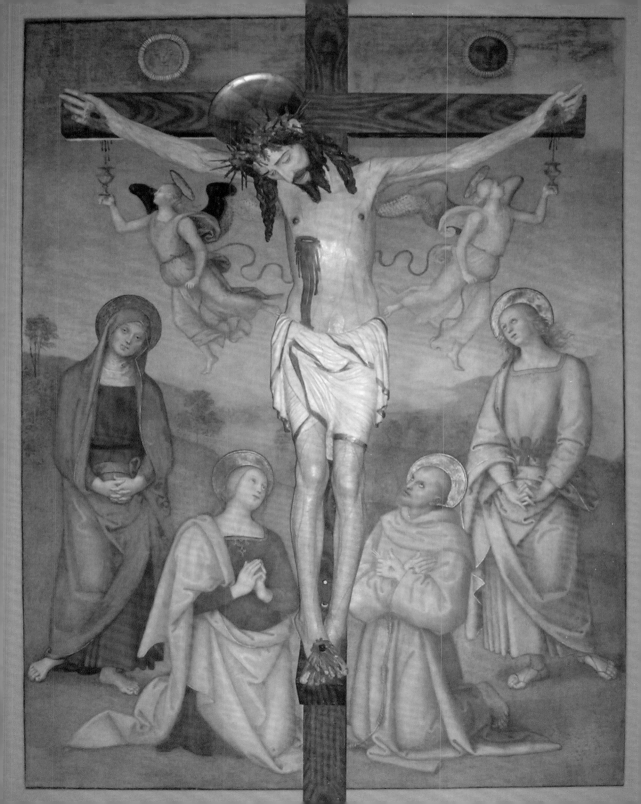

Cross and the Crown of Thorns

Jesus, crowned with bitter thorns,
By mankind forsaken,
Jesus, who through scourge and scorn
Held thy faith unshaken,
Jesus, clad in purple raiment,
For man's evils making payment:
Let not all thy woe and pain,
Let not Calvary be in vain!

Jesus, open me the gate
That of old he entered
Who, in that most lost estate,
Wholly on thee ventured;
Thou, whose wounds are ever pleading,
And thy Passion interceding,
From my weakness let me rise
To a home in paradise!

Theoctistus,
c. 890

Painting, oil on panel, *Christ as the Man of Sorrows,* Bernadino Fungai
(c. 1460-1516), Sienese School, Mason Perkins Collection, Museum of the Basilica
of St Francis, Assisi, Italy.

Photograph: Jennifer, Marchioness of Bute.

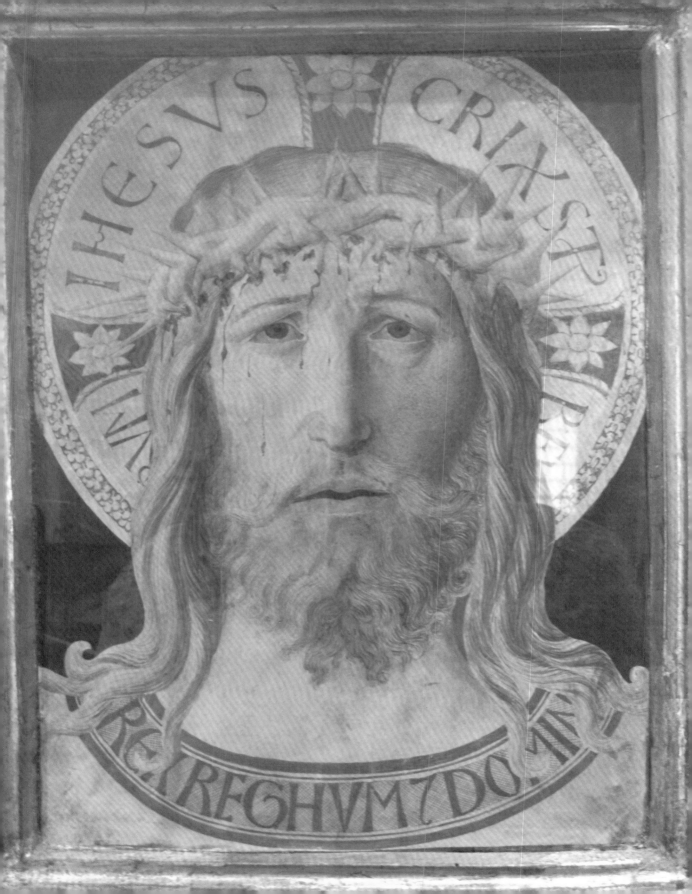

Cross on an Obelisk

Frequently kiss, with all the tenderness of your heart, the crosses that our Lord sends you, without looking of what sort they are, for the more revolting and ungracious they are the more do they deserve this name; seeing that the merit of crosses does not depend on the weight of the same, but upon the manner in which they are borne; and there is sometimes greater virtue in bearing a cross that is light and made of straw, as it were, than one that is very thick and weighty; for light crosses are those also that are most hidden and abject, and on that account less conformable to our inclinations, that always seek after things that are conspicuous.

St Francis de Sales, (canonised by Pope Alexander VII in 1665)
1567-1622

Renaissance Cross of 1665, mounted on an Egyptian Obelisk by Pope Alexander VII (1599-1667) to underline the supremacy of Christianity over paganism, Piazza di San Giovanni Lateran, Rome, Italy,

The 105.6 foot red granite Lateran Obelisk, weighing over 230 tons, is the largest, best preserved obelisk in Rome. Erected in the Piazza di San Giovanni in Laterano in 1588, it is the tallest Egyptian obelisk in the world and the last to be brought back from Egypt. Originally created by Pharaoh Tutmosis in the 15th century BC, it was taken from the temple of Amun in Karnak by Constantine the Great, who moved it to Alexandria in 357. The giant obelisk was finally transported to Rome in a special ship with 300 rowers, ordered by Emperor Constans I, the son and successor of Constantine, and was originally placed in the center of the Circus Maximus. On the base are inscriptions that mention the history of the obelisk, Constantine and its journey from Egypt to Rome.

Left: Bernini's Cross of 1667 atop the obelisk from Sais, standing outside Santa Maria sopra Minerva, Rome.

Cross on a *Trullo*

Gracious and holy Father,
please give me:
intellect to understand you;
reason to discern you;
diligence to seek you;
wisdom to find you;
a spirit to know you;
a heart to meditate upon you;
ears to hear you;
eyes to see you;
a tongue to proclaim you;
a way of life pleasing to you;
patience to wait for you;
and perseverance to look for you.

Grant me:
a perfect end,
your holy presence.
A blessed resurrection,
And life everlasting.

St Benedict,
c. 480-547

Late 20th-century painted Cross on the roof of a typical *trullo* house in via Monte Pertica, Alberobello, Bari, Puglia, Italy.

These small rural dry stone buildings with conical roofs, date from prehistoric times, and are unique to the Murge region of Italy. Usually whitewashed and often topped by spires, they dot the surrounding countryside and in Alberobello there are over a thousand districts of trulli. There are many theories behind the origin of the design: one is that due to high taxation on property, the people of Puglia created dry wall constructions which could be dismantled when inspectors were in the area. A *trullo* is essentially a rural building which with its thick walls and its inability to form multi-storey structures, is wasteful of ground space and ill-suited to high density settlement. The building material used is hard limestone or calcareous tufa. The vast majority of *trulli* only have one room under each conical roof, with additional living spaces in arched alcoves and children slept in alcoves made in the wall. The golden age of *trulli* was the 19th century.

Cross on a Naval Jack

To You, great and eternal God,
Lord of heaven and of the deep,
to Whom winds and waves obey,
we, men of the sea and of war,
Officers and Sailors of Italy,
from this sacred vessel armed by our Fatherland,
lift up our hearts.
Save and exalt, in Your faith,
Oh great God, our Nation.

Give righteous glory and power to our ensign,
order that storms and waves serve her,
put on our enemies the fear of her for ever prompt breasts of iron,
stronger than the iron that protects this ship, to encompass her in defence,
to her for ever grant victory.
Bless Oh Lord our distant homes, our dear folks,
bless in the falling night the repose of our people,
bless us who for them watch at sea.
Bless.

Antonio Fogazzaro,
1842-1911

Jack of the Italian Navy, Tall Ships Race 2001, Bergen, Norway.

The Jack is the small flag that flies at the bows of a warship. The same crest also
defaces the central white band of the Italian flag, with a crown for military ships,
without the crown for merchant ships. It is interesting to note that in the national
ensign used by the merchant mariners the lion has no sword but an open book with
the words *pax tibi Marce evangelista,* which means, "Peace to you, Mark my
Evangelist". The four quarters represent the four main Italian maritime republics: *top
left:* red cross on white field: Genoa; *top right:* lion on red field: Venice; *Bottom left:*
white cross on red field: Pisa; *bottom right:* white cross on blue field: Amalfi.

The "*Preghiera del Marinaio,*" or "Seaman's Prayer". As the Captain of the Italian
Navy ship "*Giuseppe Garibaldi,*" Captain Cesare Agnelli was so moved by the words
of this prayer that he asked the Navy for authorization to recite it every night. Since
1909 the youngest officer on board receives it at sunset when the sign is
lowered, with all the members of the crew who are not on duty, assembled at the
stern. Since then, this tradition has extended to all ships of the Navy fleet. This prayer
is read during the flag lowering and at the end of Mass celebrated by the Italian
Navy. It is recited only when the ship is under way at sea. On land it is recited only at
the end of a requiem Mass or other memorial service for deceased sailors.

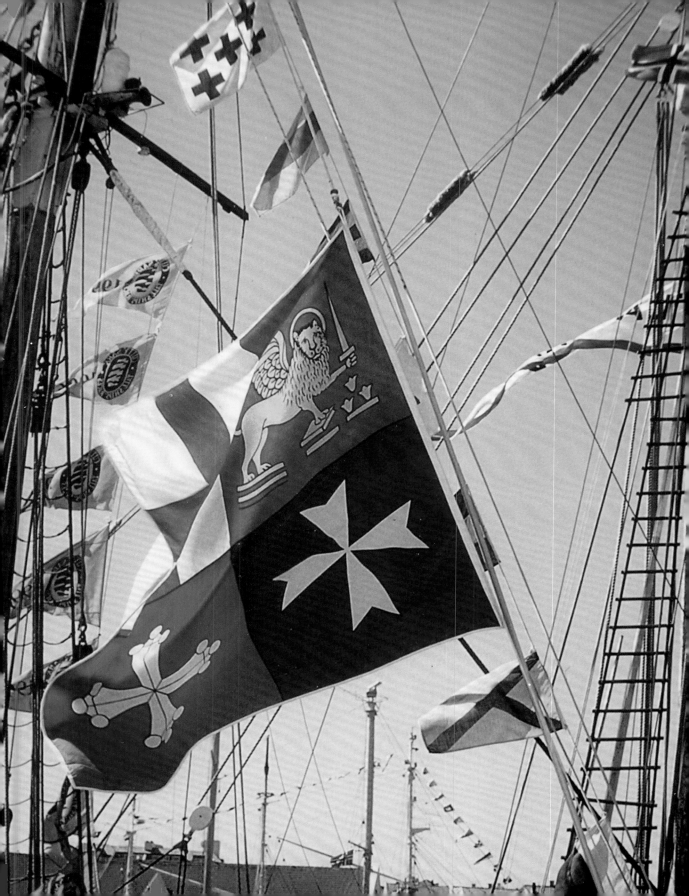

Cross of the Knights of Malta

May the angels lead you into Paradise;
May the martyrs welcome you into the heavenly city of Jerusalem.
May the choirs of angels receive you and as with Lazarus once so poor,
May you find eternal rest.

In Paradisum.

Requiem Mass, for Fra' Andrew Bertie, Basilica of Santa Sabina, Rome, Italy.

Photographs: courtesy of Peregrine Bertie.

Fra' Andrew Bertie was the 78th Grand Master and first Englishman, of the Sovereign Military Order of the Hospital of St John of Jerusalem, of Rhodes and of Malta since 1258. He served as Grand Master for nearly 20 years from 1988 until his death in 2008. Grand Masters, like Popes, are elected for life. Until his final breath on 7 February 2008, Fra' Andrew Bertie carried the title "His Most Eminent Highness". The monumental candle symbolises faith in the resurrection.

Left: Fra' Andrew Bertie (1929-2008)

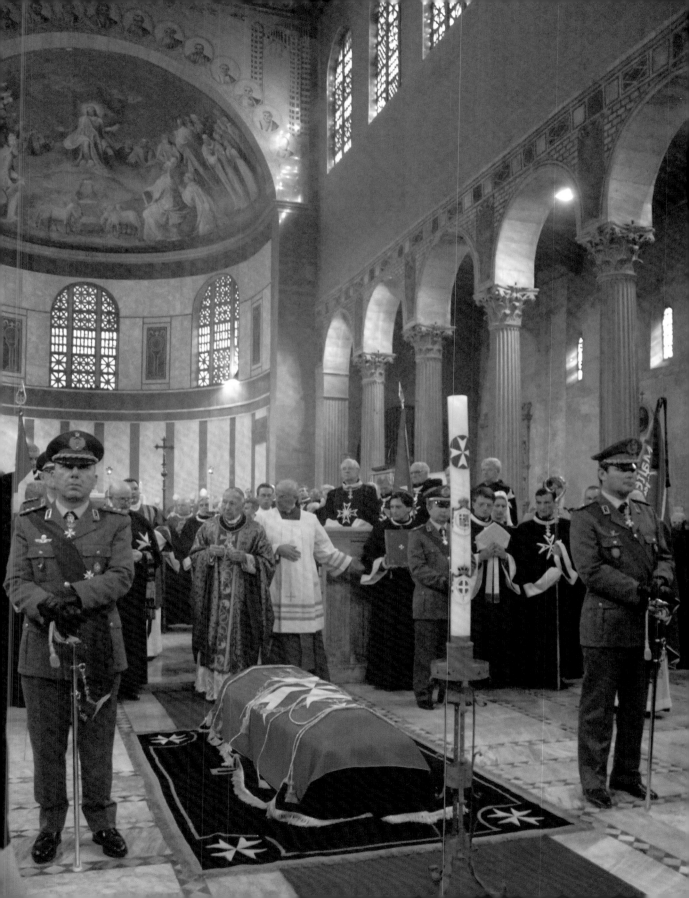

Cross on a Gold Tabernacle

Grant me, O Lord my God,
a mind to know you,
a heart to seek you,
wisdom to find you,
conduct pleasing to you,
faithful perseverance in waiting for you,
and a hope of finally embracing you.

St Thomas Aquinas,
1225-1274

12th-century champlevé gold and enamel tabernacle, Limoges, France.

Photograph: Blaise Junod

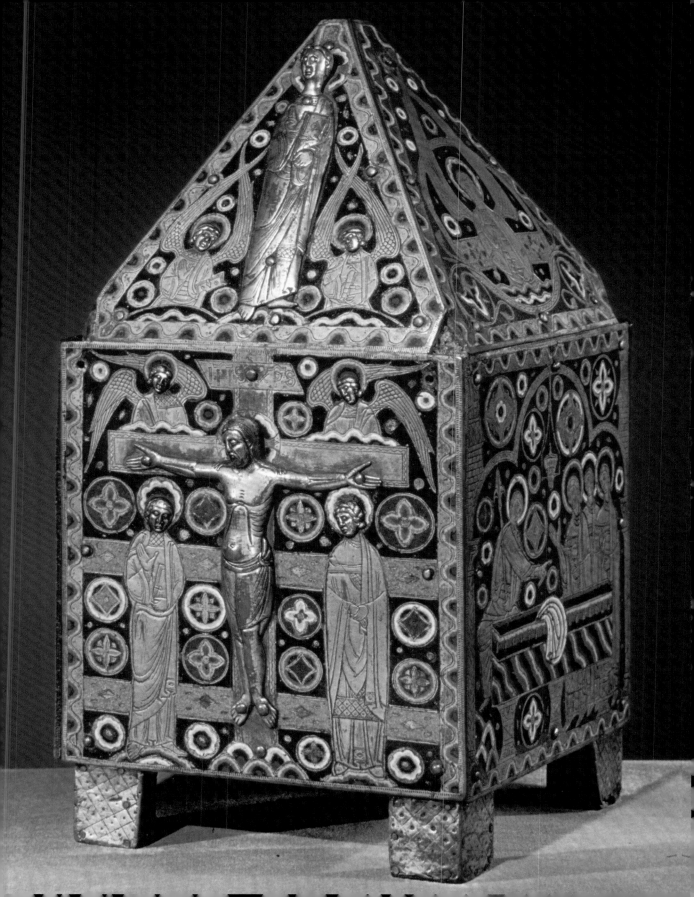

Reflected Cross

I believe, then, in God the Father omnipotent. I believe in Jesus Christ his only Son, our Lord God, born of the Father, not created. I believe that he has always been with the Father, not only since time began but before all time. For the Father could not have been so named unless he had a son; and there could be no son without a father. But as for those who say: "There was a time when he was not," I reject them with curses, and call men to witness that they are separated from the church. I believe that the word of the Father by which all things were made was Christ. I believe that this word was made flesh and by its suffering the world was redeemed, and I believe that humanity, not deity, was subject to the suffering. I believe that he rose again on the third day, that he freed sinful man, that he ascended to heaven, that he sits on the right hand of the Father,that he will come to judge the living and the dead. I believe that the Holy Spirit proceeded from the Father, that it is not inferior and is not of later origin, but is God, equal and always coeternal with the Father and the Son, consubstantial in its nature, equal in omnipotence, equally eternal in its essence, and that it has never existed apart from the Father and the Son and is not inferior to the Father and the Son. I believe that this holy Trinity exists with separation of persons, and one person is that of the Father, another that of the Son, another that of the Holy Spirit. And in this Trinity confess that there is one Deity, one power, one essence. I believe that the blessed Mary was a virgin after the birth as she was a virgin before. I believe that the soul is immortal but that nevertheless it has no part in deity. And I faithfully believe all things that were established by the three hundred and eighteen bishops. But as to the end of the world I hold beliefs which I learned from our forefathers, that Antichrist will come first. An Antichrist will first propose circumcision, asserting that he is Christ; next he will place his statue in the temple at Jerusalem to be worshipped, just as we read that the Lord said: "*You shall see the abomination of desolation standing in the holy place.*" But the Lord himself declared that that day is hidden from all men, saying; "*But of that day and that hour knoweth no one not even the angels in heaven, neither the Son, but the Father alone.*" Moreover we shall here make answer to the heretics (the Arians) who attack us, asserting that the Son is inferior to the Father since he is ignorant of this day. Let them learn then that Son here is the name applied to the Christian people, of whom God says: "*I shall be to them a father and they shall be to me for sons.*" For if he had spoken these words of the only begotten Son he would never have given the angels first place. For he uses these words: "*Not even the angels in heaven nor the Son*", showing that he spoke these words not of the only-begotten but of the people of adoption. But our end is Christ himself, who will graciously bestow eternal life on us if we turn to him.

Creed of St Gregory of Tours,
c. 538-594

Cross-shaped Basilica of the Sacre Coeur begun by St Hugues of Cluny in 1109, Paray-le-Monial, Burgundy, France.

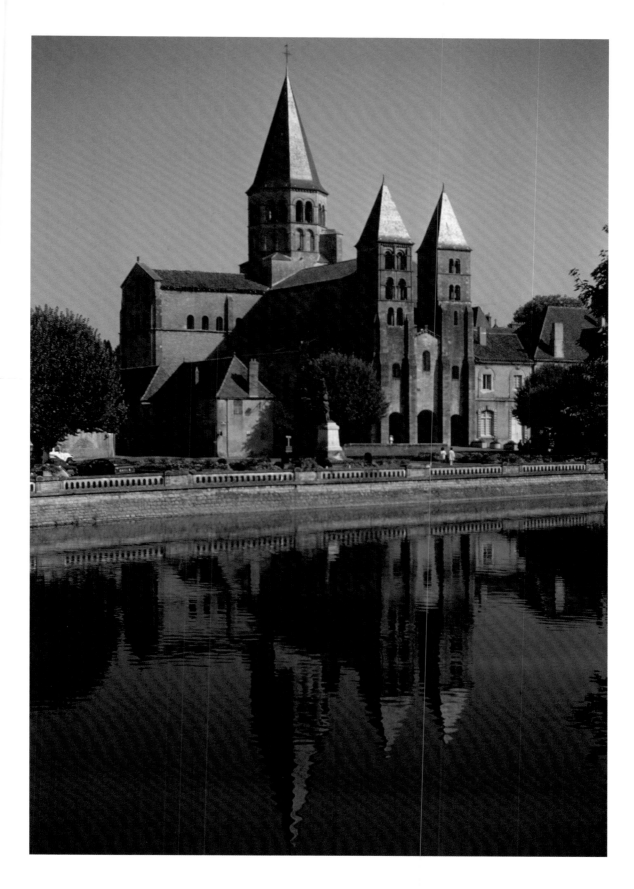

In the Shape of the Cross

The road to heaven is narrow. He then who would walk along it with greater ease should cast aside every encumbrance, and set out leaning on the staff of the cross: that is resolved in good earnest to suffer in everything for the love of God.

St John of the Cross,
1542-1591

Church and monastery of Sainte-Foy, Conques-en-Rouergue, Aveyron, France.

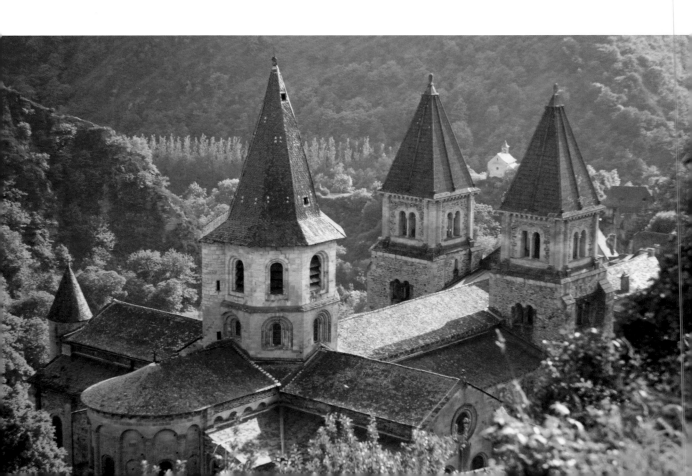

Cross on a Tympanum

It happened once to the great Saint Bernard that, being ill with a dangerous sickness, he was rapt in spirit, and it seemed as though he was brought before the judgment-seat of Christ, and that then the devil tempted him to despair. Upon which the saint replied to the tempter: "I confess and acknowledge that for my own works I am not worthy of heaven; yea, rather I deserve the very reverse: nevertheless, my Lord and Saviour has merited it for me on two grounds; the first, because he is the Son of God; the other, because he had died for me upon the cross. Now, by the first title he possesses heaven for himself, but the second he has made over to me; and for this motive I hope, and despair not."

St Bernard of Clairvaux,
1090-1153

Painted polychrome tympanum of 1130 showing Christ in Judgment, the Church and monastery of Sainte-Foy, Conques-en-Rouergue, Aveyron, France.

Pilgrim's Wayside Cross

The people of God on pilgrimage is made up of an endless variety of types. Each carries a special burden of responsibility – bishops, priests, religious and the laity who seek to sanctify the everyday world in which they live and work. There are the pilgrims who are marked out by the particular cross they carry, by the way they share the mystery of Christ's suffering. They are the handicapped, the dying, those asked by God to share the special pain of loneliness, especially those deserted by husbands or wives and called upon to raise a family on their own or to suffer the death of a marriage partnership.

His Eminence Cardinal Basil Hume OSB OM,
Cardinal Archbishop of London (1976-1999),
1923-1999

12th-century pilgrim Cross at Estaing, France, on the Pilgrim Route to Santiago de Compostela, Spain.

Left: Wayside Calvary, Brittany, France.

Photograph: Blaise Junod.

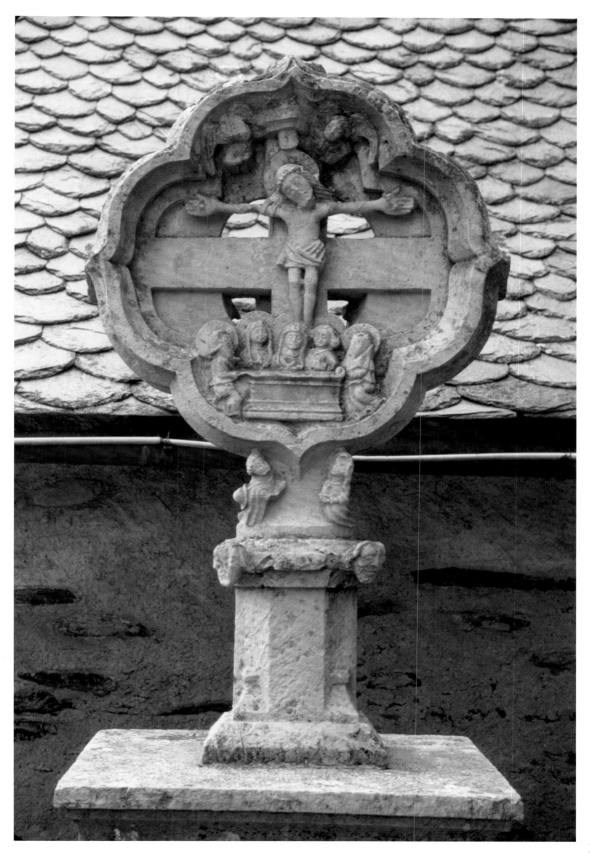

249

Cross on a Knight's Pillow

A knight there was, and he a worthy man,
Who, from the moment that he first began
To ride about the world, loved chivalry,
Truth, honour, freedom and all courtesy.
Full worthy was he in his liege-lord's war,
And therein had he ridden (none more far)
As well in Christendom as heathenesse,
And honoured everywhere for worthiness.
At Alexandria, he, when it was won;
Full oft the table's roster he'd begun
Above all nations' knights in Prussia.
In Latvia raided he, and Russia,
No christened man so oft of his degree.
In far Granada at the siege was he
Of Algeciras, and in Belmarie.
At Ayas was he and at Satalye
When they were won; and on the Middle Sea
Of mortal battles he had fought fifteen,
And he'd fought for our faith at Tramissene
Three times in lists, and each time slain his foe.
This self-same worthy knight had been also
At one time with the lord of Palatye
Against another heathen in Turkey:
And always won he sovereign fame for prize.
Though so illustrious, he was very wise
And bore himself as meekly as a maid.
He never yet had any vileness said,
In all his life, to whatsoever wight.
He was a truly perfect, gentle knight.

Geoffrey Chaucer,
Canterbury Tales: Prologue
1343-1400

250

Tombstone of a Crusader Knight showing him in full battle dress, including his glove and his cross-hilted sword. The Musée d'Unterlinden, Colmar, Alsace, France.

"Undertake this journey for the remission of your sins, with the assurance of the imperishable glory of the Kingdom of Heaven!"

On November 27, 1095 at the Council of Clermont, France, Pope Urban II, in one of history's most impassioned pleas, launched the Crusades, which were to continue for two hundred years. In a rare public session in an open field, he urged the knights and noblemen to win back the Holy Land, to face their sins, and called upon those present to save their souls and become "Soldiers of Christ." Those who undertook the venture were to wear an emblem in the shape of a red cross on their body. And so derived the word "Crusader," from the Latin word *cruciare* – to mark with a cross. By the time his speech ended, the captivated audience began shouting "*Deus le volt!* – God wills it!" The expression became the battle-cry of the Crusades.

Cross Bottony

On Zion's hill, clothes stripped, outside the wall,
Our beaten, bloodied, breathless Saviour's call.
"Eloi, Eloi", but answer came there none;
The crowd, who'd cried 'Hosannah,' now had fun
With mockery and red wine mixed with gall.
The sky was darkened, Heaven's holy pall,
To spare angelic eyes the tortured Son
Until He'd swallowed death, the victory won.

Oh could it be, so long ago, this death,
Could give to humble lives His holy breath?
Oh could it be that He would come to me?
Could I be cleansed from sin, my soul set free?

Why, Yes, my friend, but dying is the way,
'Tis only death can win the eternal day.

John L F Wright,
1934-

Gothic Cross Bottony, Basilica of St Crépin, Évron, France.

Photograph: Blaise Junod

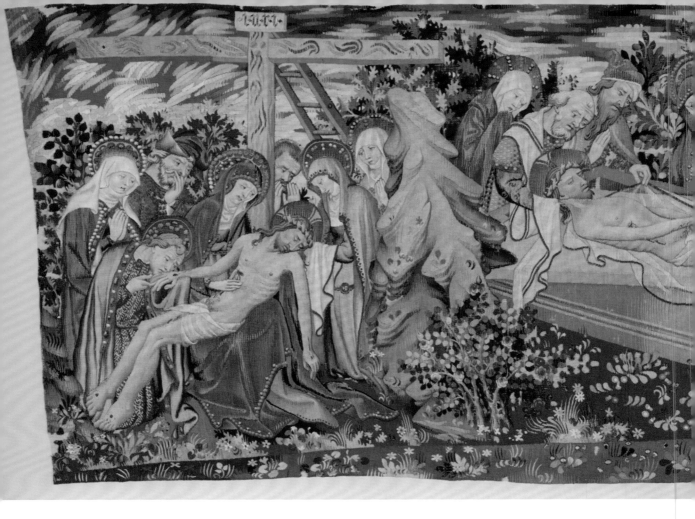

Cross on an Alter Cloth:
Descent from the Cross, the Entombment and the Resurection

Lord, what did You suffer as you saw Your beloved son hanging on the Cross, His scourged back against the unshaven wood, blood seeping from His head, His shattered hands, His shattered feet? What did You suffer as You saw His enemies close Him round on every side for their desperate last attack, our sin piled on Him? It must have rent Your heart of love to hear Him cry "My God, My God why have You forsaken Me". Lord, You risked Your only son for us. Were we, are we, worth that terrible path? Your love contained Your pain, such unknown love.

Yet, as His life dimmed to death, you saw Him still untinged with evil. Lord, when He said "Father, into Your hands I commit My spirit", and His spirit came to You, what must have been

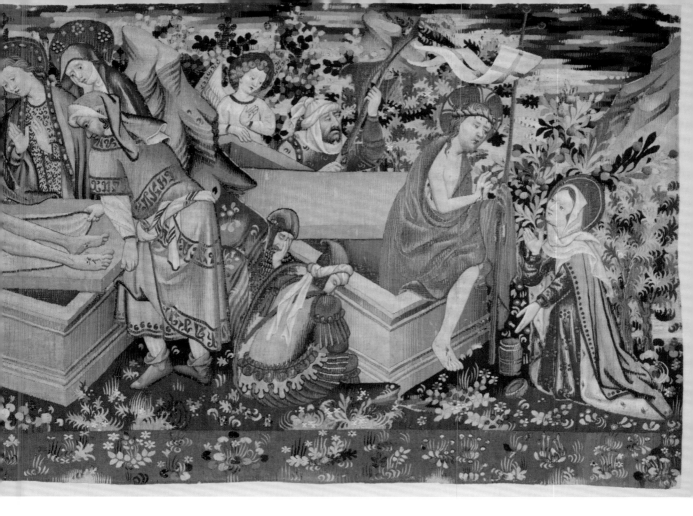

Your joy. So He became our way. So to Mary He could say "I have not yet ascended to My Father and Your Father, to My God and Your God".

Lord, have mercy on us, miserable sinners. By His blood, purge evil from us. Build us into His sacred life that we may live."

Nigel Inglis-Jones,
1935-

Tapestry Altar cloth of 1400-1425, woven of silk and wool with gold and silver threads, Amiens, France.
Photograph courtesy of the Victoria and Albert Museum, London, England.

Cross with the Virgin Mary and Saints

As we gaze on Jesus hanging on the cross we acknowledge Him to be our high priest, the one who presents Himself, in his emptiness, to His loving Father on our behalf. In every moment of prayer, we unite ourselves to Christ that we may become part of His offering, His prayer to God, who is the same God and Father of us all.

On the cross, Jesus cried out: *'I thirst'* and he was given vinegar, sour wine, to drink. Here are strong echoes of the Old Testament and in particular Psalm 69:: the just man, in his suffering, laments that *"for my thirst they gave me vinegar to drink."* Jesus is that just man, every just person, exposed to suffering and distress.

In his last moments, Jesus also cries out *"It is finished, it is accomplished."* His great task is complete. All that remains is for the Father to complete His task: that of raising Jesus to new life. What exactly is the task of Jesus? It is that of bringing to the Father, the whole world, summed up in His body, for He is truly both God and man, the Word through whom all things are made. In this way Jesus consecrates our world. As priest He hands it over to God, right unto the end, until all is accomplished. And the sign of it being accomplished is the piercing of His side so that the last drops of blood and water are shed.

This happens at the very hour when the lambs of the Jewish liturgy are being slaughtered in the Temple. In Jesus that form of worship comes to an end, for He is now the Lamb of God who takes away from the world the ultimate effects of our sin. In this way, too, He is our high priest and in Him all our prayers for forgiveness and mercy find their answer. This is now the new, true worship for now His body is the new Temple, and, most remarkably, we are now that body. Here is the greatness of our calling: to be the Body of Christ in our world; to be the point of true prayer, the point at which all the world's troubles are raised up before God in union with Jesus. This is the great dignity of being a priestly people called to consecrate the world to God through lives of holiness and faith.

So we approach our true place: at the foot of the cross, ready to venerate our Lord, to receive Him with love and to be those who will continue in our lives His work of bringing all things to God for healing and redemption.

The Most Reverent Vincent Nichols, Archbishop of Westminster, (2009-)
1945-

The Crucifixion: Painting, oil on panel, c. 1495-1500. Gerard David (c. 1455-1523), Flanders, depicting Christ, St John the Evangelist, the Virgin Mary, St Mary Magdalene and St Jerome reading from the bible. Metropolitan Museum of Art, New York, USA.

Photograph: The Metropolitan Museum of Art.

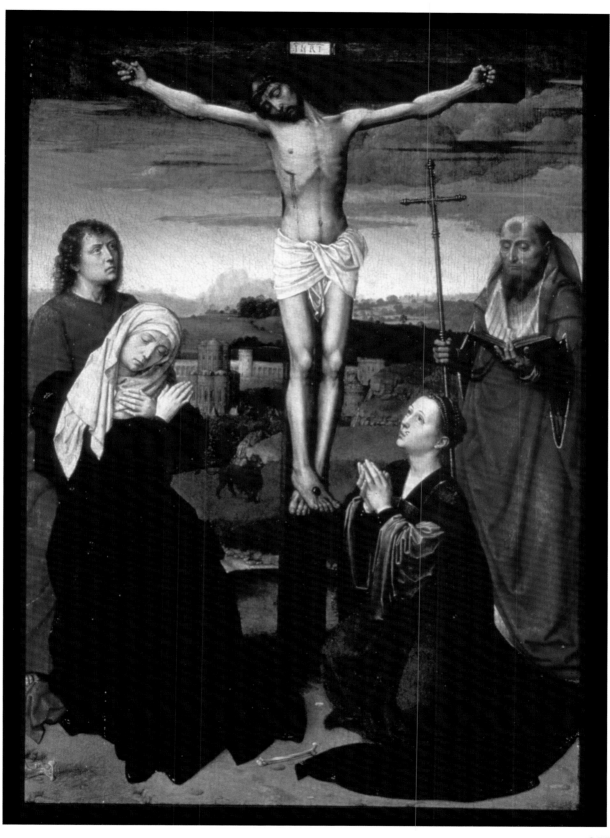

257

Cross in a Tapestry

We see three wooden crosses standing in the ground
And wonder where the crucified are bound.
To heaven or hell? Had they done well?
To stack them on the rubbish dump of life – Sad Destiny;
Or find a resting place to end their strife – Epitome.
For good or ill; a bitter pill; What Agony.

One of the three has many witnesses that put him among the good who had done well. The witnesses included Pilate who asked "What evil has he done?" And one thief said to another "This man has done nothing wrong." This man who went about doing good (Acts 10:38) was willing to hang there with those who had done wrong and accompany them in their agony. This in turn reminds us that one of the names given to Jesus at birth was Emmanuel, meaning "God with us", and one of his last words was "Lo, I am with you always even unto the end of the world" (Matthew 28:20). The Penitent Thief's end was now, and in the agony of crucifixion there was with him One who said "Today you will be with me in Paradise".

Here was a man who was in the wrong and was being punished for it, finding himself with one who was in the right being wrongly punished.

The degree to which Jesus was with the wrongdoers varies. He spoke to one but not to the other. The one to whom he spoke was the one who showed humility and some realism about his own situation and some belief about the kingdom of Jesus Christ.

The other just pleaded for, almost demanded, salvation but with doubt as to who Jesus was. Jesus had nothing to say to him. It was the first who received the offer of Paradise.

We do well to ask whether we place ourselves before Jesus in a way that enables him to give us the good things that he has in store for us.

Lord Jesus help me to find time to be with others in their time of need.

Roy Calvocoressi,
1930-2012

16th-century silk and wool tapestry panel of the crucifixion, part of a set made in Flanders, now in the Abbey of La Chaise Dieu, Auvergne, France.

Photogarph: Blaise Junod

Cross for a First Communion

Perfection consists in only one thing, which is to do the will of God; since, if according to the declaration of God, it is necessary to deny ourselves, to bear our cross and to follow him, if we would be perfect, who can be said to deny himself better, to bear his cross better, or to follow Christ better than he who never studies his own will, but always that of God? See, then, how little is necessary in order to become a saint! Nothing else than to habituate oneself on every occasion to desire that which God willeth.

St Vincent de Paul,
1581-1660

Eight year old girl proudly wearing her wooden cross as she takes her First Communion, Auvergne, France.

Cross of Sacrifice

O Valiant hearts, who to your glory came
Through dust of conflict and through battle flame;
Tranquil you lie, your knightly virtue proved,
Your memory hallowed in the land you loved.

Proudly you gathered, rank on rank, to war,
As who had heard God's message from afar;
All you had hoped for, all you had, you gave
To save mankind – yourself you scorned to save.

Splendid you passed, the great surrender made,
Into the light that never more shall fade;
Deep your contentment in that blest abode,
Who wait the last clear trumpet-call of God.

Long years ago, as earth lay dark and still,
Rose a loud cry upon a lonely hill,
While in the frailty of our human clay,
Christ, our redeemer, passed the self-same way.

Still stands his cross from that dread hour to this,
Like some bright star above the dark abyss;
Still, through the veil, the Victor's pitying eyes
Look down to bless our lesser Calvaries.

These were his servants, in his steps they trod,
Following through death the martyred Son of God:
Victor he rose; victorious too shall rise
They who have drunk his cup of sacrifice.

O risen Lord, O shepherd of our dead,
Whose cross has bought them and whose staff has led,
In glorious hope their proud and sorrowing land
Commits her children to thy gracious hand.

J S Arkwright,
1872-1954

Temporary WW1 wooden cross, French Flanders, France. These crosses stood until
the Imperial War Graves Commission created the cemeteries after the end of
hostilities and the wooden crosses were sent back to the men's Parish Churches.

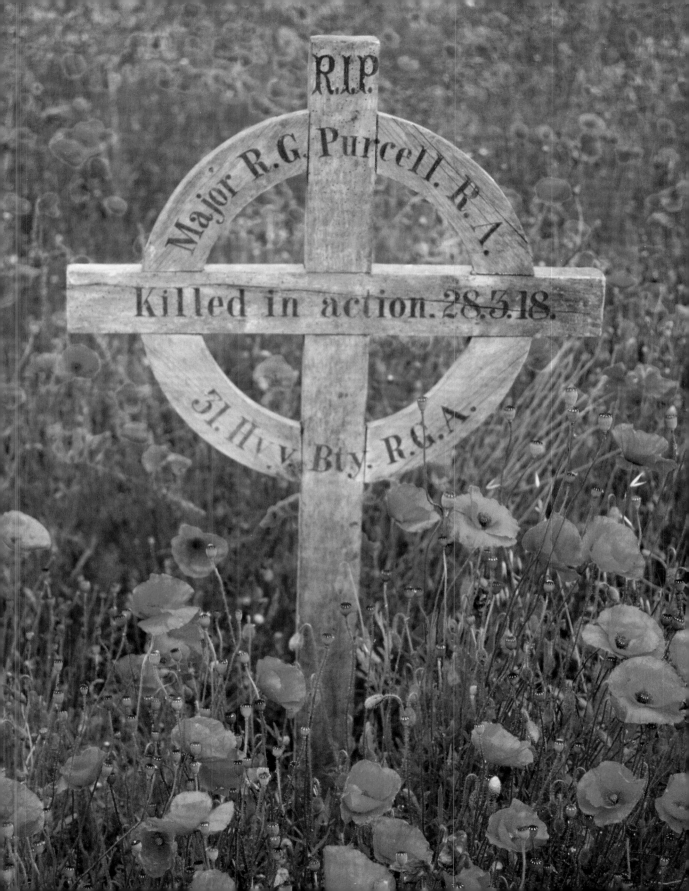

Cross of Lorraine

The Cross has always been a symbol of conflict, and a principle of selection, among men. The Faith tells us that it is by the willed attraction or repulsion exercised upon souls by the Cross that the sorting of the good seed from the bad, the separation of the chosen elements from the unutilisable ones, is accomplished at the heart of mankind. Wherever the cross appears, unrest and antagonisms are inevitable. But there is no reason why these conflicts should be needlessly exacerbated by preaching the doctrine of Christ crucified in a discordant or provocative manner. Far too often the Cross is presented for our adoration, not so much as a sublime end to be attained by our transcending ourselves, but as a symbol of sadness, of limitation and repression.

In its highest and most general sense, the doctrine of the Cross is that to which all men adhere who believe that the vast movement and agitation of human life opens on to a road which leads somewhere, and that that road climbs upward. Life has a term: therefore it imposes a particular direction, orientated, in fact, towards the highest possible spritualisation by means of the greatest possible effort. To admit that group of fundamental principles is already to range oneself among the disciples – distant, perhaps, and implicit, but nevertheless real – of Christ crucified. Once that first choice has been made, the first distinction has been drawn between the brave who will succeed and the pleasure-seekers who will fail, between the elect and the condemned.

The Cross is therefore not inhuman but superhuman. We can now understand that from the very first, from the very origins of mankind as we know it, the Cross was placed on the crest of the road which leads to the highest peaks of creation. But, in the growing light of Revelation, its arms, which at first were bare, show themselves to have put on Christ: *Crux inuncta*. At first sight the bleeding body may seem funereal to us. Is it not from the night that it shines forth? But if we go nearer we shall recognise the flaming Seraph of Alvernus whose passion and compassion are *incendium mentis*. The Christian is not asked to swoon in the shadow, but to climb in the light, of the Cross.

Pierre Teilhard de Chardin,
1881-1955

Monumental stone Cross of Lorraine in memory of General Charles de Gaulle (1890-1970), Colombey-les-deux-Églises, France.

Photograph: Blaise Junod

General de Gaulle, Brigadier General and statesman, led the Free French Forces during World War II. In 1958 he founded the Fifth French Republic and served as its first President from 1959 to 1969.

AU GENERAL DE GAULLE

Cross of the Angels

Hear us, O never-failing Light,
Lord our God, our only Light, the Fountain of Light,
the Light of your angels, thrones, dominions,
principalities, powers, and of all the beings of this world;
you have created the light of your saints,
the bright cloud of witnesses around us.
May our souls be your lamps, kindled and illumined by you.
May they shine and burn with your truth,
and never go out in darkness and ashes.
May we be your dwelling, shining from you, shining in you;
may we shine and our light never fail;
may we worship you always.
May we be kindled brightly and never extinguished.
Being filled with Christ's splendor,
may we shine within, so that the gloom of sin is cleared away,
and the light of everlasting life abides within us.
Amen.

Mozarabic prayer (before 700).

Cross of the Angels, reliquary of gold, studded with precious stones, 808, presented by Alfonso II of Asturias to the Cathedral of San Salvador, Oviedo, Asturias, Spain.

Photograph: Blaise Junod.

The *Cross of the Angels* is the symbol of Oviedo and the earliest surviving example of jewellry made in the Kingdom of Asturias. The typical Greek cross is formed by two pieces of cedar wood with a round disc at the centre.

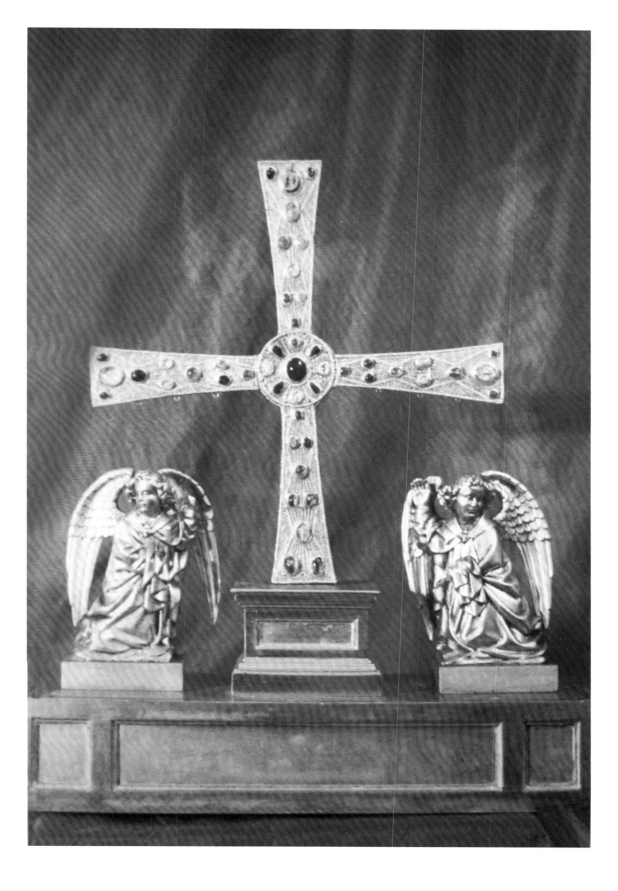

Cross of King Ferdinand I of Castile

O God, who of Thy great love to this world, didst reconcile earth to heaven through Thine Only-Begotten Son; grant that we, who by the darkness of our sins are turned aside from brotherly love, may by Thy light shed forth in our souls Thine own sweetness and embrace our friends in Thee, forgiving our enemies, even as Thou, for Thy Son's sake, dost forgive us.

Mozarabic prayer.

Reverse of the 11th-century *marfil* Cross of King Ferdinand I of Castile, (1015-1065), Spain.

Photograph: Blaise Junod, courtesy of the Museo Arqueológico Nacional, Madrid, Spain.

Left: front of the 11th-century *marfil* Cross of King Ferdinand

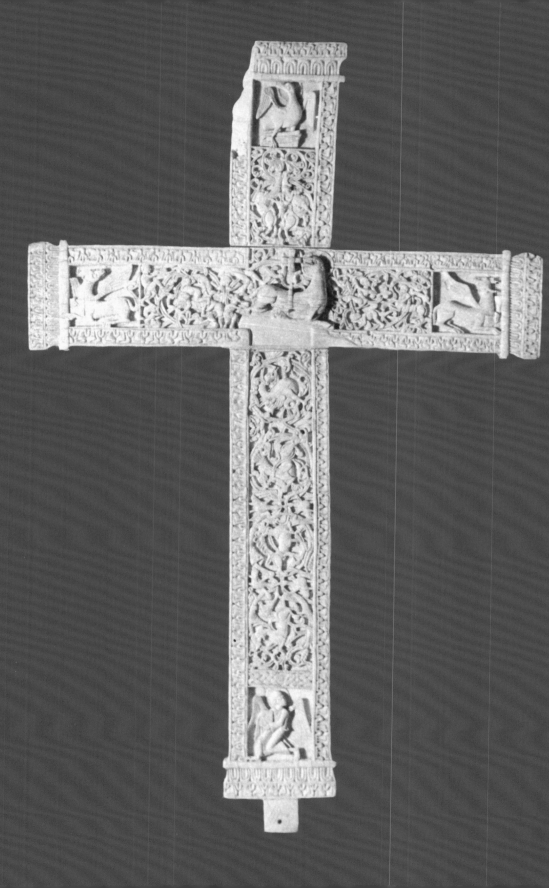

Cross in the Cloister

May God the Father who made us bless us.
May God the Son send his healing among us.
May God the Holy Spirit move within us and
give us eyes to see with, ears to hear with,
and hands that your work might be done.
May we walk and preach the word of God to all.
May the angel of peace watch over us and
lead us at last by God's grace to the Kingdom.
Amen.

Prayer of St Dominic,
c. 1170-1221

12th-century stone panel, the cloisters of the Benedictine Monastery of Santo Domingo de Silos (province of Burgos), Northern Spain.

The monks of Silos became internationally famous with the issue of several Gregorian chant Albums, most famously *Chant.*

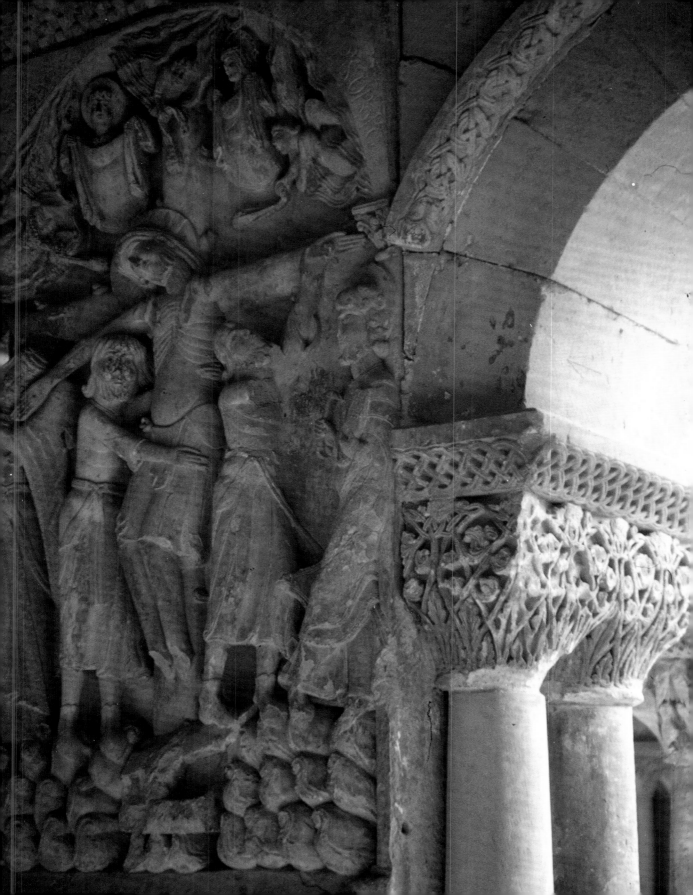

Cross of Santiago

To walk the Camino de Santiago, the Spanish pilgrimage route to Santiago de Compostela, is a walk that truly becomes a pilgrimage. The outer journey gradually leads to, and becomes, an inner journey too. The whole idea of making a pilgrimage is very powerful and one that seems to have captured people's minds in so many different times and places. Nor is the idea confined to Christianity: Moslems have continued to aim at journeying to Mecca at least once in a life time. In India I saw plenty of evidence of Hindus making the long pilgrimage often on foot to Varanasi (Benares) and other holy places of the Indus and Ganges rivers.

Nowadays pilgrimages are once again back in vogue. But why? Let me suggest three reasons. Firstly, people went on pilgrimage quite simply because there are such things as very special places; places of tangible prayer and service, where the veil between time and eternity, between the physical and the spiritual, between this world and the other, between humanity and God, is just that – very thin – almost transparent. They are places where you just are very close to God. Many of the great places of pilgrimages are just like that and people stop and catch their breath and say "*In this place people have prayed – you can feel it in the stones – truly God is in this place*" So pilgrimages then are journeys to "thin places" – places of encounter with God.

But it's not just the goal of the pilgrimage that is important, but the process – what actually happens on the way to these places matters as well. The first thing that seems to happen is learning. To travel on with a wide variety of different people from different places, with different experiences and different stories, but really united in a common goal will, if you will allow it, always be an education and a transformation in itself. It becomes a way of opening windows of fresh understanding on to others, on to oneself, and on to God.

Spending time with the same people, really getting to know them, sharing their joys and sorrows, really entering into their lives, and letting them into yours, begins to produce that precious thing called fellowship, something which goes beyond mere friendship – valuable as that may be – but becomes a deep sense of belonging to one another, with a real sense of mutual responsibility for one another's lives, and produces community, common participation in the Holy Spirit of God.

The Rt Rev'd Michael Langrish, Bishop of Exeter,
1946-

Wayside cairn, with an image and the *Cross of Santiago*, on the Pilgrim route to Santiago de Compostela, the Roncesvalles Pass, Spain.

Cross on the Daily Bread

Take this bread that we have broken
Multiply it for the world,
Many loaves for many millions,
Hungering on the edge of life.

Suffering souls to life awoken,
By the Bread of Life you give,
Bodies strengthened by your bounty,
Given by a human friend.

May the words that you have spoken,
Guide our lives to servant love,
And the wine that you distribute
Be our lifeblood every day.

Roy Calvocoressi,
1930-2012

Huge loaf of bread, baked for a family and embellished with a giant cross, Santiago de Compostela, Spain.

Cross on the Douro

O ye souls that desire to walk in the midst of consolation and security, if only ye knew how acceptable to God is suffering for his love, and how great a means it is to arrive at every other spiritual good, ye would never seek for consolation in anything, but you would rather rejoice when ye bear the cross after your Lord.

I wish I could persuade spiritual persons that the way to perfection does not consist in so many different practices; nor in thinking much; but in denying ourselves on every occasion, and in giving ourselves up to suffer all things for the love of Christ; if they fail in the performance of this exercise, every other method of walking in the spiritual life is but standing still and mere trifling, without any profit, even though they had the gift of the venerable bishop Palafox exercised himself much in this blessed meditation. In spirit he represented his soul like unto a bird flying on its course through the air, and stopping, when weary, to perch on the nail of our Lord's feet on the cross: here he gave himself to contemplate our Lord, and spiritually to drink his precious blood as it flowed from those wounds, and very great was the consolation of his heart. At other times he likened himself unto a bee gathering honey, first from one flower, then from another, of the wounds of Christ, those true and blood-red passion-flowers, but specially that sweetest and fairest of them all, the wound of his blessed side, opening to the treasure of treasures, the heart of Jesus, that most secret dwelling of the elect.

Venerable Bishop Juan de Palafox y Mendoza,
1600-1659

Port barge of the Santa Cruz *finca,* the Douro, Oporto, Portugal.

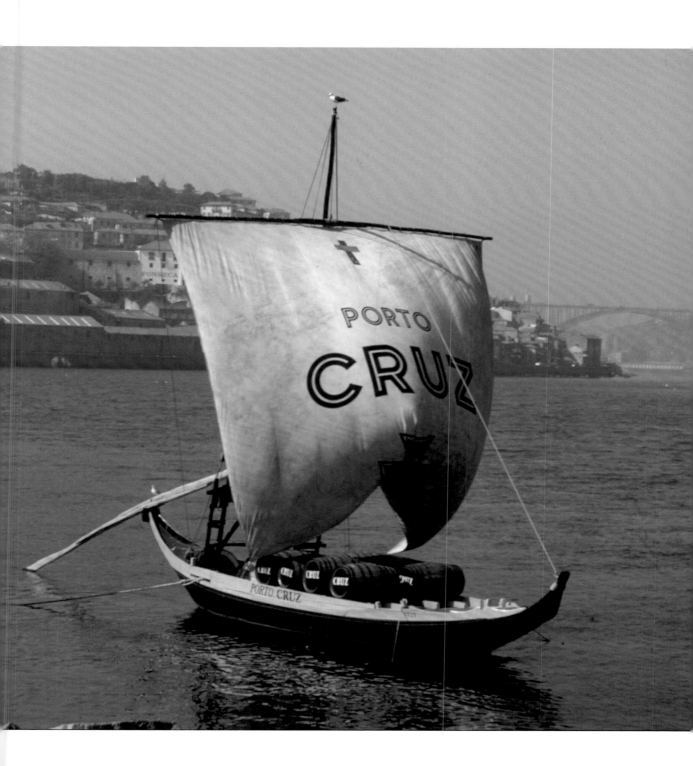

Celtic and Pictish Lands:

Ireland
Scotland

Catholic and Protestant Lands:

England
Wales
Norway

Cross in Britannia

3rd-4th-century large multi-coloured stone *tessere* floor designed for a Roman villa, Hinton St Mary, Dorset.

Photograph: courtesy of the Trustees of the British Museum.

This is the earliest example of the *Chi-Rho* motif to be found in England.

279

Ahenny Cross

I arise today through the strength of Christ in his incarnation,
The strength of Christ in his baptism and his death on the Cross for my salvation;
His bursting from the burial tomb, his riding up the heavenly way;
Through the strength of his descent to the dead and his coming at the day of doom.
I arise today through God's strength to pilot me;
His might to uphold me, his wisdom to guide me, his ear to listen to my need;
God's shield to protect me, his host to secure me alone or in a crowd.

Canticle of St Patrick,
c 387-461

St Patrick's Breastplate, attributed to the Saint during his ministry in the 5th century; was probably written in the 8th century.

10th-century High Cross of Ecritures, Clonmacnoise, County Offaly, Ireland.
Photograph: Blaise Junod

Late 8th to early 10th-century Celtic High Cross at Ahenny, County Cork, Ireland.

Probably the earliest group of ringed high crosses in Ireland, the Ossory group includes this fine 8th-century high cross in the graveyard of the monastic site of Kilclispeen, at Ahenny in Kilkenny. It imitates the earlier wooden crosses which were encased with a metal binding and the stone bosses imitate the studs which would have covered the rivets that held the metal and wooden crosses together. This Ahenny cross is skillfully carved with intricate geometrical, spiral and reticulated Celtic designs. The cross within the ring has been regarded as a sacred symbol of the sun since pre-Christian times and the Celtic Druids worshipped both the sun and the moon. The circle represents the moon, and the cross the sun. The circle signifies infinity...with no beginning and no end, while the cross extends in four directions and has a distinctive centre point.

When Christian monks began carrying out their mission in Ireland, crosses were frequently carved out of stone and intricately embellished with knot-work and artistic depictions of the Gospels. Sometimes these crosses were called "Scripture Crosses". Celtic crosses are the definitive emblems of the unique evolution of the faith of the Irish people and symbolize the revolutionary union of Druid and Christian beliefs.

Celtic Crosses are a symbolic union of two powerful emblems, the cross and the circle, and they represent many profound and sacred truths: the balance and harmony between male and female; the four corners of the earth from one source; the eternal cycle of the four seasons and the eternal connection of all things in the Heavens and the Earth.

Cross on a Bell Shrine

The pilgrim through life's journey needs light for guidance along the road that leads to our true and final home. That pilgrim is you, and that pilgrim is me, often confused and often wounded.

Holiness involves friendship with God.

The movement towards the realisation of God's love for us is similar to our relationship with other people.

There comes a moment, which we can never quite locate or catch, when an acquaintance becomes a friend.

In a sense, the change from one to the other has been taking place over a period of time.

But there comes a point when we know we can trust the other, exchange confidences, keep each other's secrets. We are friends.

There has to be a moment like that in our relationship with God.

He ceases to be just a Sunday acquaintance and becomes a weekday friend.

His Eminence Cardinal Basil Hume OSB, OM,
Cardinal Archbishop of Westminster (1976-1999),
1923-1999

Copper gilt and rock crystal bell shrine of St Conall Cael, the Island of Inishkeel, Donegal, Ireland made in 1450-1500, inscribed: "Pilgrims' cures through drinking well from sacred bell".

Photograph: courtesy of the Trustees of the British Museum, London, England.

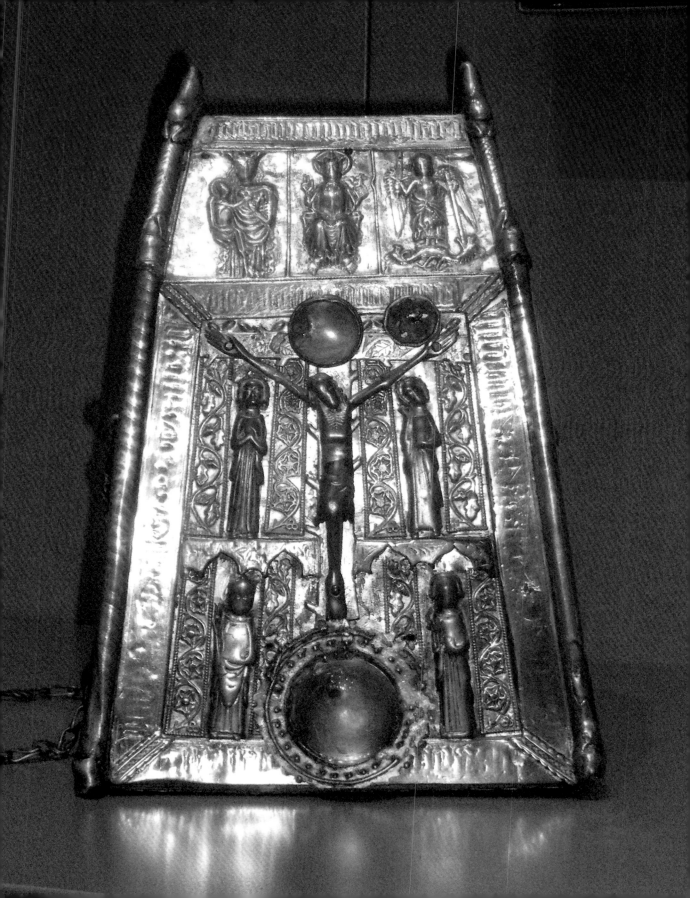

Dupplin Cross

In 600 BC, about 1500 years before Kenneth MacAlpine, (thought by many to have driven out the Vikings and become the first King of Scotland) erected the Dupplin Cross near Forteviot in Perthshire, the prophet Ezekiel in Babylon had a vision. He saw water coming out of the rebuilt Temple flowing ankle-deep, knee-deep, deeper and deeper until it became a river he could no longer pass through.

St John saw this vision fulfilled on the Cross of Christ when one of the soldiers pierced His side and out of His body – the new Temple – came blood and water. (St John 19:34). The blood covers the sins of the world, yours and mine. The water representing the Spirit (John 7:37-39) the giver of new life.

As we look again at this ancient piece of stone we reflect on the generations before us who have experienced this life and we echo in our hearts the prayer of the Venerable Bede (673-735) "I implore you, good Jesus that, as in your mercy you have given me to drink in with delight the words of your knowledge, so of your loving kindness you will also grant me one day to come to you, the fountain of all wisdom, and to stand for ever before your face."

The Rt Rev'd Sandy Millar, Assistant Bishop in London, 1939-

The Dupplin cross, dating from 800, marked the boundary set by the peace treaty between the Picts and the Scots, Dupplin, Perthshire, Scotland.

Photograph: Lord Forteviot.

Whilst being relatively common in Ireland and Northumbria, this is thought to be the earliest free-standing, stone cross in the lands of the Picts.

St Bede was born and lived his entire life in the north of England, yet he became perhaps the most learned scholar in all of Europe. He became a monk in the new monastery at Jarrow, in Scotland and remained there until his death. He lived a routine and outwardly uneventful life of prayer.

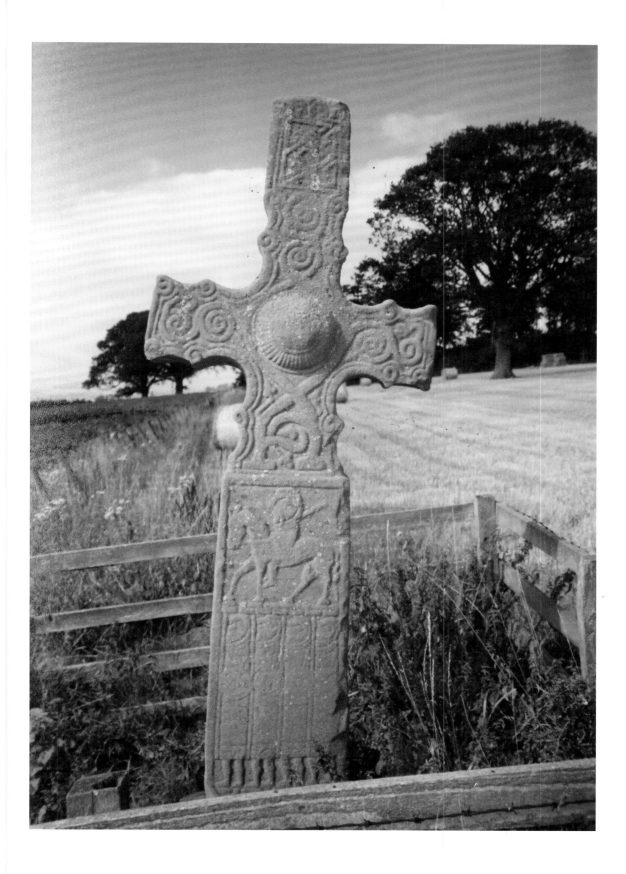

Pictish Cross

Kindle, O Lord, in our hearts,
we pray, the flame of love
which never ceases,
that it may burn in us and give light to others.
May we shine forever
in your temple,
set on fire
with that eternal light of yours
which puts flight to
the darkness of this world;
in the name of Jesus Christ,
your Son, our Lord.

Amen.

Prayer of St Columba,
Apostle of the Picts,
521-597

9th-century Pictish Stone, Glamis, Perthshire, Scotland.

It stands in the front garden of the former manse at Glamis. Scholars think the stone might still be in its original location in the churchyard of St Fergus church, Glamis, Scotland.

The Synod of Whitby was held in 664. Unlike the Orthodox portion of the early church, the decision of this Synod was to place northern England and its Celtic Christians prayer foundation under the authority of the Bishop of Rome. Thus ended the Celtic Church's historic independence and existence in England. The Celtic monks returned to the Celtic monastic communities on the island of Iona in Scotland, and Ireland.

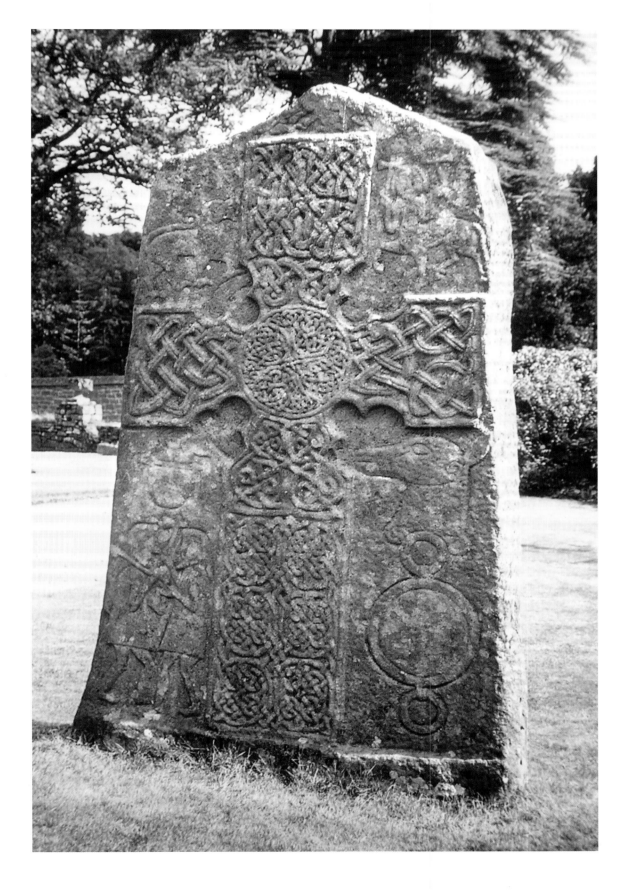

Ivory and Gold Cross

Let me share with thee His pain,
who for all my sins was slain,
who for me in torments died.
Let me mingle tears with thee,
mourning Him who mourned for me,
all the days that I may live:
By the Cross with thee to stay,
there with thee to weep and pray,
is all I ask of thee to give.
Virgin of all virgins blest!,
Listen to my fond request:
let me share thy grief divine;
Let me, to my latest breath,
in my body bear the death
of that dying Son of thine.
Wounded with His every wound,
steep my soul till it hath swooned,
in His very Blood away;
Be to me, O Virgin, nigh,
lest in flames I burn and die,
in His awful Judgment Day.
Christ, when Thou shalt call me hence,
by Thy Mother my defense,
by Thy Cross my victory;
While my body here decays,
may my soul Thy goodness praise,
Safe in Paradise with Thee.

Stabat Mater Dolorosa
13th century

Translation: Edward Caswall
Lyra Catholica 1849

12th-century gold filigree Cross with an ivory figure and enamel roundels.

Photograph: courtesy of the Trustees of the Victoria & Albert Museum, London, England.

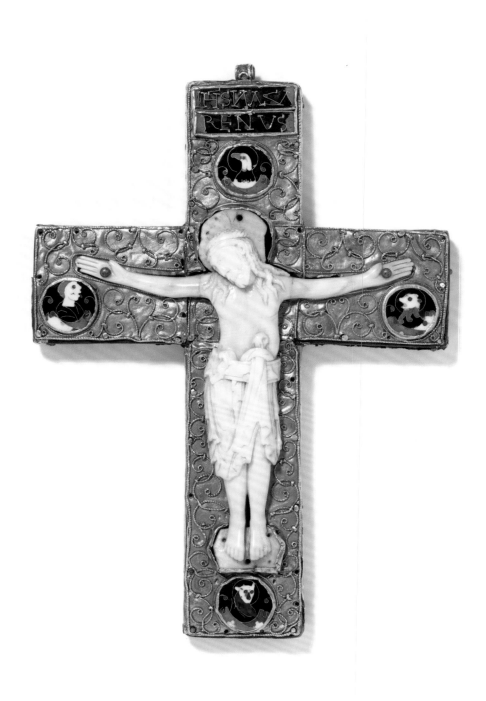

Cross on the Crown of an English Queen

O Lord Jesus,
for as much as thy life was despised by the world,
grant us so to imitate thee,
though the world despise,
and with thy image always before our eyes,
to learn that only the servants of the Cross
can find the way of blessedness and true light.
Hear us and save us,
Lord Christ.

Thomas à Kempis,
1380-1471

The Crown of an English queen – the "Bohemian" or "Palatine" crown made around 1370-80, of gold, enamel, sapphires, rubies, emeralds, diamonds and pearls, Munich Treasury.

Photograph: courtesy of the Residenz, Munich, Germany.

This is the oldest surviving crown of England. It is recorded in a list of jewels and plate drawn up in England in 1399 and probably belonged to King Edward III or Anne of Bohemia, the wife of King Richard II, who was deposed that year by Henry IV. Henry's daughter, Princess Blanche, married the Palatine Elector Ludwig III in 1402 and the crown passed to the Palatine Treasury in Heidelberg as part of her dowry. In 1782 it was transferred to the Munich Treasury along with other jewels belonging to the Palatine branch of the Wittelsbach family.

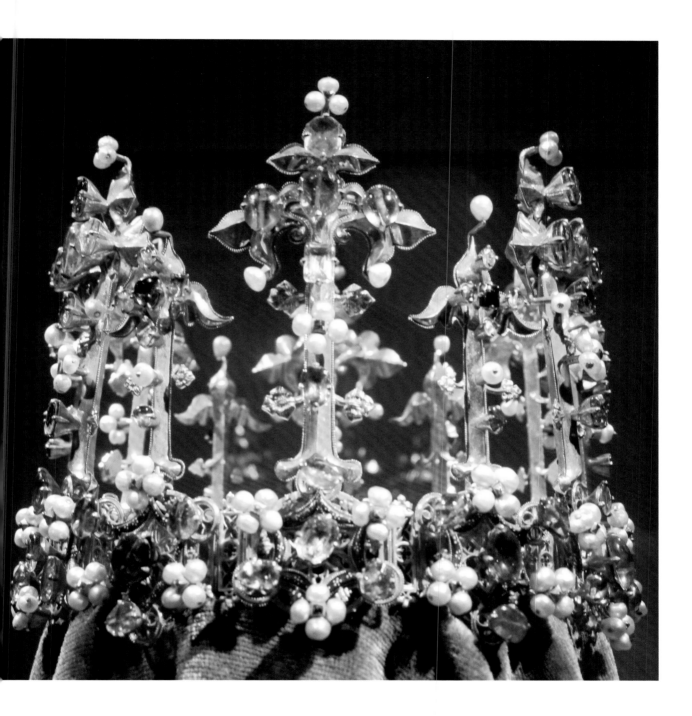

The Bury St Edmund's Cross

O Lord Jesus, forasmuch as thy life was despised by the world, grant us so to imitate thee, though the world despise, and with thy image always before our eyes, to learn that only the servants of the Cross can find the way of blessedness and true light. Hear us and save us, Lord Christ.

Thomas à Kempis,
1380-1471

The Bury St Edmund's Cross, 1160, made of whalebone in Bury St Edmund's for St Edmund's Abbey, Suffolk, England. Bought from a bank vault in Zurich for the Metropolitan Museum.

Photograph courtesy of the Cloisters Metropolitan Museum of Art, New York. USA.

Left: Reverse, showing the *Agnus Dei* and three of the four Evangelists.

Descent from the Cross

He reveals His cross to us and His earthly Passion so inevitably we suffer and struggle with him because of our weakness. He allows this to happen because in His goodness He wants to raise us all the higher with Him in bliss. In place of our slight suffering here, we shall know God supremely and for ever – and this would never have happened without that suffering. The greater our suffering with Him on the cross, the greater will be our glory with Him in His Kingdom.

We are now dying with Him on His Cross in His Pains and Passion… and we shall be with Him in Heaven. In place of the slight suffering we endure here we shall know God supremely and for ever – and this would never have happened without that suffering.

Then our Lord placed this cheering thought in my mind: "What point is there in your pain and grief now?" So I was totally happy. I understood our Lord to mean that we are now dying with Him on His cross, in His Pains and Passion. and that when we deliberately remain on that same cross, holding on to the very end, with His help and grace, then suddenly we shall see His expression change and we shall be with Him in Heaven. Without a moment's break we shall pass from one state to the other – and we shall all be brought into joy. That is why He said in this vision: "What point is there in your pain and grief now? And we shall be completely happy.

Mother Julian of Norwich,
c. 1342-1416

Walrus tusk depiction of the Descent from the Cross, carved in 1150, Hereford, England.

Photograph: courtesy of the Trustees of the Victoria & Albert Museum, London, England

Cross on a Chasuble

O my sweet Saviour Christ,
which in thine undeserved love
towards mankind so kindly wouldst
suffer the painful death of the cross,
suffer me not to be cold nor lukewarm
in love again towards thee.

St Thomas More,
In coldness of heart
1478-1535

Early 15th-century Erpingham Chasuble, showing the Crucifixion, Apostles and the Arms of Sir Thomas Erpingham. England.

Photograph courtesy of the Victoria and Albert Museum, London, England.

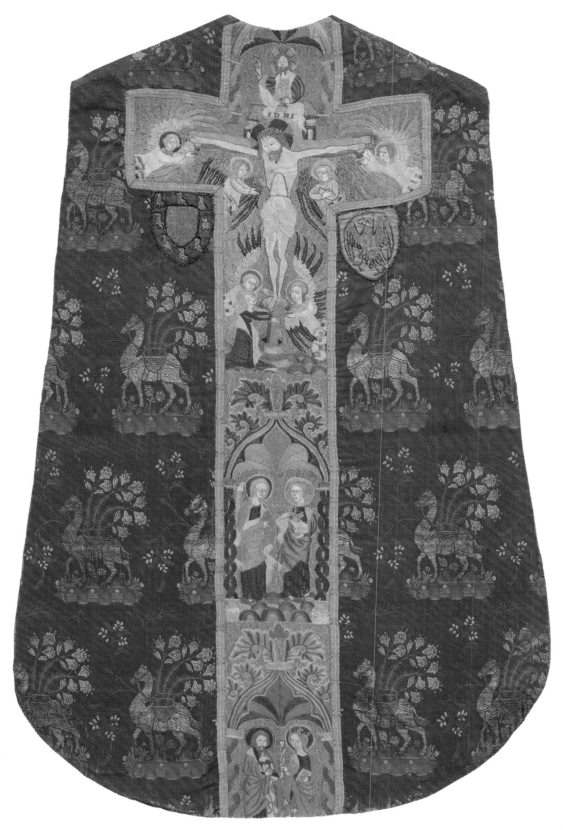

297

Cross of the *Agnus Dei*

The lamb plays a central part in the Passover story as a sacrificial victim, which ensures the survival of the Israelites as they attempt to escape their slavery in Egypt. And so this title identifies Jesus as a victim whose own death brings salvation. There is also another ancient tradition, picked up in the Book of Revelation, of a victorious lamb who will destroy evil. These two traditions blend together to give us Jesus as the Lamb of God, both Victim and Victor.

The title has been so popular that it is widely used in Christian prayers and the *Agnus Dei* is regularly said or sung when the communion bread is broken.

In Christian iconography, as here, the Lamb characteristically carries a flag with a cross, which has given us the popular inn sign of the Lamb and Flag.

The Very Rev'd Derek Watson,
Dean, Salisbury Cathedral (1996-2002)
1938-

16th-century fragment of a woollen tapestry, Winchester College Chapel, Hampshire, England.

Photograph courtesy of the Warden and Scholars of Winchester College.

The fragments of tapestry in Winchester College Chapel are known as the Roses tapestry. It is thought they were originally part of a much larger piece and the suggestion is that it was made to mark the christening of Prince Arthur (son of Henry VII) in Winchester Cathedral on 19 September 1486 (he was born in Winchester on 15 September). Prince Arthur adopted the arms shown in the tapestry. The two large panels include the monogram IHS, roses, and shield showing the imaginary arms of King Belinus, legendary King of Britain and from whom Henry VII claimed descent. There are two further fragments, one with another IHS monogram and the other showing this Pascal lamb. There is no certainty as to why or when the College acquired the tapestries. The accounts record a number of pieces purchased in 1575 from Warden Thomas Stempe, but there is nothing to show which tapestries this entry relates to. The chapel certainly had all the pieces by 1619.

299

Cross on a Rood Screen

What if the present were the world's last night?
Mark in my heart, O Soul, where thou dost dwell,
The picture of Christ crucified, and tell
Whether that countenance can thee affright.
Tears in his eyes quench the amazing light,
Blood fills his frowns, which from his pierced head fell.
And can that tongue adjudge thee unto hell
Which pray'd forgiveness for his foes' fierce spite?
No, no; but as in my idolatry
I said to all my profane mistresses,
'Beauty, of pity, foulness only is
A sign of rigour', so I say to thee:
To wicked spirits are horrid shapes assign'd,
This beauteous form assures a piteous mind.

John Donne,
The Dream of the Rood
1572-1631

15th-century painted rood screen showing Jesus on the Cross with the Virgin Mary
and St John, parish church of St Nicholas, Monmouth, Wales.

Cross on a Tabard

He who would valiant be 'gainst all disaster,
Let him in constancy follow the Master
There's no discouragement shall make him once relent
His first avowed intent to be a pilgrim.

Who so beset him round with dismal stories
Do but themselves confound – his strength the more is.
No foes shall stay his might; though he with giants fight,
He will make good his right to be a pilgrim.

Since, Lord, Thou dost defend us with Thy Spirit,
We know we at the end, shall life inherit.
Then fancies flee away! I'll fear not what men say,
I'll labour night and day to be a pilgrim.

John Bunyan,
1628-1688

Heraldic Tabard of the Herbert family which hangs above a Herbert tomb in St Nicholas Church, Monmouth, Wales. The funeral helmet carries the crest of a Wyvern.

They date from before the Herberts became Earls of Pembroke (the first Earl died in 1469). As well as Herbert and Montagu coats of arms, it includes several Armigerous ones: if a girl of noble birth has no brothers and marries, she is called a heraldic heiress and her husband takes all her quarterings. Families simply added quarterings to their coats of arms until the family became extinct. "Family identification" was practiced in northern Europe even before the Norman Conquest, and all heraldry in England is the derivation of the heraldic devices brought by the families who accompanied William the Conqueror. English Nobles assumed "arms" from 1066; only very great nobles began using heraldry after the early council of Bologne. The oldest documented example of a coat of arms borne on a shield is the one King Henry I of England is said to have bestowed on his son-in-law, Geoffrey Plantagenet, Count of Anjou, in 1127: the azure shield bore four gold lions rampant. Regardless of their origins, coats of arms became military status symbols, and their popularity increased

RARA EST IN NOBILITATE SENECTUS

Cross on a Matrix

Fight this day the battle of the Lord, together with the holy angels,
as already thou hast fought the leader of the proud angels,
Lucifer, and his apostate host, who were powerless to resist.

Meditating upon this image of St Michael, Archangel, we are confronted by a model of martial prowess. While the Word became flesh in Christ Jesus to "empty himself, taking the form of a servant", allowing Himself to be sacrificed for us "like a lamb lead to the slaughter", this image also reminds us that Christ is a king. God is sovereign in all and lord of all creatures. As such, we are called to fight spiritually for our King, for goodness and justice in the world.

While the image of St Michael as a medieval warrior may seem far removed from our contemporary world, let it inspire us to meditate upon the fact that Our Lord will not abandon us if we are fighting against evil. Our Lord has told us that in His kingdom those who "hunger and thirst for righteousness" are amongst the blessed. We can rely on His help. But this fight must always start within ourselves. Let us look first to our own lives. Let us purify ourselves first. Then our light will "shine before men" so that, at length, we may gain a place beside St Michael in the heavenly court.

Christian de Lisle, seminarian at Allen Hall Seminary, London,
1988-

Medieval monastery matrix of an Abbot, Private collection, England.

Matrixes were used to impress designs into the wax seals that authenticated medieval documents. This is an Abbot's matrix of cast bronze made for an English Monastery in 1400 and used to seal the monastery's official documents. Counterseals provided an additional means of authenticating documents as they were impressed into the otherwise plain reverse of an institution's normal wax seal. Here the Archangel Michael carries a shield, and a lance with a cross on the top with which he is slaying the dragon at his feet, representing Evil. Around the outer edge, the inscription reads "The power of Michael will destroy your evil dragon." St Michael subsequently came to represent the triumph of light over darkness as interpreted by the Christian church, in the teachings of which he was to embody the triumph of Christ over Antichrist. This conception has its roots in the Revelation of St John (12:7-9) *"And there was war in heaven: Michael and his angels fought against the dragon….And the great dragon was cast out, that old serpent, called the Devil, and Satan, which deceiveth the whole world."*

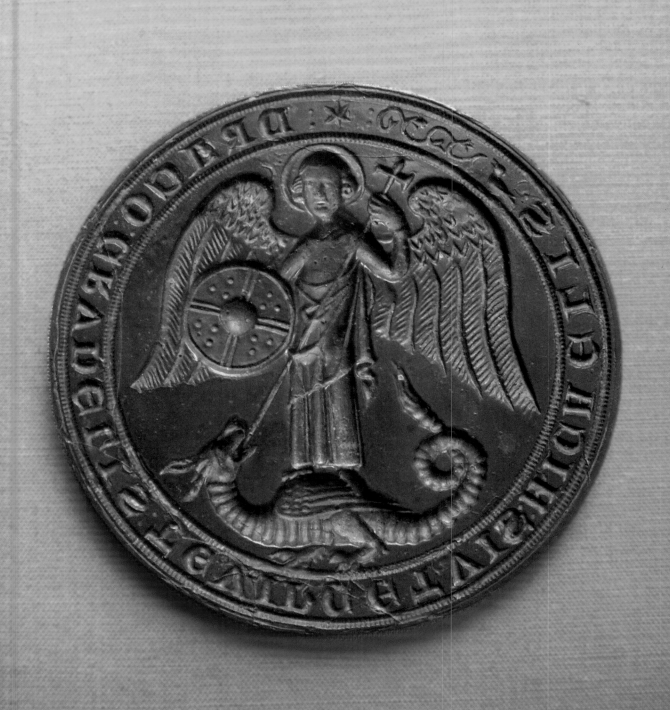

Queen Eleanor's Cross

Thanks be to thee, Lord Jesus Christ,
for all the benefits thou has given me,
for all the pains and insults thou has borne for me.
O most merciful Redeemer, Friend, and Brother,
may I know thee more clearly,
may I love thee more dearly,
may I follow thee more nearly.

Amen.

St Richard of Chichester,
1197-1253

Eleanor Cross, Geddington, Northamptonshire, England.

In 1290 Eleanor of Castile (1241-1290), the beloved wife of Edward I and mother of his 14 children, died at Harby in Nottinghamshire. Twelve stone monuments were erected between 1291 and 1294 in her memory, marking the route of her body, escorted by the King, as it was taken to London for burial in Westminster Cathedral. During the twelve day journey they rested each night at the locations which were subsequently marked by these monuments, with a cross adorning the top. Only three crosses remain, of which this one at Geddington in Northamptonshire was erected to mark the third night of rest. The stately triangular Geddington cross, with its canopied statues surmounted by a slender hexagonal pinnacle, is the best-preserved of only three intact survivors. Other crosses stand at Hardingstone near Northampton, and Waltham Cross, Hertfordshire. Charing Cross in London is named after the final cross, but the original was destroyed and the actual site has been built over. A replica monument stands in front of the station and the underground station is adorned with images of the story.

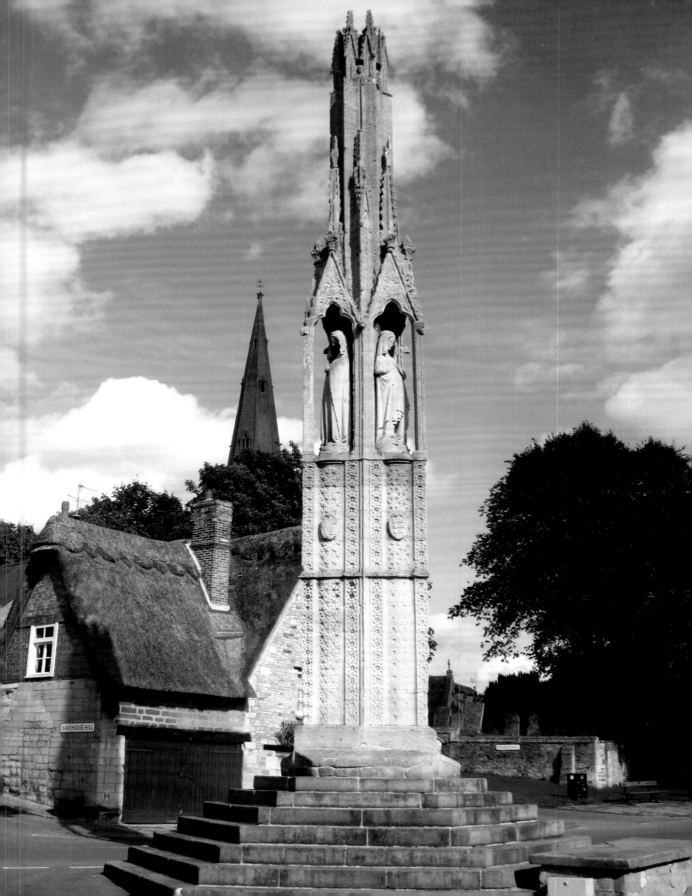

The Victoria Cross

Let it not be in vain that they risked all for the cause of righteousness and honour;
And in Thy mercy send Thy peace into the hearts of all people everywhere;
Through Jesus Christ our Lord.
Amen.

It is ordained that the Victoria Cross shall be awarded for most conspicuous bravery or some daring or pre-eminent act of valour or self-sacrifice or extreme devotion to duty in the face of the enemy. Their names and their heroism live for evermore. Ordinary men and women, unaware of their bravery and careless of their own safety, showed extraordinary courage in the face of the enemy. In life and death they prove that man can rise above preoccupation with the self, that we can disregard self in favour of our neighbour, and that altruism, disinterested practical concern for others, is truly possible.

Case of medals including the Indian Mutiny Victory Cross, Spinks, London.

The important Indian Mutiny Victoria Cross, (*top left in the case*) made from French Cannons, captured at Waterloo in 1815, is one of a group of six, given to General Sir Charles John Stanley Gough VC, GCB 1832-1912, late Bengal Cavalry, Corps of Guides Cavalry, and Hodson's Horse, in recognition of four separate acts of gallantry, one of the three famous Gough family Victoria Crosses. The Gough family provided one of the only four instances of two brothers winning the Victoria Cross and one of three instances of the award having be bestowed upon father and son. As a family with three Victoria Crosses they are unique: Major C J S Gough, Lieutenant H H Gough, both for the Indian Mutiny, and Captain Brevet Major J E Gough (son of C J S Gough), for Somaliland 1903.

Photograph: courtesy of Spinks, London.

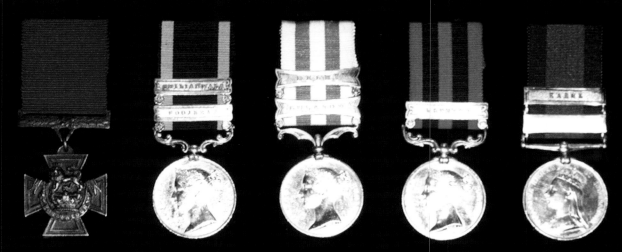
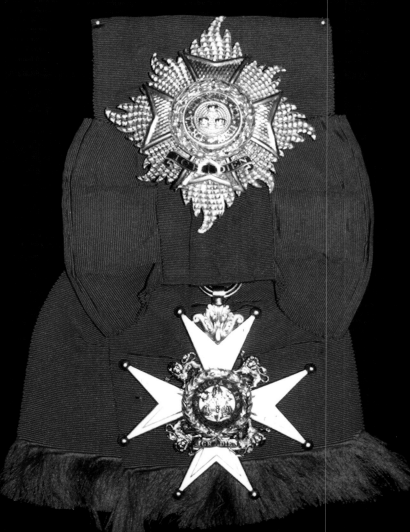

MEDALS AND DECORATIONS
OF
GEN. SIR CHARLES GOUGH V.C. G.C.B

Patchwork Cross

What is this strange and uncouth thing,
To make me sigh, and seek, and faint, and die
Until I had some place where I might sing
And serve Thee; and not only I,
But all my wealth and familie might combine
To set Thy honour up as our designe?

And then, when, after much delay,
Much wrestling, many a combate, this deare end,
So much desir'd, is giv'n; to take away
My power to serve Thee; to unbend
All my abilities, my designes confound,
And lay my threatnings bleeding on the ground.

One ague dwelleth in my bones,
Another in my soul, – the memorie
What I would do for Thee, if once my grones
Could be allow'd for harmonie;-
I am in all a weak disabled thing,
Save in the sight thereof, where strength doth sting.

Besides, things sort not to my will
Ev'n when my will doth studie Thy renown:
Thou turnest th'edge of all things on me still,
Taking me up to throw me down;
So that, ev'n when my hopes seem to be sped,
I am to grief alive, to them as dead.

Ah, my deare Father, ease my smart!
These contrarieties crush me; these crosse actions
Doe winde a rope about, and cut my heart;
And yet since these Thy contradictions
Are properly a crosse felt by Thy Sonne
With but foure words, my words, 'Thy will be done!'

George Herbert,
The Crosse
1593-1633

English patchwork quilt, c.1708, Levens Hall, Cumbria, England.
Photograph: Justin Hunt

Cross on a Stained Glass Window

Domine, Jesu Christe,
qui me creasti, redemisti,
et preordinasti ad hoc quod sum;
tu scis quæ de me facere vis;
fac de me secundum voluntatem tuam cum misericordia.
Amen.

O Lord Jesus Christ,
who hast created and redeemed me
and hast foreordained me unto that which now I am;
thou knowest what thou wouldst do with me;
do with me according to thy will, in thy mercy.
Amen.

King Henry VI,
1421-1471
Founder's Prayer of 1440

Stained glass East window, Evie Hone (1949-1952), Eton College Chapel, Windsor, Berkshire, England.

Photograph: Roddy Fisher.

Eton College was founded in 1440 by King Henry VI as "The King's College of Our Lady of Eton besides Wyndsor". Never completed due to the Wars of the Roses, the Chapel built in the late Gothic or Perpendicular style, should have been a little over double its current length.

Left: Stained glass memorial window to an Old Etonian.

Cross of Nails

Still falls the Rain –
Dark as the world of man, black as our loss –
Blind as the nineteen hundred and forty nails
Upon the Cross.
Still falls the Rain
With a sound like the pulse of the heart that is changed to the hammer-beat
In the Potter's Field, and the sound of the impious feet
On the Tomb: Still falls the Rain
In the Field of Blood where the small hopes breed and the human brain
Nurtures its greed, that worm with the brow of Cain.
Still falls the Rain
At the feet of the Starved Man hung upon the Cross.
Christ that each day, each night, nails there, have mercy on us –
On Dives and on Lazarus:
Under the Rain the sore and the gold are as one.
Still falls the Rain –
Still falls the Blood from the Starved Man's wounded Side:
He bears in His Heart all wounds, – those of the light that died,
The last faint spark
In the self-murdered heart, the wounds of the sad un-comprehending dark,
The wounds of the baited bear, –
The blind and weeping bear whom the keepers beat
On his helpless flesh … the tears of the hunted hare.
Still falls the Rain –
Then – O I'll leap up to my God: who pulls me down –
See, see where Christ's blood streams in the firmament:
It flows from the Brow we nailed upon the tree
Deep to the dying, to the thirsting heart
That holds the fires of the world, – dark-smirched with pain
As Caesar's laurel crown.
Then sounds the voice of One who like the heart of man
Was once a child who among beasts has lain –
"Still do I love, still shed my innocent light, my Blood, for thee."

Dame Edith Sitwell,
Still Falls the Rain
(*The Raids, 1940. Night and Dawn*)
1887-1964

Cross of Nails presented to Roy Calvocoressi of CHIPS (Christian International Peacemaking) on 9.9.1999 in recognition of his many years of Peacemaking work. The Cross of Nails was created after Coventry Cathedral was bombed during the "Coventry Blitz" of World War II" . The cathedral stonemason, Jock Forbes, saw two wooden beams lying in the shape of a cross and tied them together. Another cross was made of three nails from the roof truss of the old cathedral by Provost Richard Howard of Coventry Cathedral. It was later transferred to the new cathedral, where it rests on the altar. The cross of nails has become a symbol of peace and reconciliation across the world. There are over 160 Cross of Nails Centres all over the world, all of them bearing a cross made of three nails from the ruins, similar to the original one.

Student's Terracotta Cross

The artist presents the Father as a God of energy, holding with some firmness, the cross on which his Son hangs. The Holy Spirit appears from the side as if to affirm the truth of what has happened.

All of us live with the possibility of sudden death, death in war, death by accident, death by natural disaster, death by sudden organ failure. For many it provokes the question "Why me, Why now?" It faces us with that fundamental question, "who 'owns' my life?" Sudden death offers us a choice of answers: either God or chance.

The question is posed in this presentation. Life comes from the Father, the Holy Spirit is the "communicator", while the crucified Son lies silent, at peace. In the image of the dead Son is contained the "sudden deaths" of all who we know and the many millions of others who have died suddenly.

We are comforted seeing behind the dead Son the life of the Father-Creator, constantly giving life as if there was no real death and communicated to us through the Holy Spirit-who-is-Energy.

As we look we are being invited to put our loved ones who died suddenly before the image of the dead Jesus. For God there is no sudden death, in God there is no sudden death and with God death is but a moment before life.

So for us who grieve and pray for those who have died suddenly, there is comfort in this. By looking at the dead Christ we give resurrection its true dimensions.

It is also a moment for us to pray that our own death, at the moment God has chosen, does not catch us unprepared. Each day we take a step to this inevitable moment, each day we pray that our longing for it grows ever stronger. Looking at 'Guthrie' we can say: "if God the Father is the author of all life, then we can pray that we will be held as firmly in His arms as he held Jesus when he died."

Abbot Timothy Wright OSB,
Abbot of Ampleforth (1997-2005)
1942-

Large modern terracotta plaque of the Holy Trinity, A-level art school project by Andrew Guthrie, Ampleforth College, Yorkshire, England.

It belongs to his parents, Lord & Lady Guthrie of Craigiebank.

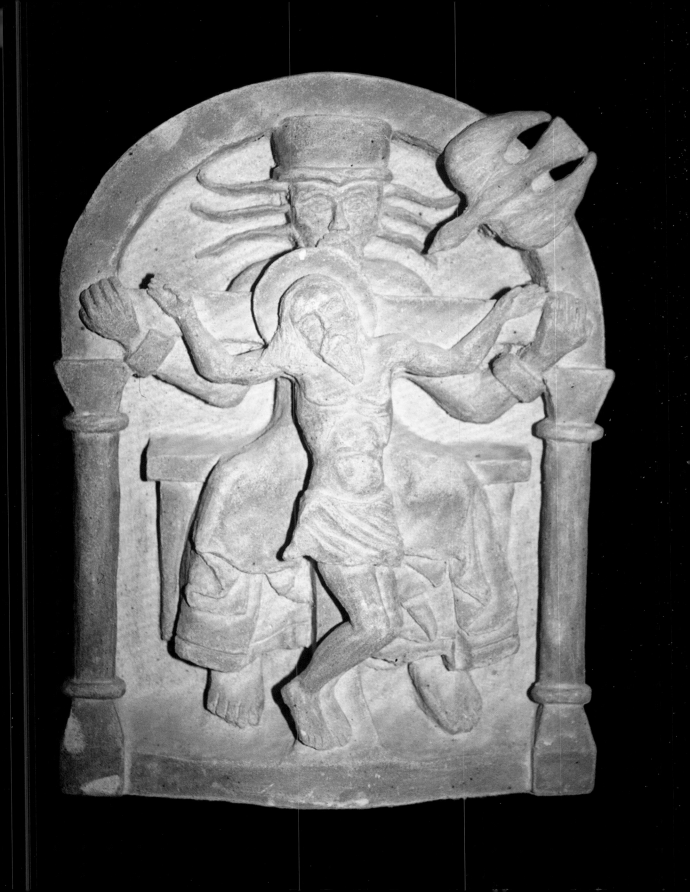

Cross of the Astronauts

This processional cross, representing both the Old and the New Testaments, is dedicated to the Astronauts and all those who worked with them, for the world's first landing on the moon. The vision of this cross was the last of the eight dreams experienced by the artist, in June 1959, in Florence, Italy.

The enamel jewel of Christ Emmanuel is set in gold with pearls, diamonds and a ruby for the lamb's eye. It was found in 1962 in the "Jewel Box", Mount Street, London. The cross was completed in 1968 and was exhibited by The Somerset Guild of Craftsmen in Taunton County Hall, Somerset. It was not until 13th November, 1994, that the artist received from Dr Michael Dennis, USA, shavings from a bolt from the landing pod of the lunar module. These shavings were to be placed in the representation of the moon at the base of the staff of the cross.

In 1999, Mrs Polly Guth, USA, introduced her friend Judith, Lady Ogden, to the artist. Lady Ogden generously offered to try and procure a piece of moon rock for this base and it was her friend, Dr Robin Butt of NASA, who provided some lunar dust on 6th May, 2000. This was to be placed in the base of the cross, as a symbol of the moon. An orb with two crosses joined together and wrapped around it, illustrating the word of God going around the moon.

Buzz Aldrin celebrated the Eucharist and read a message from his Bible to the world from the beginning of book of Genesis.

On the front of the cross are the words, *I can of myself do nothing*.

The entire surface of the cross is covered with swirls representing the words of St John 3:8, describing the Holy Spirit. On the reverse side of the cross are the words from St Matthew 6:8, *Thy Will be Done*.

David H Maude-Roxby-Montalto, Duke of Fragnito, the diamond-point, stipple engraver of glass, 1934-

Modern processional cross made by David Maude-Roxby-Montalto in conjunction with Plowden & Smith, London.
Photograph Plowden & Smith.

Far left: Jewel of Christ Emmanuel in the centre of the cross.

Left: Wooden base of the cross, containing a piece of moon rock.

Cross on the Stave Church

Dear Lord it was in wood you wrought
Your boyhood's dream to joist and beam,
Creator's thought expressed in joy.
On wooden board were wine outpoured and bread broken:
"Body and blood" – life-words spoken –
"Remember me". Surely all wood must holy be?

Dear Lord it was on wood you died.
Your blood was shed and where you bled
Mercy's tide was in full flood;
On the true Cross our greatest loss was turned to gain;
Love soaked into the crimson grain.
From that one tree all wood will ever holy be.

A thousand years elapse, elide;
Then Viking axe – vobiscum pax –
Struck, and died a thousand trees;
Sharp Viking sword trimmed trunk and board to build this kirk;
War tools wielded in peace-blessed work
Wrought holy wood. A Cross within, for peace it stood.

A Cross within, Crosses outside
For peace it stands – yet, made with hands,
It can't abide; it needs must cease.
Grown within its wooden skin a kirk, soul-built
– Norway's folk, Cross-purged of guilt –
Will take its place. Thank God His trees so serve His grace.

Rodney Elton,
Stavkirken
1930-

St Olav's stave church, dedicated to the Apostle St Andrew, built around 1180 and
restored in 1870-1880, Lillehammer district, Borgund Mountains, Norway.

Norway's most outstanding contribution to architecture is the Stave Church.
Christianity was introduced here around the year 1000 and from then onwards,
during the Middle Ages and until 1537, about 1000 stave churches were built.
Christianity in Norway began in Trondheim: St Olav was buried there in about 1200.
All Stave churches in Norway are now Protestant. St Olav's medieval Stave Church
is a Gol replica. In 1851 a law demanded that all churches should have room for three
tenths of the congregation, so during the next 30 years, half of all the remaining
churches were torn down. After 1885, only 27 remained.

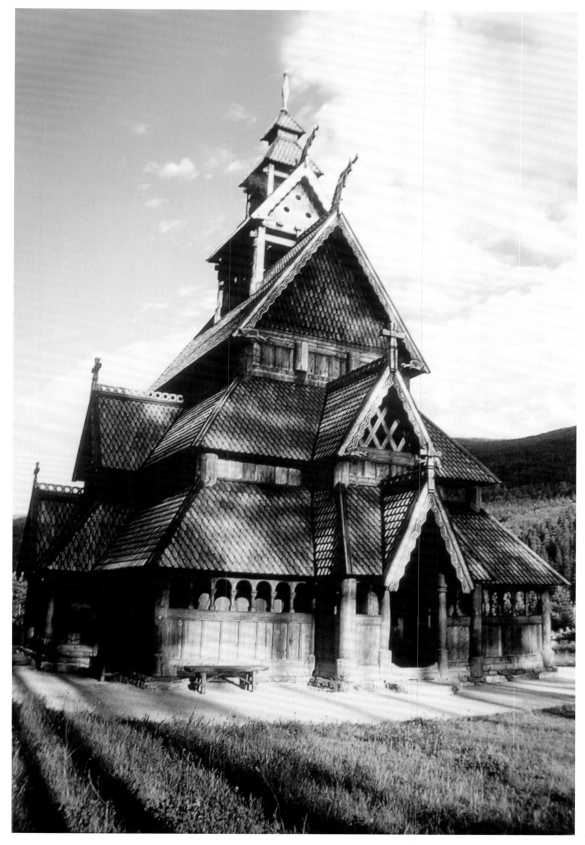

Cross of the *Vierge Ouvrante*

The silent, suffering, interior martyrdom of Mary, in union with her Son, throughout his hidden years and public ministry through to his Passion Death and Resurrection, is the fertile soil which enables her to stand with Jesus at Calvary. It is also the precursor of the Motherhood of Mary of all people bestowed upon her by Jesus himself at the foot of the Cross.

When Jesus saw his mother and the disciple there whom he loved, he said to his mother, *Woman, behold, your Son*. Then he said to the disciple, *Behold your Mother*. And from that hour he took her into his home. John 19:22-27

Jesus entrusted all the people of the World to his Mother in his dying breath. Jesus gave his virginal Mother to each one of us specifically and individually. Gift unsurpassed, sublime promise of mystic grace and divine intimacy. Mystery unfathomable, hope of relational healing and wholeness. Entrustment by Jesus to intimacy within the virginal womb, the same womb which nourished Him and hope for us to find solace deep within the heart of our beloved Sorrowful and Immaculate Mother. A place for us to find rest in singular moments of divine holding, and space for entrustment of our heart wounds, and the sorrows of the World, to Jesus through Mary.

O Sorrowful Mother, Handmaiden of the Lord, open and expand my heart as yours to Jesus, Son of God, Crucified Messiah, Risen Lord and Saviour of the World. Amen.

Antonia Moffat,
1961-

The *Vierge Ouvrante* is a sculpture of the Virgin Mary, which can be opened like a shrine, and shows basically one of three iconographical motifs. A *Vierge Ouvrante* may contain scenes of the Incarnation and Passion of Christ; another version (exclusively in Spain and Portugal) may show scenes of Mary's life. A third variant shows representations of the Trinity (God the Father sitting, holding the crucifix with the dove of the Holy Spirit hovering over both of them). Thus, the symbolism is to make visible the mysteries of our salvation. Mary in her role as *Theotokos* makes visible the salvific work of the second person of the Trinity, not to supersede or replace it, but to bring it to our attention.

The oldest extant shrine of the *Vierge Ouvrante* is Bourbon and dates from around 1200. This type of Statue of the Virgin originated in women's monasteries, and was inspired by medieval mysticism and Cistercian spirituality. It is believed that the Cantigas de Maria of Alphonso el Sabio in Spain influenced the creation of the *Vierge Ouvrante*. Other sources of influence were mysticism from the Rheinland (spousal mysticism), St Bridget of Sweden's visions, Dorothea of Montau, and not least the influence of the Teutonic Knights and their Marian devotion. This type of statue almost disappeared during the post-Reformation period with the exception of some nineteenth century copies of the Bourbon shrine Madonna. The statue was originally in the nearby church of Yvon and (which became Protestant) but was taken to Cheyre (which remained Catholic) at the time of the Reformation. It was stolen from Cheyre in 1978 and a copy was made shortly after that.

Photograph: Blaise Junod, taken before the theft.

Notre Dame de Grace

Cross of the Reformation

We move from Geneva, and all that it represents, to Jerusalem. There the destiny of humankind was played out, and our minds turn to Jerusalem now as we observe Pentecost in May 1986.

The story of Pentecost as related in the Book of Acts is a long and complex narrative, but I single out two elements: First, the initiative of God, the outpouring of the Holy Spirit: "And suddenly a sound came from heaven like the rush of a mighty wind, and it filled all the house where they were sitting."

Secondly, the reference to the words of the prophet, read and reread from generation to generation, and acknowledged as Holy Scripture: Peter, addressing the amazed and perplexed crowd, said, "This is what was spoken by the prophet Joel: I will pour out my Spirit, God declares, on all flesh, and your sons and your daughters shall prophesy." Acts 2:17.

Holy Spirit and Scripture. Not one or the other, but both. To evoke only the Spirit involves the risk of all sorts of disorder, of sowing seeds of unrest and of encouraging confusion. On the pretext of being inspired, people talk about themselves, take delight in themselves, listen only to themselves and are swept along by their own natural impulses – we know the bitter fruits of such behaviour!

But, to hold only to Scripture, the Bible, is to forget that the letter kills, stifles and oppresses. People become fossilized in outmoded formulae, imprisoned in a straitjacket of tradition. They thus become incapable of coping with new situations and take refuge in the past. They no longer live: they merely continue in existence!

The Reformation arose precisely out of the meeting of the Holy Spirit and Scripture. Through all its uncertainties, its difficulties, its weaknesses and its errors, the enduring genuine fruit of its presence in history depends on this combination of Spirit and Scripture.

The Reformation depends, on the one hand, on God, his inventive liberating Spirit, his creative and renewing action in his faithful purpose for humankind.

And, on the other hand, the Reformation depends on a distributed, studied, read and commented on Bible from century to century. Scripture is the source of the Church's message, of renewal, and a permanent reminder of God's activity, to which prophets and apostles bear witness. Scripture invites us to live free and obedient lives.

Geneva has experienced this meeting, this convergence. Geneva has no monopoly of it: before her, around her and after her, other places and other times have been and will be witnesses of this meeting of the Holy Spirit and the Bible.

Today Geneva celebrates the 450th anniversary of the Reformation with gratitude and rejoicing. We may not keep this event to ourselves, but must assess its results and pass them on.

What of today? We should not be ashamed of our past, not deny it in the name of some 'ecumenical terrorism'. We must be what we are, truly become what we are, and thus humbly and peaceably make our contribution to the One church.

The Reformation is not behind us: it is ahead of us. The Reformation is always to be achieved, or rather to experience ever afresh the fruit of the meeting of the Holy Spirit and Scripture.

Ecclesia reformata semper reformanda!
Amen.

Sermon marking the 450th anniversary of the Reformation in Geneva.
The Revd Professor Robert Martin-Achard, Geneva,
1919-1999

20th-century Cross by Gilbert Albert, jeweller, the courtyard of the Musée International de la Reform.

Photograph © Musée International de la Réforme (MIR), Geneva, Switzerland.

Cross on a Car Sticker

I have a Friend so precious, So very dear to me,
He loves me with such tender love, He loves me faithfully,
I could not live apart from Him, I love to feel Him nigh,
And so we dwell together, My Lord and I.

Sometimes I'm faint and weary, He knows that I am weak,
And as He bids me lean on Him, His help I gladly seek;
He leads me in the paths of light, Beneath a sunny sky,
And so we walk together, My Lord and I.

He knows how much I love him, he knows I love him well,
But with what love He loveth me, My tongue can never tell;
It is an everlasting love, In ever rich supply,
And so we love each other, My Lord and I.

He knows how I am longing, Some weary soul to win,
And so He bids me go and speak, The loving word for him;
He bids me tell His wondrous love, And why he came to die,
And so we work together, My Lord and I.

I have His yoke upon me, And easy 'tis to bear;
In the burden which He carries, I gladly take a share;
For then it is my happiness, To have Him always nigh-
We bear the yoke together, My Lord and I.

Hymn sung in the caves of France during the fierce persecution of the Huguenots.

Car sticker, Huguenot Cross, Geneva, Switzerland.

The word Huguenots was the name given to the Protestants in France in the 16th century, particularly by their enemies. The Huguenot Cross was probably designed in 1688, and combines a Maltese cross whose branches are connected by a circular decoration, which points to the crown of thorns of Christ crucified and also forms a heart between each branch – the symbol of the love that Jesus has for us and recalls his command *Love one another*… The dove represents the Holy Spirit, which descends on us from Heaven.

Cross in the Mountains

Serene, unmovable and far withdrawn
The mountains lean down to the vales below
Flushed with the transient radiance of dawn
Their summits girdled with eternal snow!

High peaks to me your secret give,
Lend me your strength that I may live!
Here mid the Alpine meadows near the pass
Deep silence broods throughout the long warm day

Save for the crickets chirping in the grass
And cow bells faintly ringing far away,
Sweet peace, to me your blessing give
Let me be still and I shall live.

Henry E Verey,
Levavi Oculos 1950
1877-1969

Granite Cross, Mont San Salvador, Lake Lugano, Switzerland.

Photograph: Blaise Junod.

Catholic Middle Europe:

Germany
Austria
Hungary
The Czech Republic
Poland
Lithuania

Cross of the Holy Roman Emperor

The Imperial Crown of the Holy Roman Empire. Late 10th century, (probably made during the reign of Otto I). West German, the Treasury of the Kunsthistorisches Museum, Vienna, Austria.

The crown is constructed from eight plates of 22 carat gold, and is set with 144 cabochon stones: sapphires, emeralds, and amethysts as well as more than one hundred pearls. The twelve largest gemstones on the front represent the twelve apostles. Four cloisonné Byzantine-style enamel plates show scenes from the Bible; three portray Old Testament kings and the fourth is of Jesus with two angels.

Photograph: courtesy of the Treasure of the Kunsthistorisches Museum.

Cross of St Wenceslas

But his deeds I think you know better than I could tell you; for, as is read in his Passion, no one doubts that, rising every night from his noble bed, with bare feet and only one chamberlain, he went around to God's churches and gave alms generously to widows, orphans, those in prison and afflicted by every difficulty, so much so that he was considered, not a prince, but the father of all the wretched.

Cosmas of Prague, (c. 1045-1125)
Writing about St Wenceslas in 1119

Painted linen reliquary box of St Agnes & St Clara, 1300-1330, the Cathedral Treasury, Regensburg, Germany.

The Chapel of St Wenceslas, St Vitus Cathedral, Prague Castle, Prague, the Czech Republic.

St Wenceslas I (907-935), Duke of Bohemian and Prince of the Premyslid dynasty was assassinated by his own brother. The Gothic chapel was built on the former Romanesque rotunda to house the relics of the saint between 1344 and 1364 by the Holy Roman Emperor, Charles IV's favourite architect, Peter Parler. The lower part of the walls is decorated with over 1300 semi-precious stones made in Bohemia; the joints between them are covered with gold. The saint's relics are in a case on the tombstone beneath the altar. Every coronation started when the King came to pray in this chapel. Night masses were said here whenever the Czech nation was in danger. Masses are still held here every year on 28th September, the feast day of St Wenceslas.

The Virgin Mary and St John at the Foot of the Cross

At the Cross her station keeping,
stood the mournful Mother weeping,
close to her Son to the last.
Through her heart, His sorrow sharing,
all His bitter anguish bearing,
now at length the sword has passed.
O how sad and sore distressed
was that Mother, highly blest,
of the sole-begotten One.
Christ above in torment hangs,
she beneath beholds the pangs
of her dying glorious Son.
Is there one who would not weep,
whelmed in miseries so deep,
Christ's dear Mother to behold?
Can the human heart refrain
from partaking in her pain,
in that Mother's pain untold?
For the sins of His own nation,
She saw Jesus wracked with torment,
All with scourges rent:
She beheld her tender Child,
Saw Him hang in desolation,
Till His spirit forth He sent.
O thou Mother! fount of love!
Touch my spirit from above,
make my heart with thine accord:
Make me feel as thou hast felt;
make my soul to glow and melt
with the love of Christ my Lord.
Holy Mother! pierce me through,
in my heart each wound renew
of my Savior crucified.

Stabat Mater Dolorosa
Attributed to Jacopone da Todi (1230-1306)

Life-size Gothic polychrome and wood scene of the Crucifixion in the *Dom* (Cathedral), Munich, Germany.

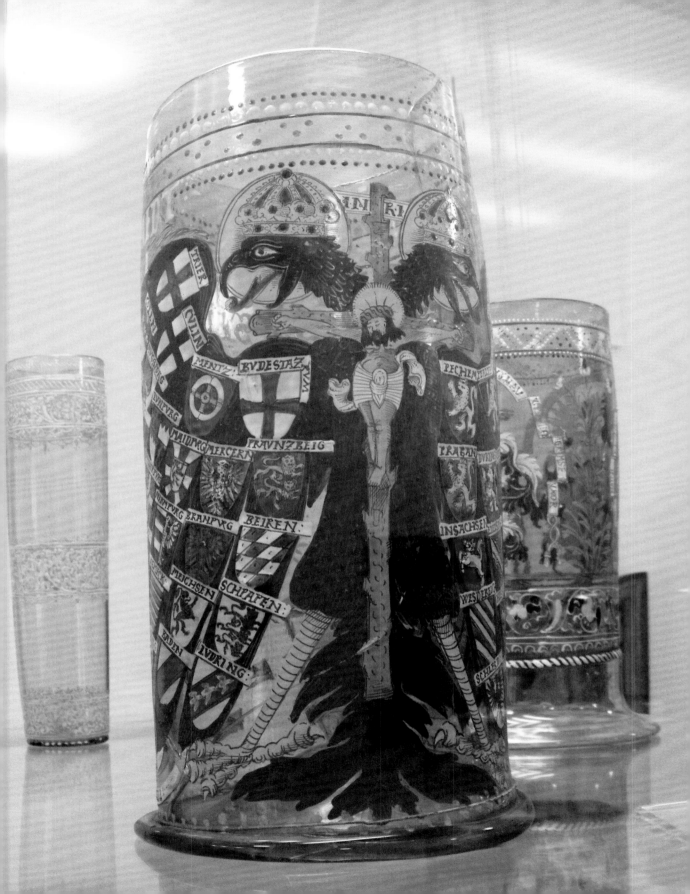

Cross at Calvary

When Jesus says the words, "It is finished" as He hangs on the cross; they are spoken towards the end of the account of the passion narrative. That account gives graphic descriptions of Jesus being humiliated as He is first dressed in a purple robe and crown of thorns and mocked; then later as He is stripped of His clothes and flogged. Then it gives the terrible description of Him being nailed to the cross and taunted and teased by passers by.

The gospel writers also tell us of the various words spoken by Jesus from the cross, showing that even in His extreme suffering He thinks of others. He asks God to forgive those driving in the nails because they don't know what they are doing and He assures the penitent thief that today he will be with Him in paradise. We can picture Jesus' agony, His mental and spiritual torture as well as His extreme physical pain.

As we contemplate those words, "It is finished" there is for us a feeling of "thank goodness His suffering is nearly over, soon He will be put out of his agony". But as St John records these words they have a much deeper significance than something being completed, ended or over. Throughout John's gospel there is reference to Jesus' glorification and to "His hour" There are a number of incidents recorded where Jesus gets into conflict with the Jews and there is a suggestion that they will seize and arrest Him; but they don't because "His hour has not yet come". But then there is a change of tempo and Jesus speaks the words: "The hour has come for the Son of Man to be glorified. Very truly I tell you, unless a grain of wheat falls into the earth and dies, it remains just a single grain; but if it dies, it bears much fruit."

Jesus is clear what His purpose is and that is to go to Jerusalem where He knows He will give up his life – but that will be the moment of His glory, giving up His life for the world He loves and has come to save. On the cross His work on earth reaches its climax – Jesus has fulfilled His Father's plan and resisted the temptation to avoid this cup of suffering. He has finished what was begun 30 years before, when through Mary, He came into the world as a helpless baby. But as Jesus eventually breathes His last breath and gives up His spirit, we might ask, is this the moment when his work is truly finished? In one sense it is – His sacrifice is complete – as the words of the Book of Common Prayer puts it, "who made there by His one oblation of Himself once offered a full, perfect, and sufficient sacrifice, oblation and satisfaction for the sins of the whole world".

The Venerable Dr Jane Hedges, Canon Steward and Archdeacon of Westminster, 1955-

Ivory relief, 1631. *Crucifixion*, Christoph Angermair (c. 1580-1633). Based on an engraving by Aegidius Sadeler II after Tintoretto's famous painting of the same subject in the Scuola Grande di San Rocco, Venice, but with the figure groups more symmetrically arranged. Treasury of the Residenz, Munich, Germany.

Photograph: courtesy of the Residenz, Munich, Germany.

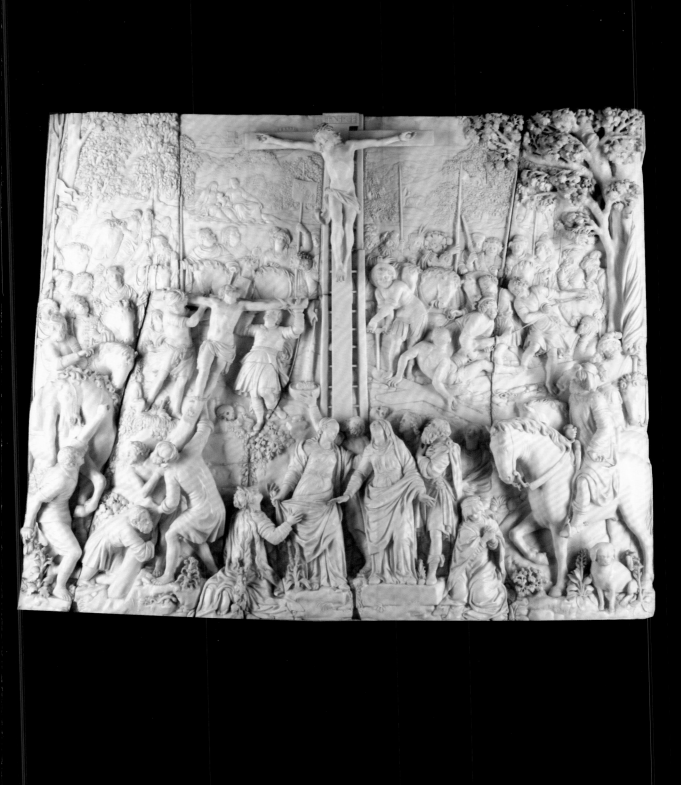

Cross on a Salt

You are the salt of the earth... You are the light of the world: this is the theme I have chosen for the next World Youth Day. The images of salt and light used by Jesus are rich in meaning and complement each other. In ancient times, salt and light were seen as essential elements of life.

You are the salt of the earth... One of the main functions of salt is to season food, to give it taste and flavour. This image reminds us that, through Baptism, our whole being has been profoundly changed, because it has been "seasoned" with the new life which comes from Christ. The salt which keeps our Christian identity intact even in a very secularised world is the grace of Baptism. Through Baptism we are re-born. We begin to live *in Christ* and become capable of responding to his call to *offer our bodies as a living sacrifice, holy and acceptable to God*. Writing to the Christians of Rome, Saint Paul urges them to show clearly that their way of living and thinking was different from that of their contemporaries: *Do not be conformed to this world, but be transformed by the renewal of your mind, that you may discern what is the will of God, what is good and pleasing and perfect.*

For a long time, salt was also used to preserve food. As the salt of the earth, you are called to preserve the faith which you have received and to pass it on intact to others.

Blessed John Paul II,
World Youth Day, Toronto, July 2002
1920-2005

Silver-gilt and enamel Salt, Nuremburg 1550. Christ, the centurion on his horse, the Virgin, St John and Biblical scenes depict the drunkenness of Noah, Abraham and the three angels, Lot and his daughters, the baptism of Christ, the woman of Samaria, and the good Samaritan. Private collection.

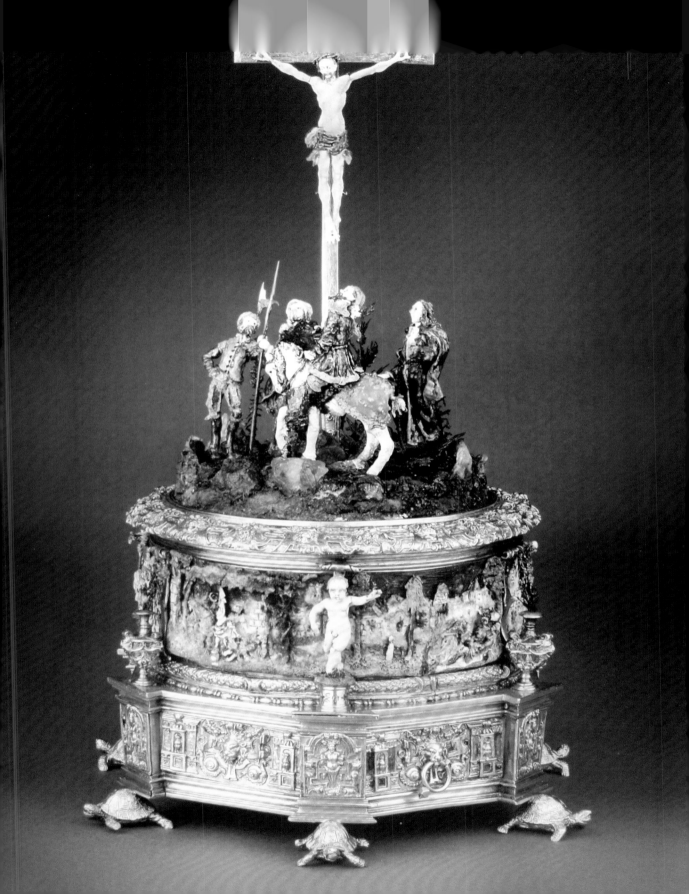

Cross on a Saddlecloth

The disconcerting thing is that England's Patron Saint is one of the most obscure and doubtful personages in Christian hagiography, and that's saying something! And yet, look how mightily he has been built up over the centuries. Since the end of the 14th Century St George has been acknowledged Patron Saint of England, but long before that he was such in popular imagination. Soldiers went into battle bearing the sign of St George on their front and backs. Shakespeare gave voice to this in his wonderful Henry V:

'I see you stand like greyhounds in the slips,
Straining upon the start. The game's afoot:
Follow your spirit; and, upon this charge
Cry God for Harry, England and St George!'

But England is not the only country to claim him as patron. He is also the patron saint of Aragon, Catalonia, Georgia, Lithuania, Palestine, Portugal, Germany and Greece; and of Moscow, Istanbul, Genoa and Venice (second to St Mark). He is patron of soldiers, cavalry and chivalry; of farmers and field workers, Boy Scouts and butchers; of horses, riders and saddlers; and of sufferers from leprosy, plagues and syphilis.

And yet very, very little is known of him! Let me tell you what we do know.

Our earliest source, Eusebius of Caesarea, writing c. 322, tells of a soldier of noble birth who was put to death under Diocletian at Nicomedia on 23 April, 303, but makes no mention of his name, his country or his place of burial. According to doubtful tradition, George held the rank of tribune in the Roman army and was beheaded by Diocletian for protesting against the Emperor's persecution of Christians. George rapidly became venerated throughout Christendom as an example of bravery, defending the poor and helpless and standing up for the Christian faith. Though little is known of him, he remains today as an example of a Christian who is prepared to go into battle, risking everything for his or her Lord.

The Rt Hon and Rt Rev'd Dr George Carey, (Archbishop of Canterbury 1991-2002)
From a sermon on St George's day
1935-

Gold, pearls and other precious stones, statuette of St George, made to house a relic of St George that Archbishop Ernst of Cologne sent to his brother Duke Wilhelm V of Bavaria in 1586.

Photograph courtesy of the Residenz, Munich, Germany.

344

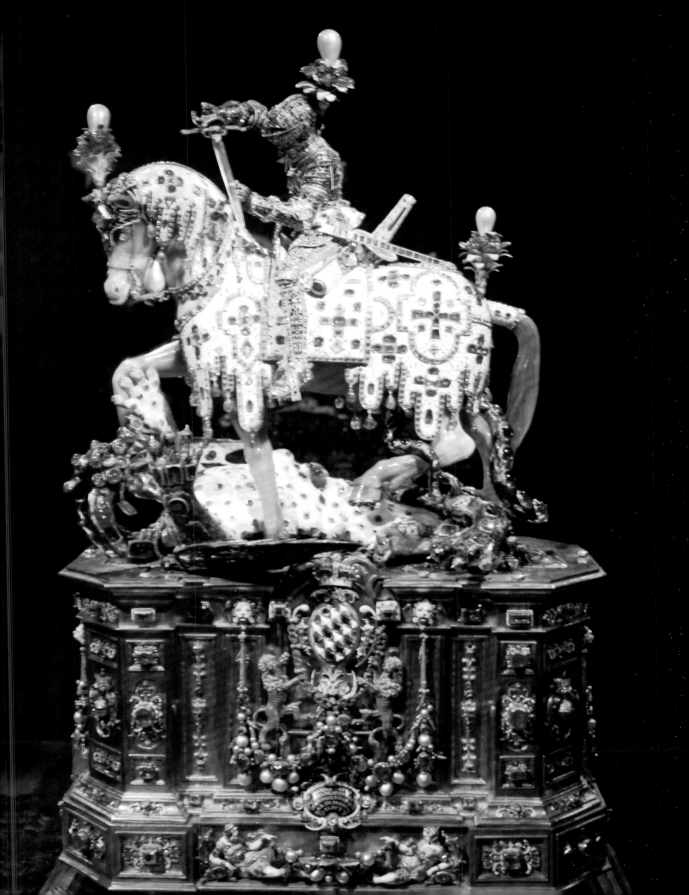

Cross on a Shopfront

In grüner Landschaft Sommerflor,
Bei kühlem Wasser, Schilf, und Rohr,
Schau, wie das Knäblein Sündelos
Frei spielet auf der Jungfrau Schoss!
Und dort im Walde wonnesam,
Ach, grünet schon des Kreuzes Stamm!

Bei kühlem Wasser, Schilf und Rohr,
Schau, wie das Knäblein Sündelos
Frei spielet auf der Jungfrau Schoss!
Und dort im Walde wonnesam
Ach, grünet schon des Kreuzes Stamm!
"Auf ein altes Bild"

In the green countryside in summer bloom,
Beside cool waters, reeds and canes,
See, how the blameless child
Plays free in the maiden's lap.
And there in those woods so sweet,
Oh, there grows already the wood of the cross!

In a landscape decked in summer green,
by cool water, rush and reed,
see how the little innocent child
plays on the virgin's!
Ah, but there in the delightful forest
the tree of the Cross is already in leaf.

Eduard Mörike,
1804-1875

Painted shop front, 1633 and repainted in 2010, Oberammergau, Germany.

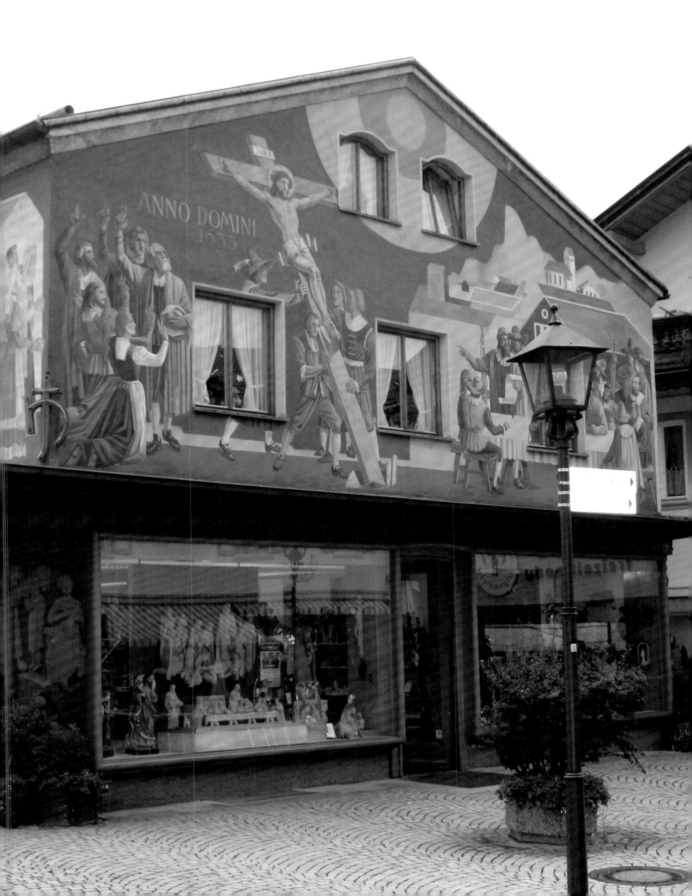

Cross of the Passion

O sacred head, sore wounded,
defiled and put to scorn;
O kingly head surrounded
with mocking crown of thorn:
What sorrow mars thy grandeur?
Can death thy bloom deflower?
O countenance whose splendor
the hosts of heaven adore!

Thy beauty, long-desirèd,
hath vanished from our sight;
thy power is all expirèd,
and quenched the light of light.
Ah me! for whom thou diest,
hide not so far thy grace:
show me, O Love most highest,
the brightness of thy face.

Arnulf von Loewen,
1200-1250
Translated by P Gerhardt,
1607-1676

Carved and painted wooden statue, parish church of St Peter and St Paul, Oberammergau, Germany.

Left: Baroque lid of the Baptismal Font, Monastery of Ettal, Bavaria, Germany.

Miniature Crosses on Golgotha

Are you afraid to follow me to Calvary
in case you are involved
in something you cannot control?
I want friends who follow me even to the cross itself,
who accept even the most painful changes in their comfortable lives.
I want each of you as an individual,
so do not slip back into the anonymity of your group,
like a timid person in the crowd
by the way of the cross in Jerusalem.
What part would you have played on that day?
Would you have spoken up for me?
Helped me to carry my cross?
Wiped my brow?
I loved everyone along the road,
those who jeered,
those who were afraid,
those who beat me.
I did not judge anyone.
There is no need to be afraid;
I was not recording
who was a friend and who an enemy.
I loved them all and longed for their repentance.
Come, follow me and do not fear nor judge.
I am for all.
All are welcome to follow me.

Richard Hobbs,
1934-1993

Carved wooden tableau, the Heimatmuseum, Oberammergau, Germany.

This small box showcases tiny painted wooden figures of the Passion.

Crosses of Wood Shavings

Lord, help us to see in your crucifixion and resurrection an example of how to endure and seemingly to die in the agony and conflict of daily life, so that we may live more fully and creatively. You accepted patiently and humbly the rebuffs of human life, as well as the tortures of your crucifixion and passion. Help us to accept the pains and conflicts that come to us each day as opportunities to grow as people and become more like you. Enable us to go through them patiently and bravely, trusting that you will support us; for it is only by dying with you that we can rise with you.

Blessed Teresa of Calcutta,
1910-1997

A small wooden image of Christ on the Cross is made of wood and then painted. The remarkable woven and embroidered spider's web that surrounds the central motif is made of wood shavings in Oberammergau, Bavaria, Germany.

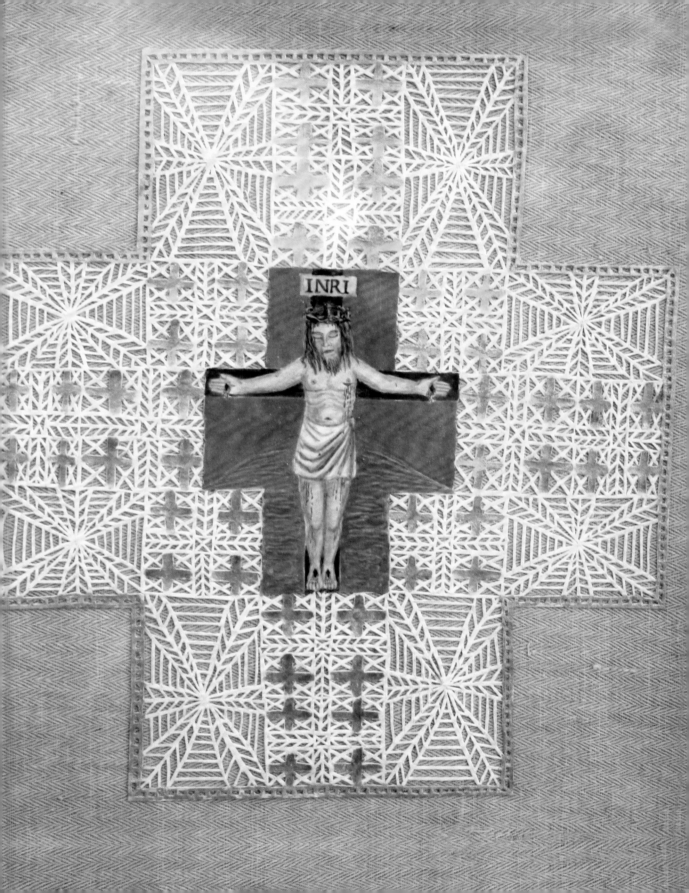

Cross on the Berlin Wall

Jesus wants to take your life and join it to His.
Let yourself be embraced by Him.
Gaze no longer upon your own wounds,
Gaze upon His.
Do not refuse His love.

Pope Benedict XVI,
1927-

Crosses on the Berlin wall, marking the spot where young men were killed trying to escape to the West. Berlin, Germany.

The 96 mile-long Berlin wall, designed to keep the East Germans inside, stood for 28 years until 9 November 1999 when the wall was cracked. More than 130 people were killed trying to flee to the West. To mark the anniversary of his death in 1990, a grieving mother takes a bunch of flowers to her son's grave beside the Berlin Wall where he was shot while trying to escape. His crime, like so many thousands of East Germans during the 28 years their country was divided, was a simple desire to climb a wall.

Cross commanding the Bridge

Eternal, omnipotent God, in whom the sole hope of the world is,
Of Heaven the Maker Thou, of earth, too, the lofty Creator:
Consider, we pray Thee, Thy people, and gently, from out Thy high dwelling
Look down lest they turn their steps to the place where Erinis is ruler;
There where Allecto commands, Megaera dietetic the measures
But rather by virtue of him, this emperor Charles whom Thou lovest
O most beneficent God, may'st Thou graciously please to ordain it
That, through the pleasant glades of forests ever in flower,
And through the realms of the bless'd, their pious leader may bring them
Into the holy shades, where the heavenly waters will quicken
The seeds that were sown in the life, and where the ripe crops are made glorious
Cleansed in supernal founts from all of the thorns they have gathered.
Thus may the harvest be God's, and great may its worth be in future
Heaping a hundred fold the corn in the barns overflowing.

The Holy Roman Emperor, Charles IV,
The Golden Bull of 1356

A statue of Christ holding His Cross on the 1770 foot long Charles Bridge, built originally in 1357 to connect the two halves of the city of Prague. At the beginning it was simply a functional construction and during many years the only decoration on the bridge was a simple Crucifix, but later in 16th-18th centuries the urge for ornamentation resulted in the construction of 30 statues. Prague, the Czech Republic.

Left: St Wenceslas (907-935) presents the Holy Roman Emperor, Charles IV (1316-1378) to the Virgin Mary and the infant Jesus; oil painting on wood,1350 by the Master of Vyšší Brod, the Cistercian Monastery of the Assumption, Vyšší Brod, Bohemia, now in the convent of St Agnes of Bohemia, Prague, the Czech Republic.

Photograph courtesy of the convent of St Agnes of Bohemia.

Cross in a Psalter

Warmth, love and tenderness are not to be associated with Christ's crucifixion and yet the autumnal colours of this depiction are warm as they speak of God's love for us through a death that unexpectedly brings life.

Both Mary and John are looking at Jesus at the precise moment at which he is pouring out His life for the sake of the world. This death is costly and the expression on Jesus' face underlines this truth: His earthly life is draining away. Any moment now… "By the will of the Father and the work of the Holy Spirit your death brought life to the world."

John, the disciple, is holding out his hand to Mary as he looks at the crucified saviour. Mary, it would seem, is not ready to let go and to take John's hand to whom she has been entrusted by Jesus. She too looks at the crucified one, her Son. Her hands are clasped tightly in a gesture of fervent prayer and wrapped firmly in her outer garment. She is not ready to take the hand that John is offering and entrust herself to him. She must not abandon hope. She must stand in prayer at the foot of the cross until the very end. She is fully present to the situation, whereas John while in the moment is looking to the future by opening Himself to Mary.

As blood gushes from Jesus' side to soak the world forever with His life, blood is also issuing forth from the wounds of the crucifixion. The blood from the nails driven into Jesus' legs is making its way to the place of shadows (Sheol). There it will conquer death and bring forth life. The moment in which a new creation in His blood will be born is imminent! The blood from the wounds of Jesus' wrists is trickling down onto His mother and the disciple, that they who are at the foot of the cross may be the first recipients of the life that only He can give: the fullness of life that He came to bring. "By His wounds you have been healed." (1 Peter 2:24)

The Venerable Patrick Curran, Archdeacon of the Eastern Archdeaconry, Chaplain of Christ Church, Vienna with Klagenfurt, Ljubljana and Zagreb, Diocese of Gibraltar in Europe, 1956-

Parchment psalter illumination of the Crucifixion, 1260, Melk Abbey.

Photograph: courtesy of Melk Abbey, Austria.

One of 12, thought to have been made in Bamberg in 1255, the manuscript of Melk is one of the several (roughly 1200) medieval scriptures of the Benedictine monastery of Melk and contains, apart from a calendar and 150 psalms, 15 full length page miniatures and various initials. These pictures are not only decorations for the manuscript but have also the function of dividing and highlighting important text passages. Each scene is framed in various ways by ornamental or floral borders and is depicted in front of a golden ground. The action is concentrated on the figures, with only the slightest hint of either interior or landscape.

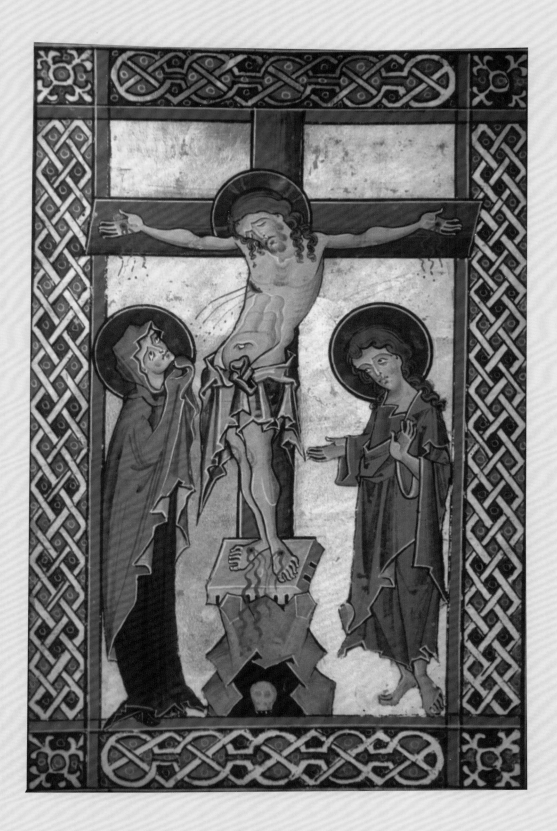

Cross of Queen Gisela

My beloved son, delight of my heart, hope of your posterity, I pray, I command, that at every time and in everything, strengthened by your devotion to me, you may show favour not only to relations and kin, or to the most eminent, be they leaders or rich men or neighbors or fellow countrymen, but also to foreigners and to all who come to you. By fulfilling your duty in this way you will reach the highest state of happiness. Be merciful to all who are suffering violence, keeping always in your heart the example of the Lord who said, "I desire mercy and not sacrifice." Be patient with everyone, not only with the powerful, but also with the weak.

St Stephen of Hungary,
975-1038

Jewelled gold Cross commissioned by Queen Gisela of Hungary in 1006 for the tomb of her mother, Gisela of Burgundy, Duchess of Bavaria, who was buried in the Niedermünster in Regensburg, Germany.

Photograph courtesy of the Residenz, Munich

Left: Modern iron statue of St Stephen, King of Hungary, Fisherman's Bastion, Budapest, Hungary.

Cross in the Auditorium

Was putting His Son to death on the cross necessary for the salvation of humanity? We must ask ourselves: Could it have been different? Could God have *justified Himself* before human history, so full of suffering, without placing Christ's Cross at the centre of that history? Obviously, one response could be that God does not need to justify Himself to man. It is enough that He is omnipotent. From the perspective everything He does or allows must be accepted. This is the position of the biblical Job. But God, who besides being Omnipotence is Wisdom and – to repeat once again – Love, desires to justify Himself to mankind. He is not the Absolute that remains outside of the world, indifferent to human suffering. He is Emmanuel, God-with-us, a God who shares man's lot and participates in his destiny.

God is not someone who remains only outside of the world, content to be in Himself all-knowing and omnipotent. *His wisdom and omnipotence are placed, by free choice, at the service of creation.* If suffering is present in the history of humanity, one understands why His omnipotence was manifested *in the omnipotence of humiliation on the Cross.* The scandal of the Cross remains the key to the interpretation of the great mystery of suffering, which is so much a part of the history of mankind.

Blessed John Paul II,
Crossing the Threshold of Hope: *Scandalum Crucis*
1920-2005

Mass, Wroclaw, Poland.

Photograph: Deidre McNair-Wilson.

At the recent commemoration of the millennium of St Adelbert's martyrdom, Pope John Paul II sits on his Papal throne under a replica of the cross of St Francis of Assisi, addressing the crowd during the 46th International Eucharistic Congress in Wroclaw, Poland in May 1997. The 46th International Eucharistic Congress in Wroclaw centering on the main theme: *For freedom Christ has set us free* (Gal 5:1) marked the 1,000th anniversary of St Adalbert's martyrdom and the 600th anniversary of the foundation of the Jagiellonian University of Kraków. The Eucharistic Congress began on Trinity Sunday, 25 May, and finished with a solemn Mass – *statio orbis* – celebrated by Blessed John Paul II.

Hill of Crosses

Thank you, Lithuanians, for this Hill of Crosses which testifies to the nations of Europe and to the whole world, the faith of the people of this land.

A stone inscribed with the words of Pope John Paul II,
Šiauliai, Lithuania, 1993

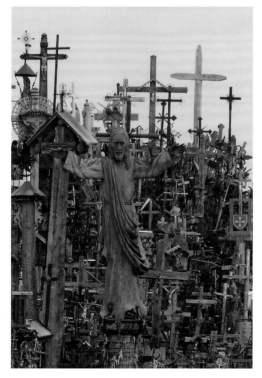

The Hill of Crosses: Kryžių kalnas, a site of pilgrimage north of Šiauliai, northern Lithuania.

Photographs: Godfrey Smythe

Over the centuries, the place has come to signify the peaceful endurance of Lithuanian Catholicism despite the threats it faced throughout history. The precise origin of the practice of leaving crosses on the hill is uncertain, but it is believed that the first crosses were placed on the former Jurgaičiai or Domantai hill fort after the 1831 Uprising. Over the centuries, not only crosses, but giant crucifixes, carvings of Lithuanian patriots, statues of the Virgin Mary and thousands of tiny effigies and rosaries have been brought here by Catholic pilgrims. The exact number of crosses is unknown, but estimates put it at about 55,000 in 1990 and 100,000 in 2006. The site took on a special significance between 1944 and 1990, during the Soviet Union's occupation. Lithuanians continued to travel to the Hill and leave their tributes, demonstrating their allegiance to their original identity, religion and heritage. It was a venue of peaceful resistance, although the Soviets worked hard to remove new crosses.

Left: Statue of Christ on the Hill of Crosses, Šiauliai, Lithuania.

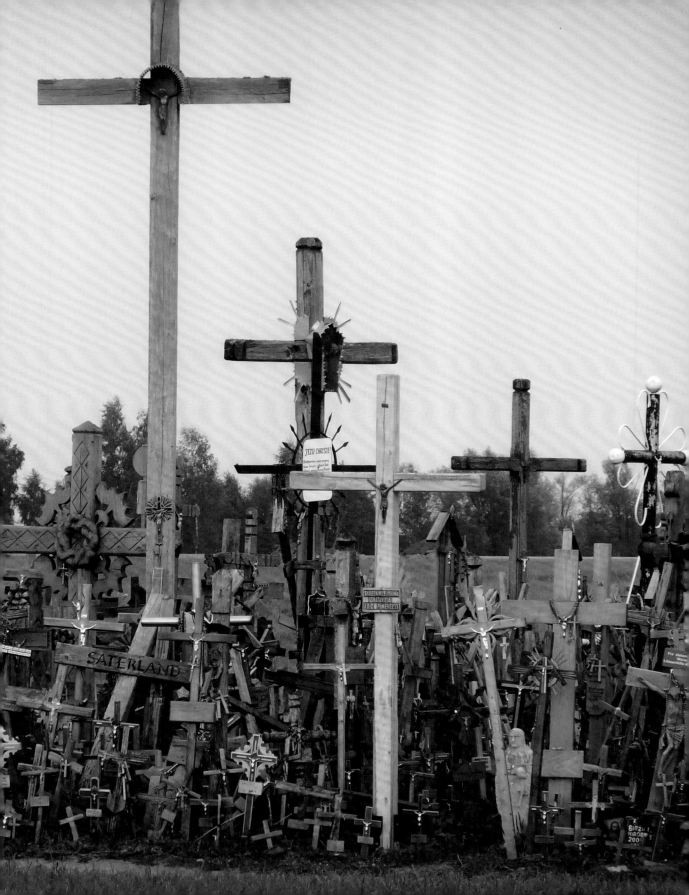

The British Empire in the East:

India
Sri Lanka
China
Australia

The Americas:

The United States
The Bahamas
Mexico
Brazil
Argentina
Peru

The Cross in Nature

Cross on an Orb

C. 1600, miniature, opaque watercolour and gold on paper. Attributed to Abu'l Hasan (b. 1588; fl. 1600-1630), Mughal, Allahabad, India. Collection: Mr and Mrs Indar Pasricha.

Photograph: Justin Hunt.

The miniature might well have been done for the Mughal emperor Jahangir (reigned 1605-1627) when a prince, after he had rebelled against his father Akbar (reigned 1556-1605) and set up a rival court at Allahabad in 1600. With him were the young Abu'l Hasan and his father, Aqa Riza. On the reverse are the seals of the librarians of Shah Jahan (reigned 1627-1658) and Aurangzeb (reigned 1658-1707). The composition (in reverse) is derived from an engraving by Hieronymus Wierix (1553-1619), Flemish. Jahangir collected European prints brought by the Jesuits from Goa, had a passion for accurate copies by his artists and an obsession with the identity of Jesus. An impression of the engraving is in the British Museum.

Cross of St Francis Xavier

Eternal God, Creator of all things, remember that You alone has created the souls of unbelievers, which You have made according to Your Image and Likeness.

Behold, O Lord, how to Your dishonor many of them are falling into Hell.

Remember, O Lord, Your Son Jesus Christ,
Who so generously shed His Blood and suffered for them.

Do not permit that Your Son, Our Lord, remain unknown by unbelievers, but, with the help of Your Saints and the Church, the Bride of Your Son, remember Your mercy, forget their idolatry and infidelity, and make them know Him, Who You have sent, Jesus Christ, Your Son, Our Lord, Who is our salvation, our life, and our resurrection, through Whom we have been saved and redeemed, and to Whom is due glory forever.
Amen.

St Francis Xavier,
Apostle of the Indies,
1506-1552

16th-century cross of St Francis Xavier, the avenue of the church of Bom Jesus, Old Goa, India.

Cross and the Virgin Mary

Lean on the Cross of Jesus as the Virgin did and you will not be deprived of comfort. Mary was as if paralyzed before her crucified Son, but one cannot say that she was abandoned by Him. Rather how much more did she not love Him when she suffered and could not even weep?

St Padre Pio of Petrelcina,
1887-1968

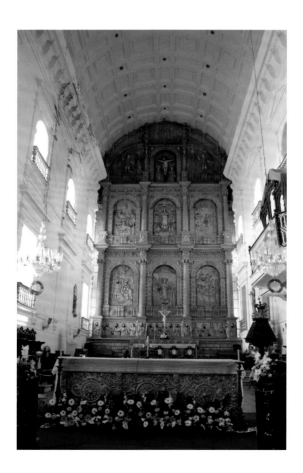

Side altar dedicated to the Virgin Mary, Se Cathedral of St Catherine of Alexandria, 1619, Old Goa, India.

Christianity arrived in Goa with the Portuguese explorer Vasco de Gama in 1497. The Se Cathedral was built to commemorate the Portugeuse victory under Afonso de Albuquerque over a Muslim army, leading to the capture of the city of Goa in 1510. As the day of his victory was on the feast of Saint Catherine, the cathedral was dedicated to her. In 1552, Governor George Cabral was commissioned to enlarge the cathedral on the remains of an earlier structure. Construction began in 1562 during the reign of King Sebastian of Portugal and was finally completed in 1619 and consecrated in 1640. It originally had two towers, but one collapsed in 1776 and was never rebuilt.

The State of Goa was only absorbed into India in 1956. It still has hundreds of Roman Catholic churches in use to-day.

Left: The Golden reredos, Se Cathedral, Old Goa, India.

370

Cross in Kashmir

My Lord, I offer myself as a sacrifice of thanksgiving.
Thou hast died for me, and I in turn make myself over to thee.
I am not my own: thou hast bought me;
I will by my own act and deed complete the purchase.
My wish is to be separated from everything in this world;
to cleanse myself simply from sin;
to put away from me even what is innocent,
if used for its own sake and not for thine.
I put away reputation and honour and influence and power,
for my praise and strength shall be in thee.
Enable me to carry out what I profess.

Blessed John Henry Newman,
1801-1890

Marble tomb of Mabel Emily, aged 25, wife of Lt Col. Cunningham, died in Srinagar, Kashmir, India, 1905.

Cross of a Tea Planter

Almighty God, who hast shown in the life and teaching of thy Son the true way of blessedness, thou hast also showed us in his suffering and death that the path of love may lead to the cross, and the reward of faithfulness may be a crown of thorns. Give us grace to learn these hard lessons. May we take up our cross and follow Christ in the strength of patience and the constancy of faith; and may we have such fellowship with him in his sorrow that we may know the secret of his strength and peace, and see even in our darkest hour the shining of the eternal light, for his sake who died and rose again for us, the same Jesus Christ our Lord.

John Hunter,
1849-1917

Tombstone of British tea planter, Cecil William Charles Shelley aged 42, Holy Trinity Church, Nuwara Eliya, Sri Lanka.

IN MEMORY
OF

CECIL WILLIAM
AGED 42 YEARS

Calligraphy Cross

In comparing my former experience with what I now desire to move into, myrrh and frankincense were then only as drops of perfume. Henceforth these sweet odours must be like mountains and hills in their fullness so that, by this fuller identification with Christ in His cross and resurrection, there may spring up within me a transcendent overcoming power, a greater degree of spiritual perception, a closer relationship between my soul and God, and a more complete deliverance from this wilderness world.

What is meant by "follow"? To follow signifies that the way I tread and the place where I go are all decided by someone else. We are following the Lord; therefore we have no authority to decide our own path. The body in its relation to the Head can only obey and follow.

If we wish to live out the life of the body of Christ we must cover our own head; that is to say, we must not have our personal opinion, egoistic will or selfish thought. We can only obey the Lord and let Him be the Head.

Many times I like to think of God's Word as God's pocket for His work. God put all His work into His Word. If God were standing among us today, and He wanted to show us His Son's work and the proof of this work, how could He do it? He put the work of His Son's cross in his Word. He also put the proof of His Son's resurrection in His Word. Today God communicates all these things to us through His Word. When we receive His Word, we receive the proof of His work. Behind the Word are the facts. If there were no facts behind the words, the words would be empty. Behind the words there surely are the facts. God has placed the work of His Son in the Word and has communicated this Word to us. When we believe in His Word, we are believing in Him.

Watchman Nee,
1903-1972

Symbol of PEACE as rendered in Chinese calligraphy.

Image courtesy of Jane Blunden and Carmel Scerder, Looe, Cornwall

Cross in Hong Kong

Jesus in the gospel tells us "that the world is opposed to those who stand under the authority of Jesus as Lord." Now, we have to be careful here. It is clearly not the case that everything in the world is bad. Far from it, it is God's world and it is a place of beauty where we are nourished and fed. The world too is not full of bad and evil people who oppose what we stand for. But in John's gospel the world stands for all those who fight the good, who seek to build a different kingdom. We see signs of that by the way Western culture is going in declining standards, in rejection of traditional moral values based on the Christian faith, and resistance to spiritual things. George Orwell was among the first, nearly 70 years ago, to notice what was going on. In one of his books he writes these words: "I thought of a rather cruel trick I once played on a wasp. He was sucking jam on my plate, and I cut him in half. He paid no attention, merely went on with his meal, while a tiny stream of jam trickled out of his severed œsophagus. Only when he tried to fly away did he grasp the dreadful thing that had happened to him. It is the same with modern man. The thing that has been cut away is his soul".

It is easy to feel despondent when a nation seems to be turning away from God, and there often rises a corresponding temptation to engage in more activities to somehow meet the challenge. But Jesus says something startling in the gospel reading which may be a word for us. You are "chosen" he tells his disciples. Now to be chosen means that our place is secure; there is no need to struggle as if our place is in danger. We might translate this in terms of the church's mission as a call to remain constant, firm and rejoicing.

Timothy in his epistle offers us a different thought. There Paul says this; "Share in suffering as a good soldier of Jesus Christ" In this passage Paul uses three images for the Christian going about his or her business. The three are soldiers, farmers and athletes. He hammers home one point: nothing worth while is ever painless.

We must be noted for depth and for quality. Few things in life come easily. T S Eliot in Murder in the Cathedral says "A Christian martyrdom is never an accident, for saints are not made by accident". A church is in the saint making business, busy with the task of preparing people for God's kingdom. It is always hard work with some disappointments along the way, but often many rewards.

The Rt Hon and Rt Rev'd Dr George Carey, (Archbishop of Canterbury 1991-2002) 1935-

Stained glass window of the Crucifixion, St John's Cathedral, Hong Kong, China. Built in 1849, this is the oldest surviving Western ecclesiastical building in Hong Kong, and the oldest Anglican church in the Far East.

Photograph: David Wright.

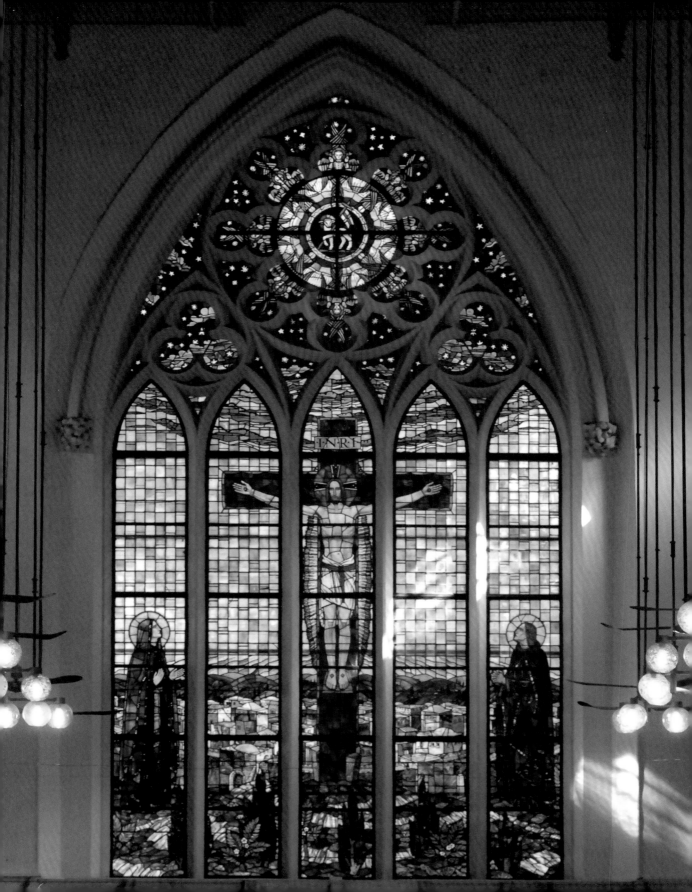

Cross under the Southern Cross

When your fathers fixed the place of GOD,
And settled all the inconvenient saints,
Apostles, martyrs, in a kind of Whipsnade,
Then they could set about imperial expansion
Accompanied by industrial development.
Exporting iron, coal and cotton goods
And intellectual enlightenment
And everything, including capital
And several versions of the Word of GOD:
The British race assured of a mission
Performed it, but left much at home unsure.
Of all that was done in the past, you eat the fruit, either rotten or ripe.
And the Church must be forever building,
and always decaying, and always being restored.
For every ill deed in the past we suffer the consequence:
For sloth, for avarice, gluttony, neglect of the Word of GOD,
For price, for lechery, treachery, for every act of sin.
And of all that was done that was good, you have the inheritance.
For good and ill deeds belong to a man alone,
when he stands along on the other side of death,
But here upon earth you have the reward of the good and ill that was done
by those who have gone before you.
And all that is ill you may repair if you walk together in humble repentance,
expiating the sins of your fathers;
And all that was good you must fight to keep with hearts as devoted as those
of your father who fought to gain it.
The Church must be forever building,
for it is forever decaying within and attacked from without;
For this is the law of life; and you must remember that while there is time of prosperity
The people will neglect the Temple, and in time of adversity they will decry it.
What life have you if you have not life together?
There is no life that is not community,
And no community not lived in praise of GOD.
Even the anchorite who meditates alone,
For whom the days and nights repeat the praise of GOD,
Prays for the Church, the Body of Christ incarnate.

T. S. Eliot,
Choruses from *The Rock*
1888-1965

St Peter's church, Sydney, the first church to be built by the British on the continent of Australia.

Cross for a Coffin

There is one thing we must not forget: it has always been the Mother who reached people in missionary situations and made Christ accessible to them. That is especially true of Latin America. Here, to some extent, Christianity arrived by way of Spanish swords, with deadly heralds. In Mexico, at first, absolutely nothing could be done about missionary work – until the occurrence for the phenomenon at Guadalupe, and then the Son was suddenly near by way of his Mother.

Pope Benedict XVI,
1927-

Flower seller with a customer buying an elaborate cross for a coffin, Mexico City, Mexico.

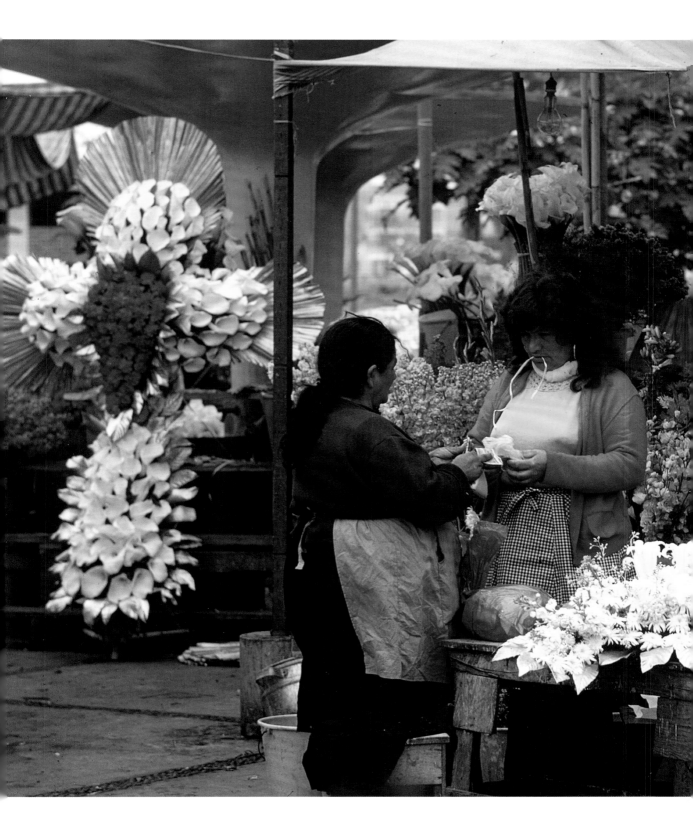

Christ shoulders His Cross

God's love shines down on me like the light rays of the sun,
God's love is poured forth lavishly like a fountain
Spilling forth its waters in an unending stream.
God's delight and joy is to be with the ones called God's children – to be with me.
God cannot do enough to speak out and show love for me,
Ever calling me to a fuller and better life, a sharing in divine life.

St Ignatius Loyola,
1491-1556

Brazilian baroque life size polychrome and wood statue of Christ carrying His Cross.

Photograph: Dr John Hemming.

One of a set of life size statues created between 1796 and 1800 by Antonio Francisco Lisboa, (always known by his nickname Aleijadinho "Little Cripple"). marking the Stations of the Cross, in alcoves beside the steps leading up to the Sanctuary of Bom Jesus do Congonhas (Santuário do Bom Jesus de Matosinhos), a religious complex built in 1773 in the state of Minas Gerais, Brazil.

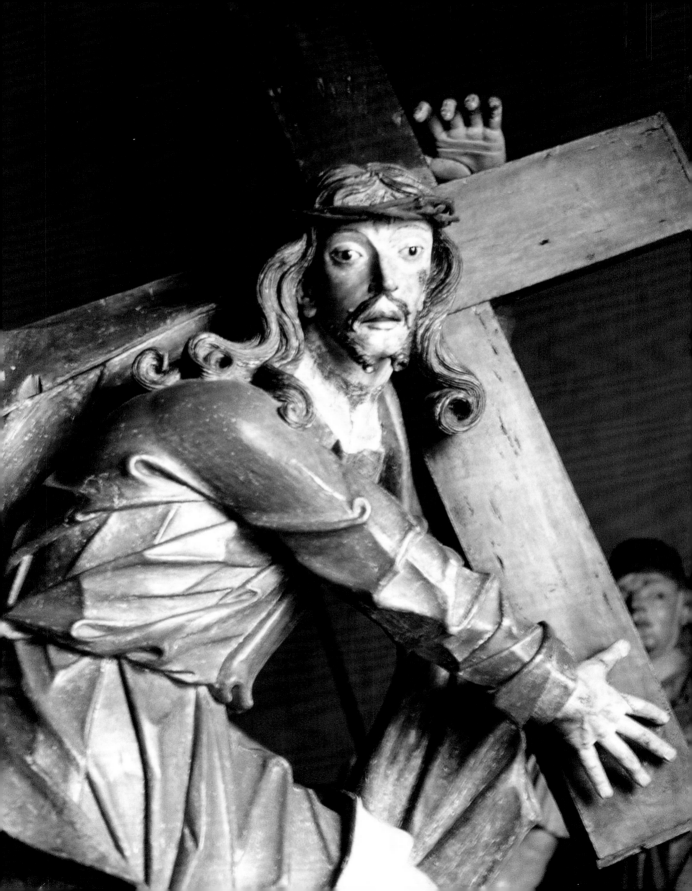

Cross in Argentina

O ye souls that desire to walk in the midst of consolation and security, if only ye knew how acceptable to God is suffering for his love, and how great a means it is to arrive at every other spiritual good, ye would never seek for consolation in anything, but you would rather rejoice when ye bear the cross after your Lord.

I wish I could persuade spiritual persons that the way to perfection does not consist in so many different practices; nor in thinking much; but in denying ourselves on every occasion, and in giving ourselves up to suffer all things for the love of Christ; if they fail in the performance of this exercise, every other method of walking in the spiritual life is but standing still and mere trifling, without any profit, even though they had the gift of the highest contemplation and the most intimate communication with God.

St John of the Cross,
1542-1591

18th-century alterpiece: Christ on His cross with the Virgin Mary and St Dominic, the church of San Jose, province of Salta, Argentina.

Photograph: Harriet Cullen.

Cross and the Virgin of Sorrows

The highest and most perfect kind of prayer is contemplation. But to arrive at this is altogether God's work, it being supernatural, and far above our poor natural powers; and therefore it is that in this prayer the soul can do nothing; all she can do is to prepare herself for its coming, when it shall please God to send it upon her. Now the best preparation she can make for so great a grace is to walk with humility, and with all earnestness to seek after every virtue, and chiefly that of brotherly charity and the love of God; to have a most firm purpose in all things to do the will of God: to tread the thorny way of the cross, and to make all self-love die within us; for if we kill not self-love, it will make us strive to please ourselves rather than God.

St Theresa of Avila,
1515-1582

18th-century altarpiece from Peru, chapel of El Carmen, province of Salta, Argentina.

Photograph: Harriet Cullen

Cross on a Breastplate

O Glorious Prince of the heavenly host, St Michael the Archangel, defend us in the battle and in the terrible warfare that we are waging against the principalities and powers, against the rulers of this world of darkness, against the evil spirits. Come to the aid of man, whom Almighty God created immortal, made in His own image and likeness, and redeemed at a great price from the tyranny of Satan.

Fight this day the battle of the Lord, together with the holy angels, as already thou hast fought the leader of the proud angels, Lucifer, and his apostate host, who were powerless to resist thee, nor was there place for them any longer in Heaven. That cruel, ancient serpent, who is called the devil or Satan who seduces the whole world, was cast into the abyss with his angels. Behold, this primeval enemy and slayer of men has taken courage. Transformed into an angel of light, he wanders about with all the multitude of wicked spirits, invading the earth in order to blot out the name of God and of His Christ, to seize upon, slay and cast into eternal perdition souls destined for the crown of eternal glory. This wicked dragon pours out, as a most impure flood, the venom of his malice on men of depraved mind and corrupt heart, the spirit of lying, of impiety, of blasphemy, and the pestilent breath of impurity, and of every vice and iniquity.

Arise then, O invincible Prince, bring help against the attacks of the lost spirits to the people of God, and give them the victory. They venerate thee as their protector and patron; in thee holy Church glories as her defence against the malicious power of hell; to thee has God entrusted the souls of men to be established in heavenly beatitude.

Amen.

16th-century oil painting of the Archangel Michael, the church of Santa Catalina, Arequipa, Peru.

Wall Tapestry of Crosses

For the Cross of Jesus Christ and its sacrifice, the love it offers,
the forgiveness it provides and the life it promises,

For the great company of Christian believers who carried the message
of the Cross to the nations of the this world,

For brothers and sisters in Jesus Christ who stand with us all
around the world at the foot of the Cross,

For this quilt of crosses in all its beauty and variety,

For your servant and our friend, Richard Bergmann,
who designed this tapestry,
for the women of this congregation and community who prepared these cross

y this work of love be for all who enter this hall a compelling reminder of you

faithfulness to our Lord who gave his life for the sins of the world upon the C

We dedicate these crosses, O God.

May this our church be a genuine fellowship of the Cross that our lives in wors
sharing and service may reflect your love,

In the name of the Father, the Son and the Holy Spirit. Amen.

Richard Bergman,
A Litany of the Crosses, 1995

Tapestry, Noroton Presbyterian Church, Darien, Connecticut, USA.

Photographs: courtesy of Richard Bergmann.

Richard Bergman, the architect and designer of the tapestry, wrote this pr
dedication of the tapestry. Each square depicts a different cross, embroide
member of the congregation.

Cross of Woven Grasses.

God is always on the side of the suffering. His omnipotence is manifested precisely in the fact that He freely accepted suffering. He could have chosen not to do so. He could have chosen to demonstrate His omnipotence even at the moment of the Crucifixion. In fact, it was proposed to Him: "Let the Messiah, the King of Israel, come down now from the cross that we may see and believe" (Mk 15:32). But He did not accept that challenge. The fact that He stayed on the Cross until the end, the fact that on the Cross He could say, as do all who suffer: "My God, my God, why have you forsaken me?" (Mk 15:34), has remained in human history the strongest argument. If the agony on the Cross had not happened, the truth that God is Love would have been unfounded.

Yes! God is Love and precisely for this He gave His Son, to reveal Himself completely as Love. Christ is the One who "loved ... to the end" (Jn 13:1). "To the end" means to the last breath. "To the end" means accepting all the consequences of man's sin, taking it upon Himself. This happened exactly as prophet Isaiah affirmed: "It was our infirmities that he bore, / ... We had all gone astray like sheep, / each following his own way; / but the Lord laid upon him / the guilt of us all" (Is 53:4-6).

The Man of Suffering is the revelation of that Love which "endures all things" (1 Cor 13:7), of which Love is the greatest (cf. 1 Cor 13:13). It is the revelation not only that God is Love but also the One who "pours out love into our hearts through the Holy Spirit" (cf. Rom 5:5). In the end, before Christ Crucified, the man who shares in redemption will have the advantage over the man who sets himself up as an unbending judge of God's actions in his own life as well as in that of all humanity.

Thus we find ourselves at the center of the history of salvation.

Blessed John Paul II,
Crossing the Threshold of Hope
1920-2005

Cross of woven grasses mounted on wood, by Diana W. Lockwood. St Andrew's Cathedral, Honolulu, Hawaii, USA.

Photograph: Terence Tofield.

Tau Cross in the Passion Flower

The venerable Bishop Palafox exercised himself much in this blessed meditation. In spirit he represented his soul like unto a bird flying on its course through the air, and stopping, when weary, to perch on the nail of our Lord's feet on the cross: here he gave himself to contemplate our Lord, and spiritually to drink his precious blood as it flowed from those wounds, and very great was the consolation of his heart. At other times he likened himself unto a bee gathering honey, first from one flower, then from another, of the wounds of Christ, those true and blood-red passion-flowers, but specially that sweetest and fairest of them all, the wound of his blessed side, opening to the treasure of treasures, the heart of Jesus, that most secret dwelling of the elect.

Venerable Bishop Juan de Palafox y Mendoza,
1600-1659

Blue Passion flower: (Passiflora caerula), England,

Photograph: Jim Wheeler

It clearly shows the Tau cross and the five wounds of Christ. Passion flowers or passion vines (Passiflora) are a genus of about 500 Species of flowering plant. The Passion in passion flower does not refer to love or sex, however, but to Christ's Passion. In the 15th and 16th centuries, Spanish Christian missionaries adopted the unique physical structures of this plant, particularly the numbers of its various flower parts, as symbols of the last days of Jesus and especially his Crucifixion. The pointed tips of the leaves were taken to represent the Holy Lance; the tendril represent the Whip used in the Flagellation of Christ; the ten petals and sepal represent the ten faithful Apostles (without St. Peter the deserter and Judas Iscariot the betrayer); the flower's radial filaments, which can number more than a hundred and vary from flower to flower, represent the the Crown of Thorns; the Chalice-shaped Ovary (plants) with its receptacle represents a hammer or the Holy Grail; the three gynoecium represent the three Nails and the five anthers below them the five Stigmata (four by the nails and one by the lance).

Left: Sand dollar shell, the Bahamas. It displays the same characteristics of the five wounds of Christ's Passion as in the Passion Flower.

Cross on a Donkey

When fishes flew and forests walked
And figs grew upon thorn,
Some moment when the moon was blood
Then surely I was born.

With monstrous head and sickening cry
And ears like errant wings,
The devils walking parody
On all four-footed things.

Fools! For I also had my hour;
One far fierce hour and sweet:
There was a shout about my ears,
And palms before my feet.

G K Chesterton,
The Donkey
1874-1936

Young donkey, Dubai, United Arab Emirates.

Cross in flight

O Christ who holds the open gate,
O Christ who drives the furrow straight,
O Christ, the plough, O Christ, the laughter,
O holy white birds flying after,
Lo, all my heart's field red and torn,

And thou wilt bring the young green corn
The young green corn divinely springing,
The young green corn for ever singing;
And when the field is fresh and fair
Thy blessed feet shall glitter there,
And we will walk the weeded field

And tell the golden harvest's yield,
The corn that makes the holy bread
By which the soul of man is fed,
The holy bread, the food unpriced,
The everlasting mercy, Christ

John Masefield,
1878-1967

A seagull, representing the Holy Spirit, flies over Mount Athos, Greece.

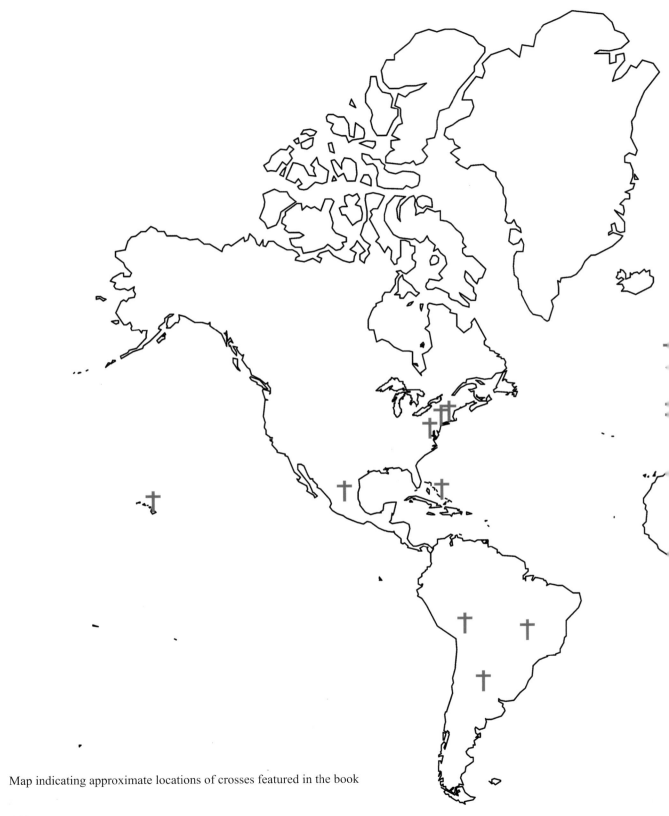

Map indicating approximate locations of crosses featured in the book

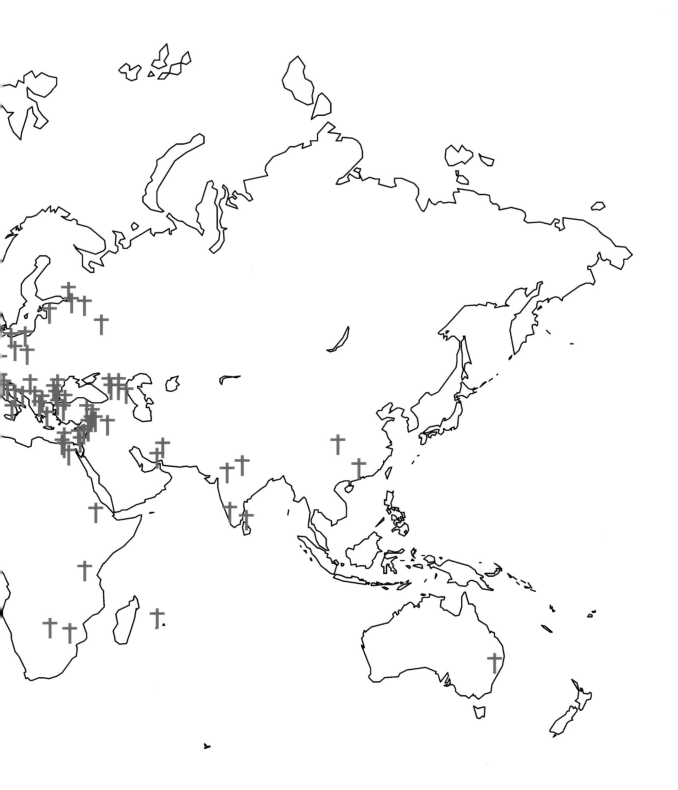

Authors

Sources

Aksit, I . *Ancient Civilisations and Treasures of Turkey*, Aksit, Istanbul, 2005

Alexander, J. & Binski, P *Art of Chivalry* Catalogue, Royal Academy of Arts, 1987

Arnold, B, *Irish Art* Thames & Hudson 1969

Benedict XVI, Pope *Jesus of Nazareth* Bloomsbury, 2007

Barraclough, G *The Christian World* Thames & Hudson, 1980

Beridze, Vaxtang, Alibegasvili, Gaiane, *The Treasures of Georgia* Century Pub. 1983

Blackhouse, J *Lindisfarne Gospels* Phaidon, Oxford, 1981

Bible, the New International Version Hodder & Stoughton, 1987

Borchegrave, H de *A Journey into Christian Art* Lion Publishing, 1999

Brion, M *The Medici* Elek Books, 1969

British Museum Press Catalogue: *Treasures of Heaven* 2010

Brookee, D *Wild Men and Holy Places* Canongate Press 1994

Brunner, H *The Treasury in the Residenz Munich* 1977

Burns, R *Monuments of Syria* I.B. Tauris, London, 1992

Capuami, M *Christian Egypt* American University Press, Cairo, 2002

Carey, T Therese of Lisieux, OCD *A Discovery of Love* New City Press, NY

Carter, W *Pontius Pilate* Liturgical Press, Minnesota, USA, 2003

Dalrymple, W *In Xanadu: a quest* Collins 1989

Dalrymple, W *From the Holy Mountain* Collins 1997

Deasy, J M *Cyprus, Byzantine Churches and Monastries*, Melinda, 1998

Ehrman, *B D Lost Scriptures* OUP, 2003

Eliot, T S *Selected Poems* Faber, 1957

Ethiopian Orthodox Faith, Order of Worship Tensae Publishing House, Tewahedo

Evans, H C & Wixom, W D *The Glory of Byzantium* Catalogue, Metropolitan Museum of Art, 1997

Finaldi, G *The Image of Christ* Catalogue, National Gallery, London, 2000

Fletcher, R *The Conversion of Europe* Harper Collins 1997

Forest, J *Praying with Icons* Orbis, New York, 1997

Hamel, C de *The Book: A History of the Bible* Phaidon, 2001

Hayward Gallery, London, Catalogue: *English Romanesque Art 1066-1200* 1984

Galey, J *Sinai and the Monastery of Saint Catherine* Chatto & Windus, London, 1979

Gilbert, A Magi: *The Quest for a Secret Tradition,* Bloomsbury, 1997

Gullick, Mayhew McCrimmon *God's Word for Our Time* Hollings, 1984

Goldner, Professor J P *Oberammergau* Gemeinde Oberammergau, 1980

Grabar, A *Byzantine Painting* Skira, 1960

Gumbel, N *Questions of Life* Kingsway Publications, 1993

Hancock, G & Willetts, D *Under Ethiopian Skies* Camerapix, Nairobi, 1997

Hanks, G *60 Great Founders* Christian Focus Publications, 1995

Harada, T *The Book of Ahtamar Reliefs* A Turizm Yayinlari, Istanbul, Turkey, 2003

Harcourt, G. & Melville. *Short Prayers for the Long Day* Collins, 1982

Hardy, Dr D A *From Byzantium to El Greco* Royal Academy of Arts, London, 1987

Hartin, P J *James of Jerusalem* Liturgical Press, Minnesota, 2004

Hobbs, R *The desire of My heart* Anthony Clarke Publications, 1995

Holland, T *From Rome to Jerusalem* Penguin 2007

Holland, T *Millennium* Little Brown, 2008

Hollerweger, H *Turabdin*, Freunde des Tur Abdin, Germany 1999

Hume, Cardinal B *To be a Pilgrim* Saint Paul Publications, 1984

John Paul II, Blessed *Crossing the Threshold of Hope* Jonathan Cape, London, 1994

John Paul II, Blessed *Faith & Reason* The Incorporated Catholic Truth Society, 1998

Kinross, P *Hagia Sophia* Reader's Digest, London, News Week, New York, 1973

Koc, V *Reunited After Centuries* Sadberk Hanim Museum, Istanbul, 2005

Lane, T *Christian Thought* Lion, 1984

Lisle, A de *The Diurnal of the Soul*: *or Maxims and Examples of the Saints for Every Day in the Year* London & Leamington Art & Book Company 1897

Lisle, A de *The Catholic Christian's Complete Manual* 1847

Lisieux, St Therese of, ed. Caret, T. OCD *A Discovery of Love* New City Press, NY

Loxton, H *The Encyclopedia of Saints* Chancellor Press, 1996

Luciani, A *Illustrissimi; The Letters of Pope John Paul 1* William Collins Ltd, 1978

Magnusson, M *The Wealth of a Nation* Catalogue, National Museum of Scotland, 1989

Meinardus, O F A *Monks and Monasteries of the Egyptian Desert* AUP, Cairo, 2006

Metcalfe, J *Christ Crucified* The Publishing Trust, 1987

Nee, Watchman *The Song of Songs* Christian Literature Crusade, 1977

Norman, D Siena, *Florence and Padua 1280-1400* Open University, 1995

Norwich, J J *The Normans in the South* Longman, 1967

Norwich, J J *The Kingdom in the Sun* Longman,1970

Norwich, J J & Sitwell, R *Mount Athos* Hutchinsons of London, 1966

Norwich, J J *A History of Venice: the Rise to Greatness* Alan Lane 1977

Norwich, J J *A History of Venice: the Greatness and the Fall* Alan Lane 1981

Norwich, J J *The Byzantine Trilogy* Longman, 1995

Norwich, J J *The Middle Sea* Doubleday 2006

Norwich, J J *The Italian World* Thames & Hudson, 1983

Norwich J J *The Popes* Vintage 2011

Pakenham, T *The Mountains of Rasselas*, Weidenfeld Nicolson

Polidoro, G *Francis of Assisi* Velar Franciscan Missions

Roberts P *John Chrysostom: The Jewish Gospel for a Gentile World* Arthur James 1996

Roberts, P *In Search of Early Christianity* Vantage Press, New York, 1985

Royal Academy Catalogue: *Age of Chivalry* 1987

Runciman, S *The First Crusade* Cambridge University Press, 1980

Saul, N *The Oxford Illustrated History of Medieval England* OUP, 1997

Sebag Montefiore, S *Jerusalem* Weidenfeld & Nicolson, 2011

Teresa, Mother & Roger, Brother *Meditations on the Way of the Cross* Mowbray, 1989

Temple, R *Icons and the Mystical Origins of Christianity* Luzak 2001

Thiede, C & D'Ancona, M *The Quest for the True Cross* Weidenfeld & Nicolson, 2000

Simpkins *Splendour of Egypt: Sinai 1982*

Speake, G *Mount Athos: Renewal in* Paradise Yale University Press 2002

Swaan, W *The Gothic Cathedral* Omega, 1984

Teilhard de Chardin, P *Le Milieu Divine* Fontana Books, 1970

Thiede, C P & D'Ancona, M *The Quest for the True Cross* Weidenfeld & Nicolson, 2000

Thomas, G *The Jesus Conspiracy* Lion Hudson, 2005

Thomas, G *Trial* Lion Publishing plc, 1997

Toman, R *Baroque, Architecture, Scultpture, Painting* Konemann, 1998

Toman, R *The Art of the Italian Renaissance* Konemann, 1995

Vassiliadis, N P *The Mystery of Death* Orthodox Brotherhood of Theologias 1993

Volskaja, A, Xuskivadze, L, Hasratyan, M, Sargsyan, Z *Armenia: 1700 Years of Christian Architecture* Moughni Publishers Yerevan, Armenia, 2001

Walker, A & Carras, C *Living Orthodoxy in the Modern World* SPCK, 1996

Walker, P *In the Steps of Jesus* Lion Hudson, 2007

Walker, P *In the Steps of Saint Paul* Lion Hudson, 2008

Weyer, R Van de *Celtic Fire* Darton, Longman & Todd 1994

Weyer, R Van de *Apostles of Peace*: Arthur James Ltd, 1996

Williams, H. A *True Resurrection* Mitchell Beazley, 1972

Yancey, P *The Jesus I Never Knew* Marshall Pickering, 1995